RUNNIN
WITH THE
DEVIL

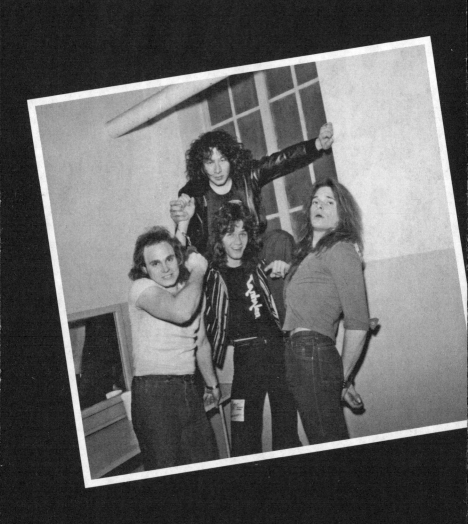

RUNNIN'
WITH THE
DEVIL

A BACKSTAGE PASS TO THE WILD TIMES,
LOUD ROCK, AND THE DOWN AND DIRTY
TRUTH BEHIND THE MAKING OF VAN HALEN

NOEL E.
MONK

with JOE LAYDEN

DEY ST.
An Imprint of WILLIAM MORROW

RUNNIN' WITH THE DEVIL. Copyright © 2017 by Noel Monk. All rights reserved. Printed in the United States of America. No part of this book may be used or reproduced in any manner whatsoever without written permission except in the case of brief quotations embodied in critical articles and reviews. For information, address HarperCollins Publishers, 195 Broadway, New York, NY 10007.

HarperCollins books may be purchased for educational, business, or sales promotional use. For information, please email the Special Markets Department at SPsales@harpercollins.com.

A hardcover edition of this book was published in 2017 by Dey Street Books, an imprint of William Morrow.

FIRST DEY STREET BOOKS PAPERBACK EDITION PUBLISHED 2018.

Designed by Paula Russell Szafranski

Library of Congress Cataloging-in-Publication Data has been applied for.

ISBN 978-0-06-247412-4

23 24 25 26 27 LBC 15 14 13 12 11

This book is dedicated to Bill Graham,

who put me on this path and encouraged

me to take the first steps on this amazing,

whirlwind of a journey. Thanks, man.

I owe you one, wherever you are.

PROLOGUE
1982

As the boys in the band descend from their limo, the smell of sex hangs in the air.

It grabs them by the nose, by the crotch, and yanks them forward, through a throbbing crowd of early arrivals, young girls mostly (but not exclusively), screaming and pleading, doing anything to get noticed and, perhaps, later in the night when the show is over, gain access to the inner sanctum where the real party begins. The boys pretend not to notice—by this point, roughly four years into a spectacular seven-year run during which they will evolve into the most popular band in rock—they've become accustomed to the adulation, and the perks that come with it. For David Lee Roth, brothers Edward Van Halen and Alex Van Halen, and Michael Anthony—a quartet of Southern California buddies who started out as a backyard party band before ascending to multiplatinum superstar status as Van Halen, purveyors of a particularly palatable brand of pop-savvy heavy metal—

this is as good as it gets. Right here, right now. In the midst of a tour that will take them across the Americas, to Europe, and eventually to East Asia, pushing an album that isn't even one of their best, artistically or commercially. But maybe the definition of success isn't just talent—maybe, instead, it's securing your place in history as one of the best live bands in the business, complete with a devoted following, strong record sales, and a veritable avalanche of merchandising revenue.

Sure, you could argue that the band's apex would come two years later, with the release of the brilliant LP *1984*, and an accompanying megatour that made Van Halen a household name and among the first true superstars of the music video era. But I was there and I know differently. I was with the band when they started to break—first as their road manager and then as their manager—and I'd seen them through it all, enjoying the ride and loving just about every minute of it. By '84, Van Halen, the band I loved and helped guide to fruition, was on life support, though not many people realized it. They saw the sold-out arenas and the platinum-selling album (and singles) and presumed everything was okay. Diamond Dave could still jump off the drum riser and deliver high kicks like an Olympic gymnast; Eddie still had the fastest fretwork in the business, routinely burning through blistering guitar solos that begged comparisons to Hendrix and B. B. King and just about any other legendary guitar player whose name you'd care to invoke. They had the world by the balls, these guys.

And then they loosened their grip.

Even as *1984* racked up sales and critical acclaim, and while the band was playing one sold-out show after another, the foundation on which the band had been constructed was beginning to come apart. Well, not really "beginning"—it had been crumbling for some time. By the middle of 1984 (the year, as well as the tour), Van Halen was a band divided—a victim of disputes both petty and legitimate. Long-simmering artistic differences (to say nothing of personality quirks) between Eddie and David had reached the boiling point.

Drug and alcohol use in the band had escalated into out-

right abuse. Love and brotherhood and the simple and time-honored adolescent dream of putting together a band with the hopes of getting laid and making a few bucks had been replaced by bitterness, complacency, and at times hatred. The tour itself was incredibly successful—which was a good thing, considering that we were otherwise hemorrhaging money. The fact was that we were trapped in a labyrinth of our own design, filled with tons of working parts, crew members, and flashy sets that threatened to swallow us whole, had it not been for one simple truth: Van Halen was fucking unsinkable. Or so we thought. Whatever we were, we were good. Not only did we break even—against all odds, we actually made money.

Being the life of the party isn't really worth it if you're not having a good time, though—and that was the problem. By '84 the pleasurable days of soaking up life on the road, traveling the world, and living for the music were long gone. The band was still playing their hearts out to adoring fans, but once the show was over and the crowd began to dissipate, the truth set in: Van Halen wasn't having fun anymore. By mid-1984 Van Halen was a glossy but depressed replica of its former self, meeting contractual obligations with little joy, and its four members typically went their separate ways when the lights were dimmed and the trucks loaded up.

I was in the middle of all this, often serving as de facto referee, until eventually I was shown the door. So I know for a fact that while 1984 might *seem* like the greatest year in the life of Van Halen, it really wasn't. You want a snapshot of the peak, a backstage pass to when the boys were at their most hedonistic and creative? Well, then you have to go back a little further. Why not '82?

Let's say we're arriving at the show. There's an overall pungency to the backstage area, a weird concoction of smells that can be challenging to separate and identify. The first thing that hits you is fumes: it's like walking into an auto repair shop or a gas station. Take the typical 15,000-seat arena in Portland or Pittsburgh, or the Checkerdome in St. Louis. It really

doesn't matter—they're all the same. At the back of each you will find a ramp for the loading and unloading of equipment. At the base of the ramp is a forty-four-foot semi . . . with a half dozen others right behind it, awaiting their turn, all belching noxious fumes into the stale air. A thick haze of smoke and exhaust settles over the entire area. It reminds one of flying into LAX on a nice day. You know how that goes. As you get closer to the ground, the sky thickens and changes hue, from clear blue to vaguely pink, and eventually to something resembling sludge when you're a couple thousand feet above it.

The backstage area on concert day is layered that way. Outside you've got the trucks and the sweat-covered roadies. And the groupies. Oh, yes, the tonic for the troops. The girls give off an overpowering scent—not just cheap perfume, but of sex, sweat, and need, as well. It's intangible, almost, but you can sense it nonetheless: the smell of desire, and the overpowering urge to let go. Drink a bottle of booze, pop a couple 'ludes, smoke a joint or two (or ten), and see where the night takes you. Maybe the road leads nowhere; maybe it leads to a glimpse behind the curtain, to an evening (or at least a few feverish sweat-soaked minutes) of carnal pleasure with a member of the band. Failing that, you settle for a member of the crew or support staff. Maybe you even go home to your boyfriend and climb into the sack while visions of David Lee Roth dance in your head. At a Van Halen concert, the yearning is palpable, and it comes across as an intoxicating smell, like patchouli oil, drifting through the doors and into the backstage area itself.

As the hour of the show approaches, you become keenly aware of an increase in energy. It isn't just noise—although there is that—but something you can *feel*. The building almost seems to come to life.

When I walk through the back door the band is already there—Edward with his guitar in hand (he never goes anywhere without it; he even showed up to a crime scene with it once); soft-spoken Michael, Van Halen's Everyman, just sort of standing around (bass nowhere in sight); David, ever the per-

snickety showman, giving detailed instructions to the sound guy ("When I get to the end of 'Atomic Punk' and I say, 'Let the show go on and on,' put an echo on that part, okay?"); Alex sitting backward on a chair, rapping at the backrest with two drumsticks, his beady eyes like two scanners, tracking whatever "talent" comes within range. As a young, attractive member of the catering staff puts a plate of chicken wings on the buffet table, Alex ceases drumming and playfully grabs one of the woman's thighs. He smiles; she giggles and swats his hand away, and goes on with her work, seemingly unfazed. But I have a feeling she has a pretty good poker face—or maybe she is simply used to the unwanted attention that comes with catering for rock bands. What can you say? Sexual harassment in one walk of life is merely harmless banter in the world of rock. Times have changed, of course, but thirty-five years ago? Well, you had to expect a little caveman from your rock star. These guys were conditioned to believe that just about every female who crossed their path was a potential—and potentially eager—playmate. That's rock 'n' roll, baby. It's not just about the music. It's about sliding back down the slippery pole of evolution.

As we move farther into the arena, away from the loading dock, the smells begin to change. The scent of petroleum gives way to a mix of food and drugs. Chili and chicken one second, alcohol and a combination of weed and cigarette smoke the next. Back then, everyone smoked—your mom, your sister, your weird uncle with the lazy eye, the quack charging you $150 an hour to help you quit. You name it, they smoked it, and so a fog hangs in the air.

Listen closely and you can hear the persistent sound of sniffing. Is there a bug going around? Allergies, perhaps? Or just the soundtrack of several dozen people snorting cocaine and other inhalants? Take your pick. And remember, this is the eighties; this is rock 'n' roll.

After eating and flirting with a few groupies who have already been granted backstage access, the boys begin moving toward their dressing room.

"Where the fuck are we again?" Edward yells.

"Lubbock," someone responds.

"Lubbock, Texas?" Edward says.

"No, Lubbock, Iceland, you dumb fuck."

"Nah, that was three days ago," Alex chimes in.

David, meanwhile, shouts out to a passing groupie. "Hey, sweet pea. You gonna be here after the show for Dave? Huh? Maybe we'll have a little rendezvous."

The girl laughs and smiles. Again, this appears not to be an unwelcome advance.

Soon the boys are behind closed doors, getting dressed, preparing for the night's work. The easy camaraderie and playful repartee are replaced by the sounds of four young musicians putting on their game faces. It's an appropriate metaphor, since the "dressing room" is really just a locker room with a few extra curtains thrown up. Hockey one night, Van Halen the next. If you're standing nearby, you can hear them swearing and yelling:

"Where's my fucking shirt!?"

The odor of the arena merges with their voices, and you can feel the anticipation building for the show.

Me? I'm feeling it as well, although I'm anticipating not just the show but also the rush of adrenaline that comes with the possibility of a little of the old *ultraviolence*: fun things like slamming the head of a merchandise bootlegger against a car door. Part of my night is always devoted to this sort of activity (accompanied by two or three members of the road crew, and a bodyguard; I'm not stupid)—it's all part of the job of protecting and promoting the Van Halen brand.

Speaking of promoters, in walks the man behind this particular show at this particular venue. He shall remain nameless, because there is nothing unique about him. He smells of Vitalis or Brylcreem, slathered on so heavily that the scent arrives about thirty seconds before he does. In the dressing room he fawns over the boys (particularly David and Edward), but he won't even look me in the eye. This guy is fucking us over eight ways from Sunday—assigning stagehands who

don't exist, charging me for labor that never happened, tripling the catering costs, and generally padding the bill in every way possible. He's sweating and sniffing as he extends a nicotine-stained hand—first to the boys and then to myself. I not so politely decline. Why is it that every single promoter in every part of the fucking country seems to have a cold? And why are they always so eager to share it? Then again, maybe it's not a cold; maybe it's just that the promoter is fond of coke. A lot of promoters, while doling out said coke, would also pass around their own personal and oftentimes bloody c-note—complete with whatever strain of hepatitis happened to be going around at the time.

God knows they're only too happy to make sure the band is well oiled and happy. Alcohol, weed, coke—it's all there for the taking. Hell, most of these guys would give us heroin if we wanted it, but that's not our bag. Never was.

As showtime approaches I walk to the stage area and peer between the curtains. Holy shit. An arena that was empty and quiet just a few hours earlier is now packed to the rafters with fifteen thousand fans—kids, mostly—lighting joints, drinking beer, stomping their feet, and clapping their hands in unison. The lights go down. A roar rises from the crowd like thunder as the boys approach the stage and a single spotlight trains itself on Rudy Leiren, whose job it is to introduce the band.

"Ladies and gentlemen . . . here is . . . THE MIGHTY VAN HALEN!!"

Just when you think it can't possibly get any louder, the band hits the stage, and it does get louder. Much louder. The crowd surges forward, filling every inch of space around the stage, and testing both the patience and physical strength of the security staff. And then the show finally begins. David struts out onto the twelve-foot runway that extends into the audience. It's known as an "ego ramp" because, well, you need a big fucking ego to walk twelve feet out into an audience of fifteen thousand screaming, inebriated rock 'n' roll fans.

Ego is not an issue with David. He never lacked confidence,

not even when Van Halen was strictly a backyard band. Now, as the frontman for one of the biggest bands in the world? David is right at home.

"I want to hear you make some noise!" he shouts, holding the mic out to the audience. The response is immediate and overwhelming, an ear-splitting roar. David smiles and tosses his head back, his mane briefly covering his face. Within a few more years the relentless creep of male pattern baldness will rob Dave of this signature look and, simultaneously, his youth. If you look closely you can see it even now, but he does a masterful job of mitigating the effects. He looks out over the sea of fans, roughly 60 percent of them women. Some have already removed their tops to gain attention. David smiles again.

"I see that rock 'n' roll ain't the only thing that's big in this part of the country!"

He begins bouncing up and down, then saunters from one end of the stage to the other, like a king about to address his subjects.

"Nobody rules the streets at night like me!" he shouts. "The Atomic Punk! I'm the one you want!"

And then it's on, as the band shifts into high gear. There's Edward at one end of the stage, his fingers racing over the fretboard with lightning speed and dexterity, his thin smile betraying just how much he loves what he does, and how at home he feels with a guitar in hand. At the other end of the stage is Michael Anthony, a serviceable bass player and a sweet guy whose greatest asset is an uncanny ability to provide backing vocals and harmony. His limited skill as an instrumentalist is virtually unnoticeable because of the virtuosity of Edward and the showmanship of David. All eyes are on Dave and his black leather pants and vest, a thicket of chest hair protruding from beneath it as he jumps around to the beat of Alex's drums. He commands the attention of every single person in the auditorium.

In the middle of one of Eddie's scorching solos, David leaps off the drum riser, some ten feet in the air. He's worked his

ass off to perfect this move, and even sustained a few injuries along the way, but it's second nature to him now. He is in prime physical condition, twenty-seven years old and not yet ravaged by time or drugs or alcohol. I've had my bad moments with Dave and I'll have more in the future, but as I watch him dance and spin across the stage, I have to admit that the guy puts on one hell of a show. David always knew what he wanted. And what he wanted, more than anything else, was to be famous.

Mission accomplished.

There is more free-verse patter, all kinds of crazy shit that David makes up on the spot. He is a car crash of pop culture iconography: part Borscht Belt standup comic, part Vegas troubadour, part heavy-metal samurai. The other guys laugh at his antics, and it occurs to me that, at least while they are onstage, everything is right in the world of Van Halen.

As Michael launches into the opening notes of "Runnin' with the Devil," and the crowd erupts en masse and begins headbanging to what has become one of the more recognizable riffs in the annals of rock, I find myself smiling. This is the moment, the one that makes it all worthwhile; a moment so pure and joyful—so quintessentially rock 'n' roll—that I feel lucky to be a part of it. But I also can't help but wonder: How long can it last?

1

WE GOT THEM FOR A STEAL

Music is my life. Or at least it was, for a great many years.

By the late 1970s I had apprenticed under the legendary Bill Graham as a stage manager and sound engineer at the Fillmore East and spent time in Europe working for the Rolling Stones, among other bands. I loved rock 'n' roll, and I loved the rock 'n' roll life: traveling around the world, experiencing different cultures, never settling into a quiet and pedestrian nine-to-five existence. Admittedly, rock stars are not always the easiest folks to work with, but by and large the benefits outweighed the negatives. I was young and single and enamored of the bohemian, vagabond life. It suited me, and I was pretty good at just about any job that came my way.

But nothing quite prepared me for the seven-year ride that was Van Halen. And when I refer to "Van Halen," I refer to the original incarnation of the band, which disintegrated in

1985 with the departure of David Lee Roth. (I left around the same time, which, as you'll see, was not exactly a coincidence.) Nothing against Sammy Hagar—fine singer and by all accounts a genial enough guy—but the real Van Halen died with the departure of David. I say that as both a compliment and a condemnation, for David's exit brought about the wreckage of a band that was at the height of its powers and popularity and could have dominated the music scene for another decade had common sense and reason prevailed.

Maybe that's part of what made Van Halen so great: almost from the outset this was a band that appeared, at least from the inside, to have a limited shelf life. Too much talent and too much ego, too many disparate personalities, too much drugs and alcohol. They had to be great right from the beginning, because there was no way it could last.

Not that I knew any of this in late January 1978, when I got a call from Carl Scott, a senior vice president in charge of artist development and touring at Warner Bros. At the time, I was living in New York, but had made a second home out of the Hyatt House on Sunset Boulevard. The Hyatt House was nicknamed the Riot House because of its popularity with the bands that would come through LA—they'd stay there while playing the Whisky a Go Go, or one of the other nearby clubs. Like I said, rock 'n' roll was my life, on or off the road. I was thirty-one years old and fit right in at a hotel frequently overrun with drunk and drugged-out rockers and their entourages. It felt like home. Well, fewer cockroaches, but you can't have everything.

While technically an independent contractor, paid by the gig, I was, for all intents and purposes, an employee of Warner, and Carl Scott was my mentor. Gifted at business and generous of spirit, Carl taught me a lot about the music industry and helped ensure that I had a steady stream of work. Although primarily a sound engineer and stage manager in my younger days, I had just come off a short, but nonetheless memorable, stint as head tour manager for the Sex Pistols, the infamous punk band fronted by snarling vocalist John Lydon (aka Johnny Rotten) and doomed bassist–slash–heroin addict

Sid Vicious. The Pistols, assembled in 1975 as a gimmick by London artist, boutique owner, and all-around textbook narcissist Malcolm McLaren, was founded to stick it to English classism while simultaneously providing his store with millions in free advertising. After a handful of lineup changes and the release of the seminal punk album *Never Mind the Bollocks,* they briefly became, if not the hottest band in the world, by far the most controversial.

And the most polarizing.

The Sex Pistols were poster boys for a nascent punk movement that owed as much to New York's Ramones as it did to any of the other UK bands that had come before them. They were volatile and vitriolic, fueled not by a need to change the musical landscape but by a lethal combination of anger, alcohol, drugs, and youth. They hit hard and fast, destroying everything in their paths, only to burn out before they'd barely gotten started. Although sometimes dismissed by detractors because of their apparent nihilism and onstage antics—antics that included Vicious mutilating himself with broken beer bottles and Lydon hitting the snarling, spitting, and cursing trifecta, doing his best to agitate the audience through a mouthful of gray teeth—there was much more to the band than initially met the eye.

In reality, the Pistols were a sensational band whose lone album remains one of the most influential and critically acclaimed records of all time. They were a ferocious live act that terrified older and more staid members of the music industry, not to mention the parents of the adolescents who bought *Never Mind the Bollocks* and who attended shows deemed not just raucous and unwieldy but downright dangerous. Ragged and unpolished, they made up for a lack of musical sophistication with an insane amount of energy and a live show that always threatened to devolve into utter anarchy. That they often appeared drunk or stoned onstage and in interviews, and frequently cursed out reporters and innocent bystanders alike was a bonus—and only added to their appeal and marketability.

Not that there weren't obstacles. When the Sex Pistols came to the States in January 1978, for their first and only tour, executives at Warner Bros. were both excited and terrified. This was an Important (capital *I*) band, one with enormous commercial and artistic potential. They were also a band with so many issues and challenges that they could implode at any moment. Concerts in the UK had frequently been marked by violence and onstage vulgarity; postponements and cancellations had become commonplace as promoters and local authorities simply didn't want to deal with the hassle of a Sex Pistols show.

Who could blame them?

The US tour lasted less than two weeks and was concentrated, improbably enough, in the Deep South—not exactly a hotbed of punk counterculture. I had been assigned the task of guiding these so-called miscreants through an environment that vacillated wildly between drunk adulation and outright hostility. The beauty of the Sex Pistols is that they really didn't give a shit either way. They fought and fucked their way across the country, trashing hotels and instigating brawls with fans and foes alike. Sid was by then a full-blown heroin addict with a tenuous grip on sanity; thus, you had episodes of him simulating oral sex onstage in Baton Rouge, or spitting blood at a woman while suffering through withdrawal during a show in Dallas. Lydon was disgusted by Sid's behavior and disenchanted with not just the tour but, as it turned out, the entire band. It was a nightmare that, in part because of the band's subsequent dissolution, remains one of the more infamous and important chapters in rock 'n' roll history.

I lived through it, and later wrote a book about it. Like all great survival stories, time has only enhanced the appeal of this one. You see, the tour wasn't a disaster. That it happened at all was a minor miracle. No, forget *minor*; it was a fucking major miracle, and by the time it ended I had earned considerable cachet with the brass at Warner. The tour, short and crazy as it was, helped make the Sex Pistols a notorious and

successful band in the United States, and represented a major breakthrough for me and Carl Scott.

Think about it: I was the tour manager, which meant I was responsible for just about everything entailed in getting the band from city to city and venue to venue. I was the one who would get on the phone every morning and call the guys, rousing them from a drunken slumber by shouting, "Rise and shine! Pack your bags, we leave in an hour!" This didn't always make me the most popular member of the entourage, but it was a necessary role and I embraced it in a professional manner—even on the days when I was tempted to just hose them down and be done with it.

I didn't line up the dates, it should be noted. That was McLaren's idea—book the foul-mouthed British punks into a bunch of redneck saloons and watch the sparks fly. Sounds like fun, eh? I was in charge of all logistics on the tour, which basically entailed babysitting Sid and the boys 24/7. In addition to waking them up in the morning, I made sure they were fed, watered, bathed, put into taxis, and taken to the venue—everything was on my back, and when the Sex Pistols invaded America, it was a heavy load indeed. For this effort I was paid the princely sum of five hundred dollars a week. No health insurance, no pension. Nothing. If I wasn't low man on the totem pole, I was standing on his flimsy shoulders.

But I pulled it off, or at least didn't screw it up too badly, which was enough to raise my stock at Warner Bros. So, a few days after the Sex Pistols tour ended, I was called to the Warner offices in Burbank for a meeting with Carl Scott, ostensibly to thank me for the work I did on the Sex Pistols tour, and to pay me for services rendered.

"Come on down, and bring your bookkeeping with you," Carl said. "Time to settle up."

One of the first people I saw when I walked into the building was Ted Cohen, head of special projects; he worked out of both Boston and Burbank. The Sex Pistols tour was obviously a "special project," so Ted and I had talked a lot both before

and during the tour. But this was the first time I had seen him since the tour ended.

"Here you go, Noel," he said, throwing me a T-shirt. "Try it on."

The shirt was black, in true rock 'n' roll fashion. On the front were the words *I survived the Sex Pistols tour.*

I smiled at Ted.

"Thanks, man."

I went into Carl's office and we talked for a while about the tour. I handed over all my accounting info so that Carl could issue a check, and figured I'd be on my way shortly. Before I could leave, though, Carl took the conversation in a totally different direction.

"We've got a new band," he said. "And I think they're going to be the biggest act we've signed in a very long time."

"What's the name?" I asked.

"Van Halen. They're going to be huge."

I'd like to say that my interest was instantly piqued, or that I felt a spark of destiny based merely on the name, or on Carl's prediction. But I didn't. As much as I admired and respected Carl, I also knew that it was fairly common for record company executives to get caught up in a certain amount of hype and optimism, and to believe that the next band would be the game changer.

"Whatever you say, Carl. How can I help?"

He leaned forward and put his elbows on his desk.

"Noel, you don't understand. No bullshit. This band is fucking brilliant. I've heard the tapes of the studio stuff. We've never had a band like this." He paused, pointed his index finger at me. "You and I are going to oversee this project, and we're going to break this band. And it's going to change your life."

I could never have imagined how right he'd be. At the time, I knew absolutely nothing about Van Halen. I had no idea that a quartet of Southern California kids had been making the rounds near their hometown of Pasadena. All four of them were actually transplants, each of them born someplace

else—which, if you think about it, is the quintessential essence of Los Angeles—but they perfectly embodied the West Coast surfer, stoner, and partying culture. Los Angeles might not have bred them, but they had been raised on its sunshine, schooled on its highways, and weaned on its smog-filled air; and in the end they'd adopted it as their own. It informed their sound and their attitudes, this baseline belief that there's not much more to the world beyond bongs, babes, and parties, as represented by their lyrics.

They loved California, and California loved them back. For years after my departure, I would run into people—on the street, in Ralph's, at the gas station—who would swear up and down that they'd been to a Van Halen house party and seen them perform. Hundreds of them. Maybe it was just wishful thinking, or maybe the boys really did reach that many people, even in the early days.

Van Halen started, as most bands do, in high school—or close to it. Alex and Edward, who was two years younger, had been raised in the family music business by their father Jan, a Dutch jazz musician, and their mother Eugenia, who was of mixed Indonesian-Dutch descent. The brothers had been born in Holland, but had moved to the States with their parents in the early '60s. Jan was an interesting man—a jack of all trades who played the saxophone, the clarinet, the piano, and dabbled with shooting guns, something he and I later found common ground with—one who he took his music very seriously, and wanted his sons to aspire to the same thing. No doubt hoping to inspire greatness, he and Eugenia gave Edward the middle name of Lodewijk, the Dutch equivalent of Ludwig (named after the one and only Beethoven; good thing he lived up to it) and had both boys taking piano lessons around the same time they started school. They both eventually outgrew it. Alex picked up the guitar and Eddie bought a drum kit. It wasn't long before Alex started sneaking in drum sessions while Eddie was out delivering newspapers, eventually mastering the drum solo to the Surfaris' "Wipe Out." He played it for his brother, and they made the switch; Eddie picked up the

electric guitar and never looked back. Eddie's guitar became an extension of himself—it was how he interacted with the world around him. The way he carried that thing around with him, it's hard to imagine there was ever a time when he didn't have it.

When they were barely in their teens the two of them formed their first band, The Broken Combs. Well, one thing led to another, and the Combs ended up changing their name to The Trojan Rubber Co.—whether this was a nod to one of their favorite consumer products is beside the point. Back then Eddie handled the vocals in addition to the guitar, but his voice lacked range and smoothness. A couple years later they regrouped again, renaming themselves Genesis and putting their friend Mark Stone on bass. Unfortunately, the name was already in use, having been taken by a progressive rock band fronted by Peter Gabriel (and later Phil Collins), and so the Pasadena-based Genesis became a band called Mammoth. Mammoth quickly cultivated a reputation, building their résumé in true grass-roots fashion: by playing not just small clubs, but mostly private (and underage, of course) keg parties in suburban neighborhoods.

Meanwhile, on the other side of the railroad tracks, David was the lead singer of the Red Ball Jets. They weren't much of a band, but they did have a first-rate sound system (bankrolled by David's father, Nathan, an ophthalmologist). Sometimes the boys in Mammoth would rent the PA system from David, whom they'd met in a community college theater course, which eventually resulted in a partnership being formed. I think David joining the band was purely practical on the part of the Van Halen brothers: David had resources that could help them advance their careers at virtually no cost. Well, not exactly *no cost*. The quid pro quo was that David would join the band and Edward would cede to him the role of lead singer. This was fine with Edward, who knew he wasn't much of a vocalist and who didn't want the responsibility of fronting the act and chatting with the audience anyway. There was just one minor hitch to this solution: David was an untrained and

limited vocalist. In short: he sucked. In fact, the first couple times he auditioned for the band, he was deemed unacceptable. But David is nothing if not persistent, and eventually the combination of his ambition, charisma, and obvious stage presence—combined with his financial support—won the boys over. While David never did become a great singer, over time he certainly became a better one, and he was clearly the *right* voice for Van Halen.

He'd been born in Bloomington, Indiana, to a Jewish family that eventually moved out to Massachusetts, and then to Los Angeles when he was in his teens. While David grew up in luxury—specifically, in the 14,000-square-foot estate (which would eventually come to be known as "Rothwood") of his father, who had built his wealth in a traditional and conservative manner—he was no stranger to show business. One of his uncles, Manny Roth, had owned Café Wha, a club in New York's Greenwich Village, and David had grown up seeing incredible luminaries such as Hendrix, Dylan, and Springsteen. Maybe it was because of this that he became obsessed with stardom. He told me on numerous occasions, and I quote, that he was "going to be famous!" He wasn't just saying it—he was declaring it. "I was destined to be famous!"

It didn't embarrass him to admit it, either. Actually, I think he viewed it as a noble, if not particularly practical, ambition. I could just imagine him standing in front of a bathroom mirror as a pimply-faced teenager, holding a hairbrush as a faux microphone, and stating his affirmation for an imaginary audience.

"I am going to be famous!"

And he certainly was—no question about that. Maybe he was right, or maybe he turned his dreams into reality through sheer force of will. Either way, it was impressive.

David's obvious and valuable talents in some areas counterbalanced his over-the-top behavior in others—both on and off the stage. Edward was the most talented and artistically gifted member of the band, but David was the brightest and most broadly creative, with a vision that went well beyond

simply playing music and getting laid. Yes, his intelligence was equaled and sometimes obviated by his bombastic, demanding, and occasionally cruel behavior. Diamond Dave was a hyperactive showman from the start and ultimately a diva of the first order, and his mighty tantrums frequently gave those around him the sense that disaster was imminent. But he did have a vision for Van Halen, and for himself, and he made that vision a reality. He had help, obviously, but there is no question that, among the four members of the band, David was the true leader.

He was also a true opportunist.

I always found it interesting that although David never changed his name, he rarely discussed or openly embraced his Jewish heritage. The reasoning, he explained to me on countless occasions, was this: rock stars are supposed to ooze sex appeal, and the Jewish stereotypes did not fit that image. Jews were seen as accountants and bookkeepers; financial managers and attorneys; they were doctors (like his father).

Being a Jew myself, and proud, I was confused and irritated by David's apparent shame and his tendency to paint with a broad brush. Jews aren't sexy? Tell that to Bob Dylan, Billy Joel, Leonard Cohen, Lou Reed, Simon and Garfunkel, Lenny Kravitz, and any number of other Jewish recording artists. Jews can't be rock 'n' roll stars? Quick—someone better let Gene Simmons know before KISS puts out another rock anthem. Hell, it had been that sexy Jew in question that helped discover them! Kidding aside, it was a silly and narrow-minded point of view, but I understood that it came from a place of insecurity (yes, you can be insecure and simultaneously have a big ego—the entertainment industry is bloated with artists who fit that description), so I mostly just let it go.

For Edward, the music always came first—stardom was simply a part of the deal. Not that he didn't partake of the perks that came with being a rock star, but I always got the sense that Edward had a purity of purpose; he wanted to completely reinvent the way guitar-based rock 'n' roll was played. He may not have been the smartest guy in the room, but musi-

cally, the man was a genius. Edward created sounds with his guitar like nothing anyone had ever heard before. He was an innovator, a shaker, and that was important to him. To say the least, he was dedicated to his craft.

Perhaps it was destiny, perhaps it was fate—or maybe perseverance and a little bit of luck, but the Van Halen brothers became the backbone of their band, spending countless hours fine-tuning their work and sharpening their abilities, so it's no wonder David decided—after Mammoth had outlived its usefulness—to name the band after them.

There's some question as to whose idea it really was to call the band Van Halen. David's long taken credit for the switch, which occurred in 1974. To anyone who knows him and his oversized ego, this would seem to be an uncharacteristically magnanimous suggestion. But I don't think so. When it came to career aspirations, David was nothing if not pragmatic. He wanted nothing less than to be famous, and he knew exactly what it would take to get him there—and that something was Edward Van Halen. When they first met, David saw straight past Edward's long hair, insecurity, ragged vocals, and innate shyness; instead, he saw Edward's potential to be a guitar virtuoso. Somewhere underneath Ed's rough and unrefined exterior, David recognized, instantly, that he had just witnessed greatness in the making.

This kid is a genius. Let him have the name.

David later told me that he loved the sound of the name— that it was about more than just an acknowledgment of its founding brothers, but simply a "cool fucking name." It was simple, declarative, and powerful.

Van Halen!

David was smart. He understood that in order to make his dream come true, he would need someone extraordinarily talented on his team, and he knew that Edward—with his natural gift and obsessive dedication to cultivating it—was already on an upward trajectory toward fame. David responded accordingly, by doing whatever he could to be a part of Edward's musical vision, and by magnifying his own strengths:

charisma, a strong sense of humor, and a personal brand of creativity. Also, he could jump pretty freaking high. He had a lot of dreams, and he spent as much time in his own little world as he did trying to impress the crap out of this one.

I certainly don't mean to minimize David's contributions in those early days; nor do I mean to imply that he merely rode Edward's coattails. Having spent considerable time with both men, I think I have an unusual degree of insight into their complex relationship. They were friends, partners, rivals; they both inspired and infuriated each other.

By the time the name was changed and the band's back-yard shows were becoming so large and unruly that police intervention was often warranted, a new bass player had been added to the lineup. His name was Michael Anthony Sobo-lewski, although Van Halen fans know him only by his stage name: Michael Anthony. Why Michael chose to legally change his name to one that neatly hid his ethnic background (born in Chicago, he was of Polish descent), I do not know. Michael was not a young man who wore his anxiety on his sleeve, or who liked to share his deepest feelings. He was sweet and like-able and ultimately a bit of a loner.

A former baseball player, he had played in several bands by the time he got to know Edward when the two were tak-ing classes at Pasadena City College. When Mark Stone left the band, Edward offered Michael a chance to audition as his replacement. He passed the audition and accepted an invita-tion to become the final member of Van Halen. While he may not have been the greatest bass player in history, Michael was a solid supporting player whose most underrated skill might have been his ability to provide backing vocals during live per-formances. He actually had a very nice voice and was perhaps a more technically proficient singer than David, but there is more that goes into being a lead singer than just technical proficiency, and Michael certainly had neither David's cha-risma nor his unique stage presence. He was content to be a role player and he filled that role exactly as it was written.

For three years after their formation, Van Halen worked

their asses off, playing as often as humanly possible in every-thing from small clubs and high school gymnasiums to subur-ban back lawns and bar mitzvahs. They would print up their fliers and distribute them to local high schools and burger joints, eventually amassing a small army of loyal, local fans. The truth is, they did it like everyone else with a dream does it. They hauled ass, hustled, and got people talking. Van Halen had a reputation in SoCal as a hard-drinking, hardworking, hard-playing force to be reckoned with. In short, Van Halen brought the party like no other. They earned every inch of their rep, and it wasn't long before they were playing clubs like the Whisky a Go Go or Gazzarri's, both conveniently lo-cated on the Sunset Strip. It was at the latter—where they had once been turned away for being too loud—that they were approached by none other than Gene Simmons of KISS. He helped the boys put a demo together, which he proceeded to bring to his own management team, who promptly tossed it in the trash.

Even as Van Halen was emerging as a hot property in the party town of LA, they remained just one of hundreds of wan-nabe acts from the outskirts of the strip. This was the age of the vinyl LP, when record companies were flying high and ruling bands, promoters, and the industry in general with an unyielding fist. The lawyers who advised the bands and their frequently inexperienced managers were to some extent in the pockets of the record companies. Simply put, the young and eager band members of Van Halen, while talented and loaded with potential, not to mention a unique sound, were at the mercy of forces well beyond their control.

Still, it was only a question of time before someone with might and muscle saw the commercial appeal of Van Halen. That person—or in this case persons—was Mo Ostin, chair-man of the board of Warner Bros. Records, along with Ted Templeman, producer extraordinaire. In addition to produc-ing a long string of hit singles in the '60s and '70s, Ted worked with Van Morrison, the Doobie Brothers, Eric Clapton (Eddie's all-time idol), Aerosmith, Carly Simon, and Fleetwood Mac,

among others, producing some of the most groundbreaking and unprecedented albums of that time. By '77, his position as a legendary producer was cemented in stone, and together he and Mo were two of the most powerful and influential men in the record industry. Their presence at the Starwood, a club in Hollywood, lit the fire under an explosive show that signaled Van Halen's life-altering rise to stardom. Forget about backyard beer parties and bar mitzvahs; say goodbye to 300-seat clubs on the SoCal minor league circuit. Seemingly overnight, Van Halen had become a hot commodity.

A few months later, they were signed to Warner Bros. and preparing to venture out on their first US tour. Since I had successfully wrangled the Sex Pistols, Carl Scott had a good feeling that I'd be up for the job. He also wanted me to understand what a fantastic opportunity this was, and so when I sat there in his office that January day, he did not spare the superlatives.

"This band is going to change everything for us," Carl explained. "And for you." I underestimated just how right he was.

In January of '78, while I was out on the road with the Sex Pistols, Warner Bros. distributed a five-song Van Halen EP, pressed on red vinyl. The record was not available for sale and was released only to radio stations for advance airplay. On one side of the EP was the track list—"Runnin' with the Devil," "Eruption," "Ice Cream Man," "You Really Got Me," and "Jamie's Cryin'"—while on the other side was the image of Elmer Fudd emerging from the Looney Toons logo. (This was Warner Bros., after all.) The EP had precisely the desired effect, gaining considerable airplay and whetting the public's appetite for a band that promised to reinvigorate the guitar rock genre. (Van Halen would occasionally get lumped into heavy metal, but the band was generally far too melodic and accessible to fit that category.)

Most of the tracks were recorded in the fall of '77, at Sunset Sound Recorders. The Hollywood studio reeks of pedigree, which is exactly what you'd expect from the place where the Rolling Stones' *Exile on Main Street* and the Beach Boys' *Pet*

Sounds were both recorded. Whether inspired by the ghosts of artists past, or merely working with the tireless spirit of youth, Van Halen needed just three weeks to record the album, which was mostly done "live"—live, in this case, meaning that the band played in one sound booth and David sang along in another.

There was little overdubbing or any other sonic tricks typically utilized to polish a band's sound—techniques that had become common practice among many arena rock bands of the era, most notably Boston. The idea was to capture the intensity and spontaneity—the sheer *rawness*—of a live Van Halen show. To that end, minor mistakes were not just overlooked but embraced. The album was completed and stashed away for several months while Warner put together a marketing campaign and launch strategy, and Van Halen went back out on the road, continuing to build a following despite not yet having even released an album.

Until I met with Carl Scott that day, I knew none of this, because I'd been on tour with the Pistols. It's amazing the way your world contracts when you go out on the road with a band. Your entire existence revolves around the needs, desires, and obligations of a small handful of musicians and the promoters who have booked them into various cities around the country (or the world). Nothing else matters. In terms of music, you know your band's set list and maybe the set list of the supporting act—or the headliner, if you happen to *be* the supporting act. Other than that? Silence. It wasn't just Van Halen; I didn't even know who Fleetwood Mac was, and at that time they were the biggest band in the world. It didn't matter—my focus was on the band I was working for, and no one else.

Carl and I had worked together on a number of projects over the years, and while some had been more successful than others, not one of them had been catapulted to superstardom. Nevertheless, I really did love the work. I enjoyed putting together tours, advancing the bands, working with promoters. In those years I learned an enormous amount about all facets of the music industry, and most of it I learned either

directly from Carl Scott or because of opportunities that he provided. So, while I had developed a layer of skepticism that naturally comes with seeing the dreams of one band after another dashed by the harsh realities associated with trying to earn a living in an artistic field, I was still eager to jump aboard any ship that Carl chose to captain. That day in Carl's office—and this might sound shocking—I didn't ask to listen to the demo. I didn't give a shit what the band sounded like. Carl said they were great, and that was all I needed to hear, especially if he wanted to hire me as their tour manager. I trusted his opinion.

This, by the way, was a promotion I did not expect and certainly did not anticipate when I sat down in Carl's office. I only knew that Carl liked winners, and that he had expressed an unusual degree of confidence in these four young men from Pasadena. In fact, as Carl gushed on and on about them, I thought that they seemed almost too good to be true.

Wait till you see this guitarist. Just amazing!

The front man is incredible!

And by the way—we got them for a steal.

This last part was a little too accurate, as I would later find out. But for now it wasn't important. What mattered to me was the product. The guys in Van Halen were young, handsome, and talented; they were going to make a lot of money for Warner Bros. The enthusiasm was infectious.

"Carl, this sounds fantastic," I said. "I can't wait to meet them."

"Glad to hear it, Noel," he said. "Because you're having lunch with them next week."

2

VAN HALEN UNLEASHED

I can't believe they're late.

That's what I remember thinking as I sat at a table in a restaurant in Burbank with Carl Scott, Ted Cohen, and a member of the Warner Bros. publicity department. The four of us were supposed to meet with the guys from Van Halen at one in the afternoon. Now, I understood as well as anyone that the majority of musicians have only a tenuous grasp on the concept of time, so punctuality is generally not to be expected. But I'd hoped this would be different. A new band—young, eager, and on the cusp of stardom, having just received its big break; a band whose first album was scheduled to be released on a major label within the next month; a band that soon would be embarking on a major tour to support said album. You would think (or at least hope) that a band in this situation would show up for a meeting with its bosses and new tour manager on time, or maybe even a little early.

But you'd be wrong.

I looked at my watch. 1:10. Then I looked at it a bunch of times. 1:15. 1:20.

Where the hell are these guys?

Finally, around 1:35, they showed up, looking not just disheveled, which is what I had expected, but utterly exhausted. And by "exhausted" I don't mean that they looked like they'd been up all night, living up to their reputation; no, instead they were red-faced, sweaty, and breathing heavily. They looked like they had just competed in some sort of athletic event—and lost. David, naturally, did most of the talking, as would be the case for the next seven years, although he was far more subdued in that moment than the man I would come to know. He apologized on behalf of himself and his friends and explained that no disrespect was intended.

"Our car broke down on the way over," he said, rather sheepishly. "And we ran the rest of the way."

Behind him were the Van Halen brothers and Michael Anthony. They nodded in agreement before taking a seat at the table. I looked at Carl, then at Ted. They both just sort of shrugged.

Ah, what the fuck. It's rock 'n' roll, right?

Actually, no. As the meeting went on, I came to the conclusion that these guys were probably telling the truth. Their car really had broken down and they really had legged it all the way across town to the meeting. It was one of those things that showed the kind of dedication needed to make an impression in a business like this. Whatever it takes, you do. They didn't carry themselves with even the slightest bit of arrogance or hubris; indeed, they seemed downright shy and humble—not exactly what I had come to expect of musicians in general, and certainly not from a band that had been so highly touted by Carl Scott. I expected these guys to strut into the restaurant like kings, as if they believed that rock 'n' roll was theirs for the taking. Given what I had heard (and I'm not talking about their music—I still hadn't heard a single Van Halen song), I expected them to be self-assured, if not downright cocky.

They weren't.

Instead, they were a quartet of long-haired kids in tattered jeans and worn boots, barely out of their teens. If I had seen them on the street, I probably would have assumed they were younger—maybe even in high school. They were shy and reserved and clearly nervous about meeting the men who were going to be largely responsible for whether their careers soared or sank over the next few months. They knew they were late for an important meeting, and they clearly felt bad about it, which I found rather endearing. They understood the stakes, and they conducted themselves in an appropriate and respectful manner. Truth be told, it was pretty charming.

Carl introduced everyone, and I quickly tried to put names and faces to the descriptions I had heard from him beforehand.

David was tall, good-looking, with long hair and a mouthful of big teeth (teeth that needed a good bleaching, by the way; David had ignored dental hygiene for some time, an issue that we had to address fairly early on, but it was an easily correctable flaw). Here was the lead singer and front man that Carl had raved about. He talked more than the others, but not so much that I could gain any insight into his true nature, or into the charisma that he would display onstage.

Edward was cherubic, with an ever-present smile and eyes that always seemed half-closed, as if he were stoned. He was friendly, polite, and surprisingly shy—and I liked him right from the start. Was he a great guitar player—who the hell knew? I certainly couldn't tell just by looking at him.

Alex and Michael were supporting players, even in this setting. Alex was skinny, with long, kinky hair and protruding teeth. He didn't talk much, and neither did Michael, who was shorter than the others, and much stockier, with a strong upper body and muscular arms that he liked to show off. He was friendly, if reserved.

None of the boys did a lot of talking at this meeting, but David and Edward handled whatever needed to be said, and made it clear that they were the leaders of the band, not just onstage and vinyl, but in matters of business as well. Here's

the thing: I could tell right away that they were naive and innocent, or maybe just intimidated. For whatever reason, they asked very few questions during this meeting, nor during the follow-up session after lunch at the Warner Bros. headquarters. I was the person designated to be their tour manager, so one might have expected that they would be curious about the logistics of touring. But they weren't. Mostly, they just wanted to ask me about the Sex Pistols and what I thought of Johnny Rotten and Sid Vicious.

Unlike so many of the other bands I was used to working with, Van Halen were really still just . . . *normal.* They were excited and enthusiastic, of course, but also as awestruck and intimidated by the industry as you'd expect a bunch of So-Cal kids to be. It was kind of refreshing. So I told them the truth—that Sid and Johnny were just like them. Younger—definitely dirtier. Worse table manners. Hopefully much more difficult to take out on tour than Van Halen would be. I had high hopes—what can I say?

And, as is common in the record industry, this innocence had already been exploited, long before I entered the picture. By the time we met for lunch, they had already been fed into the music machine and spat out in a tale as old as time: find a new, unproven and unmanaged band desperate for stardom, offer to propel them to the top, and have your high-priced Hollywood entertainment lawyers wave a stiff, extremely skewed contract in their faces. Like many that came before them, and would no doubt come after, the boys were unprepared for the ruthlessness of the industry, and so they signed said contract amid assurances that it was "industry standard." After all, what if they never got another offer like this? Or another offer, period? Their future as a band hung in the balance, so to speak. So it's no wonder that Van Halen had signed a contract that heavily favored Warner Bros.

Similarly, their personal manager had been suggested by Mo Ostin, an astute judge of talent and commercial potential, and one slick motherfucker. I have no doubt Mo wanted a manager that would be favorable to his company.

That person was Marshall Berle.

Marshall had a long history in Hollywood, fueled by deep family ties in show business. Before moving into the personal management game, he'd spent more than a decade as a talent agent at William Morris, where his clients included the Beach Boys, Little Richard, Creedence Clearwater Revival, and Marvin Gaye, among others. I never did find out exactly how he came to know about Van Halen, but I do know that he was at the Starwood on the same night that Mo Ostin and Ted Templeman came to see the band play. He introduced the boys to Mo and Ted, and shortly thereafter became their personal manager (at Mo's urging).

Even at this first lunch, it wasn't clear to me exactly what Marshall's relationship was to the band—mostly because he wasn't there. I found it strange that he hadn't attended the initial meeting in Burbank. In my opinion, a personal manager should always be present when a band is meeting with record company executives, and should be heavily involved when they're planning a tour—especially when it comes to a brand new contract. I tried to ignore my initial reaction; maybe he was out of town, or maybe he had already gone over the talking points with Carl. I had no idea, and at the time I didn't really care. Later, as I got to know Marshall and saw his behavior up close and personal, the fact that he had missed the initial meeting made perfect sense to me and was a sign of things to come.

After lunch, we all went back to the offices and took the band on a quick meet-and-greet, introducing them to a few other key players. Then we went our separate ways. Within forty-eight hours I was on the road with another band whose tour would last the next few weeks. I wouldn't see any members of Van Halen until nearly two months later, at the end of February, when I caught up with them in Chicago, ready to kick off the tour. Then, for better or for worse, Van Halen became my world.

WHILE I WAS AWAY, the buzz surrounding Van Halen became louder and more substantive. They had dropped one

of the best debut albums in the history of rock 'n' roll, becoming a household name practically overnight. There wasn't a car radio in any part of the country that wasn't routinely blasting their cover of "You Really Got Me," a fresh-faced, upbeat version of the classic Kinks song, and Van Halen was promising to live up to the hype Carl had predicted. The man had been right. Everyone loved David's energy, and Edward's electric, out-of-the-box guitar work. They were a hit.

All this came as a huge relief. Sure, Carl and I had both done well with the Sex Pistols, but after almost four months on the charts, and perhaps attributable to their very specific audience, *Never Mind the Bollocks* still hadn't reached gold status. Even so, the Pistols had become the center of much media attention, which cemented the album's place in history as a cult hit, so we had counted it as a win (or, at least, I had, and I had the "I Survived the Sex Pistols Tour" T-shirt given to me by Ted Cohen to prove it), but with success comes pressure. Van Halen was crucial to advancing our careers and credibility, and the stakes were higher than ever. Naturally, they were much higher for Carl. He was a vice president, after all, and it was his ass on the line much more so than mine, but I sympathized, and had my own role to play.

See, this is where I came in. It was my job to steer Van Halen through the rough, rigorous, and grueling process that separates the great bands from the wannabes and one-hit wonders. It was up to me to help Van Halen transition from a club mentality—with limited resources and production—to the Big Show. At the end of this tour they would either be a band that would be right at home in front of several thousand fans, or their careers would be over.

I knew how to guide them along this journey; with Carl's backing—and with his emotional support and the financial muscle of Warner Bros.—I could make it happen.

But not without a great record.

Until then, I had been worried that I'd been saddled with

the impossible task of transforming chicken shit into chicken salad. I'd been down that road before, albeit with less at stake, and it all rests on the album. Artists' careers hinged on whether those twelve-inch sheets of black vinyl had any substance to them or not. Without a good one, you were dead in the water. If the music sucked, people wouldn't buy the records, and if they didn't buy the records, they sure as hell weren't going to shell out even more of their hard-earned cash to see the band live. This was synergy at work. The single caught their attention, then the album grew the audience, and then the audience supported the tour. I knew the reality of the world in which I worked: no matter how much money you threw at a project, or how talented and hardworking your production and promotional staffs might have been, it all came down to the record. It's not something you could fake.

Van Halen didn't need to. They were the complete package.

There's an old saying in the music business: *We want the girls in the audience to want to be with the boys in the band, and we want the guys in the audience to wish they were in the band.*

Van Halen nailed it. They nailed the girls in the audience, too—but that's beside the point.

Released on February 10, 1978, the album sold briskly from the onset, although it wasn't an overnight sensation. Rather, it peaked at a high of number 19 on the US charts roughly one month after it was released. *Van Halen* made good on the promise of the previously released EP, and time has served only to burnish its reputation. Simply put, the album holds up. A few years back *Rolling Stone* placed *Van Halen* at number 27 on its list of the 100 greatest debut albums in rock 'n' roll history:

> The strutting frontman as spandex-clad love machine, the finger-flying guitar hero, the kegstand rhythm section: Van Halen was the ultimate party band and their debut feels like the Eighties arriving two years ahead of schedule. Tunes like the fist pumping "Runnin' with the Devil," the muscular "Atomic Punk," a thunderous cover

of "You Really Got Me" and "Ain't Talkin' 'bout Love" put the show-biz swagger back in hard rock, and Eddie Van Halen's jaw-dropping technique raised the bar for six-string pyrotechnics, particularly on "Eruption," the solo that launched a thousand dudes messing around at Guitar Center.

Yeah, that all sounds about right. *Van Halen* was a fantastic debut that instantly displayed everything fans came to know and love about the band. More than two dozen songs were brought into the studio and considered for inclusion on the album, with the final list pared to a tight and muscular eleven: nine original compositions and two covers. The album was not an overnight sensation, but man, did this thing have legs. In part because of the band's stellar live shows and a youthful commitment to endless touring, *Van Halen* became one of those albums that simply would not go away, spending an incredible 169 weeks (more than three years!) on the charts. It reached gold status on May 24, 1978, and platinum status the following October. The album surpassed 10 million copies sold in 1996, and continues to be a staple of classic rock radio stations today.

That, my friends, is what is known as a legacy.

Despite all this, as I prepared to join the band in Chicago for the first date on their tour, I still hadn't heard a single Van Halen song, a feat which, in hindsight, I can only attribute to dumb luck. Van Halen had announced themselves with a thunderous roar, and by the time I headed out to Chicago to meet up with them, they were sending shock waves through the industry. They were more than ready for their first show as the opening act for Ronnie Montrose and (would-be) rock legend Journey, kicking off what would prove to be—what would have always been, regardless of what came next—one hell of a memorable tour.

WHEN THE BAND got off the plane in Chicago on February 28, 1978, they were dressed exactly as they had been

the last time I saw them. By that I mean they were wearing the exact same clothes, which in retrospect is kind of sweet and refreshing. David was a rich kid, so he could afford a rich kid's wardrobe, but I had met him twice now and both times he was dressed like any other Southern California kid who wanted to look like he was in a band: jeans and T-shirt and boots. The other guys had barely two nickels to rub together and weren't about to waste what little they did have on clothes. At the risk of sounding sentimental, all four of them had stars in their eyes and smiles on their faces. In that moment, I found them enormously appealing. They were poised for stardom, but I don't think they realized it (if David did, it was only in the abstract). Their album had been out less than three weeks and they had not yet played a live show in support of it; they had no idea of what lay ahead. Then again, neither did I.

The first day was given over to travel and acclimation, which was a welcome respite for me. Two days of rehearsals at SIR Studio and Instrumental Rentals would follow before the band played its first live show on March 3, at the Aragon Ballroom, a 5,000-seat venue on West Lawrence Avenue, roughly five miles from downtown Chicago. I caught bits and pieces of the first rehearsal, but much of my day was devoted to logistical issues. The band was accompanied on this trip by roughly seven or eight handpicked crew members, including a drum technician named Gregg Emerson, who was Alex's buddy from high school, and Rudy Leiren, a guitar tech whose primary qualification was that he was a very close friend of Edward's. (I had brought along my old friend, Gary Geller, aka Red Roadie, to fill the dual roles of stage manager and bass tech for Michael Anthony.) This was the first time I had met the road crew, and they seemed like decent enough guys, every bit as starstruck and goofy as the band members themselves. I hoped that they would be good at their jobs, because I knew that, given their friendships with Eddie and Alex, there was no way I could ever fire them. To their credit, Rudy and Greg took their work seriously . . .

but hey, what good is nepotism if you can't take care of your friends?

Until Van Halen joined them, Journey and Montrose had played Davenport, Iowa, and Racine, Wisconsin, respectively. As you can imagine, the crowd at the Aragon Ballroom was twice the size, easily. No offense, but Davenport and Racine were the minors; Chicago was the majors, and Van Halen hadn't just come to play; they had come to win.

This was a great opportunity, and we were here to take full advantage of it. We were a supporting act, filling the third spot on a triple bill, and we'd be getting our feet wet playing to venues that seated from twenty-five hundred to as many as eight thousand screaming, drunken fans. On paper, it was the perfect way to kick off Van Halen's first major label tour. For a band just starting to gain traction, this was a pretty sweet spot to be in. We'd been added to the bill because Journey—which, after years of being unable to break through, had just hired a new vocalist, Steve Perry, revamped its sound, and released a game-changing album, *Infinity*—still wasn't big enough to sell tickets on its own. Ronnie Montrose, formally the front man of Montrose, a band that had been fairly popular prior to the departure of lead singer, Sammy Hagar, two years earlier, was beginning to fade from public perception.

Van Halen brought a lot of energy to the lineup, and as soon as we were announced, tickets started selling. We were new, fresh-faced, and exciting, but Journey was the best known of the three bands at that point, with the brightest résumé, and so they were accorded headliner status. That was fine with us. It gave the boys the opportunity to play in front of bigger crowds than they had ever experienced and to polish their live show without the burden of expectation that comes with headlining a tour. If they were good enough, they would blow the headliners off the stage anyway.

A tour is very much a meritocracy. It can be challenging to play in front of an audience composed almost entirely of fans

who have paid to see the headliner. (Later, we'd start calling the supporting bands "T-shirt acts," because all they had to do was occupy the stage while the fans were outside purchasing merchandise.) But sometimes, if a band is good enough, it will win the crowd over. We were that band, there was no doubt about that, and we were more than confident that it wouldn't be long before all eyes were on us.

Ah, but nothing is ever that simple on the road.

We arrived at the theater in the early afternoon and found a tiny dressing room waiting for us. The space was cramped and not well lit, but this was hardly unusual. How much room do you really need to change from street clothes into stage clothes? Hell, these guys had been changing in their cars or in high school locker rooms for years—when they bothered to change at all, that is. Part of the beauty—and fun—of taking a new band out on the road is that everyone tends to be very low-maintenance. While naturally somewhat nervous and anxious, the guys in Van Halen were mostly thrilled just to be out of Southern California. Aside from David, they were not exactly world travelers. And now, here they were, in Chicago. They couldn't have been more excited, nor cared less about their dressing room accommodations.

Unfortunately, the dressing room was not the only place that was a bit too small for comfort. You see, the problem with booking three bands into one venue on a given night is that there isn't always space for each band's equipment. As the headliner, Journey took precedence. Montrose came next. There isn't time to completely break down the stage and equipment after each act performs, so all three road crews work together during the day. The headliner's equipment (amps, instruments, etc.) goes farthest in the back; the middle act places its equipment in the middle, and the opening act takes whatever space is left at the front of the stage. Then, as each band completes its set, a layer of equipment is peeled away or pushed to the side during a quick changeover.

By the time we began setting up our equipment—after Journey had assembled its back line of amps and drum kit, and Montrose had done the same in front of Journey—there was almost no space left. It had taken so long for the other two bands to load and set up their equipment that our crew was forced to load through the front aisle of the theater. Onstage, we were left with a space only twelve to fourteen feet wide in which David, Edward, and Michael could strut their stuff. For David (and, to a lesser extent, Edward) this was a serious impediment. David was accustomed to running around the stage and even into the audience. He used every inch of the performance space.

While the guys were still in the dressing room, I went out into the arena to see how things were going. The stage was impossibly crowded. There was equipment everywhere; tangled, knotted electrical cords formed nests on the hardwood and provided another potential obstacle. My first stop was the mixing board, where Tom Broderick, our soundman, was hard at work.

"How's it going?" I asked him.

He responded with a thumbs-up and a confident smile.

Then I checked on Peter Angelus, our young and somewhat inexperienced (but talented) lighting man. Peter would go on to become a successful cinematographer and music video director, as well as talent manager, but at this time he was relatively new to the business. Before I even had a chance to say a word, I could tell something was wrong. Pete's face was ashen, his expression grim. I jumped up on the light platform next to him.

"Hey, Pete. Is there a problem?"

He nodded.

"My headset isn't working right. I have no communication with the spotlight operators." He paused. "We're fucked."

Strictly speaking, he was right. Pete would normally spend the entire night on his headset, telling each of his spot operators when and where to direct their equipment. It was a

complicated dance and required not just complete focus on the part of everyone involved but also a blueprint to guide the proceedings. Pete had seen multiple Van Halen performances and knew the band's stage show intimately. But without properly functioning headsets, he was basically helpless—like an air traffic controller without radar.

Ah, but the show must go on, right? As a former soundman and stage manager, I had seen firsthand just about everything that could possibly go wrong in a live show. There was always a way around it.

"Let's not panic, Peter," I said. "I have an idea."

"What's that?"

"I'll call the spots as you do the stage lighting."

Peter looked at me like I was crazy.

"No offense, Noel, but you've never even seen the show."

I laughed. This was an irrefutable point. It also didn't matter. Drastic times call for drastic measures.

"Guess I'll have to wing it," I said.

I jumped off the platform and headed to the ladder that ascended to the four spotlight operators. They were all holding their useless headsets in their hands.

"Okay," I said, "I'm going to direct spots from up here."

They looked at me quizzically, then looked at each other. Then they shrugged.

I didn't take this as a sign of complacency or disrespect. These guys were unflappable, which is exactly what we needed in a time of crisis. It also turned out that they were a knowledgeable bunch of spot operators, which made my Band-Aid approach to the evening much more successful than it might otherwise have been.

I looked at my watch and realized that Van Halen was scheduled to take the stage in less than half an hour, so I scrambled back down the ladder and made my way to the dressing room. The place was a mess—tight and cramped and musty—and the boys were clearly agitated and nervous. This was to be expected, given the stakes, but the anxiety was surely height-

ened by the overall feeling of claustrophobia and chaos that accompanied the show. And now I was obligated to add to the tension.

"Listen, guys, there's a problem with Peter's lighting headset. I'm going to have to call spots on the fly."

At first, no one said anything. I think they were distracted. I didn't mean to make them more nervous, but they had to know the situation, as we'd all be doing a bit of ad-libbing. Finally, David spoke up.

"How the fuck are you going to call spots?" he said, his voice already raspy from warming up. (This was not a bad thing—Dave was at his best when his voice became a low growl.) "You don't even know the show."

As was the case with Peter, David was stating the obvious, and there was no reasonable counterargument. I hadn't seen the show, but I had seen, and worked, thousands of other shows, so I figured we could get through this.

"Don't worry," I said. "It'll be fine."

Dave laughed sarcastically. "It better be, man."

"Look," I said to Dave, "I'm going to put you in the wings, stage left. When Marshall says 'VAN HALEN!' you just take control and do the best show you can. Let me worry about calling spots."

Marshall Berle had gotten into town that day and would be introducing the band to the audience. What I did not tell the band was that Carl Scott and more than a dozen Warner Bros. executives from promotion and artist development were also in attendance. They didn't need any more pressure. I ran out to the spot ladder and got into position.

"Get ready to hit all four guys when they come out," I said to the spotlight operators. "Just follow your man."

How can I best describe that first show? It certainly won't be remembered as one of the finest nights in the annals of Van Halen history. Technical issues, a congested stage, and a spectacularly bad footwear decision on the part of the boys made for a challenging night. During rehearsals I had noticed that all four band members had decided for some reason to wear

platform boots with thick, three-inch heels. I had suggested more sensible shoes for opening night, but had been rebuffed, most notably by Alex.

"These are our KISS boots," he said, smiling proudly. "We paid three hundred bucks for these. We love them!"

This seemed to me like a staggeringly poor use of funds, especially for the three-quarters of the band that did not come from family money. But I didn't argue about it. There were too many issues taking up my time, and it wasn't my place to dictate the band's wardrobe. In retrospect, maybe I should have pressed the matter. From the opening notes of the opening song—"On Fire"—it was apparent that the platform shoes were a bad idea. Maybe they worked for KISS—especially when anchoring outrageous black costumes and makeup and traversing a vast performance space, as was usually the case with KISS in those days. But here, at the Aragon Ballroom, on a stage shrunk to half its normal size because of an overabundance of equipment, with electrical cords and audio cables lurking underfoot, KISS boots were an imprudent choice.

Still, the band soldiered on, as did those of us providing technical support, and together we got through it. Van Halen cranked out ten tunes, a bass solo, and a drum solo in an energetic set that lasted roughly thirty-five minutes. The sold-out crowd of 5,450 seemed astonished by Eddie's virtuoso guitar work. If the boys were somewhat less animated than usual, well, that's only because they wanted to avoid tripping or falling off the stage. Sometimes discretion really is the better part of valor.

As soon as the show ended, I thanked the lighting guys and then shared a celebratory handshake with Peter. Then I went to the dressing room, where I found Alex, Eddie, Michael, and David already deconstructing the show. They weren't angry, but neither were they pleased. I took this as a good sign—this was a band with some serious ambition. They knew they were capable of doing better, and the improvement would start with a change in wardrobe.

"Guys, you have to lose the high heels," I said. At first there

was no response. A few moments later, though, Peter came into the dressing room.

"David," he said calmly. "For God's sake, try wearing Capezios or something."

David twisted his face into a look of disgust.

"Shit, man, I'll be three inches shorter."

David was not a little guy. He stood about six foot one and had a lean but muscular build, with a thick carpet of frequently exposed chest hair. By any reasonable definition, he cut an impressive figure onstage. But it wasn't enough for Dave; he wanted to tower over everyone else—his bandmates, the audience . . . everyone.

For now, though, David was a reasonable and ambitious artist willing to check even his oversize ego in the pursuit of a better performance.

"David, you looked awkward out there," I said. "You don't want that. It detracts from the show. You guys are an athletic band; people need to see that."

Begrudgingly, David agreed, and the others followed suit. That night at the Aragon Ballroom was a turning point for Van Halen and heels. David did indeed switch to Capezios, while the other guys donned sneakers. Van Halen was never a glam-rock band; they were a guitar rock band, and one of the most dynamic live acts of the late 1970s and early 1980s. From that moment on, they dressed the part.

As we were leaving the venue, I spotted the road crew, who were still standing around the truck.

"How come you guys haven't left yet?" I asked.

A couple of them laughed in that road-weary way I had heard among crews many times before. It's a knowing laugh that comes with having seen almost everything, and understanding that when it comes to the road life, Murphy's Law is no joke. *Anything that can go wrong, will go wrong.*

The first person to speak up was Red. According to him, one of the guys had left the light on, and the battery was dead. Red assured me not to worry—Ryder was on its way to fix the battery, and they'd catch up with us at the hotel.

By the time we got back to the Holiday Inn City Center, we were all in need of a bit of lubrication following a long and exhausting day. I went straight to the bar with Pete and Tommy. The guys in the band were already there.

"You guys like Jack Daniel's?" Michael Anthony asked.

"Sure," I said. "Who doesn't?"

"Well, all right then," Michael said, smiling. "I got first round."

By the time we got to the second round, the rest of the crew had arrived. Apparently Ryder had come to the rescue, and, seasoned pros that they were, the crew had loaded up the truck quickly and gotten back in time to celebrate the end of a hard day of work. As the evening wore on I had time to chat individually with each member of the band and found them all congenial. They wanted to be a great band and were willing to work hard and take advice in order to make that happen. Despite all the problems we had faced on opening night, and the fact that it was demonstrably not a great show, I could not have been more optimistic. Van Halen had a terrific debut album and, with a few minor adjustments and a lucky break or two, they would be an equally terrific live act.

I look back on this night now as an almost impossibly innocent and happy time. Imagine walking into a hotel bar even one year later and seeing the guys from Van Halen throwing back shots of Jack Daniel's, rubbing elbows with assorted businessmen and tourists, none of whom had any idea who these kids were. The anonymity would not last, of course, and neither would the innocence. But then, it never does.

By midnight we were all tired and the bar was getting ready to shut down. We finished our drinks and headed to a bank of elevators. By rock 'n' roll standards—or any standards, for that matter—it certainly had not been a long night of partying. But it had been a long night. As the elevator began to climb, Edward nudged David in the ribs.

"Hey, man. You got any krell?"

Dave nodded.

"Yeah, I'll meet you in your room."

The elevator stopped on the eighth floor, they politely said good night and exited. Pete and I were on the eleventh floor. As the elevator rose, I had to admit my ignorance, and curiosity. I'd been around a bit in my thirty-one years. I'd traveled all over the world and ingested my share of illicit substances (although rarely to excess), but I had never heard of "krell."

"What the hell are they talking about?" I asked Pete.

He chuckled.

"Krell is our slang for cocaine," he said. Then, perhaps in an attempt to intercept the next question, he added, "Want to know what we call weed?"

"Sure, why not?"

"Snade," he said.

"Snade?" I repeated. It sounded like such a ridiculous word. It also sounded a lot like "weed," so I wondered . . . why bother changing it?

"Interesting," I said. "Where did that come from?"

Pete looked at me. His eyes were glassy from whiskey and too many hours without sleep. A perplexed look came across his face, as if this were the first time he'd ever been asked this particular question.

"You know what?" he said. "I have no fucking clue."

We both laughed as the elevator lurched its way to the eleventh floor.

That night I slept only a few hours before being awoken by a phone call from Carl Scott. To this day Carl will deny making this phone call, but I was on the receiving end, and I know it wasn't a dream. In his voice there was concern, if not outright panic. He had seen the show at the Aragon and was not happy.

"Noel, what are we going to do?"

I tried to shake the cobwebs from my head. "What are you talking about?"

"The show," he said. "It was terrible. We have a lot invested in this act and that's the way they start out?"

I took a deep breath. On one hand, Carl had a point. It was

not a stellar debut for Van Halen, and yeah, Warner Bros. (Carl in particular) had a great deal riding on the band's success. On the other hand, Carl did not understand what a colossal clusterfuck the day had been. Circumstances wildly beyond the band's control—beyond anyone's control—had conspired to make it a challenging debut. Under the circumstances, I thought, it had been a respectable performance. You couldn't have come away from that show without being impressed by Edward's guitar work; and moon boots withstanding, it was apparent also that David was a potentially great front man. They were limited by time and space, and we all were hampered by technical difficulties.

Truthfully, we were lucky it went as well as it did. But I didn't say any of this. I was too tired. Instead, I just tried to calm him down and get off the phone as quickly as possible.

"Don't worry, Carl. Give us a couple weeks and we'll be ready for prime time."

"Okay," he said. "I hope so."

3

THE ROAD LIFE

We were monsters. All of us.

Not just Alex, Edward, David, and Michael but also the roadies and the support staff and anyone else who joined us on the road. I include myself in this group. And when I say "monsters," I don't mean that in a malevolent way. I mean that when you're on the road with a young and hungry rock band on the cusp of stardom, the usual rules of decorum that one adheres to in polite society simply do not exist. Spend six months on the road, sleep in buses and hotels, perform a hundred shows before drunken, adoring crowds, and see what happens to your moral compass. Things just get . . . twisted.

Look, no one gets into the music business because they want a sensible, safe, and boring nine-to-five routine. (Quite the contrary, in fact.) This is true of the artists themselves, as well as the people who support their careers. You get into the music business because you enjoy the excitement of working

with the stars, or trying to make the unknown but promising musician become a star. Sure, the perks of the job are enticing, as well—the drugs, the women, the opportunity to rub elbows with the rich and famous. But don't think for a moment that it's a walk in the park. The work is hard and sometimes tedious, the hours interminable; there is no division between professional life and personal life, not if you're doing the job right. For better or worse, the job *is* your life. Whether you are an artist, record company executive, promoter, or manager, the perks and money can be amazing. But unless everyone does their job correctly, and fate smiles upon you as well, the artists will never develop into stars and no one will make any money. And the perks dry up quickly. The goal is to make the musician into a rock 'n' roll deity—someone bigger than life. Then everyone rides the train for as long as possible.

I knew from experience that the ride was often short and unglamorous. But Van Halen was different, and they were different from the very beginning.

Despite the issues with the Aragon Ballroom show, there was certainly cause for optimism, and by the time we had a week under our belts, optimism had metamorphosed into something much more concrete. You had to be deaf, dumb, and blind—and stupid—not to see that this band was going to be something extraordinary. Sure, the set was brutally short, leaving David little time for his signature raps, but he was obviously a gifted and confident front man who moved with the grace and agility of an athlete. Whatever range his voice might have lacked was offset by his stage presence (and covered neatly by Michael's backing vocals). Edward was a nightly force of nature. I was too busy to see much of that first show, but after seeing Van Halen perform its next two shows, in Springfield, Illinois, and Indianapolis, I was convinced I had landed the job of a lifetime. And the primary reason was the guitar playing of Edward Van Halen.

"Holy shit!" I'd hear people yelling. "This guy is like Hendrix."

Now, I was never out on the road with Jimi Hendrix, but

I'd heard and seen him play enough to know that this was a comparison one did not make lightly. Hendrix was the acknowledged greatest of all rock 'n' roll guitarists, and to invoke his name in the same sentence with almost any other guitar player—especially one barely out of high school—was to risk being accused of blasphemy, but such was the burden foisted on Edward from the moment *Van Halen* was released on an unsuspecting public.

Still, I knew from experience. In the summer of '69, when I was stage managing at the Fillmore East, I'd worked with everyone from Jefferson Airplane to B. B. King to the Who. That year I saw Jimi Hendrix twice, the first time from a sound booth at the Fillmore East, and then a second time on the last day of Woodstock from the light booth I was perched in, where I watched him play his legendary version of "The Star-Spangled Banner." I came to believe it was a legitimate comparison, just as I came to believe that Van Halen compared favorably with any band I had ever gotten to know up close and personal.

Since then I'd been doused in LSD by the Grateful Dead, I'd shared shots of Southern Comfort with Janis Joplin, and I even fixed Chuck Berry's amp for him (he was so damn grateful he offered to sing at my wedding—he didn't, but that's beside the point). I'd been out on the road with David Sanborn, James Taylor, Bonnie Raitt, Tom Waits, the Sex Pistols, and countless others you might not know. The only band with which I traveled that compared to Van Halen in the late 1970s and early 1980s was the Rolling Stones. And I don't think even they were as dynamic. I'm not saying Van Halen was a "better" band than the Stones. I'm talking about the power of a live performance, the ability to captivate an audience. Van Halen was the best I've ever seen. And I'll say this: as great as Keith Richards was in his own genre, he couldn't touch Edward for sheer musical brilliance and innovation.

So, was I excited about the prospects for Van Halen breaking out?

You bet your ass I was.

This was not like going out on the road with a half-formed

band that had been playing mostly covers in small clubs. Van Halen was a band that seemed almost instantly to be at the peak of its powers—in part, because they'd been writing and playing for years, accumulating the catalog and charisma of a seasoned band, one just dying for its big break. And here it was. I still get goose bumps even thinking about it. Standing just offstage with Van Halen in those first few weeks was one of the most exciting experiences of my professional life. They were playing brand-new material off probably the best debut record I have ever heard, and playing it with attitude and energy like nothing I had ever seen.

Incidentally, about that first record? I was introduced to most of it live, as performed by the band, three times in that first week. It wasn't until we finally got a day off that I listened to the actual recording. And that's when I knew: *These guys are going to be unstoppable*.

After Indianapolis—our third show in as many days—we had a day off. But the respite was short, as we were scheduled to do a show in Madison, Wisconsin, on March 7. That morning I continued my wake-up calls to the band. I'd been doing it for many years and had grown accustomed to the abusive reaction my voice seemed to provoke at that hour of the day. For some reason musicians just don't like getting up early.

"Good morning," I'd usually say, in as cheery a voice as I could manage. "Bags in thirty, we leave in an hour."

This was a routine that lasted until the end of every tour and almost always resulted in some version of the following response: "Fuck you, Noel. We just went to bed."

Like that was my problem or my fault, or I had any control over the schedule. Well, actually, I did, but once it was set in stone, there was no changing it. A tour manager's life is dictated entirely by the clock—if he falls behind, everyone falls behind. So he has to be not just a stickler for details and organization but thick-skinned, as well. It was during the first North American tour that the guys started calling me Li'l Caesar, a nod to my supposed dictatorial ways (despite the fact that I really had very little power).

By the fourth gig, in Madison, Van Halen had already made a small but not insignificant change in support staff. It happened during a short afternoon rehearsal, when David suddenly stopped and turned to Marshall Berle.

"Hey, Marshall, I have to say this. The way you introduce the band? It's kind of lame."

This was somewhat cruel (and an early indication of David's bluntness) but also entirely accurate. Marshall, who apparently was prone to microphone-induced anxiety, had stammered and coughed his way through three awful versions of "Ladies and gentlemen . . . I give you . . . the mighty V-V-V-Van Halen!"

He had already made it clear that he would be leaving the road shortly and returning to LA, so the announcer's job was going to be open anyway, but I guess David felt compelled to take care of the matter right then and there.

"Who else can we get?" David asked, looking around the arena. Unsurprisingly, there were no volunteers. "We need someone who is going to be around for the whole tour." Another pause as David surveyed the small crowd, which consisted entirely of Van Halen crew and management staff. Suddenly, he looked at me.

"Hey, Monk. How about you?"

I held up my hands in a desperate attempt to deflect the query. Even though I was going to be with the band on every date of the 1978 world tour—which eventually reached an exhausting 174 shows in a span of less than ten months—I was not about to get trapped into having to be on-site for the start of every show. Not only that, but I, like Marshall, had an almost pathological hatred of microphones.

"Thanks for the offer," I said, "but I'm going to have to decline."

To my relief, David shrugged and moved on. "Okay, well, who else we got?" Bullet dodged.

For some reason that I have never figured out, aside from the fact that he happened to be nearby, Rudy Leiren's name was thrown into the ring. Rudy was a perfectly fine guitar

tech and a loyal friend to Eddie's, but as far I know, he had no experience as an announcer. He simply happened to be in the right place at the right time.

"Let's go, Rudy," David said, stepping away from the mic. Rudy walked up, looking a bit uncomfortable, cleared his throat, and shouted, "The mighty Van Halen!" His voice echoed through an empty arena, strong and clear, without a hint of a stammer. Everyone smiled; there was even some light applause.

"You're hired!" David laughed.

And so he was. From that moment on, right up until the band imploded, more than six years later, Rudy the guitar tech was also Rudy the announcer—the howling, disembodied voice that kicked off hundreds of Van Halen shows. Marshall, whose obvious discomfort betrayed the fact that he was completely out of his element, left the next day for the safety of a Southern California office building (and did not return for quite some time), and Rudy took over the mic. It was, in my opinion, a favorable trade in every possible way. The band got a credible announcer, Rudy got to introduce his buddies, and none of us had to put up with Marshall. I'd call that a win.

FROM DAY ONE— or at least week one—Van Halen was a partying band, and everyone on the road with the band got pulled into this orbit. Not that anyone complained, mind you. This was the late seventies, a time when there was virtually no stigma attached to any illicit substance, assuming it was used in moderation (a relative term; the bar for partying was set abnormally high in the music business, particularly when you were on the road). For the first year or two it really wasn't much of a problem. The guys all liked to drink and smoke weed, and I got the definite impression that they weren't exactly new to this lifestyle when I first met them. But it wasn't excessive. Not in the beginning. David had some money, so he was the occasional conduit for coke, but it wasn't like they were doing piles of blow in the dressing room before going on-

stage. We all knew how to work hard and put on a great show and then unwind afterward.

And then do it all over again the next day.

Drug use sneaks up on you—I've seen it destroy countless bands, and it would eventually prove to be instrumental in Van Halen's unraveling, but for the first couple of years we mostly just had a fantastic time. If these guys weren't born to play the role of rock stars, they certainly adapted to it quickly—all those years of playing wild backyard gigs had been a superb apprenticeship.

By the time we got to Madison, the boys had already embraced the time-honored tradition of trashing their hotel rooms. Now, it was a bit early in the game for Van Halen to start behaving this way, but again . . . it wasn't like they had come out of nowhere. It only seemed that way to the uninitiated (as legend has it, corroborated by the guys in the band, they were not averse to trashing the homes of friends when they played on the backyard circuit). Manners flew out the window—along with tables, chairs, lamps, and anything else that was of little obvious use and had the misfortune not to be nailed down. I had been with other bands that had trashed their surroundings, but they had nothing on Van Halen.

Madison was a two-night stay, and as the damage accrued, I realized that we weren't going to simply be able to sneak out of town without being held accountable. And, frankly, I didn't want to do that. I knew that at some point I would have to speak with the hotel manager, try to put as positive a spin on the matter as I possibly could, and agree to pay for any and all damages. What I hoped to avoid was any sort of police involvement or bad publicity; fortunately, this was decades ahead of social media, when every inappropriate celebrity act is recorded by someone and instantly uploaded to the internet.

Van Halen was not yet big enough to attract much in the way of mainstream media attention, so the band could beat the shit out of a hotel room and no one would really care—as long as we agreed to pay for damages.

This particular room was nearly destroyed. Not only was

furniture broken and or heaved out the window but the room itself had been smeared with ketchup. And when I say "smeared," I am not being hyperbolic. It was here, you see, that I was introduced to the Ketchup Queens, a pair of delightful and exuberant groupies with a bit of a fetish for condiments. When I walked into the room I saw two beautiful girls, completely naked, lying next to each other on one of the hotel beds. The band members were standing over them, armed with plastic squeeze bottles filled with ketchup. At first I was horrified at the sight of the boys firing ketchup into their guests' every available orifice (and some that, frankly, were not available), but my gaze was quickly drawn to the girls' faces; they were hardly being coerced. Instead, they were laughing uncontrollably and soaking up the ketchup like lilacs enjoying a spring shower. Well, to each her own, I thought. It was all part of the process of becoming a tried-and-tested rock star; understanding that you could do almost anything, and ignoring the switch that stops you from doing it.

David seemed to understand that from the beginning, and embraced it wholeheartedly, in part because he so desperately wanted to be a star. Alex and Edward picked up on it pretty quickly. Michael, being the nicest guy in the band, remained a gentle and fun-loving soul even as chaos swirled around him. He was an unlikely rock star, and therefore suited to playing the least flamboyant instrument in the band. Michael was the antistar of Van Halen, and fans identified with him. He was impossible to dislike.

"Michael, it's a good thing there are only four strings on a bass," I'd tease. "That way you won't get confused."

It was just a joke and I'd say it before almost every show because I knew that it would elicit a laugh and a knowing nod from Michael, as if he was saying, "Yeah, I'm the luckiest guy on the planet."

Even when we trashed hotel rooms and dressing rooms, Michael was usually the least involved. For him, it was the height of debauchery to use the food supplied by catering as paint for a mural—which he did rather often, and sometimes

to impressive effect. We (meaning Red Roadie and I) actually introduced him to our favorite drink, the boilermaker, which made ample use of the Jack Daniel's Michael already favored, and which ultimately became his weakness.

I didn't stay in the room with the Ketchup Queens very long—just long enough to have gotten the gist of things. But when I returned a short time later, the room was an absolute disaster. The furniture was either missing or shattered, and there was a copious amount of ketchup all over the place, and on every conceivable surface, includng the floor and even the ceiling. As I surveyed the damage, and narrowly avoided some of the evidence dripping onto me from a particularly disgusting ceiling fan, I honestly couldn't tell whether it looked like there had been an orgy or a gangland massacre. It was the kind of scene that would have made Caligula proud.

The next morning, I met with the manager.

"I'm very sorry," I began. "There's really no good explanation for the condition of our rooms."

"How bad is it, Mr. Monk?" he asked.

An image of the previous night's debauchery flashed across my mind's eye. I winced. Then I choked back an urge to laugh.

"Not great," I said. And then I gave him the gory details. By the time I had finished, the manager's face had turned red. "Really, it's unusual for them to behave this way," I added, lying through my teeth to the poor guy. "They're a nice bunch of young men. Maybe there's something in the water that caused a personality change."

The manager laughed.

"Mr. Monk, you're not the first band that has ever stayed in our hotel. And you're not the first to wreck one of our rooms."

I let out a sigh of relief. "Okay, what do we do?"

"Very simple," he said. "Just write a check."

I went upstairs and called the boys in to my room. I explained that the hotel manager would not be pressing any charges, and that he had graciously agreed to simply allow us to pay for damages. He would be up shortly to survey the carnage and give us a bill.

"Do we have the money for this?" David asked.

"Don't worry," I replied. "Warner Brothers will be picking up the tab."

They all smiled and exchanged high-fives.

"That's great, Noel," Edward said. "Good job."

"Thank you. Of course, eventually it will come back to you."

"What do you mean?"

"It's called recoupment, boys. I'll explain later."

It would be some time before they grasped this concept: that everything came out of their pockets. For now, though, they seemed satisfied with my explanation, and with knowing that there would be no further consequences. After the manager had surveyed the damage, presumably made an appointment with his shrink, and put together an itemized bill, I paid with plastic.

"We appreciate your understanding and professionalism," I said. "And your discretion."

He nodded. "And we appreciate your business. Feel free to come back." He paused, smiled. "You'll get the floor that's being renovated."

SOMETIMES THE TRASHING OF HOTEL ROOMS

was simply the by-product of boredom and entitlement. This was not a normal lifestyle we were leading. Throw in groupies and copious amounts of mind-altering chemicals, and you have a recipe for destruction. It rarely stemmed from any sort of hostility. It was just childish and irresponsible . . . and, quite often, a lot of fun. But there were occasions when interpersonal dynamics and fragile band relationships factored into the equation. I am talking specifically about the deep and unusual bond between the brothers Van Halen.

It was fairly early in the tour when I saw them go at it for the first time, but it would not be the last. Look, I get it—families are complicated and codependent organisms. I grew up in a dysfunctional household myself, with an alcoholic father and an abusive mother; my sister and I both suffered in

this environment, and because of that I am no stranger to the complexities of family dynamics. Still, the Van Halen brothers seemed to test those familial bonds to an extreme, beginning with their relationship to their father, Jan Van Halen.

The first few times I met Jan, I found him to be a likable man who had led an interesting life. He obviously loved music and wanted his sons to succeed. Most of what I learned about Jan's life was revealed during sessions the two of us shared at a local shooting range in Los Angeles. Jan enjoyed making his own ammunition and collecting and trading weapons. But most of all he enjoyed shooting. Does this make him sound like a scary guy? Not to me. I've been around guns most of my life and know they are only as dangerous as the hand in which they are held. Which, of course, is not to say that everyone should own a gun. But Jan seemed like a reasonable enough fellow, although he had that peculiar way (not uncommon for the Dutch) of seeming both laid-back and intense at the same time. Still, we shared many good times together.

The shooting range we visited most frequently was close to Jan's house. We would swap old stories, and his were always more harrowing than mine. And as I got to know Jan a little better, I saw behavior that I found odd and frankly unappealing. For one thing, he was an alcoholic. Forget for a moment that drunks and drug addicts shouldn't mess with guns—Jan always seemed responsible in that particular arena; it was the way he talked about drinking and how it affected his kids that gave me pause.

I don't doubt that Jan loved his children, but he had an odd way of showing it, and of attempting to foster that love. For one thing, he believed that one of the best ways to bond with his boys was to drink with them. I'm not talking about a father sharing a beer with a couple of grown children of legal drinking age. I'm talking about a guy getting shit-faced with his teenage boys in the hope that the camaraderie of drinking would encourage honesty and transparency in their relationship; that booze would enhance their relationship to such an extent that there would be no secrets. Jan would be the cool dad whose

kids would tell him everything that was happening in their lives: the good the bad, even the ugly. Now, it always seemed to me that Jan utilized this method to excess, to put it mildly. By the time these guys got around to bonding and communicating, they were too blasted to discuss anything of substance. To me, it all seemed completely pointless, and probably just selfish on Jan's part. It was a way to rationalize his own drinking and to avoid the admittedly hard work of raising responsible children. Instead, he was an alcoholic father blatantly passing the torch (or bottle) to his sons, who would also become alcoholics. I suppose this hit a nerve with me because I too had grown up with an alcoholic father, although mine was more obviously abusive than Jan. Still, I understood the pathology and had suffered from it firsthand, so, even though I liked Jan, I couldn't help but question the wisdom of his parental strategy.

I heard similar and corroborative stories from Alex, as well. He used to tell me that he felt like he got along best with his parents when he was completely smashed. Not when he'd had a couple drinks but "smashed." And when Alex used the word *smashed*, it carried weight, since it took more to get Alex loaded than almost anyone I have ever met. By the time I met Alex he was already well down the drunken highway, drinking copious amounts of Schlitz Malt Liquor on a nightly basis.

I liked their mother, Eugenia, but she was a complicated and unhappy woman, and my affection was born largely of compassion. You see, she suffered from what I can only assume was a type of mental illness, represented most glaringly by an irrational and sometimes paralyzing fear of Jehovah's Witnesses. Now, I understand that Jehovah's Witnesses confuse nearly all of us who are not of their particular Christian faith and interpretation, but Eugenia's feelings about them went well beyond annoyance; she was inordinately terrified of them. I don't know the origin of this phobia. During World War II, Dutch Jews and Jehovah's Witnesses (among others) were rounded up and hoarded away in concentration camps. I know only that it was excessive and irrational. Eugenia firmly believed that Jehovah's Witnesses had followed her from Am-

sterdam and were trying to destroy her. She would pull you aside as if she had a secret to tell you; then she would reveal her fears and suspicions, and eventually get around to asking whether you were "one of them" and intended to do her harm. The first time this happened to me, I mistakenly presumed that she was joking. She wasn't. Instead, once assured that I wasn't a member of the Jehovah's Witnesses dispatched to hurt her, she would ask if I had seen any of "them" on my way to her house. Were they lurking nearby? Hiding in the trees, perhaps? I didn't know how to respond; I simply felt sorry for her. It was clear from the look of abject terror on her face that this nightmarish scenario was entirely real to her. And it was crippling.

Irrational and unfounded though it might have been, this fear resulted in Eugenia's becoming largely a prisoner in her own home. While the boys played music often in front of Jan, their mother was an infrequent presence at concerts. As the wealth of the Van Halen brothers grew, I couldn't help but wonder whether they had done everything they could to help their mother. Then again, maybe they did. Perhaps there had been private consultations and medication and interventions of one sort or another. I can only assume that they did try, and that their efforts were unsuccessful.

Alex sometimes seemed to bristle over his heritage—or a portion of it, anyway. For example, he used to note that he had "chine eyes." I couldn't tell whether or not he was kidding, but I hated it when he talked like this—usually after he'd been drinking. I don't know what it was that he saw, but it had never occurred to me that the shape of his eyes, inherited from his mother, could be something negative; it didn't seem to occur to all the women routinely fawning over him, either. He was a good-looking guy (as was Edward) and together the two of them certainly did nothing to detract from the Van Halen brand, so to speak—despite Alex's apparent insecurities.

Alex drank because it was in his DNA to do so, and he was tutored at the knee of a pro, but I also think it had something to do with the fact that he toiled forever in the shadow of his far more innovative younger brother. I felt from the beginning

that the brothers' relationship was complicated by the very thing that also made them so close: music. Specifically, as I said, by the fact that Edward was so clearly the more gifted artist. No shame in that. But it had to have been challenging for Alex to see his little brother develop into a superstar. Don't get me wrong, Alex was good—damn good—in his own right, and would later go on to be named number 51 on *Rolling Stone's* list of the 100 Greatest Drummers of All Time. He could play the hell out of his drum kit, and his work functioned as the backbone to Edward's riffs, Michael's rhythmic drive, and David's crooning vocals. But Edward was, for lack of a better term, a savant. He lived and breathed his craft in a way that most people couldn't even begin to imagine. It was the way he interfaced with the rest of the world—everything was filtered through a lens of music. It came to him naturally, intuitively, but more than that, it was like it came through him, as if he was simply the universe's conduit for kick-ass chords and mind-blowing guitar solos.

Alex knew this, and I believe he understood and appreciated this more than most people would. Maybe it's about proximity—maybe if they hadn't been forged in the same environment, not just as children but also as adults trying to withstand the industry together, spending so much time in the same spaces, eating, drinking, working, and touring (and playing) around the clock—it would have been a different story. Alex was always his brother's biggest supporter and advocate, but I'd be lying if I said I never saw it get to him.

I'm not saying he didn't love Eddie—I'm sure he did. But it was fascinating, and eventually depressing, to watch their relationship change and to see the balance of power shift so completely. And yet, Edward never totally freed himself from Alex's influence. At his lowest, Alex could be extremely jealous; and, more so than Edward, Alex could be inscrutable if not downright mean, especially in the band's later years (and by later I mean near the end of my tenure), as he fell completely into the abyss.

The first time I saw Alex and Edward get into an argument that escalated into much more than an argument, it was somewhat startling. It was during that initial tour and I was leaving their hotel room as it happened. They had been drinking, of course. As a manager, I'd always rather see my band members smoking weed than getting shit-faced on whiskey. While weed might have been illegal, it rarely provoked anything more painful than a boring conversation. But get Alex and Edward drinking, and it was only a matter of time before old wounds born of sibling rivalry began to ooze.

That first occasion, we had all been sitting in the hotel room, drinking and talking. Suddenly Edward and Alex veered off into their own little discussion, the subject of which was completely foreign to me. And when I say foreign, I mean that I did not understand a word, as they began screaming at each other in what I later learned was Dutch—the tongue of their motherland. It was one of the strangest things I had ever seen—these two ordinarily placid Southern California rockers, who usually spoke in a sort of pothead surf patois, suddenly nose to nose, spitting and snarling, and growling at each other in a foreign language, as if they had become possessed. I started to leave the room as their voices got louder—it was all just a little too crazy and pathetic, even for rock 'n' roll. But before I could exit, they were on each other, slamming their fists into each other's faces, grabbing great fistfuls of hair, and rolling around on the floor like drunken idiots.

As we separated them, all I could think was, *Holy shit . . . I've got a couple madmen on my hands*.

The truth is actually both less and more complicated than this. If you want to romanticize the Van Halen story, you can point to the brothers' supposedly cosmopolitan and artful upbringing—ethnically diverse parents with an artistic bent; the boys were born to be musicians. On paper, sure—but the other side of the coin was that they came from a monumentally fucked up family that provided neither emotional nor financial stability.

In some ways, they grew up quickly; they also behaved like children well into their adult years. This, after all, was the way children settled disputes, with physical aggression. Moreover, despite appearing rather soft and skinny, both Edward and Alex carried themselves with the air of people who had spent time on the streets. I had been around a lot of people like this and had fallen prey to some of this behavior myself at times, but I was surprised to see it in the Van Halens.

I saw them come to blows only a few times, and invariably it ended with the two brothers hugging it out, as if this were the most normal thing in the world. Maybe it is. Maybe, in some families, you have to exorcise the anger on a semi-regular basis, and the only way to do that is by hitting your brother in the face. I suppose, on some level, it's preferable to suppressing years of emotional buildup with a grab bag of fun narcotics, but what do I know?

Despite occasional flare-ups, there was, in that first year or two, anyway, a genuine sense of camaraderie among not just the band members but the entire traveling circus. This was another reason why I fell in love with Van Halen: the job was fun. In all the time I spent devoting my life and sanity to this craft, I had never seen a group of guys that had such talent, personality, and unmatched sense of brotherhood between them. Van Halen wasn't just a band but an honest-to-God team; a band in which all four partners shared equally in the culmination of their hard work and superhuman efforts (although this would change in later years). It didn't matter who wrote the music or the lyrics—all the revenue was split four ways. This egalitarian approach to the business was designed to keep everyone happy and equally invested; it also served to remind them of their roots. They were friends first, bandmates and business partners second.

Quaint, isn't it?

But they believed in this philosophy, at least for a while, and it helped make the first couple of years an unmitigated blast. Van Halen was a family, and that family included everyone who was on the road with us.

M&MS AND GUACAMOLE

A young band has to learn to stand up for itself in any number of ways, pushing back against abusive or bullying tactics from a variety of sources, both expected and unexpected. It is assumed, after all, that a new band will find innumerable hands in its pockets—from crooked promoters and managers to record company executives of questionable moral fiber. But the road is a more savage existence, and the challenges can come from those with whom you are supposed to be building a collegial relationship.

Like the other bands with whom you share the stage every night.

Nowhere is it written that a headlining act has to be particularly magnanimous toward the bands on its undercard. In fact, the relationship often plays out in exactly the opposite way. An undercard band can expect to be, at best, tolerated; at worst, disrespected and given short shrift at every opportu-

nity. Like so many other aspects of the music business, it's a test. Opening night at the Aragon Ballroom, when Van Halen was given so little space to perform, was a perfect example of how we were viewed by Journey and Montrose. We were the new guys on the team and we would have to prove ourselves worthy of better treatment. Sometimes this can be accomplished simply by outperforming the other bands, regardless of the length of the set. But occasionally things must be handled in a more confrontational manner. To put it bluntly, sometimes you have to get your hands dirty.

For example, getting an appropriate sound check proved to be an ongoing exercise in frustration during the early part of the first tour. A triple bill can be great for fans and promoters, but it can be challenging for the bands themselves, especially for the band on the lowest rung of the ladder. As the headliner, Journey got to set up its equipment first and take the first sound check. Ronnie Montrose, billed second, got the next sound check. After a week of standing around in the wings, waiting and watching while Ronnie did his guitar wizard act (like he had anything on Edward), the frustration began to mount. Ronnie would stand there for an hour or more, painstakingly tuning his guitar long after his bandmates had left the stage. I can appreciate a quest for perfection as much as the next guy, but this was inconsiderate and frankly unprofessional.

"Are these guys ever going to get off the fucking stage?" David said one day. And I knew then that we had to address the issue head-on.

"Wait over there," I told him, pointing to the side of the stage. "Make sure they can see you."

"Why?" Edward asked, clearly unsure of where I was going with this.

"Don't worry about it, just follow my lead."

I had already discussed the possibility of an altercation between Montrose and his guys with our small but dedicated (and feisty) crew, who were more than willing to help out. I had expected they'd be upset by the news, but far from it—

they were excited. There was blood in the air and they were ready to help me establish the respect that was deserved and had been sorely lacking up to this point. We were fed up and poised to draw a line in the sand. I had outfitted them with the same type of gear that we'd worn on the Sex Pistols tour: all-black outfits, kick-the-shit-out-of-you, steel-toed boots, and thick, heavy police belts, with handcuffs and flashlights clanging and dangling ominously from the loops. They had a strong, intimidating effect, and just strapping this stuff on gave the crew a sense of empowerment. The guys in the band were a bit wary of the outfits but went along for the ride. They knew nothing would happen to them.

"Trust me," I said. "A show of strength is usually all that's necessary."

"Hope so," said David, smiling nervously.

As Ronnie continued with his endless guitar tweaking, I got my guys together and we moved into position. On my cue—a slight, well-timed head nod—my road crew and I began walking toward him. We formed a rough semicircle around him, closing in, until we were almost on top of him, and Ronnie finally looked up.

"Is there a problem?" he asked nonchalantly, almost like he had no idea why we might be interested in an impromptu summit.

"Yeah, Ronnie—actually, there is," I said. "We need to do our sound check. Time is getting tight here."

Ronnie barely made eye contact with me or the band, instead looking away and continuing to noodle with chords in the same mind-numbingly irritating fashion. My roadies tightened their little protective circle as he played, and after a few moments of this incessant bullshit, he finally answered us. "Umm—yeah, sure." He sounded bored, like we were the ones wasting his precious time. "I'll be done in a little while."

"When?" I asked. What I did not say was: *If you think you're gettin' out of this one, you've got another think coming, pal.*

Ronnie looked up at me, then at my guys, and then at his

own guys, who were in the wings and in no position to defend him. He shrugged. "It'll only be a few minutes."

It was more than a few minutes . . . but not much more. We did the exact same thing at the next show, and the show after that, and eventually the message was delivered and received. Van Halen began to get a block of time sufficient to adjust its gear and do a proper sound check. The boys obviously were happy about this; they were also fascinated. Although Alex and Edward were not averse to throwing drunken haymakers at one another every so often, the band was not, by nature, composed of "fighters." They were party boys, and since they were brand-new to the whole concept of touring, they had never seen or even envisioned this type of conflict before. They assumed that bands out on the road together enjoyed a sort of esprit de corps. This was sometimes true; more often they were rivals. The fact that Van Halen was signed as a third act, yet quickly demonstrated an ability to blow the headliners away, probably didn't help matters any.

The band quickly embraced the notion that a three-act tour was something of an athletic event—a test of endurance, strength, and balls, as well as of musical ability. We were on the road seven days a week, sometimes playing five or six shows, a brutal schedule for just a single truck and a bunch of young road warriors. There was no consideration given to the possibility of fatigue or boredom; we played and traveled and drank and smoked and screwed. We didn't worry about the consequences, especially the guys in the band. They were too young and energetic to care.

The ability to live this life, day after relentless day—to get by on little or no sleep and still put on one hell of a show the next night—was a badge of honor. If you were Van Halen, you wanted to give your fans a thrill every night; you always wanted to blow Montrose and Journey right off the fucking stage. And you didn't accomplish any of these things by behaving in a quiet or subservient manner. You stood up for yourself before and after the show, and once you were onstage, you

kicked ass, with no concern whatsoever about offending the delicate egos of a band whose name stood atop the marquee.

Fuck Ronnie Montrose.

Fuck Journey.

Van Halen was on a mission.

David was the first to get on board with this attitude (it wasn't a huge jump from who he was at his core anyway, although I later realized that David was a talker, not a fighter). Around this same time, for example, he initiated a workplace dress code: anyone associated with the band—artists or crew—was required to wear either a shirt emblazoned with some form of the Van Halen logo or a plain black shirt. Under no circumstances was anyone permitted to wear an article of clothing that bore the logo or name of another band. This might sound obvious, but you'd be surprised how often such an edict was ignored. It wasn't uncommon in those days for roadies—many of whom had worked for multiple bands over the years—to pull an old T-shirt out of a drawer and throw it on, so you might end up with a roadie working a Grateful Dead tour and wearing a Jefferson Airplane tee. Most bands frankly didn't give a shit, so long as the job was done well.

David, an "us-versus-them" kind of guy, saw it differently. We were already a close-knit unit, but David believed that there was something to be gained by proclaiming that allegiance to the world—all day, every day. That said, I can't deny that the wardrobe edict had precisely the desired effect: it galvanized the band and the crew. Only once did I hear anyone complain, and that was when Journey offered shirts to everyone on the Van Halen crew. These were specially designed for us, with *Van Halen* printed on the front, but they also bore the Journey logo. They were extremely cool shirts and it was a genuinely thoughtful gesture on the part of Journey to do this; nevertheless, they were never worn. Not in public, anyway. Eventually, we had our own special shirts made for the crew, to denote their different but vital role within the organization. That first tour, however, was a nameless, grueling affair. We settled for

Van Halen shirts and plain brown leather jackets. Nevertheless, we were building both a name and a brand. Not to mention a reputation.

Within a month, Van Halen had become a much bigger attraction than Montrose, and by the third or fourth month we were promoting a debut album that had gone gold. Between the albums and the sold-out shows, we had, arguably, become bigger than Journey. We were definitely a hell of a lot more fun. Journey was a slick and polished band riding the luminescent vocals of Steve Perry. They were radio-friendly, candy to the ears. Van Halen, meanwhile, was raw and unpredictable. You never knew from night to night exactly what David was going to say, or which direction Eddie might go with one of his breathtaking solos. No two shows were exactly the same, which, if you're a fan of true rock 'n' roll, is a very good thing indeed.

Everyone associated with the tour benefited from Van Halen's sudden and soaring popularity. Not just Warner Bros. (which also had Montrose under contract), but Journey's label, Columbia, as well. We played one sellout after another, in front of raucous, screaming crowds. A few months earlier this was a modest doubleheader featuring one band (Journey) finally achieving success after many years of trying, and another (Ronnie Montrose) on the downslope. Now it was a triple bill that included as its opening act, almost ludicrously, one of the hottest and most entertaining acts in the business. If you were a fan of guitar rock, this was one hell of a bargain, because Van Halen would never again be playing a supporting role in venues this small, at such a low price point.

You want to know who wasn't happy? Ronnie Montrose and Journey. Sure, we were helping them fill arenas and make money; we also were setting a nightly standard that they could not match. Typically, a warm-up band merely tries to survive the tour without getting booed off the stage. Disinterest is about the best you can hope for. Not on this tour. After a few months Van Halen was a warm-up act in

name only. We were selling as many, if not more, records as Journey, and attracting just as many fans. And we sure as shit put on the better show. Don't get me wrong; Steve was a fantastic vocalist with an impressive range and style. Technically speaking, he was ten times the singer David Lee Roth would ever be. But he was only half as charismatic as David, whose howling, growling delivery and impromptu monologues, combined with a tendency to prowl the stage like a feral cat, lent every performance an air of mystery and danger. He was an actor playing a part, and he played it perfectly.

Steve was a nice enough guy, and normally we all got along just fine offstage, but with Van Halen's sudden surge in popularity, the guys in Journey naturally became defensive and territorial. It didn't help that by the time Journey was set to hit the stage, the boys from Van Halen were already in full party mode, which sometimes interfered with Steve's preparation.

Here's the way it worked. While Van Halen churned through its thirty-five- to forty-minute set (which was never lengthened, despite the band's rapid ascent), I'd snag as many promotional people as I could find and escort them to our dressing room. As we were a new band on its first tour, we had a feeble little contract rider at the time. A rider is basically a list of items required by a particular artist at a given venue; riders can be short and sweet, or they can be long and gratuitous, depending on the status and ego of the artist involved. A rider can and often does include food and beverage requirements, backstage access for friends and family, dressing room specifications, and other accoutrements. The degree to which one is considered a diva—i.e., an asshole—can often be measured simply by the number of items in the rider and by their absurdity. Which is not to say that a rider is unimportant. It's actually very important, which is why Van Halen wound up, a couple years later, with a rider that included, rather famously, a demand that the dressing room be well stocked with M&M candies—but with all of the brown M&M's removed.

Yes, it is true, and I was the architect of this little feat of genius, at the band's urging, but I assure you that there was a method to my madness, so to speak. You see, the intent of this portion of the rider wasn't to create more silly and degrading work for some poor promoter's assistant or un- paid intern—although that was an unintended by-product— but instead acted as a sort of insurance clause that proved that the things that really did matter in our contract (safety measures and the like) had been given proper weight and consideration. We figured that if a promoter took the time to remove all the brown M&M's from the bowl before put- ting them in our dressing room, it was far less likely he'd screwed up any of the other, really important stuff. It gave the promoters a headache and made us look like a bunch of dickheads, sure, but it saved me time, and it prevented some- thing going wrong for the band.

When Van Halen was signed to its first tour, however, the band was in no position to demand much of anything, so the dressing room was rather austere. I'd usually aug- ment the rider by asking the promoter for some beer and soda. Then, on my own, I'd buy some Jack Daniel's (mostly for Michael), some vodka, maybe a little scotch, and we'd set up a little bar backstage. David usually had some weed on him, maybe coke if it was a special occasion, like a Tues- day, and as soon as the show ended we'd throw ourselves a little party. The promotional guys loved visiting our dressing room; it was a fun and lively place, especially after a few months on the road, when the band experienced a massive uptick in the quantity and quality of the young women who craved backstage access.

Edward, David, and Al were getting laid all the time. Every night, sometimes multiple times per night. Michael not so much, but not for lack of opportunity; he simply rebuffed most advances. It was rather perplexing to the other guys in the band, but it was just one of the many reasons I liked and admired Michael. He had his priorities straight, and he knew where his loyalties lay, with his high school sweetheart, Sue

Hendry, unlike the other boys, whose priorities were to lay as many different women as humanly possible—which is quite a lot, if it's a Tuesday and the, uh, extracurricular activities are being fueled by copious amounts of blow. Alex accumulated the most partners. Both his appetite and stamina seemed boundless, and he made no effort to harness any of his compulsions.

Many nights the party was in full bloom before Montrose even began playing, which left Journey in the unfortunate position of trying to warm up and prepare in the middle of a Van Halen bacchanal. One night a member of the Warner Bros. promotional staff passed out in the dressing room shower. I'm not sure how or when he got home—hell, he might still be in there. Another time I walked into the dressing room while Montrose was still onstage. The room was eerily quiet, an immediate indication that something was seriously amiss. The whole band was there, along with some of the guys from Journey and other various hangers-on. Ordinarily, the place would have been rockin'. This time, in stark contrast, it felt almost funereal.

I thought briefly about backing out of the room and claiming plausible deniability, before I finally asked, "What's going on, guys?"

I was met with complete silence, and my heart sank. I looked around the room. My gaze came to rest on a large and well-lit full-length mirror, the type artists would normally use to check themselves out before going onstage. For some reason, there was a broad green streak running diagonally down the length of it, as if someone had splashed paint on it. In the middle of this swath was a large, man-shaped gap—as if someone had been standing in front of said mirror when the shit went down. I moved in to get a better look. Around me, no one said a word. I reached out to touch the evidence, and on closer examination, the "paint" revealed its true nature: it was guacamole, thick and viscous and already starting to turn brown.

Oh, shit.

I turned to face the band. David and Edward were slumped in their chairs, trying not to make eye contact with me. I didn't blame them.

"All right, boys," I said, mustering up all of my courage, and preparing for the very real possibility of our being kicked off the tour. "Out with it. What the hell happened?" If that makes me sound like a parent dealing with children, well, that's pretty much the way I felt. After a few moments of tense silence, Edward spoke up.

"David started it," he said, pointing an accusatory finger. "He threw a bowl of peanuts at me."

There was a pause, and I noticed David trying to stifle a laugh. Are you fucking kidding me? I thought.

"Fuck you, Dave," Edward said and looked back at me. "See, I had to retaliate. He deserved it."

This was excellent logic—for a six-year-old. (And, I suppose, for a rock star.) "What did you do, Edward?" I asked.

By now they were all laughing. The tension began to clear from the room—no doubt being absorbed straight into my shoulders and chest instead. "I threw a bowl of guacamole at David's head," Edward explained, shrugging and smiling that goofy grin of his. "But I hit Steve instead."

Oh, boy.

"Steve? As in . . . Steve Perry?" I braced myself for an answer I knew I wouldn't like, and Edward nodded sheepishly. Someone giggled. Well, I thought, that's the end of that. We've had a good run. Time to pull the soil over the freshly dug graves that Edward Fucking Van Halen had dug for us and call it a night. "Shit," I said, rubbing at my mustache and trying not to lose my cool. Something funny happens to you in the middle of a disaster—sometimes you're able to hold it together just long enough to try to fix the shit show.

"Where is he?" I asked.

David nodded toward the bathroom. "In there, I think."

The next thing I knew, I had gone against every single instinct I had and walked into the bathroom, where I found Steve standing in front of the sink. From the top of his luxuri-

ous mane of silky black hair to the middle of his shimmering new sateen Journey jacket, he was completely covered in guacamole. "Hey, Steve." I tried to keep my tone gentle, and the sheer terror out of my voice. "You okay?"

Steve slowly turned around so that I could get a full frontal view of the onslaught. "I was going to wear this onstage tonight," he told me, tapping the chest of his jacket, his lower lip quivering. "Look at it now—it's fucking ruined." Words failed him, and for a moment I thought he was about to erupt—to start screaming, to demand that we pay for damages and leave the tour immediately, have our heads mounted on spikes and set outside the front doors of our next gig, but instead he simply began crying, a soft, sad little whimper, and I felt bad for him. Here he was, an emerging rock star fronting a ridiculously popular tour, and he had been reduced to tears by a pack of incorrigible, food-fighting kids. I can only imagine that Steve must have felt like he was back in middle school, crammed into a cafeteria with a bunch of heartless, mean children. If it had been me, I would have thrown that bowl of guacamole right back at Edward. Or punched him in the face. Maybe both. Alas, for better or for worse, not everyone is built this way. Steve had a titanic voice, but it came from a small and gentle man. He was an artist, not a fighter or a guacamole thrower.

"It's okay, Steve," I said. I won't lie, I was a little relieved—but I did my best to conceal that fact. "We'll get you cleaned up, and we'll find another jacket."

"There's not enough time."

"Sure there is." I offered him a smile and armed myself with paper towels. For the next half hour, I stood in that bathroom and helped wipe guacamole from Steve Perry's hair, face, and clothes, all the while talking to him, trying to cheer him up—and keep our asses from getting canned. Eventually, through much hard work and determination, we reached a point of respectability, if not outright cleanliness. He still smelled faintly of avocado and onion, sure, but you had to be awfully close to notice. It certainly could've been worse.

"How do I look?" he asked.

"You look great, Steve. Go get 'em."

As we walked out of the bathroom, Edward was the first to speak. "You okay, Steve?" He sounded apologetic.

Steve, ever the trouper, nodded at him. "I'm fine. Don't sweat it."

They didn't. No sooner had Steve exited the dressing room than the party resumed, albeit with a noticeable absence of guacamole. I breathed a sigh of relief.

Later that night, I was approached by Journey's capable but understandably exasperated road manager, Pat "Bubba" Morrow. Bubba was in the unfortunate position of having to act as an intermediary between the bands; as tour manager of the headliner, he also took most of the heat when our boys acted out, which they did quite frequently. "Noel, this can't continue," he said. "Your guys have got to start behaving better or we're going to ask you to leave the tour."

I understood his dilemma; I also knew that, since Van Halen deserved as much credit as Journey for the tour's success, he was in no position to make threats. We were selling far too many tickets to be tossed off the tour, notwithstanding trashed hotel rooms, ketchup massacres, or any collateral damage from the occasional guacamole bomb. Did we get credit for not setting anything aflame? (No, no, we did not.)

I presume Bubba's complaints eventually made their way to Warner Bros., because I next received a call from Jane Geraghty, the booking agent for the tour.

"They're going to throw you off the tour if you keep this up." Her tone was serious, a bit like that of an elementary school principal. I felt bad that she had been put in this position. Frankly, I had very little control over the band's actions—as long as they were getting from town to town and playing well, which they were, what was I going to say? And, under the circumstances, Warner Bros. had no more control over the situation than I did. They wanted to make money, and Van Halen was making them a lot of it, both in record sales and at the

gate. After all, the band was being paid a relative pittance for their efforts: $750 per show, split four ways. Oh, and twenty-five dollars per diem to cover meals and other sundries. Think about that: each night when Van Halen went onstage, each band member earned approximately $187 to perform. Given the fact that we were selling between twenty-five hundred and eight thousand tickets per night and promoting a record that had already achieved gold status and would reach platinum before the end of the tour, it's fair to say that Van Halen was a good investment for Warner Bros. (and that's not even factoring in the band's onerous initial contract). It would have been self-destructive, if not downright crazy, for the label to pull Van Halen from the tour.

Hell, we *were* the tour.

"Come on, Jane," I said. "Let's be honest. How are they going to throw us off the tour? You'd have half-empty arenas without us."

There was a long pause, followed by a deep sigh of resignation. It was a hollow threat and Jane knew it.

"Well, you have a point there," she said. "But can't you please do something about their behavior?"

"Like what?"

"I don't know! Something . . . anything."

"Okay . . . I'll talk to them," I said.

And I did. Not that it mattered. They were having too much fun to sweat the details or worry about the mess. That was my problem.

IN THE 1970S, if you wanted to listen to music in the privacy of your own home, choosing your own favorite artist and repeating a track as many times as you wanted, there were only a few options, and vinyl was by the far the best. People bought LPs by the boatload in those days—great, silky slabs of black vinyl. If you wanted to hear just a single song, you might buy the single, a small but shimmering vinyl disc.

You'd put the record on your turntable, and bask in the sonic purity. You could hear everything on vinyl, every note of every instrument—from the loudest and strongest guitar riff to the subtlest background vocals. And if you wanted to hear a particular track over again, you had to do it manually, gently picking up the tone arm, moving it back a few grooves, and dropping it carefully in place.

To anyone born in the last twenty-five years, all of this must seem terribly quaint . . . not to mention ponderous and unwieldy, as well as a colossal waste of time. Digital content and streaming services have made old-school equipment and vinyl records as obsolete as wired telephones and tube TVs. To all but the nightclub DJ and the serious audiophile, the vinyl record is nothing more than a relic of a bygone era.

But what an era.

If you loved music in the predigital days, chances are you owned records, lots of them. They filled your bookshelves or empty milk crates; they provided a fortress, literal and metaphorical, from the outside world. And unless you were stupid enough to buy a "risk-free" membership in the Columbia Record and Tape Club, the only one way to expand your vinyl horizons was by visiting a record store. There was nothing quite like wandering up and down the aisles, looking at the posters on the walls, thumbing through the latest releases. You could kill a couple hours just wandering around Sam Goody's or Tower Records, listening to music, soaking up the sights and smells, reading jacket notes. Record stores brought together a diverse community bound by a single trait: a love of music. Didn't matter if you favored country, jazz, or R&B; rock, metal, or disco. Whatever your taste, they could be satisfied under a single roof. Retail outlets were the logical endgame for the record labels. A band was introduced to an audience on radio, made real through live performances, and then promoted on vinyl. The record store was, in a very real sense, the heart of the industry, and as such it demanded a certain quid pro quo from the artists whose careers it supported and promoted.

Thus was born the "in-store appearance," wherein fans got an opportunity, however brief, to meet the artists. These were not unlike bookstore appearances by authors, except decidedly less articulate and usually much more profane. But probably a lot more fun. Van Halen did a few of these during that first tour, always in conjunction with a concert and sometimes in addition to a radio interview. The boys were utter novices at the marketing game in those days, and not yet so full of themselves that they bristled at the idea of promotional responsibilities. In fact, they kind of enjoyed these appearances.

Early in the tour we attracted only about thirty to forty fans, very low-key affairs. Our record was playing in the background, but so low that you could hardly hear it. As the guys scrawled their names on souvenir records and posed for pictures with what I can only regard now as fans who were well ahead of the learning curve, I decided to turn up the music. And I mean way up, until the walls of the store reverberated with the wails of Edward's guitar. Fans began dancing in the aisles.

"Hey!" the manager shouted. "What are you doing?! It's an old sound system; you're going to blow it up."

"Ah, who the hell cares?" I said. "We're a rock 'n' roll band and this is a rock 'n' roll event."

The manager turned down the music and stormed away. I waited a minute and turned it back up. For the next half hour we staged a battle for control of the in-store sound system. Just as we were getting ready to leave, I cranked it up as high it would go, and sure enough, the speakers blew. The manager was furious, but I scored major points with the boys, who thought the confrontation hilarious.

"Way to go," they shouted. "Fuck it up!"

A few weeks later we did another appearance, this time with roughly seventy-five to a hundred people. Once again the music was very low, and again I cranked the volume. This time the store manager simply smiled and nodded. Definitely a guy better suited to the business.

A few more weeks passed, while we were kicking ass during live shows and accumulating record sales. In those days, there was a vital statistic in the music business known as a "ten day," aptly named because it tracked how many units of a particular album had been sold in the previous ten-day period. With this, you could measure not just total sales but whether a record was trending up or down. *Van Halen* was trending up, better with each ten-day report. It was exactly the type of performance that made record company executives swoon, indicating that a band is capable of not just a momentary surge of popularity but something more profound: enduring popularity.

A similar trend could be seen in our record store appearances. So when I got word from a Warner Bros. publicity associate that our next appearance was expected to draw a crowd of a couple hundred fans, I decided that it was time to put forth a bit of extra effort.

"Guys, you can't go in there like four schleps in a station wagon," I said. "We have to do something different."

"How about motorcycles?" David suggested. "That would be cool."

He was right, it would be cool. I got in touch with a local motorcycle club and offered them five hundred dollars to let us use a few of their bikes, and to have them escort us to the store. They agreed, and we rolled up on a couple dozen Harley-Davidsons. As we approached the store, everyone revved their engines. If you've ever heard a Harley, with its distinctive *braaaaaaaap!* you know how loud that was. Let's just say we made one hell of an entrance. As expected, a couple hundred fans were waiting in line, and more kept showing up. The band happily signed records and posed for pictures for a couple hours, until I finally pulled the plug, leaving about thirty unhappy customers to go home sad and empty-handed. I felt bad about it, but we had reached the point where in-store appearances were becoming unwieldy. It was impossible to satisfy everyone; better to leave them hungry. That was my philosophy. That's why I always preferred playing a smaller,

sold-out venue to a larger venue with a sea of empty seats, even if the latter would sell a few more tickets.

There was one more in-store appearance on that first leg of the tour, and we knew the crowd would be huge.

"What do we do for an encore?" I asked the boys.

"Well, we can't do motorcycles again," David said with a laugh. Then a mischievous look came over him. "I got it. Let's get an armored car!"

So that's what we did. We arrived at the store in an armored car—like a Brink's truck—and parked by the curb. For a few minutes we just sat inside, as the crowd of fans at the door tried to figure out what was going on. Suddenly the back door of the truck was thrown open. "Security guards" (actually members of our crew) jumped out of the truck and brandished faux weapons, as the rest of us poured out the back. The crowd burst into applause as the boys walked into the store, smiling and waving, looking exactly like the young rock stars that they were.

And so it went, one town after another, one show after another, week after endless week, month after exhausting month. And it wasn't as if we were traveling in elegance. The first few weeks our gigs were relatively close together, so we traveled by bus, which the boys enjoyed; it was basically a nonstop traveling party. It also was an anomaly.

"Don't get used to this," I said. "Because you won't be doing it again until you become superstars."

Eventually we would travel the country like most platinum-selling bands: on a private bus tricked out to look and feel like a hotel on wheels. For now, though, we settled for cheap air travel: coach seats on shitty little commercial jets. If you travel only once in a while this isn't such a big deal, but when you're boarding a plane every other day, it starts to beat you down, both physically and emotionally. The cramped seats, the lousy service, the long waits in line—we were just like all the other human sardines trying to get to the next stop without falling from the sky in a fireball.

Some people find that frequent air travel eases their anxi-

ety about the potential for catastrophe—turbulence is nothing more than a bump in the road; lightning almost never causes an engine to blow out—while for others, each flight renews their sense of impending doom. This response is easy to understand, if not entirely logical: the more you fly, the greater the odds that you'll eventually crash and burn.

While none of the band or crew particularly cared for commercial air travel, most of them adapted to it just fine. (It was easy for me, as I'd already spent a considerable chunk of my life traveling and living abroad.) The only person in our entourage who truly detested flying was David, a fact that he did his best to conceal, but which eventually became obvious and presented a rather significant challenge.

The first sign was a growing reluctance on David's part to get his ass out of bed in the morning and pack his bags for a timely departure. As I said, no one was particularly fond of this routine, including yours truly, but it was a fundamental part of the job. Sleep deprivation and hangovers were the rule rather than the exception when we were out on the road, but you learned to fight through it and get to the next city. When you're young and reasonably healthy, you can get away with almost endless abuse, and God knows Van Halen pushed that theory to its limits—and beyond. Everyone bitched about my morning wake-up call—it didn't matter if the phone rang at 6:30 or 9:30—the response was always the same: a string of obscenities followed by the sound of the receiver being slammed into its cradle. My ego would be a little worse for wear, sure, but thirty minutes later bags were indeed packed; and inside an hour, everyone would be in the lobby, sipping coffee, wearing shades, and grousing about how tired they were.

Except David.

Almost every day I would have to make a personal visit to David and coax him down to the lobby. I'd walk into his room and his gear would be scattered about the floor. He'd be sitting in a chair, half-dressed, watching TV, pulling on a joint, acting like he was in the middle of a weeklong stay.

"David, what the fuck are you doing?" I'd say. "Let's move!"

He'd sort of roll his head, stretch a little, let out a groan or two—generally behaving like an arthritic old man. In fact, David was easily the fittest and most athletic member of the band, but on getaway day he always behaved like a boxer who'd gone twelve rounds the night before.

"Man, I don't feel good," he'd say.

"What's the problem, exactly?" I tried to indulge him for a few minutes, but no longer; I figured he was just being lazy.

"Not sure, man. Everything just hurts. Maybe I'm coming down with something."

"Okay, well, try coming down with your bags. Because we're out of here in ten minutes, with or without you."

Oftentimes I'd end up scooping up his clothes and stuffing them into suitcases while David trudged around the hotel room looking for his keys or his wallet or his condoms . . . or whatever. Something was always missing. It was enormously strange and frustrating behavior coming from someone who was generally the most organized and fastidious member of the band. Eventually we'd make our way to the lobby, where Alex, Edward, and Michael would be waiting impatiently. Sometimes they'd yell at David, sometimes they'd take it out on me. It wasn't a huge deal at this juncture because they all got along so well and were having such a great time, but it was clear that they found David's act selfish and irresponsible. Hell, we all could have used a few more minutes of sleep, but only David seemed to demand it on a daily basis. They thought it was a power play of some sort—David, after all, was the diva. But it turned out to be symptomatic of something much deeper.

A near-crippling fear of flying.

I'm not sure why it took me as long as it did to put the pieces of the puzzle together. The stomachaches, the refusal to adhere to a schedule (unusual because normally David loved schedules), and, especially, the incessant chatter once we boarded the plane. Some nervous fliers shut down completely once they're sealed in that metal death trap of a tube; they might practice meditation or listen to music or pop a Va-

lium and hope it takes effect long before the plane is airborne. Others reveal their anxiety through hyperactivity.

Now, David was a talker under the most mundane of circumstances, so even this quirk escaped me at first. David enjoyed sitting next to me on flights so that we could talk about the business of the business, rather than just reliving the sexual and chemical exploits of the previous night. He wanted to know what sort of publicity requirements there would be at our next stop, what the venue would be like, how big a crowd was anticipated. Invariably we'd veer off into more arcane territory—sales figures and promotional strategy, and even what the next album might sound like. Truthfully, much of this was out of my purview, as I was merely the tour manager and not the band's personal manager, but since Marshall was only occasionally on the road with us—he would jet out for a night and then go right back to LA—the questions came to me.

But there was something else at work: a desperate attempt on David's part to distract himself from the admittedly terrifying reality of flight. He would usually take the aisle seat to avoid being accidentally confronted with a 30,000-foot view down. Or he'd take the window seat and draw the shade. Any unexpected movement or sound—from the rumble of turbulence to the simple and not unexpected raising and lowering of the wheels—caused David to squirm in his seat and his speech to accelerate like he was on speed. Eventually, after several weeks of this behavior, I noticed him clutching the armrest so hard during takeoff that I thought he might leave his fingernails behind. His eyes were closed, his jaw clenched.

And then it hit me. *Holy shit! David is absolutely terrified*.

As I got to know David better, it all made sense. David was a total control freak, and flying is all about accepting the fact that there are forces in the universe way beyond your control. Sometimes the flight is smooth and easy and you arrive ahead of schedule. Sometimes there are technological or weather-

related issues that make the flight as queasy as a poorly de-
signed amusement park ride. Once in a great while, human
error comes into play, and you drop from the sky like a stone,
never to be heard from again. And there's not a damn thing
you can do about it.

Sort of like the music business.

5

THERE'S NO PLACE LIKE HOME

Sometimes a picture is worth a thousand words. And sometimes not. A photo might say almost nothing, or convey an image that isn't quite consistent with what is really happening before and after the shutter clicks.

Consider a photo taken at the base of the Eiffel Tower, shortly after Van Halen had arrived in Paris for the very first time, in May 1978. Two months of touring in the States had been followed by a short break and then a handful of concerts in Germany, Belgium, and the Netherlands. Then it was off to Paris for a one-night stand at Le Théatre Mogador, which would be followed by several days of vacation in the most beautiful city in the world, and then a four-week tour of the UK.

The four young men in the picture appear to be quite happy. They are rock stars who still don't quite realize they are rock stars, and so there is an innocence about them that is genuinely charming. They've never been to Paris, never seen the

Eiffel Tower. Life is good, the photo seems to say. Life is exciting and filled with possibility. And it's only going to get better.

The previous week had been a whirlwind of traveling and performing, of behaving like a tourist one moment and a native son returning home in the next. We had played the famous Paradiso in Amsterdam on May 6, a gig that was unique not only because patrons were allowed to purchase weed and hash from a concession stand—like soda or beer in the United States—but because it was the first time that Edward and Alex Van Halen had performed in their native country. Naturally, Van Halen had quickly became enormously popular in the Netherlands, and the brothers were treated like hometown heroes every time we visited; the band's records reached gold and platinum status in that part of the world faster than almost anywhere else.

In the dressing room after the show, there was quite a large contingent of Van Halen relatives, but I noticed that they weren't exactly the closest of families. The Dutch relatives of their father, Jan, stayed on one side of the tiny room, while Eugenia's Indonesian relatives remained on the other. The tension was palpable but did not seem to surprise Edward or Alex, who had long since grown accustomed to such familial strife. In general, they both seemed thrilled to be back in their homeland, and to be experiencing it as adults. I remember walking with the brothers through Amsterdam's red-light district on our day off, and seeing them marvel at the openness of the Dutch culture. There were coffeehouses in which hash brownies were served alongside espresso, and brothels in which prostitutes, in varying stages of undress, wriggled and writhed in the windows—and it was not only legal, but accepted.

Alex and Edward walked through the neighborhood slack-jawed and bug-eyed, as you would expect of a pair of red-blooded American males who have never been outside the country. You could almost read their minds:

Man . . . why did we ever leave this place?

I got a huge kick out of seeing how the guys responded to international travel. Not just Edward and Alex but the entire

band, and even the crew members. When I was twenty-one years old I spent three months hitchhiking alone through Europe. It was, to say the least, an enlightening experience, and one that proved foundational for my entire life. By the time I joined Van Halen, I had lived in Denmark, Paris, and Tangier, among other places. I was an American and always would be, but I understood that the earth was a large and eclectic place, and that not everyone considered Americans God's gift to the world. It's good to get out once in a while and realize that a vast portion of the world's population does not speak English and frankly has no interest in learning it.

In general, the boys of Van Halen embraced being exposed to new experiences and cultures with enthusiasm and a sort of wide-eyed innocence. Certainly Le Théatre Mogador fell into this category. Built during World War I, it is generally considered one of France's most beautiful venues, elegant and dripping with history inside and out. Mogador is a smallish space, seating roughly sixteen hundred patrons, but every seat has a perfect view and the acoustics are extraordinary. Suffice it to say, Van Halen had not yet performed in a venue that carried the weight and tradition—not to mention the elegance—of Le Théatre Mogador. (The Paradiso in Amsterdam was extraordinary for different reasons.) But these guys were nothing if not audacious. All those years of playing live, practically for free, in front of inebriated, screaming fans, either in backyards or steamy clubs, had made the band not just incredibly tight and efficient but utterly fearless. You could throw Van Halen into almost any venue, in front of any crowd, and they would simply do their thing—and they would do it about as well as any rock band had ever done it. So they weren't intimidated by Le Théatre Mogador or by the prospect of playing in front of French fans for the very first time. On some level, it was just another night and another gig.

When we first arrived in Paris, I met Jacques, the head of Warner-Elektra-Atlantic's Paris division. Jacques and his entire staff were true professionals committed to making our

trip to Paris a successful and enjoyable one. The same was true of the promoter, the renowned Albert Koski, who was sort of the Bill Graham of Paris. Over breakfast on the morning of the show, Jacques and I swapped stories and gossip about everything that was happening back at Warner corporate headquarters in Burbank, as well as in the music world at large. Jacques was a smart and erudite man and I enjoyed his company. Much as I liked hanging out with my band, it was nice once in a while to experience some adult conversation.

Jacques told me all about the great plans he and his staff had put together for our trip to Paris—the show, as well as the three days afterward, when we would have time to take what amounted to a vacation. Every detail seemed to have been considered: expensive hotel, a pair of limos with drivers at our disposal for the duration, guided tours . . . whatever we wanted or needed. Given our relative youth and inexperience, they were really rolling out the red carpet. Sure, Van Halen had created a fair amount of buzz by this time, but we weren't exactly the Rolling Stones. Nevertheless, that's the way we felt.

Back at the hotel, I went over the itinerary with the band. There would be several interviews with various media outlets in the ensuing days, both before and after the show. This, as always, elicited groans of displeasure from the guys. No surprise—it is imprinted in the DNA of virtually every rock star that they have a visceral reaction to the idea of promotion, and especially interacting with the press. David and Alex were the most pliable in this regard. In the beginning, they did probably 90 percent of the interviews. As time went on, David took on an even greater role, which was fine since he had an uncanny ability to turn on the charm for anyone with a camera or microphone, and to turn it off the moment he reengaged with those closest to him.

The show was scheduled to begin at eight o'clock (I had presumed that was for the opening act, and that we would go on around nine or nine thirty). By three o'clock we were at the theater for our sound check. Although tired and hungover, the boys were impressed by the physical beauty of the venue

and excited about playing that night. As always, David took charge, barking instructions to the soundman and complaining about almost everything.

"What the fuck, man!? That echo is not coming in on the right beat. Can you fix it, please?"

As smooth and cordial as David could be in guiding the course of an interview, he was often exactly the opposite in dealing with technicians and support staff and even his bandmates. He was fussy and easily annoyed, and had little use for diplomacy. His observations, however, often proved to be right, as in this instance. The soundman had indeed fucked up the echo effect, and it was ruining the song.

While the band continued its sound check, I ran out for a quick bite to eat. When I returned, I was surprised to see that Marshall Berle had arrived. Ordinarily, this would not be a strange occurrence; a band's personal manager should be a fixture on the road, after all, but because Marshall had been a veritable ghost on the tour, I had no idea that he was planning on joining us in Paris. We shook hands and chatted amiably. By this point, I neither liked nor respected Marshall—his absence on the tour spoke volumes to me about his involvement with the band—but I tried not to wear my contempt on my sleeve. As for how he felt about me? I don't really know. I presume he was at least savvy enough to know that I had the full support of Carl Scott, and that my time with the Sex Pistols had only enhanced my reputation as a savage road dog.

When Albert Koski walked by, I introduced him to Marshall, and the three of us chatted briefly. During a lull in the conversation I asked Albert about the opening act. A look of confusion came over his face as he turned to one of his assistants; the assistant shrugged.

"Uh, Noel," Albert said. "I don't think we have an opening act."

This didn't seem possible. Surely they didn't expect a new band—one that had never been a headliner before—to suddenly show up in Paris and fill the Mogador on its own. Right? I turned to Marshall; as manager, he should have had some

idea what was going on. Indeed, he should have been deeply involved in putting together the dates and venues and supporting acts.

"What's the story, Marshall?" I asked.

Marshall shook his head coolly. "I have no idea. I just got here." Typical. Marshall proceeded to deal with the situation the way he did most problems: he told me, curtly, "Do whatever you want, Noel. You're the road manager," and proceeded to get the hell out of Dodge.

Now, I had a great deal of fondness and respect for Albert, but I felt that he had put me in a very difficult position. I reminded him that Van Halen only had one album, and that we had been out on the road for two months promoting that album, playing essentially the same buzz saw of a set night after night, roughly forty minutes of balls-to-the-wall rock 'n' roll. We were good, but we were not yet a headliner, and didn't have anywhere near enough material to pretend we were. Especially not on such short notice.

"Oh, *merde*," Albert exclaimed.

I nodded. "Yeah, I feel the same way." But it was my problem now. I had nothing to do with setting up this tour or this particular date; nevertheless, as tour manager, it fell on my shoulders to inform the band of this situation, and to assuage whatever concerns they might have. They responded with a mixture of bewilderment and anger. At first, it was pretty obvious they thought I was joking—but when reality set in, they got pissed.

"Fix it," David said. "I don't care what you have to do. Just make it right."

"There is no fixing it," I said. "You guys are going to play tonight, and you're going to be the entire show. So let's figure out how to give these people their money's worth."

The answer was simple: we'd play a longer set, utilizing covers that had been part of the band's repertoire on and off for years, with a sprinkling of rough, unrecorded original material to pad it out. We had already decided that the regular set would end with "You Really Got Me," since it was a well-known

hit by both us and its composers, the Kinks. Even though it wasn't "ours," at the time it was our signature and most easily recognized song. They'd play the shit out of it, same as always, and then get off the stage. Easy . . . ish.

Ordinarily, as a nonheadliner, that would be the end of the night. But now, if all went well, we would wait in the wings as the crowd cheered for more. If the guys had done their job, an encore would be expected and appreciated. I reminded them, too, what was at stake—that it was not only their first show in France and a warm-up for the four-week UK tour but also a performance in front of several WEA brass. Far from being apprehensive about this scenario, the band was excited. They viewed it as a challenge.

I noticed David looking at Edward, who then looked at Alex. Michael stood off to the side, almost on his own. But after a few pensive moments, they all began to smile. And I knew everything would be okay.

A few hours later Rudy took the mic.

"Is Paris ready to rock 'n' roll?!" he screamed, using his best French accent to say the name of the city: *Pa-ree*. "Let's hear it for Van Halen!"

They were. And Van Halen was ready for Paris. The boys took the stage with a confidence that bordered on cockiness, David strutting and laughing and Edward carrying his guitar with the swagger of a true impresario, as they launched into a blisteringly authoritative version of "On Fire." Given the historic setting, the pressure of carrying an entire evening on their own, and the unpredictability of playing before a French audience for the first time, it certainly would have been understandable for the band to be intimidated, or at least anxious. But they weren't. Not in the least. Playing balls-out from the opening chords, the band performed a slightly elongated set that lasted a little more than forty-five minutes, ending with a gloriously rough and tumble version of "You Really Got Me," exactly as planned. Then came the first encore, "D.O.A.," a staple that didn't make it on the first record but would be part of the band's second release, followed by Eddie Cochran's classic

rave-up, "Summertime Blues," and a scorching instrumental outro from Black Sabbath's "Symptom of the Universe," and finally "Bottoms Up," another track that would end up on *Van Halen II*. After more than fifty-nine minutes of ferocious playing, Eddie hit the last chord and David yelled, "Thank you, Paris . . . we love you all!"

The audience reciprocated with thunderous applause. Standing in the wings, taking it all in, I felt almost like a teenager attending his first rock show. The cynicism and tedium that so often accompanied my job melted away as I watched these four kids from California gather at the edge of the stage and wave to the audience, before walking off triumphantly. On display was the transformative power of rock 'n' roll, in all its youthful glory. A crisis had not merely been averted; it had been transformed into a huge victory. On this night, it felt like anything was possible. Van Halen was invincible.

FOR THE NEXT COUPLE DAYS, we made good use of the luxury transportation that had been provided and did our best to soak up the nightlife of Paris. I shared a car with David and Peter on our first free night; our driver, DoDo, was reportedly among the most knowledgeable guides in the city, and he certainly lived up to his reputation, squiring us to an assortment of wholesome and traditional Parisian sights during the day, and then to some of the less traditional parts of town after the sun dipped below the horizon. The wine was superb and the women were beautiful—and at only one hundred francs for a brief liaison, a relative bargain. David and I walked the streets together, talking of record sales and grand schemes to raise our profile in the press and with radio stations. It was on such occasions—away from the arena, recording studio, or the Warner offices—that I felt closest to David. Sure, we were discussing business, but in a casual and comfortable environment, in a way that felt relaxed and natural, even friendly. That night, I certainly didn't mind being in his company, and I'll admit that, even when he would suddenly

cut off the conversation and introduce himself to one of the beautiful working women who passed by, he could be downright charming.

In the morning we shared stories with the rest of the band and crew. They had wound up in a slightly rougher section of town, near a park where the hard-core street girls plied their trade. Deals were made, cash exchanged, and sex acts performed quickly and without elegance. Which would have been fine, except for the fact that Alex's roadie Gregg apparently had said something inappropriate to one of the girls. As Alex related the story, the sex worker pulled a knife and attempted to slash Gregg in his backside as he leaped through the rear window of their limo. The car pulled away with the girl giving chase and screaming probably well-deserved French epithets at her foul-mouthed customer. But no one was hurt, and everyone had a good time, and Gregg presumably learned his lesson; the attempted assault merely added color to the evening and to its subsequent rehashing, which was in some ways the most enjoyable part.

To me, that three-day break in Paris was not just necessary in terms of recharging our batteries; it was one of the most enjoyable experiences I had in all my years in the business. There is nothing like Paris, of course, especially in the springtime. The trees are in full bloom, the Seine is flowing strong, and the lovely Parisian women are everywhere. And all of this is presented against a backdrop of some of the world's most extravagant and beautiful architecture. There is nothing like it, and I was thrilled to see the band and crew apparently enjoying their time in Paris.

Or so I thought, until the following day, when David knocked at my door.

"We've got a problem, Noel."

"Oh, yeah? What's bothering you, David?"

He shook his head. "Ain't me, man. It's Edward."

This seemed surprising to me, as Edward had been his usual laid-back self since we had arrived in town.

"Something wrong with Edward?" I asked.

"I guess you could say that." He paused, sort of laughed a little under his breath. "He wants to go home. Like . . . now."

To say I was surprised would be an understatement. Edward had seemed perfectly happy in Paris; he had played his guts out (as usual) at the Mogador, and had since been enjoying the sights, sounds, and tastes of the city (and its residents). And there was that photo at the base of the Eiffel Tower. I couldn't imagine what could possibly be wrong. So I walked down to Edward's room and knocked at the door. Some time passed before the door opened and Edward stood before me. His eyes were red and cloudy—I presumed he was high. Maybe he was, but he'd also been crying.

"Everything okay, Ed?" I asked.

He shook his head and began sobbing. Then he threw his arms around my neck and pulled me close, crying so hard that his body shook.

"Jesus, Edward . . . what's wrong?"

I honestly expected him to tell me that something terrible had happened—a death in the family, perhaps, or at least a diagnosis of terminal illness. Perhaps the Jehovah's Witnesses had finally caught up with his mother. But it was nothing like that. The truth was, simply, that Edward had been overcome by a severe case of homesickness.

"I want to go back to LA," he said, his breath catching on every word. "I don't want to do this anymore."

My initial inclination was to shout some sense into Edward: *Are you fucking kidding me? Every aspiring guitar player in the world wants to trade places with you right now! You have the world by the balls, young man!*

Then I would have sent him to his room without dinner or groupies, like a responsible road manger. Instead, I simply held him tight and let him cry. Eventually, the anxiety and sadness poured out of him. "Fucking David—that asshole—he wants to be a big rock star."

"Well, yes, he does," I said. "But that's kind of the point of this whole thing, isn't it?"

Edward drew a hand across his face, wiping away some

tears and snot, and shook his head aggressively. "No, not for me. I don't want to be a rock star. I hate this bullshit! I just want to go home and play jazz and funk . . . I just want to noodle around."

Noodling is what Edward did during most of his free time. You'd walk into his hotel room and he'd be sitting there on the bed, guitar in hand, just sort of . . . creating. Letting inspiration guide his miraculous fingers. He did this when he was sober or stoned, happy or sad. I've truly never met a musician who seemed more attached to his instrument, and so on some level I understood what Edward was saying. It's possible he really was at his happiest when he was alone with his guitar.

But I also knew that part of him enjoyed being a guitar god—desired by women and worshipped by young men. I mean, seriously—who wouldn't? Regardless, he had an obligation to Van Halen—to his bandmates, his record label, his fans. And to himself, for goodness sake. Didn't he wonder, *How big is Van Halen going to be?* I sure as hell did. But there was no sense in arguing the point with Edward. His sadness and isolation were legitimate. He was an unusually sensitive and introverted guy, and right now he was hurting. And I didn't doubt for a moment that he really did want to go home. So . . . as we sat down and continued talking, I played the home card.

"Listen, Ed. You've always told me you want to buy your parents a nice house in Pasadena. They live in a little home. It's nice, but it's small, and your mom and dad aren't all that happy there, right?"

Edward shrugged. "Yeah, I guess."

"Well, the truth is, you're not going to be able to get them a house this year—not when you're making a hundred seventy-five dollars a night." He laughed. I could tell he was coming around. "But I can promise you this: if things keep going the way they're going now, and this band breaks the way I think it's going to break, you'll be able to buy them a new house. You can even buy your dad a boat. You can get them a new car. You'll be able to get them everything they've ever wanted."

I paused, letting it sink in, and then asked, "How does that sound?"

He smiled at me. "Pretty good, actually."

As I looked at him, I couldn't help but see him for the kid that he practically was. It was easy to get caught up in how explosive their live show was, in how talented Eddie was, and forget how new to stardom he was. Because they'd burst onto the scene finely tuned from their years of playing together, they seemed so fully formed. And yet, they were young on so many levels—even David, who took to stardom and the music business most naturally. Having been around the block with other young bands a few times, I'd seen naïveté like this before; the difference with Van Halen was that they actually had a shot at making it. But if they were going to survive, they were going to have to grow up—fast.

Perhaps no one embodied the discomfort that rapid fame brought more than Edward. He may have been the resident genius, but he had a lot to learn about the world. And, while there were so many ways in which his complex upbringing had hardened him, there was still an innocence there that I recognized from past experiences with other artists. I also recognized how quickly it could fade away if given the right mixture of support and success.

"Look, Edward, you can't leave now. You won't just disappoint the people here, in the band and crew, but you'll also disappoint everybody back home. They're expecting you to come home a hero. Do you want to let them down? You want to explain to them that you're not interested in being a superstar and a millionaire? I know you're homesick, but you'll get over it. I promise."

Edward took a deep breath. He looked out the window, at the most beautiful city in the world, but he didn't say anything, so I did.

"Come on, Edward," I tried again. "Life is good."

He laughed. "Yeah, okay."

So I guess you could say I sort of talked Edward into becoming a superstar. What the hell—somebody had to do it.

6

HOW DO YOU LOSE A ROCK STAR?

(YOU GET HIM REALLY HIGH—THE REST TAKES CARE OF ITSELF)

What is it they say about sports? It doesn't build character; it *reveals* character. The same is true of life on the road. How you treat your coworkers and friends when you're stuck on an aging commercial bus for a month, with a persistent and thundering headache born of equal parts carbon monoxide, sleep deprivation, shitty food, and overindulgence in chemical substances, says a lot about the person you are.

After our delightful and first-class vacation in Paris, we headed out on the next leg of our tour—a grueling journey through the United Kingdom in which the band played a

breathtaking twenty-five shows in thirty days (it would have been twenty-six, if not for the fact that one date was canceled). By any measurable standard, this was an incredibly ambitious schedule, even for a band composed of four hungry and healthy young men. Even more remarkable? On every one of those dates we opened for Black Sabbath, heavy-metal legends from the UK who were more than a decade into their careers and clearly starting to feel the ravages of time, from both a creative and a physiological standpoint. But while we suffered through four weeks on a commercial sit-up bus, the hard-partying gents of Black Sabbath, who were closer to middle age than they were to adolescence, traveled in relative luxury, with a tricked-out tour bus befitting their status as rock icons.

I worried from the first day of this tour that an outburst or confrontation was inevitable; you can't live in such close proximity to the same group of people for this length of time, day after day, without tensions boiling over in response to injustices both real and perceived, major or seemingly insignificant. And I kept a wary eye on Edward—if the kid was capable of being incapacitated by homesickness while staring out the window of a luxury hotel suite in Paris, what would become of his fragile psyche on a four-week bus tour of the UK? I don't mean to be facetious. It was a legitimate concern. Touring on a bus with all the amenities of home (including wives and girlfriends), as Van Halen did in later years, is one thing; bouncing around the countryside on a commercial vehicle with wheezy shocks and a poor ventilation system is another matter entirely.

Surprisingly, though, Edward took to it just fine, as did Alex and Michael. I realized on this leg of the tour that Eddie was basically like a kid at summer camp: the best way for him to avoid homesickness and depression was to stay as busy as possible. If we could get him onstage every night, he was just fine. It was the downtime he hated. Three days in Paris without a gig left too much time for pondering the meaning of life.

The formula for keeping Edward happy in those early days was simple: lots of weed and alcohol, and as many concerts as possible. Edward may not have wanted to be a "rock star," but he loved playing guitar.

The schedule on the UK tour took care of that aspect of things. When you're playing a different show every night, there isn't time to get depressed. But the other accoutrements that typically came with being in a popular band were harder to come by. Consider, for example, that Van Halen from the outset was a band that appealed to both males and females, and our audience reflected that popularity. Lots of wannabe head-banging teenage boys, and plenty of nubile young ladies just dying for a chance to meet one of the guys in the band. When we toured in the States, and in most places internationally, there was never a shortage of female companionship. In the UK, while supporting Black Sabbath, the demographic was quite different indeed. I don't know the exact numbers, but when I looked out into the crowd every night, it seemed like 98 percent of the audience was young (and not so young) men. And they all were dressed in black: black jeans and T-shirts, black leather jackets. Lots of piercings and tattoos. A hard-core metal crowd.

Nothing wrong with that. The fans in the UK warmed quickly to Van Halen, and the guys in Black Sabbath even made jokes about how we were kicking their ass on a nightly basis. But the lack of easy sex presented a sudden and dis-heartening change of pace for a group of boys who had come to see these dalliances as part of the job—the best part.

Compounding their frustration was a distinct downturn in both the quality and quantity of drugs available. Van Halen thrived on weed and alcohol in those days—weed, especially. Marijuana was not so easily procured in the UK, so we settled for a mixture of hash and tobacco. The guys in Black Sab-bath were working-class Brits and had been rolling their own cigarettes for years, so it was no big deal to them. The four guys from Southern California had been smoking for years

but probably had no idea what was even inside a cigarette. They tried to learn, but usually wound up with something that looked like an understuffed joint. More often they would try to insert hash into their prerolled American cigarettes, but the cigarette would either break apart or there wasn't enough hash to provide much of a buzz. Sometimes they would stuff the hash into an empty can, drill a hole in the bottom, set it ablaze, and try to get high by inhaling the fumes off the make-shift bong. Didn't work very well. The stuff tasted like shit and simply didn't get the job done. That's about as bad a combination as you can get.

So, without sex, drugs, and the luxuries of the American road, the boys often were in a truly foul mood, especially David. While the others were merely aggravated and annoyed, David took this entire scenario as a personal affront—as if the paucity of drugs and women was a response by the British government to the arrival of David Lee Roth; a conspiracy of sorts to deprive the star of the very lifeblood of stardom.

David's response—and this would get worse as the years went on—was to take out his anger and frustration on those closest to him. We were maybe a week into the UK tour when David began calling daily mandatory band meetings. Ostensibly postmortems on the previous night's show, they were actually just an excuse to rant and rave—to publicly pick at whatever bug had somehow managed to penetrate the layers of spandex and leather and take residence in David's ass. We'd gather in the middle of the bus—a dozen members of the band and crew—and subject ourselves to David's wandering, unfocused harangue about the myriad ways in which we had fucked up the most recent performance. With venom and spite, David would complain about anything and everything—from sound to lights to every stage move and vocal or instrumental mishap he could think of. The tongue lashing was of indeterminate duration: if he was too tired to work up much of a lather, it might last only fifteen minutes. If he was particularly agitated, it might go on for the better part of an hour, while we all sat stone-faced and bored.

These sessions never escalated into serious confrontations (not on this tour, anyway); in fact, they rarely even resulted in any sort of serious dialogue about ways in which the product might be improved. Rather, they were an exercise in egoism by David, indulged by his bandmates and subordinates simply because it was the path of least resistance. Bully that he could be, David chose his targets carefully, seeming to direct most of his bile at those who were least capable of fighting back, or the least likely to fight back, anyway. Swipes at his bandmates were made in vague terms, except in the case of Michael, whose musicianship and backing vocals were sometimes called into question. Ridiculous, because, of course, Michael's backing vocals did nothing but enhance David's singing—especially when they played live. In the studio you can hide a singer's weaknesses with multiple takes and sonic tricks (this was true even in the days before Auto-Tune). But onstage? Every singer is mostly naked, and the easiest way to cover up the aural blemishes is with a really capable background singer (or two). In Van Halen, that singer was Michael. Unfortunately, a gentle and laid-back demeanor also made him an easy target for David; there was no threat of Michael's returning the volley. Instead, he would just sit there and quietly absorb the abuse.

Sometimes David would even go so far as to blame the drought in his sex life on mistakes made by others in the band or crew. A shitty performance, he reasoned, naturally turned off fans and diverted them from his dressing room. This was complete rubbish. Van Halen put on a series of stellar shows on this tour, night after unrelenting night, but if only a small percentage of the audience is female, then backstage groupie traffic is going to be light. That's just the way it works. David was simply suffering the pangs of withdrawal—not enough sex, not enough drugs—and the effect was unflattering, to say the least.

It should be pointed out that he said very little regarding my performance. I do not believe it was because of any obvious difference between my abilities and those of the rest of the

entourage (although it's true that I did not often screw up), but simply because David was uncertain of how much clout I had with Warner Bros. As tour manager I existed in a foggy realm somewhere between band employee and front office executive. I served two masters and tried to please both equally. But it didn't hurt that both sides were a bit confused about where my allegiance stood, or how much influence I had with either camp. Even better if it kept David off my back.

Nevertheless, he made many days a living hell for everyone. The worst of these followed a morning disclosure that Rudy the guitar tech–turned–announcer had gotten laid the previous night. Now, you have to understand that in matters of sex, roadies occasionally benefit from their proximity to rock stars. It's not an everyday occurrence the way it is for the guys in the band, and it sure as hell wasn't commonplace during that monthlong tour of the UK. But Rudy apparently had found a companion for the night and his divulging that news led to a spontaneous burst of applause on the bus. People stood and cheered and patted Rudy on the back for his good fortune. This, after all, was a time for magnanimity. Who could begrudge the guitar tech for getting laid? Surely not Edward, his best friend from high school and now his de facto boss. Eddie just smiled and nodded. So did Alex and Michael. We were all happy that somehow, in this most arid of conjugal climates, when even the biggest dick swingers on the bus were striking out, Rudy had broken the slump.

Well, almost everyone.

David said nothing, merely scowled and fidgeted angrily in his seat. Imagine the injustice of it all—the guitar tech getting laid while the lead singer—a veritable pheromone factory—goes home with Rosy Palmer. For most of us, this was cause for celebration (and Rudy downed many a beer later that night, without ever touching his wallet). For David, well . . . not so much, apparently.

What happened next was the result of a misguided attempt on my part to lighten the mood by playing a little joke on David. I might as well admit that I should have anticipated the

consequences; even then, in the early days, before he felt the full bloom of stardom and power, David was not particularly good at self-deprecation. He took himself rather seriously, which meant you poked fun at him at your own peril.

That afternoon we had lunch at a typically nondescript little English road stop on the M1 heading out of the Midlands. We all sat together at a long, heavy wooden table and tried to stuff our faces with shitty English brunch fare: steak and eggs, greasy hash browns and chips, and hamburgers charred to a carcinogenic black, regardless of how you might have ordered them. Thanks largely to Rudy's good fortune, the mood was considerably lighter than it had been in the previous few days. We ate and laughed and told stories and everyone seemed to be having a good time—everyone except David, who sat sullenly in his chair, poking at his food and generally behaving like the death of the party.

After a while David excused himself to use the bathroom, leaving behind a plate overflowing with a nest of chips and two large, virtually untouched hamburgers. For some reason that I still can't quite explain—although annoyance was probably at the root of it—I was gripped by a sudden urge to take a huge bite out of one of the burgers. Even as I swallowed it, I knew that this was probably a mistake and would not be met with the benign response I had intended. A few of the guys at the table saw me take the bite out of David's food, but no one said anything, and no one laughed. A couple of them looked at me like I was crazy, and then simply continued with their meal.

A couple minutes later David emerged from the bathroom and sauntered back to the table. He pulled out his chair, sat down, threw back his hair . . . and his face went ashen. There was a long pause before he spoke, during which he took a hard look around the table. Finally, he picked up the plate, gave it a half spin in his hand, and then slammed it back down, sending chips and hamburger juice in all directions.

A silence came over the entire restaurant as David stood up, looking like he was about to give an angry toast.

"I don't know which one of you stupid fucking shitheads did this," he said, pointing at the plate, still wobbling on the table, "but you can finish it."

And with that he marched out of the restaurant.

After a few moments of awkward silence, we all resumed eating and telling stories, leaving David to cool off on his own. I realized pretty quickly that I had overstepped my bounds. A joke to one person is an act of aggression to another; I certainly hadn't meant to upset David to quite this extent, though I did think he was behaving petulantly and deserved to have his ego tweaked. This was my dance with David throughout our time together: I appreciated and respected his talent and naked ambition but found his personality at best challenging, at worst sociopathic. Moreover, David had been getting on my nerves to a greater extent than usual, in part because we spent so much time together.

By the time we began touring the UK, David had taken to changing his wardrobe multiple times during the course of a show, and somehow it was among my many duties to man the "quick-change" booth just off the stage. The booth was really just a makeshift closet space, usually fashioned out of curtains or drapes, in which David could rush offstage between songs, or during a guitar solo, and change from black leather to brown leather, or from leather to spandex . . . or whatever. But since these changes were indeed "quick," he needed some assistance. So I would literally wait by the edge of the stage, and when David came running off, I would join him in the quick-change booth and help peel off his sweat-soaked pants or shirt.

It was not a job that I cherished. And not simply because of the obvious grossness of the act, but because David was usually in such a frenzy that working with him in this environment was like trying to collar a pit bull in a phone booth. Bruises were inevitable.

"Let's go! Hurry the fuck up! I'll go out there naked, I swear to fucking Christ!"

"Easy, David . . . easy does it."

The inherent narcissism of becoming a rock star would fuck with anyone's head, but David was well down the path before he even joined Van Halen. He had always been, as they say, a legend in his own mind, and when legitimate stardom and success came his way, he devoured it like a drug. Increasingly I would notice David posing at every opportunity, not just in the dressing room before going onstage but every time he passed a mirror or window. I'd catch him pausing and vamping, tossing his hair and sucking in his cheeks like a model. He was obsessed with his appearance.

Nevertheless, I felt bad about what I had done in the restaurant and the apparent distress it had caused him. What I disliked most about David was his tendency to bully and manipulate, and my little joke, while harmless, exhibited exactly some of those same traits. I considered it nothing more than giving David a tiny dose of his own medicine, but he obviously felt otherwise. So, to make amends, I ordered a new plate of food as we were nearing the end of our meal, asked the waitress to box it up, and delivered it to David on the bus. He was sitting cross-legged in a front window seat, indulging a mighty sulk. As I stopped in the aisle and tried to make eye contact, he did not move an inch, and steadfastly avoided my gaze.

"David, I'm sorry," I said to the side of his head. "I did not mean to piss you off." This was not entirely true—I did hope to elicit a reaction from David; I just didn't think it would be quite so severe. He didn't budge, gave no indication that he had even heard what I said, although clearly he had. I decided to press on.

"I have something for you," I said, holding out the box, which by this time was beginning to show signs of strain, with a large grease blot spreading across the bottom like some sort of industrial spill. "You're probably hungry, so . . . here. Please take this."

Through inaction, he declined, so I sat down next to him and placed the sagging box between us. I'm not sure exactly how much time passed before the tension thawed—perhaps

fifteen to twenty minutes, during which I occasionally tried to make small talk. Eventually, almost out of the blue, David turned to me and smiled.

"Ah, it's okay, Noel. I was just fooling around." He paused, reached down, and opened the box. As he withdrew a wilted burger and took a giant bite, he nodded assuredly. "Had you going there, didn't I?"

There were myriad ways to respond to this line of bullshit, but by now I knew David well enough to understand both his ego and his insecurities. He didn't want to be perceived as small or petty, even though he demonstrably was. He didn't want people to think he was thin-skinned or weak, even though he routinely threw temper tantrums. David was complicated—at heart he was an entitled rich kid, which informed many of his relationships and behavior. He was accustomed to acting on every impulse, and as his stardom and wealth (and drug use) accrued, he naturally made less effort to keep his emotions in check. On this day, though, it was clear that he felt somewhat ashamed about having stormed out of the restaurant. I felt bad, too, but I wasn't about to get into a heavy discussion about which one of us had been less mature.

"Yeah, you sure did, David," I said, slapping him on the back. Then I grabbed one of his chips and stuffed it into my mouth.

David laughed. "Help yourself, Noel."

BLACK SABBATH was a pioneering act in the heavy metal genre. They also were the real deal, with far less interest in melody and accessibility than Van Halen, and a legitimately dark and depressing outlook on life that was often reflected in their music; I liked the guys in the band, but their lust for drugs and alcohol far exceeded anything the boys in Van Halen had ever known. Sabbath, by this time, was a famous and wealthy band with the resources to keep themselves awash in chemicals, which they had been doing for years, much to the detriment of the group.

This tour was ostensibly a tenth-anniversary celebration for Black Sabbath, but they were by now a band on the downslope of a long and steady decline. In late 1977 the band's lead singer and most prominent personality, Ozzy Osbourne, had suddenly quit Black Sabbath as they were about to begin recording a new album. A couple months passed, Ozzy had a change of heart and rejoined the band, and together they recorded the album *Never Say Die*, which would be met with intense critical disfavor when it was released in September 1978. Our first monthlong UK tour with Sabbath occurred as they were putting the finishing touches on that album. A second leg, in the States, coincided roughly with the album's release.

As I said, the two bands and their respective crews got along quite well, although by the end of the second tour we had become far more adept at drinking and drugging than we had been prior to our introduction to Black Sabbath. And when I say "we," I am referring specifically to the four members of the band; I'd been around the business a long time and had been exposed to all manner of bad behavior; I knew when to say when and exercised that privilege more often than not. My job description, after all, was quite different than that of Edward or David. Someone had to be the grown-up, and that someone was me. Most of the time, anyway.

While Black Sabbath was the clear headliner on this tour, Van Halen stole the show. They were young and vital and filled with the sort of energy and ambition that had begun to drain from Sabbath. This would be the last tour Ozzy ever performed with Black Sabbath, and sometime afterward he recalled that it was while watching Van Halen that he realized his band's time had come to an end. Or, at least, his time with the band had come to an end.

"They (Van Halen) blew us off the stage every night. It was so embarrassing," Ozzy would later explain to the media. "They kicked our asses, but it convinced me of two things: my days with Black Sabbath were over, and Van Halen was going to be a very successful band."

In reality, Ozzy was fired from Black Sabbath, but I suppose that's really a matter of perspective. *You say to-may-to, I say to-mah-to*—that sort of thing. The point is, Van Halen stole the spotlight from Black Sabbath every night on the tour, winning over even the leather-clad Sabbath diehards in the UK. We beat them at their own game, on their turf, in front of their fans. Believe me when I say this: that sort of upstaging almost never happens.

Why this didn't destroy the rapport between the two bands over the course of a two-leg tour that stretched out until the late fall is something of a mystery. Although declining in stature and beset by drug and alcohol problems, Black Sabbath remained a superstar act, and it must have grated on them to lose the nightly battle of the bands. Meanwhile, Van Halen was utterly fearless and tireless each time they took the stage, and it was fascinating to see the band's confidence grow. They didn't give a shit that they were playing in front of Black Sabbath diehards—who, trust me, were some of the toughest and most hard-core metal fans in the world. By the time Edward finished his guitar solo in "Eruption," he had the crowd in the palm of his hand. And David? Well, David's swagger grew with each passing show, which occasionally led to acts of outright stupidity.

There was the time when David veered from the band's frequent end-of-show celebration, which involved spraying the audience with champagne. Instead of merely uncorking the bottles and dousing the first few rows, David, in his exuberance, decided to toss a pair of nearly full bottles high into the air. They soared above the crowd, end over end, before plummeting earthward like two-pound bricks. One landed on the concrete floor and shattered into pieces. The other bottle, unfortunately, cracked some poor bloke across the skull. There was a bit of a commotion in the crowd as the band exited the stage and went to the dressing room, unaware of what had happened. But I knew. I saw it, and I knew that we were in for a shit storm. These were not laid-back SoCal stoners. This was an audience of working-class Brits, many of them in their late

twenties and early thirties, grown men who liked to drink and fuck and fight, and not necessarily in that order. They were generally docile folks into having a good time at the show, but if you pissed them off . . . well, they were not easily appeased.

"Get everyone the fuck out of here," I said as I ran into the dressing room.

Still shimmering with the afterglow of another great show, the boys stared at me in disbelief, as if to say, *What's the problem?*

"Just get on the bus," I said. "Don't ask any questions, and don't stop to talk to anyone."

Within minutes the band was outside and I was embroiled in an ugly negotiation with one very unhappy Black Sabbath fan. Dressed in black, with a leather jacket and close-cropped hair, he had a welt the size of a golf ball on his head and blood flowing down his cheek. By his side were a couple of his mates; they were all drunk and extremely agitated. I quickly went into damage control mode. It wasn't the first time, and it wouldn't be the last.

"Fuckin' wanker threw a bottle at me," the young man cried. "Coulda cracked my fuckin' skull."

I smiled. "Look, he didn't really throw it at you. He threw the bottles into the air and one of them happened to land on your head. It was not intentional. It was stupid, I agree, but it was not intentional." I paused, leaned in for a moment of conspiratorial conversation. "David is not the brightest bulb in the box, if you get my meaning."

The kid did not respond. Nor did his buddies. Rather, they gave me a look of extreme displeasure. Knowing that they wouldn't be so easily deterred, I fell back on an old reliable tactic: bribery.

"If I gave you a thousand pounds, would that make all of this go away?" I asked.

Again, the kid said nothing. He simply seethed in a manner that seemed to say, *I'd rather just beat the fuck out of you right now.* After a few moments, though, his body language softened.

"You got that kind of money lying around here?"

A fair question. The exchange rate in those days was nearly two to one, so my offer was roughly two grand American. Not exactly chump change.

I nodded. "Give me a minute. Just wait right here."

I retreated to the dressing room, counted out a thousand pounds in cash, and folded it into an envelope. Then I drew up a quick disclaimer to ensure that further extortion would not be an issue down the road.

"Sign this," I said to the kid, presenting the disclaimer.

"Fuck off!" he said. "Why should I?"

"Look, I don't mind compensating you for injuries caused by my band's stupidity, but this is a onetime offer. Sign it . . . or no money."

The kid scrawled his signature, I handed him the envelope, and we went our separate ways. All's well that ends well. Or so I thought, until the bus pulled out of the parking lot and a brick went sailing over the roof. Moments later a second brick crashed into the side of the bus, narrowly missing a window.

"What the hell was that?" David yelled.

I laughed. "Just one of your biggest fans saying goodbye."

THE TWO BANDS got along so well through a serendipitous blend of mutual respect and craftsmanship. I don't think any of the guys in Van Halen held Montrose or Journey in particularly high regard, but they were practically awestruck by Black Sabbath. True, the band had seen better days, and Ozzy was by then a thirty-year-old alcoholic and drug addict who could have passed for midforties—but none of that matters when you're a legend. This guy was seasoned. He was a road warrior. Whether he was lucid enough to know it or not is another matter entirely. Either way, Sabbath remained an iconic presence whose music had inspired and informed the careers of countless younger artists, Van Halen among them. So, to find themselves warming up for their idols, then getting drunk together afterward, and swapping stories, . . . well,

that was heady stuff. Even David could be quiet and humble in the presence of Ozzy, like a kid listening to his grandfather tell war stories (despite the fact that Ozzy was only six years older than David, he was infinitely more experienced, in ways related and unrelated to the music business).

And, while Edward was a legitimate prodigy, he had enormous respect and admiration for Black Sabbath's virtuoso lead guitarist and founding member, Tony Iommi. It wasn't just talent and originality that separated Tony from his heavy metal and hard rock brethren; it was the backstory. When Tony was seventeen he was badly injured in an industrial accident while working at a sheet metal factory. The gruesome injury took the tips of the middle and ring fingers on Tony's right hand. Since Tony was a left-handed guitar player, this meant he suffered catastrophic damage to his fretting hand, and it occurred at a time when he was preparing to give up the working-class world for good and embark on a full-time musical career. I suppose a lesser man—and a less driven artist—might have been discouraged to the point of depression and given up on that dream, but Tony rather famously overcame his disability with the help of prosthetic fingertips and became one of the greatest guitar players of his generation and a man widely recognized as a pioneer of heavy metal.

I've heard stories over the years that Tony was saddened by Edward's brilliance on that first tour—that he became mired in self-pity and envy, like Salieri in the presence of Mozart. Not so. I think he admired Edward and saw in him the same spark of genius and ambition that had fueled his own career a decade earlier. They got along great. And I still recall the night we were treated to a shortened version of Iommi's inspiring story. We were sitting in our dressing room before a show when Tony came in and we all started shooting the shit. He was talking about what it was like early in his career, in the pre-Sabbath days, and how important it was to be focused and hungry, and how quickly things could slip away. At some point in the conversation Tony held up his right hand and re-

moved the prosthetic tips, which were sheathed in leather, to reveal a pair of nubs cut down nearly to the first joint. Everyone who followed heavy metal closely knew about Tony's story, but to see the evidence like this was at once sobering and inspiring. I couldn't help but think, if this guy could play the guitar as well as he did with a mangled fret hand, imagine what Edward would one day accomplish.

Still, it did provide for moments of dark humor, as well as inspiration. One night we left the theater late, well after Black Sabbath had already hit the road. I got a panicked call from Albert, the band's road manager.

"Noel, we have a little problem," he said.

"What's that?"

"Tony can't find his fingers. He thinks he left them on the dressing room table. Can you check?"

So I rooted around the room a bit, and indeed Tony had left behind his prosthetic fingertips.

"Yup, got them right here," I said.

Albert breathed a heavy sigh of relief. "Great, can you bring them along? We'll get them tomorrow."

"Sure thing," I said. The next day Tony and his fingertips were reunited and the show went on as scheduled. Why he didn't have a backup set, I have no idea. Or maybe he did, and this was just a favorite pair. I only know that it was hard not to admire a guy who had overcome such adversity, and I hoped that it would have a positive impact on our band.

Unfortunately, the most palpable influence Black Sabbath had on Van Halen had less to do with spirituality or art or ambition than it did with chemical experimentation. Obviously, we were hardly choirboys by the time we began touring the UK in '78, but compared to Black Sabbath, Van Halen were a bunch of rank amateurs. Now, I'm not big on blaming one's poor decisions or bad behavior on anyone else. We are all responsible for the lives we lead and the choices we make, and accountability is the ultimate reckoning. It's quite possible (actually, it's quite likely) that Van Halen would have sunk into the muck and mire of hard-core drug abuse and alco-

holism without any exposure to the mess that Black Sabbath had become; but it's fair to say that prolonged touring with Sabbath hastened the process by normalizing behavior that was in reality quite extreme—even by rock 'n' roll standards.

These guys were heavy drug users; by comparison, Journey and Montrose were lightweights, practically teetotalers. Through much of the '78 tour, even as *Van Halen* hit platinum status, we were a band with little in the way of financial resources. We didn't have the money to buy a lot of drugs. But Black Sabbath did, and once we began touring together in the States in the summer, a veritable blizzard of cocaine descended upon us. The drinking increased, as well, because, as any drunk will tell you, alcohol and cocaine complement each other perfectly. It's a potentially deadly mix, but it is effective. For a serious drinker, the beauty of cocaine is that it so effectively extends the party. Alcohol is a depressant and eventually puts its user to sleep. Throw some coke into the mix, though, and suddenly you snap back to life. I was never more than a dabbler with cocaine, but I understand its insidious appeal.

The toll this toxic combination takes on the mind and body can be catastrophic, and no more vivid example exists than that of Black Sabbath's deeply damaged front man, Ozzy, a tough, streetwise kid with tattoos on his knuckles, a fondness for dripping mascara, and a fantastically creepy wail of a voice. He was the face of a band whose satanic bent terrified Middle America, and he played the role well (even though in reality he was kind of a sweetheart). By the time Van Halen began touring with Sabbath, however, it was hard to tell what was real and what was performance for Ozzy. Most of the time, I swear, he was too fucked up to know what he was doing, and certainly too much of an addict to be an effective or reliable performer.

Our guys liked Ozzy, though, especially David, whose cocaine and alcohol use, by his own admission, escalated significantly when we were traveling across the States with Black Sabbath. David did a fair amount of partying with Ozzy. But

whereas David, like everyone else in our band, was young and healthy enough to withstand the ravages of the road, Ozzy was in free fall. The inevitable crash occurred during a particularly memorable stop in Nashville, Tennessee, in November, near the end of the tour.

We finished our forty-five-minute set and headed for the dressing room with the crowd typically whipped into a frenzy before Sabbath even took the stage. On this night, however, as the audience stomped its feet and cheered for the impending appearance of the headliners, something went wrong. I was sitting with the band in the dressing room when the promoter walked in. He looked nervous as he gestured for me to join him outside.

"Noel," he said, "we can't find Ozzy."

My initial reaction was twofold. First, what do you mean you can't find Ozzy? And second, how is this my problem? But all I could manage to say was, "Excuse me?"

The promoter nodded. His eyes were wide, a sure sign of panic.

"Yeah, he's not here, and no one knows where he is."

Contrary to romantic notions of brotherhood and shared experience, band members did not always arrive at the venue together. Especially in the case of artists of a particular longevity, or bands with a superstar front man, it wasn't unusual for band members to make their own way from the hotel to the venue, or even from the bus to the dressing room. I figured Ozzy was probably either a little hungover or exercising his right to be a diva, and that he'd arrive momentarily and shamble out onstage. Sadly, that was not the case.

"I need a favor from you," the promoter said.

"What's that?" I responded warily, knowing that under these circumstances, any favor would involve me or my band doing something unpleasant, if not downright unsafe.

"We've got to cancel the show," he said. "And we've got to tell the audience."

I nodded. "Yeah, that's going to be a tough thing."

"Tough? They'll fucking kill us. We'd like your guys to back

us up while we make the announcement. That should help soften the blow."

This struck me as an unreasonable request—to ask Edward, Alex, and Michael to return to the stage and play behind a promoter while he informed a few thousand Black Sabbath metal heads that the concert they had paid to see, and which probably had been on their calendar for months, was not going to happen.

"Why the hell should we do that?" I said.

The promoter shrugged. He looked desperate. "Hey, we're all in this together, right? Your guys are so good that if they just come out and vamp around a little while we break the bad news . . ." He paused. "I don't know . . . it might just help."

"Yeah," I said. "It might help."

Or it might put my guys in front of an angry mob throwing about nine hundred bottles at their heads.

"Tell you what . . . I have to run it by the guys, but I'm sure it won't be a problem."

"Thanks, Noel."

I walked back into the dressing room and called the band together.

"Okay's here's the deal," I began. "Ozzy didn't show up, and the promoter wants us to vamp while he tells the audience that Sabbath isn't going to play."

Predictably, this explanation was met first with utter silence, and then disbelief. Alex was the first to speak.

"What, is he out of his fucking mind? The crowd will kill us."

"Exactly," I said. "So let's pack up and get the hell out of here. I told him I'd run it by you just to get him off my back, but I'm not putting you guys at risk."

So we packed up really quickly, jumped in the limo, and went back to the hotel, leaving the promoter to fend for himself (and, indeed, the crowd responded precisely as we anticipated, by howling and tossing all manner of garbage onto the stage; for us, avoiding this scene rather than fanning the flame of disappointment was unquestionably the right call).

The topic of conversation, naturally, was: Where the hell is Ozzy? There was talk of getting the police involved, and of investigating the possibility that Ozzy had been kidnapped or otherwise waylaid through interaction with nefarious types. I did not believe this for a moment. We knew that Ozzy, like the rest of the band (and our band), had made it to the hotel early that morning. For some reason, though, he did not answer his wake-up call in the afternoon. When the road manager checked his room, there was no sign of Ozzy. So it was natural that people would be worried, given his sorry condition in those days. I just figured that Ozzy had wandered into a conference room or something and fallen asleep, but it turned out to be a much better story than that.

What I did not know at the time was that David and Ozzy had not merely been hanging out and partying together but had engaged over the previous few days in something they referred to as the Krell Wars. This was basically a nonstop party (with breaks only for performances, since we were playing practically every night), with a heavy emphasis on cocaine use. The previous night, Ozzy and David had stayed up all night, burying themselves, like Tony Montana, in mountains of coke. The party, David said, went on until nine o'clock in the morning, when our caravan left for Nashville. Keys were distributed upon check-in, and everyone grabbed a nap before wake-up calls were issued and the bands were summoned to the arena for sound check.

David was hungover but bounced back quickly in those days. Ozzy? Not so much. It turned out that he had neglected to look at the room number of his key, and instead dredged up from his barely conscious mind the number of the room he had stayed in the night before, when we were in Memphis (or perhaps the previous night's key was in his pocket; I've heard conflicting reports). Regardless, through fate or dumb luck, Ozzy wound up on the wrong floor, wobbling toward the wrong room, in a hotel that no doubt looked exactly like the one he had been in the previous night. When he arrived,

as luck would have it, the door was open and a maid was busily completing the task of cleaning the room. Ozzy politely excused the housekeeper and said he wanted to take a nap. She wasn't about to ask for evidence that he was indeed the proper tenant—Ozzy cut far too intimidating a figure for that, even when he was shitfaced (or maybe especially when he was shitfaced). He closed the door, fell onto the bed, and passed out.

For roughly the next twenty hours.

Ozzy finally emerged from an elevator the next morning, wondering what had happened and why no one had bothered to wake him up. In the world of Black Sabbath and Ozzy Osbourne, this constituted a happy ending, but there were, unfortunately, some loose ends that required tying. You see, it's not a small deal when a headlining band cancels a gig, especially for reasons that can charitably be called negligent. If the lead singer trips over a cable onstage and breaks his ankle during sound check, necessitating the cancellation of a show, then the band is not responsible for covering the cost of that show. But if a show is canceled because one of the band members did something stupid and entirely preventable—like getting in a fight or sleeping off a three-day coke jag—then there is a liability issue to address. The promoter of the Nashville show had two choices: offer refunds to everyone who had left the Nashville Municipal Auditorium feeling understandably cheated . . . or reschedule the concert for a later date.

This wasn't really our problem; Van Halen had held up its end of the deal by playing its customary set, per the terms of our contract. But we were locked into a tour as a supporting act for Black Sabbath, and if they wanted to reschedule the gig, then protocol dictated that we behave like good soldiers. We were off that night, November 17, but had another show scheduled in Midland, Texas, the following night. When we arrived in Texas that evening, I got a call from Mark Forster, Black Sabbath's tour director (and Albert's assistant).

"Noel, listen, I know you're not the manager but you're a Warner Brothers person. You have some pull there. And we need a favor."

"What's that?"

"Well, we rebooked the Nashville date on the one day off we had." He paused. "The nineteenth."

"Day after tomorrow?" I said. "That's just fucking great. I'm sure my band will love it."

"I'm sorry, Noel. We had no choice. We have to make up the show, and we need your guys on the bill. So here's my problem. If I call Marshall Berle, I know he's going to try to fuck me over; he'll want two or three thousand dollars."

I laughed. "Yeah, probably true."

"We can't do that. It's not in the budget. I need to know if you'll do it for the usual fee."

The "usual fee," as previously noted, was $750. By this point it was almost a joke. After agents' fees and manager fees, the guys in Van Halen were taking home roughly one hundred bucks per gig. And yet, here they were, a platinum-selling band. But that was the deal and we accepted it without complaint. Who would have guessed that while we were out on the road, the band would "break" in spectacular fashion? Sure, I could have asked for more money to make up the Nashville gig, but Sabbath had been good for our careers and we had mostly had a great time on the tour. I was not averse to playing hardball once in a while, but on this occasion, taking one for the team seemed like the right thing to do.

Besides, I liked the fact that they were coming to me instead of Marshall. So I agreed to the $750, and the guys in the band, while unhappy about losing a night of rest, played their asses off once again for the fans in Nashville. A few days later Marshall called to ask about the negotiation.

"Noel, we could have gotten a lot more money for that show."

"Oh, really?" I replied. "That's too bad, Marshall. I didn't realize."

There was a long pause on the other end of the line. I imagine Marshall wanted to tell me I was an asshole, or to fuck off. But he didn't. He said absolutely nothing. Marshall didn't know it at the time—or maybe he did, and that's why he chose his words carefully—but his days as the manager of Van Halen were numbered. Shit, after all, has a way of catching up with you.

7

HOW VAN HALEN'S HARD WORK AND HIGH TIMES WERE CHRONICLED

L et's first give credit where credit is due. While I felt that Marshall Berle was overwhelmingly unsuited for the job, he did execute one exceptionally cool publicity stunt during his brief tenure as the manager of Van Halen.

On September 23, 1978, Van Halen participated in a massive one-day music event at Anaheim Stadium known as Summerfest. Not a particularly creative moniker (and not really accurate, either, since it was no longer technically "summer"), but in spirit and size, Summerfest was exactly what it purported to be: a long day of music featuring some of the biggest bands of that era, including Van Halen, Black Sabbath, Boston, and future Van Halen front man Sammy Hagar, performing as a solo artist. Nine hours of heavy rock 'n' roll under the blistering California sun.

It was flattering enough for Van Halen simply to be a part of this event. Sabbath was Sabbath, as we already knew from months on the road as the band's supporting act. Boston, meanwhile, was among the hottest bands in the world. The group's eponymous debut album, released in the fall of 1976, was filled with shimmering, highly polished and radio-friendly guitar rock, and was a staple of FM playlists. *Boston* was one of the biggest-selling debuts in history and yielded multiple hit singles. A second album, *Don't Look Back*, was released in August 1978; by the time we appeared together at Summerfest, that album had already sold 4 million copies and risen to the top of the *Billboard* charts. So, yeah, Boston was a juggernaut.

Compared to Van Halen, Boston's music was light and clean, and much more reliant on dense studio production—as live performers, they were not in the same league as Van Halen—but the band did what it did extremely well. I'll give them that.

Rather than being content to simply take the stage (after Hagar but before Black Sabbath and Boston) and kick ass in the usual manner, someone in the Van Halen camp decided that in order to steal the spotlight on such a big day, something else was required. I was not involved in the original discussions surrounding this event, but it is my understanding that it emanated, as usual, from the twisted and self-promotional mind of David Lee Roth, with considerable input and assistance from Marshall Berle. David has long taken credit for the

idea, but as manager of the band, Marshall deserves a pat on the back for organizing the stunt and pulling it off.

Here's the way it went down . . .

Van Halen was scheduled to take the stage third, following an unannounced set by Richie Lecea and then Hagar. At roughly 6:30 in the evening, as the stage was being prepared for Van Halen, a low-flying plane rumbled over the stadium. A door opened and out jumped four men, one after the other. As the parachutes opened and the sky divers descended earthward, a public address announcer breathlessly revealed their identity.

"From out of the sky . . . Van Halen is coming into the stadium!"

The crowd, predictably, went bonkers. The parachutists were nothing if not expert at their jobs, and they milked the moment for all it was worth, changing directions several times, delaying the fall as long as possible, and giving the appearance that they would in fact land directly on the stage itself. You half expected them to whip out their instruments on the descent and begin playing. And as they drew nearer, the parachutists pumped greater life into the hoax, giving the crowd a glimpse of the long hair hanging from beneath their helmets.

Holy shit! It really is Van Halen!

But of course it wasn't.

The boys were in fact hiding in a van just beyond the stadium gates, dressed in exactly the same outfits worn by the quartet of professional parachutists, who were by now just a few hundred feet above the stadium. At the last moment, the parachutists expertly changed their flight pattern once again, floated safely beyond the stage and the stadium, and landed in the parking lot. There, they quickly ducked into the van, from which, moments later, emerged David, Alex, Edward, and Michael. The four members of Van Halen ran onto the stage in full hospital green garb. After absorbing a monstrous standing ovation for the better part of a minute, they peeled off their parachute gear, picked up their instruments, and lit into

a thunderous version of "On Fire." Adding drama to the scene was the fact that Alex was actually in significant pain and had trouble climbing up the drum riser, thanks to a sprained ankle incurred when he tripped over a cable on his way to the stage. The mind boggles thinking about what might have happened had he actually jumped from that plane.

While most of the crowd was appropriately duped into thinking they had witnessed Van Halen making the most awesome entrance in the annals of rock, skepticism began almost immediately backstage, among the media and other attendees who were a little less naive and a lot less inebriated. But Marshall refused to give in, instead playing the role of carny barker to the very end.

"These boys have been practicing this jump for months," he swore. "They were ready for it!"

Well, someone was, anyway.

In reality, the only "practicing" Van Halen did was making sure they knew how to unzip their outfits quickly when they got onstage. That part they executed perfectly. Once on familiar turf, they did what they always did: put on one hell of a show. With the crowd still going nuts, Van Halen left the stage sweaty and swaggering, as usual.

Boston was up next, and you could almost imagine Eddie and Dave saying *Top that, motherfuckers,* as they walked off, leaving a sea of crazed fans (including many topless young ladies) in their wake. Interestingly, at one point in Boston's set, lead guitarist and band mastermind Tom Scholz copied a guitar solo that Edward had played just a short time earlier. Was it a tip of the hat to the young virtuoso? Or was it something he did out of envy, to let the crowd know that Eddie wasn't the only guitar wizard in the house?

Anything you can do . . . I can do better.

My guess would be the latter, and certainly Eddie viewed it that way. But this was the type of response that Van Halen in general, and Eddie in particular, provoked in those days. Like most artists, musicians can be shallow and insecure, and when Eddie was on his game, as he was throughout the late

'70s and early '80s, he made most guitar players look and feel inadequate.

There is no question that Summerfest was among the highlights of the year for Van Halen, in every way imaginable. For Marshall Berle, this was a singular success, yet it could not salvage his diminishing influence on the band. For months, Marshall had not seemed to realize that one of the most important characteristics of any manager is visibility. From the outset Marshall was a mostly spectral presence, preferring the comfort of home and office to the rigors of the road. Now, there are some managers who can make this arrangement work, either through charisma or sheer power. Marshall was neither charismatic nor powerful, but I suspect he felt that his position was secure simply because Van Halen, when Marshall was appointed as manager, was a new and unproven commodity. What were they going to do, fire him?

Well, yeah. As it turned out, that's exactly what they did.

Like me, the boys in Van Halen (David in particular) figured out early on that Marshall seemed lazy; he'd show up on the road only once in a while, typically in the more attractive cities, often with his wife in tow. The band always picked up the tab. These were, technically speaking, business expenses, and I suppose they might have been overlooked had Marshall consistently given the appearance of being diligent about his job. But mostly he seemed distant and disinterested, which understandably led to nagging doubts among the band members about whether Marshall was the appropriate person to guide their suddenly soaring careers (I had doubts from the first time I met him). And once the seeds of doubt are sown, there really is no turning back. David, as the de facto leader of the band, would frequently consult with me about issues that concerned him, not because we were best friends or anything, but simply because, as the road manager, I was always there. I mean . . . *always*. Van Halen was my life, and whatever personal issues there might have been between us (not many in the beginning), I gave the band everything I had, in terms of experience, loyalty, energy, and expertise. I never lied, never

sugarcoated anything. And I sure as fuck never stole so much as a dime. It was only natural that the band's loyalty eventually shifted away from Marshall and reattached to someone they knew and trusted.

That person was me.

Appearances to the contrary notwithstanding, most relationships do not end suddenly. This is true of friends, romantic partners, and business associates alike. When someone claims to be blindsided, it's usually because they had their eyes closed. In the beginning, David and the others joked frequently about their invisible manager. Then the joking became more caustic; genuine annoyance crept into the conversation, followed, predictably, by resentment. Had Van Halen's first album not become a hit, and if the band hadn't broken big while out on the road, these issues might have gone unaddressed. But the guys, though they may have started out as dumbass stoners from Pasadena, eventually began to pick up on the vagaries of the business. Despite earning only $750 per show, they were aware of their own mushrooming popularity and the impending clout that would come with it. This led them to question the commitment of those around them. These kids were working their asses off, grinding through the most demanding and exhausting tour I had ever seen, and they hardly complained at all. They just wanted to play music, fuck, and get fucked up. In return they wanted only to know that eventually they would be appropriately compensated and that someone was looking out for their best interests.

Although Marshall didn't realize it at the time, the beginning of the end had come in late June of '78, at the conclusion of a two-week tour of Japan. Then, as now, Japan was a breathtakingly expensive country in which to do business. Van Halen had toured only in the United States and Europe by this point, so the boys suffered from both culture shock and sticker shock during that visit. We'd go out to dinner and they would laugh hysterically at menus offering hundred-dollar steaks. I don't think it was until that trip that the band began to finally understand who was paying for all of this.

I tried repeatedly to explain to them that everything came out of their pockets: food, liquor, hotel rooms . . . everything. For months, though, they labored under the illusion that Warner Bros. was picking up the tab. Which they were, but the label had every right to reimburse itself out of the band's earnings. The boys preferred not to think about this, which is pretty typical of young musicians living the rock 'n' roll road life. Eventually, though, after enough tickets and albums have been sold, they start to ask questions, like "If our album has sold a million copies, then how come I'm only making a couple hundred bucks a week?" These are types of questions an artist is supposed to ask his manager, but if the manager is back in LA, while the artist is out on the road working . . . well, resentment can build.

It doesn't help when the manager shows up in Japan with his wife at the end of the tour, then invites the band and crew to a big celebratory dinner, without informing them that for this too they'd be picking up the tab. Marshall made a big deal out of showing his appreciation for the work Van Halen had put in, and for the rewards being reaped by the label. I got the impression that the dinner was his treat. There must have been between fifteen and twenty people in our party that night, and we ate and drank up a storm. Frankly, at the time, I was impressed by Marshall's generosity; I thought perhaps I had judged him unfairly. If he was willing to dig into his wallet and pay for a party of this magnitude, then maybe he wasn't quite as lazy or unethical as I had thought.

The next morning, however, as we checked out of the hotel and prepared for our trip back to the states, I collected all the necessary paperwork and distributed accordingly. Among the bills was a receipt for several thousand dollars for the previous night's dinner. I pulled it from the stack and walked over to Marshall.

"Here you go," I said.

Marshall gave me a quizzical look. His hands remained by his sides.

"What is it?" he said.

"The dinner bill from last night."

"Oh, yeah," Marshall said, feigning surprise. "Just put it with the rest of the band's stuff. Turn it all in when you get back."

I was almost too stunned to speak. The son of a bitch had no intention of paying for the party; he was just putting on a show.

"Marshall, I was under the impression that you were taking everyone out as a show of appreciation."

There was a long pause. Finally, Marshall said, "I did take everyone out. Now, just put the bill with the other expenses."

"You're fucking kidding me," I said.

Marshall stiffened. He leaned in closer. "No, I'm not kidding. Just put it with everything else. Okay?"

What could I say? He was the manager, and I was merely the road manager. I complied, but in that moment Marshall's reputation was solidified in my eyes as an utter piece of shit. And before long the guys in the band would view him the same way. On the trip home, David asked offhandedly how much Marshall had spent on our celebratory dinner. There was something in the way he asked the question that indicated suspicion. I think David wanted to believe that Marshall had done something nice, but he was by now becoming wise to the ways of the industry. Skepticism was always a healthy attitude. And I wasn't about to lie.

"Actually, David, I should probably be thanking you for that dinner."

"What do you mean?"

"Marshall billed everything back to the band."

David's head jerked back. His face went crimson.

"How big a bill are we talking about?"

I shrugged. "His total bill, including travel, came to almost ten thousand dollars."

David's eyes narrowed. I had never seen him quite so angry.

"That motherfucker. How could he do that?"

"Perfectly legal," I said.

David scoffed. "Yeah, but still . . ."

I nodded.

David sat there quietly for a while longer before finally ending the conversation with, "What a pile of garbage."

THE FAUX PARACHUTING STUNT a few months later offset some of the contempt the band felt toward Marshall, and demonstrated that he was, when engaged, capable of creatively marketing his band (this event stood in sharp contrast to an earlier, unsuccessful attempt at merchandising in which the band overpaid for several thousand flimsily constructed painters caps that we wound up giving away). But in terms of poor judgment, nothing surpassed Marshall's almost incomprehensible decision to share with a select audience road movies of Van Halen at its best.

Or worst.

Depending on your moral compass and how easily offended you might be.

Marshall's modus operandi was to ingratiate himself with the band through an assortment of juvenile tactics, including bad jokes and stupid card tricks. When he was on the road, he was not so much inclined to join in the partying, but he enjoyed chronicling the proceedings with a handheld 8-millimeter video camera. The boys, with typical naïveté, found it all harmless and even a bit flattering: *Hey, the manager is filming me while I'm having sex with two girls at once!* I found the voyeuristic behavior thoroughly unprofessional, and deeply weird, as well. But since Marshall wasn't around all that often and the band didn't seem to mind, I let it go. Sometimes, though, I found myself wondering what he'd done with all those hours of videotape, and what might happen if they fell into the wrong hands.

I don't mean to imply that Marshall filmed only the sexual exploits of the band; that would not be true. When he was on the road, he filmed practically everything—from meaningless conversations backstage to impromptu comedy sketches in hotel rooms and on buses. And he did shoot a lot of ama-

teur pornography featuring the members of Van Halen, most notably David Lee Roth, who was the featured performer in probably 75 percent of the X-rated films. Some of these were surprisingly well done. Peter Angelus was a lighting man, of course, and often he would help out with production so the scene would be expertly lit. I remember one scene in which Peter stood off to the side, holding a hotel lamp, providing not just proper lighting but narrative accompaniment as an eager girl performed oral sex on David.

"See, girls, this is how it's done," Peter said, before providing the (ahem) blow-by-blow.

I was not present when this incident occurred, but I did see the videotape afterward, because Marshall put all the footage together and had it transferred from 8-millimeter into VHS format. Again, I did not know what to make of this behavior. If a member of the band or crew wanted to assemble such a package, I suppose it was fine. But for the manager to do it? Aside from raising questions about Marshall's judgment, it provoked legitimate concern about his suitability for the job. In my view, a manager should do his best to avoid getting down in the gutter with his band. He's supposed to make sure they rise from the gutter unscathed. I'm not sure Marshall understood this. He shot several hours of video footage, not just a couple minutes. He cataloged the results, tagging each with a descriptive term (often "X-rated" or "Funny"). I honestly don't know what he was thinking, or if he was thinking at all, because he should have realized that the emergence of these videos could make him look bad and would make the band look bad. There was nothing to be gained.

So what on earth could have compelled Marshall to hold a private screening of some of the video footage for an audience of secretaries and staff (almost entirely female) in the Warner Bros. offices in Burbank? I can only surmise that it was an attempt to portray himself as some sort of auteur, a chronicler of the high times and hard work that go into making a successful rock band. Unfortunately, embedded among

the harmless high jinks and concert footage was a significant amount of explicit sexual content. Far from being impressed by these scenes, the Warner secretaries were predictably and understandably horrified. I mean, talk about not reading the temperature of a room. What in God's name was Marshall thinking?

This was exactly the question posed to me by both Carl Scott and the guys in the band, all of whom responded with a mix of anger and bewilderment when they found out about the private screening.

"He's going to ruin their careers," Carl said. "What is he doing?"

I had no answer, nor did I understand why one was expected of me.

In the eyes of the band, Marshall never recovered from that incident. Unbeknownst to me, David spent a good portion of the latter stages of the tour contemplating the dismissal of the band's manager, and discussing with the other guys exactly how it would go down and who should replace Marshall.

One night late in the fall, David pulled me aside after a show. This in itself was unusual—most nights, David liked to get right into the party scene, lining up sexual partners and throwing back drinks or smoking weed. But now he was quiet and reserved, even in the afterglow of yet another great performance.

"I have to talk to you, Noel," he said.

"Fine, David. What's on your mind?"

He led me into a utility room filled with maintenance equipment: paint, brushes, ladders, brooms, and the like, a sad little room with no windows and a heavy scent of petroleum products.

"Better not stay in here long or we'll get too high to talk coherently," I joked. But David neither laughed nor smiled. Instead, he sat down on a bench and let his head fall into his hands. "Jesus, David, what's wrong?" I was accustomed to seeing David in various extremes of emotion—happy, angry, manic. But I had rarely seen him sad.

"We've done a lot of talking," he began. "And we all agree that we have to make some changes."

I wasn't quite sure where this was going. It almost felt like I was about to be fired. But that was preposterous. I had done a good job for the band and I knew that they believed in me and trusted me. Something else was happening.

"Just spit it out," I said. "You'll feel better."

David nodded. "Okay, here it is. We want you to manage the band."

I was flattered and surprised, and at first didn't know how to respond. First of all, Marshall was still the band's manager, although his contract was due to expire at the end of the year. Second, I understood the magnitude of the task and knew the personalities involved. It was one thing to be Van Halen's road manager; it was quite another to be the band's personal manager.

"You know, David . . . I have never been a manager before."

He nodded. "I don't care."

"Well, I want to say it anyway, just so we're clear. I have been a road manager, production manager, stage manager, and a security guy. But I have never managed in the big leagues, and I think next year you guys are going to be in the big leagues."

"Yeah, I think so, too," David replied. "And I don't care. None of us do. We want you to be our manager."

"Are you speaking for yourself or the band?"

"We've talked it out," he said. "We're all in agreement. Everyone wants you."

"Let me think about this for a second." I paused. "Okay, David, I would love to be your manager."

He clapped his hands together. "Fantastic, Noel!"

"But first . . ."

"Ah, shit."

"Let me finish, please. I would love nothing more than to take over the reins and run this band right up to the top. But with all due respect, I think it's best that you guys go out and interview some other candidates to make sure you are comfortable with this decision."

David seemed surprised. I think he also was impressed. "Got any suggestions?" he said.

"Sure, start with Bill Aucoin, KISS's manager. Talk to all the big shots, let them show you their wares, listen to their business plan, and then go with your gut."

"Okay," David said. "But you know . . . you could lose us."

I threw up my hands in surrender. "Maybe so, but I want you to get a fair deal. You owe it to yourselves to shop around, kick some tires. Meet the big shots and see what they can offer, because . . . all I can give you is fortitude and honesty and whatever knowledge I've gained over the years. I think that's worth something, but we both know that I am not a big shot."

"Fair enough," David said. We shook hands. I honestly figured that by the end of the year Van Halen would have a new and powerful management team, befitting an act so obviously on the upswing. I wasn't even sure that I'd still be the road manager. But my dignity was intact; I would sleep well knowing that I hadn't tried to steer the band in a particular direction based solely on my self-interest. If their due diligence told them that I was the best candidate, great. I was up for the job. If not, well, we'd all move on. No hard feelings.

VAN HALEN FINISHED ITS TOUR in early December. Once off the road, the boys were left with considerable time on their hands, which was devoted primarily to preparing to record a new album and interviewing candidates for the job of manager, a process that galvanized the band in that it naturally included much discussion about why they needed a new manager in the first place. For all that his absence on the tour and his professional judgment were questionable, the deal breaker, as it often is in matters of business, was actually the discovery that Van Halen owed more than a million dollars to Warner Bros. for reimbursement of expenses. Again, let's be clear: there was nothing illegal about any of this, and it could certainly be argued that David and the boys should have

been paying closer attention. Nevertheless, they were pissed off. To them (and I felt the same way), this bill represented at the very least a breach of trust. So, in addition to methodically going about finding a suitable replacement for Marshall, they also decided to get even.

And, just so you know where my allegiance stood, I helped them do it.

When the bill came due and David discovered the staggering sum that would have to be repaid to Warner Bros., he was enraged. Besides the pittance they were making per show, album royalties had not yet begun pouring in, and even when they did, the deal Van Halen had struck with the label was so bad, it failed to alleviate the sting of a million-dollar debt.

"We have to do something about this," David kept saying. "We can't just let them get away with it."

I figured that since the guys had already decided that Marshall was going to be replaced (although they hadn't told him yet), there was no point in getting in a pissing war. But David wanted to exact a pound of flesh; failing that, he suggested retrieving from Marshall's office everything that could be construed as "belonging" to Van Halen. I knew this was risky, but what the hell? I disliked Marshall at least as much as the guys in the band did, and they were right to feel aggrieved. Plus, it sounded like fun.

So, late one night, when Marshall was out of town, we all broke into his office and took everything that pertained to Van Halen: files, posters, albums, and all sorts of memorabilia—basically anything the guys thought was rightfully the property of Van Halen. I even recall a few gold records being peeled from the wall.

A few weeks later, while staying at the Sunset Marquis in West Hollywood, I returned from a show at the Roxy and noticed instantly that my briefcase was missing; the sliding glass door leading to a first floor patio was slightly ajar. I know for a fact that it had been closed and locked when I left, so obviously the intruder had broken in through the patio. Among

the items in that briefcase—never recovered—were about five thousand dollars in equipment, a Krugerrand (a one-ounce gold coin from South Africa), and roughly a thousand dollars in cash. Oh, and a small assortment of high-quality mood-altering substances.

A coincidence? Karma? Who knows? But in the future I avoided ever taking a room on the ground floor.

The next day I went to my office. There was a box sitting on my desk; I recognized it as one that we had pilfered from Marshall's office. The band had already gone through it and taken everything they wanted. The rest was left for me, but I felt weird about it now, especially in light of recent events, and so I simply picked up the box without checking the contents and stuffed it in the bottom of a closet. As often happens with items stashed away in this manner, some time passed before I even remembered that it was there. Must have been around 1981, I would guess, I was cleaning up my office and found the box buried beneath a pile of shit in the back of the closet. Curious, I pulled it out and began rummaging through the contents. Among the items, folded multiple times, was a poster of Jimi Hendrix playing his guitar. I had never seen this particular image before; more importantly, I had never seen the logo that accompanied the image: the initials *JH* in large letters, with sharp angles, almost like lightning bolts. I started at it for a moment.

Man, that looks familiar . . .

Then it hit me: with a few slight variations, the Hendrix logo was nearly identical to the iconic winged Van Halen logo that first appeared on the band's debut album. I knew there had been a bit of a dispute over the artwork for that album, that the band and Marshall had rejected the original artwork proposed by Warner Bros. I always loved the Van Halen logo and presumed it had been a purely original work of art. But now? Well, either someone had been greatly inspired by the Hendrix logo that I now held in my hands, or this was the most remarkable coincidence in the history of rock 'n' roll

artwork. Either way, it was quite the eye-opening experience. And I never did tell anyone about it.

Until now.

BY EARLY JANUARY 1979, Marshall was gone and the band had finished interviewing candidates for his replacement. The process apparently had been less than inspiring, which is why David called me one day and suggested we all get together at the Riot House, where I was staying.

"We've been to everyone," David said. Naturally, he didn't mean "everyone" but rather, a handful of people who represented top-line management. "Our opinion hasn't changed—"

I interrupted him.

"Did you meet with the guy from KISS?" I figured if anyone seemed a likely candidate, it was Bill Aucoin, who was nothing if not a starmaker. He'd shot KISS into the stratosphere of popularity practically overnight; imagine what he could have done with Van Halen.

"Yeah, we did," David said. He shook his head. "He kind of talked down to us, spent the whole meeting talking about himself. But that wasn't the worst part. In the middle of the meeting, he called a guy into his office and had him shine his shoes. While we were talking!"

"I guess he was trying to show you what a big and powerful man he is," I said.

"Well, it didn't work," David said with a laugh. Then he proceeded to tell me about some other managers they had interviewed, and how they all basically just recited their résumés and offered nothing in the way of a practical plan for taking Van Halen to the proverbial "next level."

"So . . ." David said, looking around the room at his bandmates. "Here's the thing, Noel: we've come to the conclusion that we would like you to be our manager."

"All of you?" I said, looking first at Edward, then Alex, and finally Michael. They all nodded.

"Okay . . . I'll give it a shot."

I'd like to say that after nearly two decades in the business, and after a year on the road with the boys, I knew what I was getting into. But that wouldn't be quite true. It was, in every way, more than I had envisioned. More work, more fun, and ultimately, more pain. But in that moment, as we stood in the middle of the room and shook hands, I saw and felt only the limitless potential of friendship and the transformative power of music.

8

DUMPSTER DIVIN' & CHART CLIMBIN'

The machinery of stardom requires vast amounts of fuel in order to operate at peak efficiency. When it came to the music industry in the late 1970s, that fuel was a potent mix consisting of equal parts product, promotion, and performance. There was no rest for the weary. A band on the rise was an immensely valuable commodity, from which every ounce of revenue was extracted at the quickest possible rate. The hell with art. Fuck creativity and the patience it often requires. Once an act distanced itself from the slag heap of mediocrity, there was pressure to work harder, faster, smarter.

Put out a new album, like clockwork, every year. Get out on the road for months at a time, touring tirelessly in support of the

album. And hope the record label did its job by promoting the hell out of the album, to ensure ticket sales, which in turn drove concert revenue. It was a brutal cycle that chewed up even the most energetic and ambitious artists. As Van Halen discovered, the integrity of the product was often the last consideration. Schedule was paramount. Whatever it took to get the record done and into the hands of the public was perfectly acceptable.

Van Halen finished its exhausting 1978 world tour on December 5, in Phoenix, Arizona. You would think that merely surviving that tour (to say nothing of owning it, the way Van Halen did) might have merited a prolonged and well-earned vacation. But you would be wrong. Just six days after that tour ended, the boys went back into the studio to begin work on *Van Halen II*. A prosaic title, to be sure, but what the hell? It had worked on the debut. Why waste time fussing over an album title when you have only a few weeks to record the damn thing?

Fortunately, many of the songs that appeared on *Van Halen II* were written far in advance, and demos in some cases had already been recorded. Because they had played for several years before getting their first record deal, they already had a catalog of songs waiting to be recorded. That is not an unusual story for a band, which is why it's so challenging to produce a second record that lives up to the standard set by a debut. Van Halen had cultivated a unique sound and style anchored by Edward's guitar and David's howling vocals; they had written and performed scores of original songs, the best of which (presumably) were chosen for inclusion on *Van Halen*. In fact, the only "new" song on *Van Halen II* was "Dance the Night Away," an infectious tune that highlighted Van Halen's pop tendencies, and became the band's first Top 20 single (and the vehicle for its first foray into the burgeoning world of MTV and music videos). Interestingly, like the debut album, *Van Halen II* contained exactly one cover song, which speaks to just how prolific these guys were in the early days.

Still, the production schedule was demanding, if not downright crazy, regardless of how much material the band had at the ready.

Ted Templeman returned as the producer, and *Van Halen II* was recorded in a drug and alcohol fueled frenzy over the course of less than three weeks at Sunset Sound Recorders. I wasn't witness to very much of it—I never considered it my business to be involved in the creative side of band life, preferring instead to focus my energy on their more concrete, tangible needs. Not that they needed me; David and Edward were both never-ending fountains of creative energy, and—fueled by copious amounts of illicit substances—the two of them were rarely short on ideas. It was an interesting way of doing things: burning the candle at both ends for weeks at a time, spit balling something—a note here, a lyric or two there—into a full-fledged record, but if I knew anything about Van Halen (and I knew a few things) I knew they loved to bang it out. So to speak.

The couple of times I did hang out around the studio, I felt completely out of my element. I'll be honest, I don't know how David and Edward worked with each other. They had two very different visions for what they wanted, artistically speaking, and I witnessed them at each other's throats more often than not. I'm pretty sure the coke-weed-alcohol cocktail made their nerves that much more frayed, but maybe that tension translated into Van Halen's raw signature sound. Hell, if I knew.

I just didn't feel like going down the rabbit hole with them, despite David's urging, preferring to limit myself to a line or two, here and there. It was far from a regular thing.

"Come on, Noel. Are you one of the guys or not?" he'd say, in a way that strongly implied I wasn't holding up my end.

"Sure, David . . . I'm one of the guys," I'd say, placating him.

"Then have a line. It's not going to kill you."

And it didn't. It did, however, make me needlessly agitated by the time I left the studio and headed home—come to think of it, maybe that wasn't the coke.

BY JANUARY the album was in the can and I was the new manager of Van Halen. In the beginning we had no money—

just a lot of debt and royalties caught up in accounting, and a shitty contract with Warner Bros. that would last for at least one more year. To save money I set up shop in my room at the Riot House. That's right—I was the manager of one of the hottest bands in the world, and my office was a hotel room on Sunset Strip, and it was here that we conducted much of Van Halen's business. In a way it was kind of fun—it helped keep us grounded and fostered an us-against-the-world mentality that always makes work more enjoyable.

We had almost no staff. I hired a secretary I knew from Warner Bros. She would knock on my door at 8:30 every morning, and I would take a quick shower, throw on my T-shirt and blue jeans, and start working. In retrospect, the whole situation was quite laughable, but what could I do? I couldn't take over Marshall's office, since he hadn't quite moved out yet and there was concern he was contemplating a lawsuit against the band.

I did what I could. I was a new manager with almost nothing to work with except my own knowledge of the business and a good working relationship with Warner Bros. With help from Peter Angelus, I worked very closely with the Warner Bros. art department to create the new album cover. I mean, I don't want to make it sound like I was a lone wolf, because that really wasn't the case. The band was excited about a new start, and I did have strong relationships with people within the industry. Nevertheless, reality stared me in the face every morning when I got out of bed: I might have been the manager of a platinum-selling band, but I was still working out of a fucking hotel room with a skeleton crew.

David, at this point, was instrumental. For all his quirks and emotional immaturity, David was a very bright man with a lot of good ideas, and even though he was one of the most difficult people I had ever worked with, I realized that he was the go-to guy for all things Van Halen. David was the smartest guy in the band by a wide margin—and he knew it. Look, here's the honest truth: most artists—musicians, anyway—are not particularly bright. David was the only member of the

Fantastic Four who would read eclectic material, which made him more interesting, and a credible lyricist, as well.

Ed would do the music and David would write the lyrics. David would always wait until the last minute, then come running into the studio with the lyrics written on the back of a paper bag or something. It was obvious he'd written them in a wild, untamed flurry, using deadline pressure as the primary motivation. You'd want to smack him for being so apparently cavalier, but then you'd listen to the words, and you'd see David perform the song . . . and it was often brilliant. So what could you do?

For these reasons, among others, David was a strong creative and business force, especially in the early days. If we were going to make this new arrangement work, I had to make David a partner, not an adversary. I don't mean from a financial standpoint. Contractually, we were all partners. The band members had agreed to an equal split of everything, regardless of the contributions of a particular member on the songwriting front. It's not unusual for a band member to get a greater share of royalties or publishing revenue if he was the sole author of a song. But many bands in the nascent stage decide that friendship and egalitarianism are more important than quibbling over money.

One for all . . . all for one!

This arrangement often works well in the beginning, and then not so well if one or more band members achieves a greater level of stardom, or takes a dominant role in songwriting, as would eventually be the case with Van Halen. For now, though, the pie was split into equal pieces, and my take was 20 percent. There was just one catch: for most of that first year I worked without a contract. And when we finally did put something in place, in the fall of '79, I had only a thirty-day contract. We did this with the understanding that we would negotiate something more permanent down the road. But it never happened. I worked as the manager for Van Halen for six years, and the entire time I was on a month-to-month contract. What did this mean? Well, a couple things. It meant that

while the terms of the actual contract were fine as far as compensation, I had absolutely no job security; the band could terminate me at any time, and for almost any reason, with only thirty days' notice. I would be owed nothing from the band's revenue beyond the day I was let go. More typical for a manager is a multiyear deal. I never got anything like that.

I've beaten myself up enough times over the years about that contract. I still feel it was forced on me by the band and Barry Tyreman, who at the time was Van Halen's attorney, during a meeting in his office. Maybe he wanted to prove to the band that he could be a tough motherfucker, or maybe the band wanted to protect itself better this time around. But Barry pulled out a contract that was far more onerous than the one that Marshall Berle had worked under, and asked me to sign it. I was still relatively young and hungry, and I had never been a manager. Still, I wasn't an idiot. I knew this was a bad contract; I was wary of a thirty-day deal, and I said so. But Barry pushed it and the guys went along.

Honestly, I wasn't that worried about it. I was too excited about managing this fantastic band that I just wanted to keep working. While I viewed Barry as an untrustworthy prick, I liked the guys in the band and felt they would do right by me. I figured I'd wait a little while and renegotiate the terms and get a fair deal.

It never happened. I asked numerous times over the years and each time the request was nudged aside or ignored, and I grew to live with the idea that I would never have any sort of job security. It was never much of an issue . . . until, of course, it was.

IN MARCH OF '79, a few weeks before the release of *Van Halen II*, I got a call from the promotions department at Warner Bros., informing me that a meeting had been scheduled with executives at *Billboard* magazine. *Billboard* was the most powerful and influential music trade publication, largely because its ranking of singles and albums was considered the definitive

measure of a record's success or failure. The entire process for determining these rankings was something of a mystery, but the weight that the brand carried was indisputable.

I knew a few people at *Billboard* because I had done production work for some shows sponsored by them in the early 1970s, so I was pretty comfortable taking this meeting. I wasn't sure what it was about, but figured it had something to do with Van Halen's new album. Indeed, that was the case. We met in the office of a *Billboard* executive we'll call Jeff (not his real name). Nice guy, very courteous and professional, and we'd known each other for a while.

"First of all, Noel," he began, "congratulations on your new gig with Van Halen. That's a great band you have there."

"Thanks," I said, "I think so, too. So tell me, Jeff. What's going on here?"

If this sounded like an ignorant question, well, that's because the entire meeting was far above my pay grade from just a few months earlier.

"All right, here's the thing," he said. "How's this new album?"

"It's great. Coming out in a couple weeks. Why?"

"I'm sure it's very good. But how is it going to do? What are the expectations?"

"I think we're all excited and optimistic," I said. This was bland, but absolutely true. I had no idea where the conversation was going.

"Bottom line," Jeff said. "Where do you want this album to land on the charts?"

"What chart?" I said, feigning utter stupidity.

Jeff smiled. "The only chart that matters, Noel."

My first thought was, *What the fuck is he talking about?* But I tried to just roll with the conversation.

"I don't know, Jeff. What do you think?"

He leaned back in his chair, pressed one palm into the other. "You guys are very good and ready to make a huge jump this year. Would you want to come in at five or six, something like that?"

Then it hit me: *Holy shit, he's calling our chart position. Weeks in advance.* I tried to stay calm. First of all, if he was giving me an opportunity to choose where we would debut on the *Billboard* album chart, I had to exercise some restraint, rather than get caught up in the insanity of the entire exercise.

"Maybe low forties," I said. "Forty-two, forty-four. That gives us someplace to go, rather than falling after the first week."

Jeff nodded. "Smart thinking."

The quid pro quo, as I quickly learned, was payback through advertising. A double-page ad in *Billboard* at that time was very expensive. If a record label spent enough money and had a band that was deemed destined for stardom, it was possible to manipulate the numbers. Sometimes the money came directly from the band itself. When I became Van Halen's manager, for example, a full-page ad appeared in *Billboard*, basically offering me congratulations from the band. Buy enough advertising and you could get leverage with regard to where your band's new record might show up on the *Billboard* charts.

Can I prove any of this? Not really. But I know this conversation happened, and I know that our album debuted on the Billboard chart in the forties, as requested.

Maybe it was just a coincidence.

Look, this was the way much of the music business worked back then: you scratch my back, I'll scratch yours. In some circles transactions were facilitated through what I called C&C: cash and coke. Or, depending on the person with whom you were doing business, CC&P: cash, coke, and prostitutes. Whatever it took to get the job done. And I was learning very quickly that the job was a lot more complicated, and sometimes dirtier, than it was when I was simply tour manager.

It was well known in those days that bigger and more successful artists were allocated greater resources—not just compensation but a broad spectrum that included publicity, marketing, merchandising, and tour support, to name just a few line items. Stated policy was that all bands of comparable

levels of achievement were treated basically the same. But this simply wasn't true, and everyone knew it. The monster groups received greater support, as well they should have; the stakes were higher. The strange part, however, was trying to figure out where a particular band fell in the pecking order, and whether there was any sort of document used as a guideline for determining expenditures such as promotion and marketing, or whether these things were entirely arbitrary.

As it turned out . . .

One day in the spring of '79, while sitting in Carl Scott's office discussing the plans for Van Halen's upcoming tour, the big man casually mentioned something called the "black book of artist allocations." I straightened in my seat when the words tumbled out; Carl, sensing he had let slip something intended to remain private, quickly tried to change the subject, but I pressed him for information.

"There's an actual book?" I asked. "And it's really black?"

"Nothing you need to be concerned with," Carl said. "Don't worry about it."

When I asked to see it, Carl refused. I asked again. He would not budge, and I didn't have the strength to move the big man (metaphorically or literally). Since I had no desire to offend or anger Carl, I let it go; however, I left his office that day with a burning desire to get my hands on a copy of the vaunted black book.

Back in my office, I scoured the personnel roster in search of an unwitting accomplice for my mission of stealth. I found her in the person of an assistant to one of the Warner VIPs. She was a very sweet and attractive young lady, but I wasn't interested in a serious or long-term relationship. It may not sound like the noblest gesture, but frankly I was interested in only one thing, and it wasn't the usual pot of gold men seek at the end of the dating rainbow. What I wanted from her was a copy of the big black book. By the end I think she knew what I was after and was both relieved and offended that it wasn't what she had thought it was.

After a few weeks and an investment of several hundred

dollars in lunch and dinner tabs, I held in my possession the Holy Grail of management information. As I cracked it open, my heart began to beat faster. My palms were sweating. (Come to think of it, this response wasn't so much different than the endgame men typically seek.) Inside was the entire Warner Bros. roster of talent, and precisely what they received in terms of support, broken down into every conceivable category. It was fascinating reading that kept me busy for days. As I suspected, the pie was cut into innumerable slices, and they weren't even close to being of equal size. That said, I have to admit that I was perfectly happy with the portion allotted to Van Halen for the upcoming year.

Just getting to the truth was an interesting and rewarding exercise, but there was still more to the mystery. As I went over the figures, I felt a nagging curiosity about their inspiration. Record label executives did not just throw money around capriciously. Well, actually they did, sometimes, anyway, but in general checks were written to bands that had the greatest likelihood of producing a return on the investment, and that investment was monitored quite closely; changes could and were made on a moment's notice.

Or on ten days' notice.

See, I realized that the allocation figures were most likely based on the reports produced for each act on the Warner roster. I received one of these for Van Halen every ten days. Remember when I mentioned this important ten-day report? It included information about how the band was doing in virtually every market in the country, as well as in foreign markets. The information I received pertained only to Van Halen, and not the other artists on the label; that information was delivered to the appropriate manager/attorney/publicist for each of those acts. But I knew that if I could get my hands on a complete list of the ten-day reports, I could solve the puzzle that was by now greatly exacerbating my tendency to be obsessive and compulsive.

A couple weeks later, as luck would have it, I stopped by the Warner offices in Burbank and discovered the lot so crowded

that I was forced to park in a nearby back alley. I walked around to the front door, then wandered through the building for an hour or so, touching bases with all the people who could help my band's needs and desires. This was not "work" in the traditional sense of the word, but it was crucial to greasing the wheels of our upcoming tour. I was new to the business of management, but after years on the road, I knew the importance of building collegial relationships with the folks back home in the corporate office. By chance, the last person with whom I chatted had an office near the back door, so I used that exit. Outside, while walking to my car, I passed a garbage dumpster. Now, I am not in the habit of Dumpster diving, but as I glanced to my left I noticed several stacks of paper atop the trash heap. I inched closer and recognized them immediately as ten-day reports. Scores of them. Stack upon stack of two-inch-thick reports, for just about every band on the WB roster.

I stood there for a moment, surveying the fetid but nonetheless gold-plated pile before me.

It can't be this easy . . .

I looked to my left, then to my right. There was no one in the vicinity. And since this was more than two decades before the enactment of the Patriot Act, well before we all accepted the persistent presence of Big Brother in our everyday lives, I had no reason to worry about surveillance cameras or even cell phones capturing the potentially embarrassing behavior in which I was about to engage. As for legality, well . . . garbage is garbage and in the public domain. So I held my nose and grabbed one of the comprehensive reports. I tossed it in my car, went back to my hotel room, had a shower, and began putting together the final pieces of the puzzle, aligning the numbers in the ten-day with those in the black book. Lo and behold, it was a nearly perfect match, with the greater resources going to those artists who had the most eye-popping ten-day numbers. As I suspected, there was nothing the least bit arbitrary about this entire business, and a band's fortune could rise and fall in a heartbeat.

I didn't wait long before sharing all of this information with David and the other guys in the band. They were duly impressed at the lengths to which I was willing to go on behalf of my band ("Noel, you went into the garbage for us? Pretty slick, man!"), but that was only one of the many items on the agenda. And it was far from the most pressing.

Unfortunately, there were other aspects of Van Halen's relationship with Warner Bros. that left the band (and its new manager, the poor schmuck who would have to fix the situation, me) less sanguine. There was the matter of that bill for roughly $1.2 million in tour and band expenses related to the 1978 tour, a staggering amount for a young band to repay. Now, we were all reasonably confident that, based on the success of *Van Halen*, and the apparent confidence being expressed by WB, that we'd have no trouble making up this deficit. But we would have felt a lot more confident had the terms of the band's contract with Warner been somewhat more favorable to the people who were actually creating the music and touring all the world to promote it.

It's pretty basic, really. Everyone wants to be compensated fairly for their work. No matter how much you love what you're doing, if you're not being paid what you believe you are worth, eventually you grow resentful. And there was absolutely no doubt that in at least one very important category, Van Halen was getting royally fucked.

When he had first recruited me to be the tour manager, Carl Scott had mentioned almost gleefully that he had gotten Van Halen for a virtual steal, but until I became manager I didn't know exactly what that description entailed. Now that I had access to the band's financial records, I was able to see for myself what Carl meant. Indeed, Van Halen had been led into a contract that had the potential to restrict in perpetuity the band's ability to earn what it was worth on the open market. Granted, one could argue that weighing carefully the potential for such distinctions is part and parcel of the negotiating process. Like many young artists, musicians often get screwed on the first contract, and that was certainly the case with Van

Halen. What made the deal particularly odious was the probability of that deal remaining in effect for many years to come.

I'll try not to bore you with too many of the details, but a few numbers will graphically and concisely illustrate the point. In 1977, Van Halen, as a young and naive band, had been steered into a contract that would pay them a royalty rate of approximately 7.5 points. Now, points do not translate specifically to a percentage, because the record business is enormously complicated. Suffice it to say that Van Halen earned less than one dollar in royalties for every copy of *Van Halen* sold. This was a bad deal by any reasonable measure, but it sometimes happens to a new band on its first contract. What made it worse was the fact that it covered two records, with an option for Warner Bros. to extend the contract for another two records; when that deal ended, the same option would apply. In other words, Warner Bros. could own Van Halen for the life of the band, at a royalty rate befitting . . . well, no one, actually, but certainly not one of the biggest bands in the world.

And there was absolutely nothing that could be done about it.

When I called the band together and explained all this to them, in very precise terms—including the painful truth that if they were free to negotiate a new contract, they would probably be worth nearly twice as much money as they stood to receive from Warner—the boys were predictably pissed off.

It was painful to see the band's response. It was almost like they grew up overnight, expressing not just anger, but the sort of hurt that can only come when one is new to the business, before scar tissue from repeated slashings has a chance to build up.

"How could they do this to us?" Alex said, in what struck me as one of the last innocent statements I would ever hear from him.

I looked at Al. I looked at his brother. Their faces bore the exact same expression: a mix of bewilderment and pain. The naïveté was impressive. They were like children suddenly discovering that Santa Claus wasn't real. I felt bad for them, but

I also felt it was necessary for them to shed, once and for all, the cloak of innocence. It was all well and good to get into the music business as a means to chase girls and drugs. But there comes a point in the career of every successful band when it is no longer advisable or even acceptable to ignore the business end of the business, or to trust someone else to do it for you.

"How could they do that to you?" I repeated back to Alex.

He nodded. "Yeah, really."

"Al, how could they *not* do it to you? It's all part of the game, and you guys have to start playing a little more seriously."

I wanted them to be not just more attentive but tougher. I had a plan for getting Van Halen out of its contract, and while on the face of things it might have seemed overly optimistic, it was really our only chance for success. Rather than trying to break an ironclad contract, which would cost a ton of money in legal fees, we would take a quieter and more surreptitious tack.

We would get Warner Bros. to drop the option.

"How exactly are we going to do that, Noel?"

"By throwing a ton of sand in their eyes."

"Meaning what exactly?"

I was making this up as I went along, but the gist of the tactic was that from now until the option was set to expire in the fall, I would devote a large chunk of my managerial time to pestering Warner Bros. for items large and small. And I would enlist the services of our attorney and accountant in this effort. It was all a desperate and elaborate smokescreen designed to make Warner Bros. forget all about the option on its contract with Van Halen. There was no way to win this battle in a courtroom. The only chance we had was to play a sneakier game. If Warner and its lawyers simply missed the option date because they weren't paying close enough attention, then Van Halen would be out of its contract and free to negotiate a new deal.

"We'll throw all kinds of questions at them," I explained. "We'll ask for an accounting on everything, and we'll ask for more support than they ever imagined. We'll make them want

to avoid answering the phone when we call. I know this record company well enough to know that this could work. I mean, it's highly improbable, but it's not impossible. If we throw enough sand in their eyes they'll get distracted and miss the deadline for extending the option."

I shrugged. "It's worth a shot."

It was, in fact, the only shot.

9

WHERE THE HELL IS VAN HALEN?

Whatever concessions to time and creativity might have been made in the studio, they had little impact on the public reception to *Van Halen II*. While critical response was generally positive, if not quite as warm as it was for the debut album, fans scooped up *Van Halen II* so quickly that Warner's faith in the band was immediately validated. Within a month the album was certified gold; within two months it was platinum. It peaked at number 6 on the *Billboard* album chart, and has sold more than 5 million copies to date, in part because of the popularity of the first single.

More pop than metal, "Dance the Night Away" is one of those songs that sounds absolutely great coming out of a car radio or a high-end stereo system. With its hummable melody, sing-along chorus (inspired by Fleetwood Mac's "Go Your Own Way"), and just enough of Edward's guitar flourishes to remind the listener that this was indeed a rock band, "Dance

the Night Away" reached number 15 on the singles charts, but more importantly introduced the band to a broader audience. Van Halen was no longer just a hard rock band but a band that knew how to write and record songs filled with killer hooks and vocals.

They were accessible.

Most of all, they were *fun*.

"Dance the Night Away," after all, was a song inspired by the sight of a free-spirited young woman having sex with her boyfriend in the parking lot of a club while the band looked on. She later spent the night dancing in the club with her jeans on backward, which amused the boys no end. David wrote the lyrics, as he always did; this was his way of looking at things. He saw humor and titillation in virtually everything, and of course these were common musical refrains throughout the David Lee Roth era: get drunk, get laid, have a party.

Really, though, it always came back to the live performance, and Van Halen in '79 was even tighter and better than it was in the first year. In some ways the World Vacation tour, as the '79 tour was known, was a transitional period for Van Halen, as they made the adjustment from supporting act to headliner. Set lists were expanded from forty minutes to an hour or more. Our spartan road crew mushroomed to nearly forty people, including two dozen technical staff and a security team. We employed three massive forty-four-foot trucks to haul more than twenty tons of sound equipment and ten tons of lighting. We traveled in custom coaches and on planes. If this paled in comparison to the bloated traveling circus we would become in a few more years, it was nonetheless a mind-boggling advance for a band that just one year earlier had been bouncing around the rutted back roads of England in an old commercial bus. Overnight, it seemed, we went from plastic spoons to gold-plated ones.

And you know what? If that sounds like fun . . . well . . . it was.

But it was also hard work: more than one hundred performances in North America, Europe, and Asia, in a span of

slightly more than five months. As manager, my job entailed much more than simply making sure the band got from one date to another and that each show went off without a hitch. The way I saw it, I was responsible for practically everything, and that included repairing some relationships that had been damaged under the previous regime. Specifically, I am talking about the Warner Bros. secretaries who had been traumatized by viewing Marshall's Van Halen videos. They hadn't asked to see these videos, and they certainly didn't expect the wet and wild antics they witnessed. More than once after that incident I had walked through the offices and been confronted by a secretary who told me how much they liked me and appreciated my professionalism, but "I really don't care for your band. Those guys are disgusting." What could I say—that such high jinks were perfectly normal for a successful rock band? That life on the road naturally provoked one's worst tendencies? That none of us had any idea the videos would ever surface, and certainly not in the presence of an unwitting female audience—in the offices of our record label, no less? All of this would have been true and yet woefully insufficient as an explanation. There was no excuse. But maybe an apology, coupled with a gesture of goodwill and friendship, could ease the sting.

On April 8, 1979, just the fifth date of the tour, Van Halen took part in the California World Music Festival at the Los Angeles Memorial Coliseum, a 90,000-seat outdoor stadium that at the time was home to both the University of Southern California and Los Angeles Rams football teams. The two-day festival featured nearly twenty bands playing for nearly as many hours. Van Halen was co-headliner (with Aerosmith) on the second day. Heady stuff for a band whose members just one year earlier probably would have been willing to pay for tickets to get a chance to see the likes of Cheap Trick, REO Speedwagon, and Ted Nugent; to say nothing of Aerosmith, a band, like Van Halen, built around a charismatic, somewhat androgynous lead singer (Steve Tyler) and a brilliant guitar player (Joe Perry) and a band that David and Edward in par-

ticular had grown up admiring. And now here they were, sharing top billing with that same band and playing for a fee of approximately $75,000; six months earlier they had been sweating it out in smaller venues all over the world for $750, and happy to get it. This is how far Van Halen had come in a ridiculously short time.

Since the show was in our backyard, the audience included a couple hundred personally invited guests: friends, family members, industry executives. I made sure that the VIP list included all the secretaries in the Warner Bros. Burbank office, and that their experience would be one they wouldn't soon forget—but this time in a good way. We were working at the time with a company called Pure Pleasure Limousines (I loved that name), so I called my friend Verne, who ran the company, and asked if he could arrange to have several limousines take care of the secretaries we had invited to the show.

"Probably ten or eleven secretaries, and I want each of them to be able to bring a guest," I said. "I just want to make sure they have a great time. I want a separate limo for each couple, and I want them picked up at their homes."

"No problem, Noel," he said. "We'll take care of them."

"One other thing," I added. "I want all the limos to be white."

There was a pause. "I'm not sure we can get that many white limos on such short notice," he said. "But we'll try."

I arranged everything before running it by the band, and they approved everything, naturally.

A couple days before the show, several of the secretaries came to me and offered to simplify the process by meeting at the Warner offices, where they could be picked up as a group. I balked.

"Listen, that's not what a limo is for," I said. "A limo is so you can go to the show, get fucked up, fall into your limo, and be driven home. That's the whole point—to be pampered and have fun."

Well, when you put it that way . . .

The ladies had a terrific time. I was sure most of them had

never been in a limousine before, and everything about the day was handled in an elegant, first-class manner. I wanted to change their opinion about the band; I wanted them to know that they were actually nice, fun-loving kids whose trust had been betrayed, and that together we would always treat everyone at Warner Bros. with respect and dignity. It was my opinion that the secretaries in both Burbank and New York were instrumental to our success; more important, they did hard and often tedious work that was often overlooked and undervalued. I wanted them to know we appreciated their efforts. So they traveled to the show by limo; they sat in a special section and had full backstage access. And I arranged for the limos to be festooned with roses and stocked with plenty of champagne and candy. They were appropriately impressed and grateful.

"Thanks so much, Noel," they all said. To which I replied: "Don't thank me—it was the band's idea."

"Really?"

"Absolutely. They're a nice bunch of guys and they feel terrible about what happened last year."

At the end of the day, everyone felt a little better about Van Halen, including the band members themselves. This, too, was a manager's job: to repair the relationships that invariably fray as a band climbs the ladder of success, often oblivious of the people who get trampled along the way. But it was also a practical gesture: secretaries were the gatekeepers to the VIPS; without their assistance, a band could be derailed at any moment. At the very least, their support would make my job easier. So it became standard practice that whenever Van Halen played a big show in LA or New York, the Warner Bros. secretaries received special transportation and VIP privileges. I always considered it money well spent. It made people happy and my life easier.

As for the California World Music Festival itself . . . while it wasn't Van Halen's first performance in the World Vacation tour, it served as an unofficial kickoff, in that most of the music industry was watching, and the band not only per-

formed flawlessly and energetically but demonstrated the flair for fun-loving self-promotion that I had seen from the outset. There were just more eyes on them this time around. Backstage visitors would have witnessed the usual bantering, self-medicating and pre-show ball-busting, as well as the presence of some politically incorrect guests representing questionable taste, including a pair of little people wearing black bowler hats and T-shirts emblazoned with the words *Van Halen Security*, and a chimpanzee dressed like David Lee Roth.

As if this scene weren't enough, once again David had devised an interesting stunt to punctuate Van Halen's entrance into a major music festival. Throughout the day a yellow Volkswagen Beetle was parked on a grassy area near the stage; periodically an announcer would bellow over the public address system something about the car belonging to Aerosmith, and asking the band to please move it. The joke behind all of this was that David thought it would be hilarious for the band to enter the Coliseum in a Sherman tank and crush the "Aerosmith Volkswagen" en route to the stage. Then the guys would jump out and play their set, thereby kicking Aerosmith's ass both musically and symbolically. We even did a test run the day before the festival, with a professional driver operating the tank and the boys going along for a ride. They seemed to be pumped about it.

Personally, I worried that something could go wrong either with the actual stunt or with the rush to the stage, down a flight of approximately one hundred stairs, that would follow. Hell, Alex had managed to sprain his ankle without even jumping out of a plane. This time they would actually be in the stunt vehicle. As it turned out, David pulled the plug on the whole thing the following day, when he learned that Aerosmith had apparently gotten wind of the plan and might be plotting some sort of counterattack. So the tank remained on the premises, under a tarp, and the Volkswagen sat there all day, without explanation, save for the announcements over the PA system, which, without context, must have seemed pretty ridiculous to the sweat-soaked throng at the Coliseum. Not that they would

have cared. Hell, with Aerosmith and Van Halen at the top of the bill, they more than got their money's worth.

THE EUROPEAN LEG of the World Vacation tour lasted a mere two weeks at the end of June, but it came right on the heels of three months of practically nonstop touring in North America. A few days off would have been nice prior to returning to the States for another leg, but, as the band was discovering, with stardom and success came greater expectations and responsibilities.

I was lounging on my bed in London, which was sort of my office away from home, when the phone rattled me out of an endless stream of thoughts about business, mayhem, and promotion, promotion, promotion. When I picked up the phone, I instantly recognized the voice on the other end as that of Tom Ruffino, head of the international department at Warner Bros. More than just a capable business associate, Tom was a good friend. I enjoyed working with him and appreciated everything he had done to help make Van Halen more than just a domestic success, including sending the band overseas on several occasions for both promotional and video work to advance our foreign presence.

Tom was very much a "big picture" kind of guy, and you ignored his advice at your own peril. That said, I could tell by the tone of his voice and the late hour of the call that the break between tour legs was about to be cut short, and that one or more of us would likely be heading to some location other than Los Angeles.

"Things are happening," Tom said, his voice reflecting both seriousness and excitement. "Big things. I hope you have your bags packed."

"They always are, Tom," I said. "What's going on?"

Tom's grand plan, he explained, was for me to take two members of Van Halen to South Africa for a promotional visit. My stomach churned at the very thought of it. I had already turned down several lucrative offers to play in Sun

City, the playground of the South African white elite, and I had no intention of going there anytime soon. South Africa at the time was a country deeply divided by apartheid and abuse, a violent and repressive society—repugnant in its racial segregation and dangerously stubborn in its refusal to change. Philosophically, it was hard for me to rationalize supporting any of this, and having Van Halen play in South Africa was certainly a form of support. Moreover, it wasn't the safest place to take the band.

But Tom was nothing if not persuasive. This wasn't a performance, he said, just a promotional appearance. Furthermore, Warner's South Africa division was a bastion of integration within the music industry. The company was headed by a guy named Derek Hanna, whom I had spoken to on the phone and had found to be an intelligent, knowledgeable straight shooter.

"This is important, Noel," Tom said. "Van Halen is selling a lot of records in South Africa. We need to have a presence."

I wasn't happy about it, but I understood Tom's point. There was a difference between playing Sun City and promoting the band to a broad and multicultural audience. I told Tom I would take care of it and hung up the phone. Now all I had to do was pitch the idea to the lads and hope that two of them would find it reasonably palatable. If not, I'd look like a rather foolish and ineffectual manager to Tom and the rest of the Warner Bros. brass.

I called the band together for a quick meeting and explained what was in the works. "I need two volunteers," I said. "Who's up for it?"

The result was entirely predictable. David and Alex were all in—David because he never missed an opportunity to promote both himself and the Van Halen brand, and Alex because he genuinely liked to travel and see different places. Edward, on the other hand, declined immediately. Even after a year of adjusting to touring and travel, Edward still preferred the comfort and familiarity of home to life on the road. Typical of bass players, Michael was the quiet and reclusive one of the group and rarely conducted interviews. Expecting Michael to

do a promotional visit to South Africa would have been unrealistic, but I threw it out there, just for the sake of diplomacy. He politely declined.

The next morning, David, Alex, and I boarded a flight bound for Johannesburg. As the doors of the jet closed we looked at each other, suddenly realizing just how long a trip lay ahead, and how mysterious the destination would be. I saw that David's grip on the armrests was even tighter than usual. After having flown thousands of miles with David, I could measure the intensity of a particular journey by the whiteness of his knuckles. This one was going to be a nasty trip.

Or maybe not. Alex, in his cool manner, had swept two bottles of vodka off the flight attendant's tray before we even taxied away from the gate. This was not uncommon for Al, and not because he needed to calm his nerves while flying—he just liked to drink. And while his "hobby" became a compulsion and ultimately a crippling addiction, it also at times made him an interesting traveling companion. London to Johannesburg is an eleven-hour flight, nonstop, so there would be plenty of time to get inebriated and still catch some rest. In fact, Al calculated this to be a "two-drunk" flight. Meaning there was time to get drunk, eat dinner, get some sleep, and then do it all over again—before we hit the ground.

We were on our first sleep when we were startled awake by the plane's rapid descent into what we would later learn was Nairobi. This was supposed to be a nonstop flight, so the interruption was surprising and somewhat alarming. Apparently, we were short on fuel, so a change in flight plan had been requested. Once on the tarmac, to our utter amazement, two men clad in what appeared to be HAZMAT suits quickly boarded the plane. I was still half asleep and more than a little tipsy as their forms came into focus. For a moment I thought we'd been hijacked by a UFO and were about to be kidnapped. The fear only intensified when the intruders pulled out "guns" and began spraying the cabin with some alien mist. They moved from stem to stern with great efficiency, filling the fuselage with a thick white cloud. We didn't have time to spit or

cough, let alone voice any objection. As quickly as they had appeared, the spacemen were gone, leaving behind a couple hundred gasping passengers; presumably, though, any uninvited guests—six-legged or microbial—had been vanquished.

So this is what it's like to be deloused, I thought. Welcome to the third world. We rapidly ascended to cruising altitude and went to work on drunk/meal/nap number two, during which I dreamed of ways to exact revenge on Tom for sending us on this junket.

Eventually we landed in Johannesburg, where we were greeted by most of the WB staff. They were extremely friendly and enthusiastic; they were also, as Tom had promised, a remarkably diverse collection of people. The music business in those days was generally as white as Wonder Bread, so it was both encouraging and surprising to see such an integrated group—especially in a country that embraced apartheid. We spent five fabulous days working with Derek and his staff, promoting the hell out of Van Halen. My job was short and sweet—David handled most of the interviews and photo opportunities—so there was plenty of time for me to get to know the city, which I did, with Derek as a thoughtful and informed guide.

The highlight of the trip, though, came on the very first night, while we were having dinner at a wonderful and boisterous restaurant. There is a nine-hour time difference between Johannesburg and Los Angeles, which meant that when we got to the restaurant, at 7:00 p.m., it would be ten o'clock in the morning in LA. This was perfect, as everyone would be in the Burbank office. I explained to Derek my simple but dastardly plan to pay back Tom Ruffino for sending us on a trip that included an attack by aliens.

"I love it," Derek said with a smile. "The only drawback is that I'll probably lose my job."

Al and Dave were both standing nearby and listening, cocktails in hand. In his most commanding voice, Dave bellowed, "Derek, I won't let that happen. This is a must!"

With the plan ready, we rolled into action. Derek and I

wrote the Telex and sent it to LA. It arrived in Tom's office just as he was starting his workweek.

His pleasant Monday morning was ruined by the following message.

ATT: TOM
RE: VAN HALEN
HAVEN'T HEARD FROM THE GROUP SINCE THEY WERE TAKEN FROM THE PLANE IN NAIROBI. ASSUME YOU ARE AWARE OF THE SITUATION. UNFORTUNATELY WE CAN'T PAY THE DLRS—10,000 BAIL FROM HERE—BECAUSE OF EXCHANGE CONTROL PROBLEM. DO YOU HAVE THIS IN HAND?
REGARDS,
DEREK

With that, the cherry bomb had been lit and flushed down the school toilet. All that remained was for the pipes to be blown out. Derek's calls were directed to the raging party going on at the restaurant, where Dave, Al, and I sat at the bar and waited for the fun to begin.

It didn't take long.

Within minutes after sending the telex, the phone rang behind the bar. The bartender handed the receiver to Derek. In my mind's eye I could see Tom's face, reddening with panic and disbelief. Derek, meanwhile, played his part perfectly, expressing amazement and exasperation that Tom had not already gotten us out of jail and done whatever he could to rectify a rapidly worsening political nightmare.

Finally, Derek could take it no longer. He started laughing, then explained to Tom that it was all a big prank and that everyone had arrived safely in Johannesburg. Oh, and one other thing:

"This was all Monk's idea. So you can blame him. I just want to have a job tomorrow."

With that he handed me the phone. I could practically hear the roof rattling in Burbank.

"You son of a bitch!" Tom shouted. "Where are you—really?"

"Calm down," I said. "We're having dinner at a wonderful restaurant in Johannesburg."

Tom ranted and raved for a few more minutes, but eventually he calmed down and actually started laughing. I handed the phone to Dave, and then to Al, and finally back to Derek, who did indeed keep his job. This was a happy ending. We had gotten payback for the aliens, and kept everyone at Warner Bros. happy by continuing to expand the Van Halen universe.

I DID EVERYTHING IN MY POWER to prove to the band and to Warner Bros. that I was worthy of the position of manager; I figured that whatever I might have lacked in experience, I could compensate for through tireless effort and diligence. Indeed, I had never worked so hard in my life as I did in 1979, and yet I recall that period with enormous fondness. We were traveling the world, mostly first-class, and playing sold-out venues (mostly eight thousand seats or smaller, to ensure as little deadwood as possible in the theater) in front of adoring fans. In many ways I couldn't believe my good fortune; after so many years working in the music business, struggling to make a living with acts that had a shelf life of only a few months, I had hit the jackpot. There was no way I was going to fuck this up. If it meant working 'round the clock, without a contract, or with a thirty-day contract, then that's what I would do.

From New York to LA, from London to Tokyo—we played and worked as hard as we could, burning the candle at both ends for weeks and months on end. Every city, it seemed, brought a new and memorable experience. In Tokyo, for example, we were struck by the way the fans remained seated throughout the show. Apparently, some years earlier, there had been an unfortunate incident during a concert—a barrier falling and kids rushing the stage—that had resulted in serious injury to several concertgoers. As a result, an ordinance had been put in place dictating that fans remain seated through-

out subsequent shows. I'm not sure how long this lasted, but it was definitely in effect when Van Halen played in 1979. It was an amazing sight—the band playing its guts out and fans screaming uncontrollably, while mostly remaining tethered to their seats. And it wasn't like a throng of baton-wielding security officers was required to maintain this environment. The kids knew what was expected and adhered to the policy without the need for strong-arm tactics.

The Japanese leg of the tour lasted only ten days; we returned to the States in the middle of September for a final North American leg, which ended spectacularly, with a sold-out show at the Forum in Inglewood. This was the stamp of success for the boys from Pasadena—to return home as a headliner at the biggest indoor venue in LA, and to kick ass in front of hundreds of friends and family members and record label executives. It was the perfect ending to a transformative year.

By this time Van Halen was a legitimate superstar entity, and its members began acting, and spending, accordingly. First, we paid back everything we owed Warner Bros. from the previous year. Then the guys picked up trinkets large and small: new homes for themselves and their parents; clothes and jewelry for girlfriends; and cars . . . lots of cars. Edward got his first Porsche; David got a Mercedes. I even went to the dealership with him to close the deal. Not because I wanted to tag along, but because David asked me to help him. He'd never bought a car by himself, and he wanted to make sure it was done properly. I didn't mind in the least, but I didn't understand why he later insisted on emblazoning such a fine automobile with a skull and crossbones. There is no accounting for taste.

Life was good for the guys in Van Halen, and it was about to get a whole lot better. By the time I met with Mo Ostin and David Berman, WB's legal counsel, ostensibly to discuss the state of Van Halen and contractual details for the band's next two albums, a rather extraordinary thing had happened: the deadline for Warner Bros. to exercise its option, and thereby

extend its stranglehold on the band, had come and gone. I knew it, and so did Barry Tyreman, the band's lawyer, but no one else did. I could barely control myself when I walked into Mo's office. The four of us sat around a table and began chatting amiably and superficially about the hottest young band in the WB stable, and how exciting it was to be a part of it all. Shit . . . obviously they were happy. Van Halen was making everyone rich, and Mo figured he was going to have the band locked up forever in an onerous deal.

But I had a surprise for him.

"Mo, I have to tell you something important," I said, trying to sound concerned and professional, rather than giddy with satisfaction.

"What's that, Noel?"

"Warner dropped the option to our next album." I paused. "And the one after that, and the one after that."

Mo was a powerful man, not easily shaken or intimidated. I'm sure he thought I was completely full of shit. After all, he had David right there with him, his legal eagle, for Christ's sake. And I'm betting he thought he had Barry in his pocket—working both sides of the street, as it were. Surely Barry would have known that the option deadline was approaching and made sure that Warner Bros. brass was alerted.

Right?

Wrong.

I looked at Barry, who was staring at the table, nervously rubbing his palms together. I looked at David, who was silent and ashen-faced. And then I looked at Mo.

"It's true, Mo. We're free agents now."

Mo bristled. His face turned red.

"Listen, Noel. You are a new manager. You don't know what you're talking about. Now sit the fuck back down in your seat and shut the fuck up."

And I sat back in my chair, and I shut up. Mo was no man to toy with.

Still, this was an extraordinary development in the life of Van Halen, one owing to luck and timing and a degree of in-

competence, and maybe just a bit of karma. All that was required for Warner to be protected, and to have Van Halen at a bargain rate forever, was for someone to place a "tickler" in the band's file—a reminder that a crucial date was on the horizon. Maybe this never happened. Maybe somebody didn't notice. Maybe my simple little strategy of "throwing sand in their faces" had worked. Maybe this was cosmic payback for screwing the band in the first place. Regardless, that critical day came and went without Warner Bros. exercising its option. It was a catastrophic mistake. I was now the manager of a spectacularly valuable commodity, and free to offer their services to the highest bidder.

The next day I met with the band. We sat around and talked over beers, and I explained to them what had happened.

"You wanted me to break the contract . . . well, I broke it."

There was silence. Finally, after a few moments, David laughed out loud.

"Holy shit, Noel? You're kidding."

I shook my head and smiled. "I don't joke about that kind of money, David. And we're talking about a lot of money."

"What does this mean?" Edward said, his voice and demeanor confused more than anything else.

"It means you just bought your parents a new house, right? Well, now you can buy them a mansion. You can buy whatever the fuck you want. We will double your income."

By the end of the year we had a new multirecord deal with Warner Bros. Van Halen remained with the label, but at a royalty rate roughly twice as lucrative as the one it had gotten in the first contract. It's not an exaggeration to say that with one broad stroke, which would have a ripple effect for decades, I made the band tens of millions of dollars.

This was the greatest achievement of my professional life; it made the band members instant multimillionaires, and they legitimately appreciated it.

At least for a while.

10

THE BOOTLEG WARS

We went to jail, me and my bodyguards. More than once, in fact.

That's one of the things people don't understand about being the manager of a band like Van Halen: it can be a dirty and dangerous job. I took very seriously the work of guiding and promoting and protecting my band, and that work sometimes involved dealing with folks you wouldn't ordinarily consider to be part of the music business. But the bigger the band, the longer the tentacles; by 1980, Van Halen's reach had far exceeded anything I anticipated when I first climbed aboard. It was complicated enough overseeing contracts and promotion and touring and recording. But those were merely the most visible and glamorous parts of the job. There were other equally important matters that needed attention, and sometimes they involved behaving in a way that might be considered thuggish.

Such was the world in which I lived.

Consider the lucrative but brutal merchandising arm of the business. Most bands don't even think about this when they first start out. They're too busy writing songs and playing whatever gigs they get, and chasing a recording deal. Van Halen was no different. In the beginning these guys had no concept of merchandising and little to no interest in educating themselves. But I knew from years in the business that merchandising had the potential to provide a significant and steady stream of revenue. I also knew that if we didn't market our own gear, someone else would. Bootleggers had long been a scourge of the music business, creating cheap and unlicensed merchandise and selling it to fans at a ridiculous profit, without the band ever seeing a dime. As far as I was concerned, any band that failed to take matters into its own hands and vigorously protect its brand deserved to get fucked.

I had no intention of letting Van Halen get fucked.

"Listen, guys. We have to do merchandising," I said. "We're missing out on a shitload of money if we don't."

Their initial response was largely apathetic. Even David, who rarely missed an opportunity to make a buck, seemed uncertain about the rewards it would reap compared to the effort involved.

"Who would do it for us," he asked. "I mean, this could be a real pain in the ass, right?"

Yes—it could be a pain in the ass, which is why most bands simply engaged the services of a third-party manufacturer to handle all of its licensing and merchandising. At the time, Bill Graham, promoter extraordinaire, was the titan of this end of the business, having expanded his empire through a company called Winterland (named after Graham's famous Winterland Ballroom in San Francisco), which handled merchandising for many of the biggest bands in the world. I knew Bill, of course, from my days at the Fillmore East, and could easily have contracted with Winterland to oversee merchandising for Van Halen. That would have been the simplest and most expedient route to take.

It also would have produced the least in revenue, as Winterland, like most merchandisers, took the lion's share of profit. And rightfully so, given that it was laying out the cash for manufacturing and distribution, and for selling the wares at concerts and through the various other outlets (mail-order, record stores, etc.). All Van Halen had to do was sign a contract with Winterland, let the professionals do their job, and sit back and collect the royalties.

But that's what they were: royalties. As with a record album, Van Halen would get merely a portion of the profit, usually less than twenty-five cents on the dollar, while Winterland would get the rest. There was nothing wrong with this arrangement; it worked just fine for most bands, and it would have worked for Van Halen. No fuss, no muss. Extra money in the coffers without having to do any heavy lifting. But I saw it differently.

"We're going to do it ourselves," I told the guys.

David laughed. "What the fuck do you know about merchandising?"

I smiled. "More than you think."

This was true. In fact, I had grown up in New York City's Garment District. My father had worked in the garment business as a manufacturer's representative, and I had spent time tagging along with him as a kid. I knew all about cutting garments and I knew the basics of sales and distribution. While most musicians, and their managers, looked at merchandising as a mysterious and painstaking process that was best left to someone else, I considered it an untapped vein of gold. The way I saw it, kids wanted Van Halen posters, T-shirts, baseball caps, and other memorabilia. They were going to find this stuff one way or another, and they were going to blow great wads of allowance money or income from summer jobs on it. Why should we give the majority of that revenue stream to someone else?

"Guys, this is not rocket science," I said. "I know how to do this, and we are missing a golden opportunity if we don't

take advantage of it. We come up with a design, manufacture them, and then we own them outright and sell them ourselves."

In that meeting, looks of disbelief and irritation gave way slowly to acceptance and then enthusiasm, until finally we all were in agreement: Van Halen would be responsible for its own merchandising. Very few bands in those days handled their own merchandising; it simply wasn't worth the headache. But I knew that if Van Halen's current trajectory continued, there was a substantial amount of money to be made through merchandising, and I'd be a part owner. It seemed foolish not to take a chance. We each threw $50,000 into the business as seed money, something we did every year to carry us through the first few months, and then split the proceeds equally.

The company was called PMC Manufacturing and was headquartered in Chatsworth, California, in the San Fernando Valley. While it was a bit of a hassle to get the project up and running—not to mention figuring out logistics of manufacturing, distribution, policing our venues, and chasing away bootleggers—it was well worth the effort. Instead of getting twenty-five cents on the dollar, our profit was fifty cents on the dollar. To say that this added up to big bucks would be an understatement; we're talking about hundreds of thousands of dollars changing hands every week at Van Halen concerts. By 1981 I had a semi making a round-trip run to Los Angeles every month to pick up more than a million dollars in merchandise. By '82 we were grossing a quarter of a million dollars every night in merchandise.

Every . . . single . . . night.

Half of that was pure profit, and it was all cash, too. Not because we were trying to hide anything from the IRS, but simply because virtually no one involved in the merchandise business could be trusted with a check. It was a high-stakes, high-risk game, and cash was the only reliable currency. So, if we did a weekend series of shows—Friday, Saturday, Sunday—I'd often leave with as much as three-quarters of a

million dollars in cash by Monday morning. I had a shitty thirty-day contract, but I was probably making more money than any manager in the business, thanks to a merchandising venture that was effectively doubling our income.

If there was a downside to all of this, it was that carrying around vast sums of cash was risky business indeed. In addition to dealing with legitimate issues when passing through customs during international travel, there was the far more tangible threat of being mugged and robbed. This was a serious amount of money—the kind that bad people are willing to do very bad things to obtain. To protect our lives and our livelihood, I hired a security staff comprised of eight to ten men from a variety of backgrounds, but with one thing in common: they were physically intimidating and not even slightly averse to violence or confrontation. Trust me when I say this: you did not want to fuck with these guys. Hell, I didn't want to fuck with them, and I was their boss (they also called me L'il Caesar, the nickname Edward had come up with a couple years earlier). Simply put, with these guys hovering nearby, if you tried to steal from Van Halen, you were going to pay a steep price.

It wasn't just about guarding satchels of cash at the end of a long night, and it wasn't merely about keeping crazed or deranged fans from getting too close to the band. A significant part of the job involved protecting the Van Halen brand at concert venues at home and abroad. You see, with ownership of our merchandising business came the responsibility of ridding ourselves of bootleggers who sought to cash in on the band's fame and popularity through bootlegged merchandise. We did this with great vigor, harassing and squashing anyone who tried to infiltrate our turf. It was ugly and sometimes brutal work; a certain disposition was required. The guys I hired for security had the right temperament. Truth be told, so did I.

With a background in martial arts and a permit to carry a concealed weapon, I wasn't new to these kinds of confrontations and they didn't bother me. Years earlier, I had been made

an honorary member of the NYPD after helping save the life of a police officer who had been attacked in the line of duty. All of this came in handy when dealing with large segments of the music business, where tenderness is usually rewarded with an ass kicking. Managing a band of Van Halen's scale could be enormously stressful, and I have to admit that there were times when I relieved that stress by wandering out into the parking lot and confronting bootleggers. If the confrontation escalated into physicality, well, that was okay by me. The way I saw it, these guys were nothing more than thieves. If they were stupid enough to sell shitty, counterfeit T-shirts out of the back of a van at our shows and think they could get away with it, they were sorely misinformed. This was hallowed ground for us, and we guarded it with our lives.

It helped that we had the support of security at virtually every performance venue. For instance, the head of security at the Atlanta Omni, a former cop named Henry whom I had known for years—well before Van Halen—was more than happy to look the other way when we challenged the counterfeiters in his building.

"Noel, I know you're pretty rough on these motherfuckers," he said to me on the eve of a show. "I don't like them either, so I understand where you're coming from. Just do me a favor: I don't want to find any bodies within three days of when you leave town."

We both cracked up. "Don't worry, Henry," I said. "I promise it will take you at least four days to find any bodies."

The Bootleg Wars, as I like to refer to this period in Van Halen history, was a vicious but essential stage of the band's development, at least from a business perspective. Van Halen might have been a party band that espoused mainly the time-honored teenage pursuits of inebriation and sex, but behind the scenes, they were an entity seriously devoted to protecting and furthering their own brand. Merchandising was central to this pursuit, and we crushed anyone who attempted to illegally infringe upon our business.

There was no other option.

Eventually, through the help of Jules Zalon, a copyright infringement attorney, we were able to obtain a nationwide injunction against the bootleggers that resulted in our being assisted by US Marshals in the confiscation of counterfeit T-shirts at many concert venues. This naturally cut down on much of the head-banging we normally perpetrated on the bootleggers, which was a bit of a drag, but it did have a profound and lasting impact on their ability to undercut and interfere with our business. Bootlegging was then, and remains today, a slippery enterprise that is almost impossible to completely eradicate, but we certainly didn't make it easy for them.

Over the years we confiscated tens of thousands of counterfeit T-shirts, all of which were collected as evidence to be used, if necessary, in the federal case against the bootleggers. In 1984 I finally went to Jules and said, "For crying out loud, what the hell am I going to do with all these shirts?"

"Let's ask the judge," Jules suggested.

The judge's response was, in essence, "Do whatever you want with them. They're yours now."

Our accountant wanted us to write them off as a business loss on our taxes, but that didn't seem right. Nor did it seem appropriate to sell the merchandise, even at bargain basement prices. I don't believe in profiting from ill-gotten gains; besides, the shirts were of low quality and I didn't want anyone paying for something like that when it represented their love for Van Halen. These were lousy polyester shirts mass-produced in some third world country, probably on the backs of child labor. Our licensed T-shirts were a 50/50 cotton blend, manufactured in the USA. In the end, I made a unilateral decision to donate all the counterfeit T-shirts to charity. I gave a thousand or more T-shirts to every police department with which we worked on a regular basis, and they in turn donated the shirts to their local Police Athletic League. (There were other charities, as well, that received shipments of free T-shirts that they could sell or auction to support their endeavors.)

It was important for us to maintain at least a cordial re-

lationship with police departments throughout the country. After all, we needed cops to get our job done. Every concert involved heavy interaction with the local police force, as they were responsible for traffic management, crowd control, security, and a dozen other issues. At every show, the cops could make your job harder or easier, so it only made sense to develop an atmosphere of mutual trust and respect. I liked cops and appreciated the fact that they had a difficult and dangerous mission. I also understood that if they wanted to make our lives miserable—ours, after all, was a business in which illicit activity of one type or another was an everyday occurrence—they could easily do that.

Getting this point across to the band was sometimes a bit of a challenge.

Wait a minute . . . Noel likes cops? What's that about? We fucking hate cops.

In time, they came to understand and appreciate these relationships as being crucial to their success and enjoyment on the road. It's worth noting that despite all the drugs that the band carried with them from city to city, and ingested on buses and airplanes and in hotel rooms and backstage, only once in seven years did their behavior result in an arrest, when David stupidly tossed a lit joint into the crowd in Cincinnati. The reason they so often avoided prosecution is because I always greased the cops. Except in the Northeast, where a gratuity was far more likely to be misconstrued as a bribe. But in the South, where we usually started our tours, the cops who were assigned to the venue made nothing, so I would tip every one of them fifty bucks, and I'd give the manager of the facility and the head of the precinct a hundred bucks. To a working-class police officer in 1980, this was not a small sum. It demonstrated our appreciation for their efforts, and helped lessened the chances of their busting our balls about smoking weed backstage. In general, it just lightened the mood for everyone: band members, crew, fans.

Still, my chummy relationship with law enforcement did sometimes lead to awkward encounters. I used to invite all the officers—uniformed, undercover, narcotics—backstage during the show, while the band was performing. We always had an abundance of food leftover, so rather than let it go to waste, I encouraged the cops to stop in and make sandwiches, have a cold drink or a coffee. It was a small and inexpensive gesture that went a long way to ingratiate ourselves with the cops.

I would always time it so that the officers exited the hospitality area at least twenty minutes before the end of the show. They were at their busiest before and after the show, so it wasn't usually a problem. Well, one night in Los Angeles I screwed up the timing. The show ended while a bunch of the cops were still backstage, eating their sandwiches. As the boys burst through the door, sweat-soaked and ready for a post-concert party, they ran smack into a roomful of cops—some in blue uniforms, some in undercover garb, and all carrying badges and guns.

The boys stopped dead in their tracks; their faces turned white. They didn't know whether to shit or go blind. All they knew was that their manager was standing backstage with a bunch of cops, in a time and place where this did not typically happen. I could almost read their minds.

Holy fucking Christ—we're getting busted!

Nothing could have been further from the truth. The officers said hello to the band, politely excused themselves, and then left the room. I half expected the band to chew me out for this mistake in timing, but instead they were chastened.

"Why were they here?" David asked, his voice betraying both concern and legitimate curiosity.

"I was just giving them some food, making nice. This is the way it works, David. Don't you know that by now?"

He nodded. The rest of the guys said nothing, just went about the usual postconcert routine of drying off and changing clothes. The mood was somber.

"Okay, well . . . thanks," David said.

And that was the end of the lesson.

NO AMOUNT OF FREE SANDWICHES AND COFFEE,

or even fifty-dollar tips, could shield us from the occasional unpleasant encounter with law enforcement. Smoking weed (or even snorting cocaine) backstage was one thing; kicking the ever-loving shit out of bootleggers or harassing unlicensed photographers was more visible and therefore potentially more problematic. The cops and marshals were generally sympathetic to our plight, but they couldn't just completely ignore confrontations that turned violent and chaotic. We knew this but we rolled the dice anyway.

At a show in Fort Wayne, Indiana, we got into a bit of a roughhouse with some bootleggers, and as happened sometimes, they actually fought back. You have to remember, we were a security force of less than a dozen men, trying to constrict a bootleg operation that often involved forty to fifty vendors and clerks scattered throughout the arena and parking lot. Usually the bootleggers would scatter when they saw us coming, but sometimes they stood their ground, if only for a short time. Well, on this night things quickly got ugly. We slapped a bunch of guys around, took their merchandise, threw the keys to their cars and vans into a nearby lake, and then went backstage to let the commotion die down. Well, a few minutes later, local law enforcement officers joined us, along with some bootleggers who were surprisingly eager to press charges.

"They beat us up!" yelled one of the bootleggers, a kid in his early twenties whose eye was already turning black.

Okay, if that's the way you want to play it . . .

I pointed to a welt that was rising on my cheek. "No, officer, they attacked us. We responded. It's called mutual combat."

Much yelling and screaming ensued, until the cops grew weary and disgusted and decided simply to bring in everyone

involved in the fracas. So we all went downtown, had our mug shots taken, and got tossed into the Fort Wayne drunk tank for the night.

Now, I loved my security staff. These guys would have risked their health for me and the band, and in fact did precisely that on numerous occasions. But some of them were not the brightest of bulbs. I mean, they were hired primarily for their balls, not their brains, so that's okay, but occasionally they looked at things from an almost comically simplistic vantage point.

"Listen, Noel," one of them said while we awaited bail. "These cops are little. We can take over the jail!"

I stared at him and tried not to laugh.

"I'm serious, man," he said, this time more forcefully. "We can disarm these motherfuckers!"

"Oh yeah?" I said. "And then what?"

He shrugged, apparently realizing suddenly that he hadn't thought the plan through.

"Just relax," I said. "We'll be out of here soon enough."

For the next several hours we passed the time by pitching quarters in a corner of the cell. The agreement was this: each time someone was bailed out, he would leave his quarters behind. The last person to get bailed out would get the entire pot, which amounted to only a few dollars, but nevertheless the exercise helped the clock move more quickly. By morning we were all out and back on the road. We ended up just being released, which did nothing to dissuade us from continuing to fight the Bootleg Wars.

It's funny—prior to working with Van Halen I had been arrested only once in my entire life, when I was a teenager, and I beat the rap on that one. But I spent time in jail twice during my time as the manager of Van Halen. The other time occurred in San Diego, in the summer of 1980, and resulted, once again, from our security staff zealously guarding the Van Halen brand. This included not just confronting bootleggers but also amateur photographers and videographers. Times have changed, to put it mildly. Today, with smartphones putting

high-quality video and photographic (and even audio) content in the hands of virtually every concertgoer, there is no way to prevent fans from capturing the experience for themselves. Thirty or forty years ago, however, it was much easier to shut down this practice, as it required some fairly sophisticated and unwieldy equipment. Typically, the people who owned this sort of gear, and who were willing to try to sneak it into a show, did so not because they were interested only in a simple souvenir but because they hoped to sell the images or video or audio recordings. Really this was just another type of bootlegging, and we challenged it righteously. Cameras and recording equipment were not permitted at Van Halen shows (or at any shows, for that matter); if a camera-toting fan managed to slip through the cracks, and we caught them, wandering through the venue, we would confiscate their film or tape and then return their equipment.

In San Diego, one particularly brazen young man stood outside the door to the VIP area as I exited before the show with two of my security staff, Bill and Mickey. The young man squared himself in the doorway, held his camera aloft, and began snapping away. I have no idea how he thought he would capture any image of significance, but I guess he figured this was his one shot at getting a photo of the inner sanctum. Next to him was a petite young woman, very pretty and excited. It dawned on me then that he probably wasn't a freelance photographer but rather just a kid showing off for his girlfriend; nevertheless, I wasn't about to let him flout the rules, especially right in front of us.

I stepped into the kid's path. Without any provocation or direction, Bill and Mickey went into action, flanking him and holding their positions until he finally took notice.

"Okay, man, give us your film," Bill said, holding out a meaty palm.

The kid instinctively tucked the camera under his arm. He gave his girlfriend a quick look, then smiled nervously.

"No," he said. "You can't have it."

I could see where this was headed and tried to stave off

an altercation that all of us would likely regret—especially this young man, who was about six feet tall but couldn't have weighed more than 130 pounds. Bill was roughly twice his size. Mickey, while not quite that big, was even more intimidating. He had the square jaw, wide shoulders, and steely squint you might associate with a military veteran, which in fact is exactly what he was—Mickey had served in Vietnam as a member of the Green Berets. He didn't talk about it much, but Mickey had seen and done some shit. You don't mess with a guy like that unless you have a death wish.

"Listen to me carefully, son," I began. "There are signs all over the place around here that very carefully spell out the restrictions against taking pictures or taping our shows. No pictures—anywhere. Not inside, outside, backstage, onstage, in the toilet . . . anywhere. I'm sure you can read, because you don't look stupid. But right now you're acting stupid, and you need to think very carefully about what you're doing."

As his girlfriend, perhaps out of self-preservation, subtly moved a step or two away, the kid shrugged. The veneer of toughness, though, was falling. He looked like he was about to shit himself.

"Can't have my film," he said. "Sorry."

With that Bill inched closer to the kid, further violating his personal space and surely tightening the kid's sphincter.

"Hand me the fucking camera right now, shit brain."

Finally realizing that discretion is indeed the better part of valor—even when your girlfriend is standing nearby—the kid laughed nervously and handed his camera to Bill, who popped open the back, removed the roll of film, and then handed the camera back to the kid.

"Enjoy the show," Bill said. And that was it. As quickly as the incident happened, it was forgotten. No one got hurt, we prevented the kid from taking any pictures, and we went on our way. This happened in every town, at every concert. It was no big deal. Or so we thought.

A short time later, as I was walking through the parking lot, a squad car bearing the logo of the San Diego Police De-

partment rolled up alongside me. By this time Bill and Mickey had gone off in another direction, so I was alone. The cop knew who I was because we had held meetings prior to the show, as we always did, to express our willingness to work with the local cops, as well as the federal marshals assisting in our efforts to interrupt the bootlegging traffic. This particular officer was polite but firm.

"We have a complaint against you and a couple of your guys," he said. "Some kid says you beat him up and took the film out of his camera."

"Officer," I began, "the last part of that is true. We did take his film, as we are entitled to do. But we did not hurt the kid."

"Well, he claims differently. Get in the car."

The smart thing to do in that situation is to behave with complete and utter capitulation. Right or wrong, you don't fuck with a cop. Ever. I knew that. But for some reason my temper got the best of me.

"This is bullshit," I said. "The kid is lying. It didn't happen."

With that the cop got out of the car and walked up to me. His demeanor became hostile and aggressive. I knew I was in trouble.

"Don't give me that," he said. "You guys are always pulling shit like this. You think you can get away with harassing people and doing whatever you want."

"No, I didn't say—"

"Shut the fuck up and put your hands on the car. You're under arrest."

With that he pushed me against the squad car, cuffed my hands behind my back, and steered me into the backseat of the cruiser. Then he turned on the lights and roared through the parking lot, like he had John Dillinger under arrest or something.

We ended up in a holding area with about a hundred others who had been busted for various drug offenses. I later found out that one of our truck drivers had narrowly escaped this scene, after having been investigated for possession of drugs and drug paraphernalia. What did he have? A sewing needle

that he was using to fix a tear in his pants leg while sitting in the cab of his truck. Turns out the cops had been using binoculars to survey the entire area and had seen the driver doing something "suspicious." The guy had been pulling the needle through the fabric, leaning forward and drawing it closer to his face, so he could see what he was doing. Over and over. The cops thought that each time he bent over, he was snorting cocaine or some other illicit substance (perhaps because of the glint of the needle). Four of them descended on the poor guy, dragged him out of the truck. After searching him and his truck for a good hour, the cops let him go with a half-assed apology and a warning not to look so damned guilty. Whatever that means.

Meanwhile, I was pulled from the squad car and my cuffs were removed as a booking sergeant began his interview.

"Let's see if you're one of the bad guys or the good guys," he said.

"Excuse me?"

"Turn your pockets out and take off your shoes. Let me see what you've got."

I did as instructed. He patted me down, basically executed a strip search with my clothes on, and then complimented me sarcastically for not being a "druggie."

"However," he continued, "you are being charged with assault and battery."

He cuffed me again, put me in the squad car, and there I sat for some time, until Bill and Mickey pulled up in another cop car.

Great! They're here to get me out.

No, they were not. Bill and Mickey were also cuffed, and about to join me on a trip to the San Diego County Jail. Hey, at least I'd have company. If you have to go to jail, it's best not to do it alone. We spent the night in a holding tank before getting bailed out at five in the morning. All charges were dropped because the kid, under questioning about the apparent lack of injuries he had sustained after such a vicious beating, admitted that we did not touch him, and that he had lied in an effort

to impress his girlfriend (I'm sure that worked like a fucking charm).

The band got a huge kick out of the whole thing. Here I was, the guy who supposedly knew how to keep the cops off their backs in every city in the country, and I was the one who ended up getting arrested.

"You don't mess with the cops in San Diego," David said with a laugh. "Everybody knows that. These guys are real pricks down here."

"Thanks, David," I said. "You could have warned me ahead of time. That might have been a little more helpful."

He shrugged. "Hey, man, I would have, but . . . you know. I didn't think you were going to end up in jail."

"Well, in the future," I said, "please don't keep such vital information to yourself. We're all in this together."

11

THE GIRL NEXT DOOR

She fell for him the way every other girl in America did: from a distance, while staring at the jacket of a record album.

That album was Van Halen's *Women and Children First*. Released on March 26, 1980, it was the band's third album, and while it didn't exactly break new ground, there were subtle differences from Van Halen's first two albums, indicating just enough growth to impress critics, while staying mostly true to a hard-rocking party formula that fans had come to know and love.

For one thing, this was the first Van Halen record to be comprised entirely of original material. No breezy covers of well-known songs to increase the likelihood of a hit single. This was, from start to finish, a Van Halen album, and while it was recorded in the usual Van Halen time frame (less than three weeks), the writing and preparation took considerably

longer, as this time the band did not have a couple dozen demos sitting around just waiting to be put on vinyl.

It was also, as I recall, the first album on which you could feel the growing musical rift between David and Edward. This was a heavier album, and also one on which Edward's experimentation with other musical styles and influences could be noted. A dash of electric piano here, a synthesizer there. Ted Templeman oversaw the production again, but this was the first album to feel like it belonged more to Edward than anyone else in the band, a shift that surely did not please David, and that would lead to greater friction between the two of them as time went on. Edward would sometimes come into the studio and work alone, noodling with every piece of equipment at his disposal. At heart he was still a guitar player who loved heavy and hard music, but he was branching out and pushing himself.

David, meanwhile, did what he always did. He would wait for Edward to write the music and then throw together some lyrics in a fit of creative energy—frequently great lyrics, too, or at least lyrics that perfectly fit the tone of the song Edward had composed. The formula still worked, but I could see and feel that they were starting to be pulled in different directions. While David could put words to any melody that Edward wrote (and sometimes create or modify the melody himself), and howl appropriately onstage, he began to express a fondness for lighter and more melodic compositions. Nothing wrong with that. David's pop sensibilities were acute and helped Van Halen enormously. But, as his tastes continued to lighten, the less he had in common with everyone else in the band.

Unlike the first two albums, *Women and Children First* spawned only one single, the crowd-pleasing anthem "And the Cradle Will Rock." But two other songs, "Everybody Wants Some" and "Romeo Delight," became concert staples, with the latter usually opening the band's set. Despite a lack of singles and Top 40 airplay, the album was an immediate commercial success, going gold in its first week, platinum within a couple

months, and triple platinum by summertime, in the middle of what was known as the World Invasion tour.

It was around that same time that one of the more famous celebrity couplings of the decade—and one of the more unusual in the annals of rock—was born, for that was when Edward Van Halen was introduced to Valerie Bertinelli.

Well, actually, he was introduced to her from afar, when she picked up her brother's copy of *Women and Children First*. While her brother might have been a fan of the band's music, Valerie was drawn more to the angular cheekbones and long hair of one of the young men depicted on the album's back cover (photographed by the great Norman Seeff). And it wasn't David Lee Roth, a half-naked poster of whom (photographed by Helmut Newton, no slouch himself) accompanied the album. Nope, it was Eddie Van Halen who caught the young starlet's attention.

Now, personally, I always thought it was a bit strange that this was the way she fell for Edward, but if it could happen to a million other pretty young women, then why not Valerie Bertinelli? But surely this was not a match anyone would have predicted. Valerie at the time was America's Sweetheart, barely twenty years old and the star of *One Day at a Time*, a massively popular network television sitcom. On the show, Valerie had for five years played an innocent, straight-arrow teenager named Barbara Cooper; by most public accounts, there wasn't a great divide between the actress and the character she portrayed. As it turned out, however, this wasn't quite true. Valerie would later admit that she, like her more infamous costar, Mackenzie Phillips, had used drugs and experimented with a wilder lifestyle than her viewing public might have realized or appreciated. Big shock for the seventies, huh?

Valerie was very pretty and very sweet, and perhaps tired of being viewed that way. Hell, she wouldn't be the first celebrity kid to rebel against the constraints of almost puritanical expectations. But her pursuit of, and eventual marriage to, Edward Van Halen, was a head slapper to millions of Americans—on both sides of the cultural aisle.

What does she see in him?

And why in the name of God is he willing to give up hot- and cold-running groupies for her—or any woman, for that matter?

For Valerie, I think the attraction was a combination of things: Edward was an attractive, gifted, superstar musician. He was also a genuinely nice guy, which obviously she could not know from an album cover. What she did know was that Van Halen had a reputation for wildness, and I don't doubt that all those things factored into her infatuation.

The trickier question is . . . what did Edward see in Valerie? Oh, I don't mean that to sound as disrespectful as it probably does. She was young and pretty and charming, and he certainly didn't have to worry about her pursuing him for his money; at that point in time, Valerie was surely the wealthier half of the couple. I'll float a theory that goes beyond the likelihood that they actually liked each other and fell quickly in love. You see, it was David who was supposed to marry the Hollywood starlet. He used to talk about it with some frequency, in fact, and I don't think he was kidding.

"Just watch, boys," he would say. "I'm going to find myself a fuckin' movie star."

It made sense that David would seek a partner who could help expand his own fame; someone who would attract paparazzi. A lot of rock stars have an uncomfortable relationship with celebrity: they want it only on their own terms. They love being onstage and they love the money and sex and power that come with being successful and famous. But they despise the machinery of fame—the reporters and the photo sessions and the chat show interviews. David was different. He loved all of it—anything that nudged him closer to the center of the universe was perfectly acceptable. It's what made him simultaneously a marketing dream and a personal nightmare. In the end, though, David's personality seemed to preclude any relationship lasting more than a few weeks, and I can't imagine that he would have wanted to fight another celebrity for space on the red carpet.

Edward was a different story. He was genuinely happy just

writing and playing music, and getting fucked up in his free time. I never would have had him pegged as someone who would be remotely attracted to the idea of a celebrity girlfriend (or wife). But maybe it was precisely the fact that David had bragged for so long about marrying a movie star that encouraged Eddie to choose this path instead. They were competitive, after all; and at times they legitimately disliked each other. So maybe Edward's relationship to Valerie was on some level triggered by a desire to issue a public "fuck you" to David.

But here's the real question: what would possess a stunningly talented, attractive, famous rock star, nearing the height of his popularity, to get involved in an ostensibly monogamous relationship at the age of twenty-five, while living a lifestyle that could not possibly have been less consistent with the values traditionally associated with such a relationship? Van Halen was a band whose sexual output was unsurpassed in rock 'n' roll. Was I keeping score? No, but since I had seen some exploits in my time, I could honestly say that no band had more fun than Van Halen.

And they had the doctors' visits to prove it. In the first few years they made frequent trips to local clinics for penicillin shots to clear up doses of the clap, both real and anticipated. Sometimes we would find a local doc who would come to the show to administer antibiotics or B12 supplements, or sleeping pills, if disrupted circadian rhythm was a problem (which it often was on the road). Eventually it became part of the road manager's job to find a doc who would fill any of the myriad prescriptions the guys needed to get through the tour, from codeine to Percodan, all heaped on top of the various street drugs and alcohol they were using. It was, by then, a party that had turned spectacularly messy.

The sex never stopped, and the groupies never went away, although partners were chosen with more care, and the quality improved dramatically. Fewer women were allowed backstage, and many of them looked and dressed like they had just stepped off the pages of *Playboy* or *Penthouse*. At the same time, the number of women who were desperate to meet the

band grew exponentially, and they were willing to do just about anything to fulfill this fantasy.

Here's a scene from one of the later years . . .

It's late afternoon on the day of a show. I'm traveling with my wife, Jan. We've been married a relatively short time, but she's been on the road enough to have seen some unusual behavior. Nevertheless, what she sees on this day is somewhat startling. There is a long line stretching from the back of the road crew bus across the parking lot—maybe forty to fifty guys, all nearly finished with the business of setting up the stage for the evening.

"What's going on?" Jan asks. "Are they waiting for their paychecks or something? Is there food in there? Are they eating? Can we get a sandwich? I'm starving."

I stifle a laugh. "They're not eating . . . not in the normal sense of the word."

"Then what's going on?"

I lead Jan into the venue and away from the bus. There we run into Denise, one of the band's bus drivers.

"Would you mind explaining the line outside to Jan?" I ask Denise. An uncomfortable expression crosses her face.

"No, I don't think so, Noel. Why don't you do it?"

"Because I don't want to. That's what I pay you for."

"No, you pay me to drive the bus."

I smile. In a voice barely above a whisper, I say, "Please, Denise. Get me out of this."

And so she does, pulling Jan aside and explaining to her exactly why so many men are waiting at the crew bus. Inside the bus are two girls so eager to gain backstage access that they are willing to fellate the entire crew in order to make it happen. That's right, a couple dozen blow jobs apiece, distributed quickly and dispassionately, in exchange for a chance to meet the band.

Talk about taking one for the team.

I realize how this sounds, but you have to understand that there was no coercion here. These were young women (of legal age) who volunteered for this duty. And they were at virtually

every stop on the tour. Not the *same* women, of course, but the same basic profile—devoted fans (that's putting it mildly) who would do anything to make their Van Halen experience a memorable one. So they suck the entire crew and are compensated with preferred seating, backstage access, and just about anything else they want. It's not prostitution, and it's not sexual abuse. It's just a deal.

More than once I had been invited to jump the train: "Noel, she's done eight and you can be number nine, if you'd like."

"Thanks, but I'll pass."

So this was the world in which we all lived; a world of "trickle-down sexonomics," in which everyone occasionally benefited—from David Lee Roth and Edward Van Halen to the lowest-ranking member of the road crew. And while Van Halen might have been unique in its level of excess, it certainly was not unique in its overall pursuit of sex and drugs. Behavior that almost any normal person would consider depraved was part of the musical landscape and could be found on every tour of every notable rock 'n' roll band of this era. Indeed, never was the term "Wham, bam, thank you ma'am" more appropriate than it was in the 1970s and early 1980s.

Before AIDS.

Before cocaine was considered addictive or dangerous.

For Van Halen, it was a time of both unchecked hedonism and enormous creativity and success. Into this vortex of sex, drugs, and rock 'n' roll walked Valerie Bertinelli. She could not possibly have known what she was getting into; then again, I suppose the same could be said of Edward.

THEY MET FOR THE FIRST TIME IN AUGUST 1980, after a Van Halen concert in Valerie's hometown, Shreveport, Louisiana, where she was visiting her parents. Eventually I'd get to know the whole family. Valerie's mother struck me as a typical stage mom—a little too invested in her daughter's life and livelihood—while the father, an ex-boxer who managed an auto plant, was a nice enough guy who didn't say too much

but projected an air of toughness; he seemed comfortable in his own skin, which I admired. Prior to the show that night I was walking around with the promoter. He mentioned Valerie's name, said she was at the show, and that he was going to meet her backstage shortly.

"I guess she's got a little crush on Edward," he explained. "I'd like to introduce them after the concert."

I didn't think much of this at the time—it wasn't unusual, after all, for celebrities to stop backstage to meet the band. But the promoter hinted that Miss Bertinelli was not just a casual fan.

"She really likes him," he said.

"Okay."

Then he paused and smiled conspiratorially.

"You ever see this chick?"

"Uh, sure. Not in person, but yeah."

He smacked his lips. "Man, I'd eat a mile of her shit just to get to her ass."

Whoa . . .

"You are quite the romantic, aren't you?"

Edward had no idea that a beautiful network television star was in the audience that night, or that she was waiting backstage for him after the show, until he walked offstage and headed to the dressing room. I caught him as he went by.

"Ed, you know Valerie Bertinelli is here, and she wants to meet you."

Edward barely broke stride. A quizzical look crossed his face.

"Who?"

"Valerie Bertinelli. You know . . . *One Day at a Time*."

A faint look of recognition, followed by a nod and a squinty-eyed smile. "Ohhhhh yeah, right. Cool. Let me clean up."

I don't know if Edward actually knew who she was. He was not much of a fan of pop culture in general, but I know that his father used to watch the show. Regardless, it looked as he walked away as though he was trying to dredge up an image to go with a name that he kinda, sorta recognized.

Meanwhile, just down the hall, in a private room, was Valerie, and the image she projected was at once adorable and glamorous. Valerie was a very pretty young woman, but almost in an adolescent way. She had wide, dark eyes and thick brown hair falling across a cherubic face. She was quite cute, if not exactly gorgeous or sexy in the traditional sense. She was dressed nicely—so nicely, in fact, that she resembled nothing so much as a teenager trying to show off. Which, obviously, was not the case. She was an adult with a thriving career and a ton of money. But, like millions of adolescent girls, she also carried an infatuation for the lead guitarist of Van Halen.

After Edward dried off and changed his clothes, I introduced him to Valerie. It was kind of cute to see them together— they were both clearly nervous and somewhat reticent. This struck me as a sign of genuine chemistry. After all, Valerie had spent most of her life in front of a camera or audience; she was completely comfortable with all manner of public interaction. And yet, here she was, stammering and blushing like a schoolgirl in the presence of the captain of the football team. And Edward? Here was a guy who went out onstage every night and performed, wizardlike, in front of thousands of adoring fans. In the presence of this young woman, however, the rock star façade melted away. He was clearly drawn to her, yet too shy and intimidated to take control of the situation.

If theirs was an odd match, it was nonetheless genuine. I could tell right away that they liked each other and that there existed the potential for some sort of ongoing relationship, whatever that might entail in the volatile world of celebrity romance. But not in my wildest imagination did I envision the whirlwind courtship and commitment that followed.

I WAS IN MY OFFICE in early November 1980 when I got a phone call from the band's attorney informing me that Edward was being sued by the District Attorney of Riverside County for "the responsibility of establishing paternity."

By this time Eddie and Valerie were a mere three months into their relationship, but what a torrid affair it had become. They were together all the time when the band was in California, and when we were on the road, Valerie would do her best to show up in various cities and spend some quality time with her new boyfriend. Things progressed so quickly that by the time I got this phone call, Edward and Valerie were already deep into planning their wedding, which would take place in the springtime—specifically, April 11, 1981.

Given those circumstances, the last thing I needed or expected was the threat of a paternity suit against the lead guitarist of my band. Let me put that another way: claims of paternity by jilted, crazed, or simply avaricious former sexual partners were in fact an ever-present danger in the world of big-time rock 'n' roll. For the most part, those who hooked up with a rock star got precisely what they wanted, as did the musician: a fleeting night (or maybe just a fleeting few minutes) of carnal contact with zero expectations. Fun for everyone involved.

Unfortunately, there were myriad ways in which the arrangement could get complicated for one or both parties, in particular for the rock star. Sometimes a one-night stand became more than a one-night stand, which could lead to unrealistic expectations that the relationship might grow into something more permanent and meaningful, when in fact there was almost no chance of that happening. I'm not saying these hookups were exploitative or abusive; far from it. But certainly the balance of power and the likelihood of things ending badly made it an unwise decision to develop these sorts of relationships on the road. Then, too, there was always the possibility that a single night with a millionaire rock star could lead to claims of paternity, real or imagined, simply as a means to extort money from someone who could surely afford to part with a few dollars—especially if it meant keeping things out of the media.

Did this happen with great frequency? No . . . but it did happen.

Whatever the motivation, I found myself dealing with such an accusation that November morning. I neither believed nor disbelieved the claim—given the number of indiscriminate sexual encounters that occurred on the road, anything was possible. Sex was an almost daily occurrence, and unprotected sex was common. It wasn't until Edward came to visit me that I was able to formulate an opinion on the matter.

Edward did not look well that day. He was generally an affable type whose demeanor soured only with excessive drinking or drug use, but on this day he was disheveled and nervous. Aside from music, Edward took few things seriously—and even in this area he managed to be deeply accomplished while presenting an air of indifference. In truth, when it came to playing the guitar, he was both gifted and ambitious; you just wouldn't know it by looking at him. Now, though, he seemed filled with dread. As he pulled up a chair in my office, he fidgeted nervously. He had a guitar slung over his shoulder. In one hand he held a beer, in the other a cigarette, from which he took long and frequent drags. The paternity situation was a real-life event that had to be confronted, and Edward had no idea what to do. He was paralyzed by panic.

"Noel, why is she doing this to me? What does she want?"

"Well, Ed, I believe what she wants is to be recognized as the mother of your child, which would carry with it certain financial obligations on your part."

There was no response. Edward just sat there with a pained expression on his face, rocking anxiously in his seat.

"Look, Edward, it's actually pretty simple. Do you think this woman is telling the truth or not? Could this be your child?"

Edward shrugged. "I don't know."

To me, this was as good as saying, "Yes," but there was something about the way Edward said it that made me probe deeper.

"Who is she, Ed? A one-night stand or something more?"

From there Edward launched into the story of his relationship with a woman who lived in San Diego. Theirs was strictly a sexual relationship, and usually limited to the front seat of

Edward's car—sometimes in the parking lot, and other times while they rolled along the Pacific Coast Highway.

"You know how I like a pretty face in my crotch," Edward said, his voice expressing utter sincerity, despite the comical nature of the comment.

"Well, who doesn't, Ed?"

He nodded earnestly.

"How often did this happen?" I asked.

Edward shrugged. "A bunch."

"Okay, and how many times did you have sex with her?"

Edward offered a quizzical look. "What do you mean? I told you, a bunch."

"No, Ed . . . I mean sex. You know, intercourse. How many times did you fuck this woman?"

Edward straightened up. He seemed surprised by the question.

"Never," he said. "I told you . . . she gave me blow jobs in the car."

"That's it?"

He nodded. "Uh-huh." '

There was a long pause as this information hung in the air, thick as the cloud of cigarette smoke billowing above Edward's head.

"Ed," I began. "Think about this very carefully. I know you've been with a lot of women over the last few years and it would be easy to forget some of the minor details. But this is important. Are you telling me that you never had sexual intercourse with this woman?"

By this point Edward's eyes were welling up. He felt as though his life was coming apart; he was supposed to be getting married in a few months, and now he was being sued by a woman who claimed that Edward was the father of her child. His lip quivered as he formed a response; to say the least, it was not what I expected to hear.

"I swear to God, Noel. I never fucked her." Another long pause as his eyes went wide. "Is there any way she could have gotten pregnant from giving me a blow job?"

The question was one of the funniest and saddest things I had ever heard. By this time, Edward was well traveled and highly accomplished. He was widely acknowledged as one of the greatest musicians of his generation. He was rich and famous and admired by millions.

He was also hopelessly naive. His was not a rhetorical question, nor an attempt at humor. He was not sure whether it was possible for a woman to become pregnant simply by performing oral sex, and he wanted me, the person he trusted most in the world, to tell him the truth. I wanted to laugh out loud, but I simply couldn't. Edward loved me and I loved him—in all candor, he was the only person in the band for whom I felt that strong an emotion—and as much as I found the conversation ludicrous, the situation begged for compassion.

"You know, Edward, I have never heard of that happening," I said. "As a matter of fact, I would have to say no, although I suppose we could check with a doctor, just to be sure."

Edward let out a huge sigh of relief. All that mattered to him was my opinion, based on nothing more than common sense, that there was no way he could be the father of this woman's child.

"Oh, okay, okay," he said, nodding approvingly. "That's such a relief, man. I mean, I didn't think so, but . . . you know."

No, Edward, I don't know. But I love you, anyway.

There were more meetings, discussions with attorneys and representatives on both sides of the issue. Edward had to come clean to both his fiancée and her family, which was not an easy thing to do. I don't believe he ever admitted to having had any sort of relationship with the woman—or at least no relationship that continued after he met Valerie—but he did have to make his fiancée aware of the paternity suit hanging over his head.

Around that same time, I got a phone call from Valerie's father, a man I liked very much based on the handful of interactions we had.

"Noel, what the hell are we going to do? These two kids are supposed to be getting married in a few months."

"Don't worry, I'll take care of everything."

"Yeah, I know that's your reputation—you fix things—but how exactly are you going to do that? This is not good."

He was absolutely right: it wasn't good. From a financial and public relations standpoint, it was a disaster. And from a personal standpoint, it had to be heartbreaking. I know that if I found out that the man my daughter was engaged to marry was embroiled in a paternity suit, I'd be mighty pissed. From that standpoint alone, I felt for the guy. But I also was reasonably confident that Edward had told me the truth—that he really hadn't ever engaged in intercourse with this woman, and therefore could not possibly be the father of the child she was carrying. Therefore, all I had to tell Mr. Bertinelli was this simple fact: "It's not true."

I didn't have to elaborate. No need to tell the poor guy that while Edward had not fathered a child, he certainly had engaged in plenty of traditional rock 'n' roll behavior. And that behavior did not stop just because he fell in love with Valerie Bertinelli. I knew we'd get Eddie out of this jam, but it wasn't going to be easy. This was about damage control—about making a frivolous paternity suit go away as quietly as possible without writing a massive and unwarranted check. There was only one way to do that.

"Ed, you're going to have to take a paternity test."

"What? Why? I mean . . . how?"

Three different questions, each easily answered.

"You're getting married in a few months," I said.

"You think I don't know that?"

"It's not that you don't know, it's just that you're not dealing with it. These things are all happening simultaneously on the same set of tracks, and you're about to experience one hell of a train wreck. So we need to stop this before the collision, and the only way to do that is for you take a blood test."

"But . . . I only got a blow job."

It became a mantra for Edward—*I only got a blow job, I only got a blow job, I only got a blow job*—as if saying it often enough would somehow make the problem go away. It didn't.

He was going to have to prove through DNA testing that he could not possibly be responsible for this child. Was that fair? Maybe not. But he had put himself in this position, and there was only one way out.

"Look, Ed, I believe you. But the fact is, you are a famous rock star with a lot of money, and sometimes people are going to try to take advantage of you. You have to deal with this paternity suit or you're going to find yourself walking down the aisle on your wedding day, and someone is going to hand you a summons to appear in court. Trust me, that is not going to look good in the press. There will be a big picture of you being handed a summons and Valerie looking on stoically. And the headline will read: 'But I only got a blow job!' How does that sound?"

Edward sighed. "Not so good."

It took two more meetings in my office to convince him, but eventually Edward conceded and took the test, which did, in fact, exonerate him. The paternity suit ultimately disappeared into the ether.

Meanwhile, in the wake of this nonsense, David Lee Roth got it into his head that some protection was required from the sea of greedy groupies who were out there just waiting for the chance to trick him into fathering their child, or at least entangling him in a lawsuit. And by protection I'm not talking about condoms—although that would have been the easiest course of action.

"Noel, I want you to see if you can get me paternity insurance," he said not long after Edward's troubles.

"Paternity insurance? David, I don't think there is such a thing."

"Well, there should be. Look into it. I need to protect my penis."

I did as instructed and made a call to someone I knew at Lloyd's of London and said I was interested in obtaining a million-dollar policy to protect one of the guys in my band against a paternity suit. He was polite enough not to laugh but declined to offer coverage. I tried other agencies and got

the same response from all of them: *Paternity insurance? For a rock star? Ummmm . . . no thanks.*

I went back to David and broke the bad news; we both had a little laugh over it, and at some point I got a wicked idea: Let's tell the media we actually did buy a paternity policy. I subsequently leaked to the press a tidbit about David purchasing a million dollars' worth of paternity insurance, and to my great amusement they all took the bait. Even in the days before the internet, gossip could take on a life of its own. One outlet would report the story, and others would pick it up. Pretty soon it became established as fact that David Lee Roth had purchased a million-dollar paternity insurance policy.

It simply wasn't true. But it helped that David played along, and as a result the story would not die. To this day people still believe that we purchased such a policy. Believe me—it was all a joke. I just wanted to throw shit against the wall and see what would stick.

WITH THIS BULLET SUCCESSFULLY DODGED, the wedding went on as scheduled—a large and traditional ceremony at St. Paul's Catholic Church in Westwood, California, attended by several hundred guests. Admittedly, I did not see as much of the wedding as I had hoped to see. I was bored and restless, so I spent a good deal of the ceremony walking around outside, talking with security guards. In reality, this was just another workday for me. Sure, I was there to help celebrate the marriage of Edward and Valerie, but I was also there to keep an eye on all things Van Halen, just like I did at any other public performance by the band and its members. And make no mistake—a wedding is a performance.

I didn't even bring a date to the festivities; the last thing I needed was someone else who required my attention and might distract me from the task at hand. I already felt somewhat out of place—these posh parties made me feel rather ill at ease and out of my depth, and they never seemed to get any easier. I had grown up on the West Side of Manhattan, and

it wasn't like I didn't know what to expect when members of high society gathered. Still, when it came right down to it, I preferred the road, in all its gritty glory.

I managed to duck back into the church in time to see Ed and Valerie take their vows, and a short time later the ceremony ended and everyone departed for the Grayhall, a historic mansion in Beverly Hills. Ed and Val came out of the church first, and I grabbed two security guards to help them make their exit. I held one security guard with one hand and grabbed Ed with the other. The second guard took Valerie by the arm and whisked her down the church's endless front staircase. We descended together into a sea of paparazzi, their cameras and video recorders all straining for the perfect wedding shot. To my ear, it sounded like the cameras were all going off at once, the shutters clicking and crackling, the flashbulbs lighting the evening sky as we raced toward our limousine.

By the time we reached the car, I was becoming dizzy and nauseous from sensory overload; I worried for a moment that I might faint or vomit on the newlyweds, but I took a deep breath as we fought through the crowd and guided the couple into the car. I still can't put into words the relief I felt when I saw the two of them settling into the leather seats in the back, Valerie adjusting her wedding dress and Eddie, a little shaky but no worse for the wear, grinning mischievously as one of the security guards closed the limo door behind them. I let out a deep sigh before heading with the security guards to the next limo in line. For some reason, the cameras continued to click and crackle, even though Ed and Valerie were safely tucked away. I couldn't imagine they wanted a picture of me or the guards, but paparazzi are nothing if not relentless.

As the limo pulled away, I prepared to kick back a bit before the reception. So far, so good, I thought.

Knock on wood.

I should have known better than to think the day would be a smooth one. I'd worked closely with Edward for more than three years by this time, and had spent hundreds of days on the road with him. As much as I loved Ed, nothing was

ever truly easy with him or with the band. Fun, yes. Reward-ing, certainly. But easy? No. Never. From the moment I had heard that Edward was marrying Valerie, I wasn't sure how any of it would turn out. The paternity suit had been challeng-ing enough, but that was far from the only concern. Valerie's family was conservative, and I wondered how they would feel about the possibility of their daughter's wedding day devolv-ing into rock 'n' roll chaos.

I had broached this subject with Edward a couple months in advance of the big day. "Are you going to try to stay straight for the wedding, at least?" I asked.

I was not being facetious. Ed was used to drinking and smoking weed virtually every day, and by now he'd started getting deeper into cocaine. It was one thing to live like that on the road, during a Van Halen tour; it was quite another to get totally fucked up on one of the most important days of your life. It wasn't hard to imagine a catastrophic outcome if caution was not exercised. Edward promised restraint.

Sort of.

"I'll try to stay as straight as I can," he said, laughing at the absurdity of the question.

It shouldn't have come as a complete surprise, therefore, that before the reception even shifted into high gear, Edward went missing. In fact, so did Valerie. As everyone funneled into the grand ballroom and began drinking cocktails and eat-ing hors d'oeuvres, I began looking for the happy couple. Not that it was my responsibility to prevent Edward from getting lost. The guy was twenty-five years old. He'd been around the world a couple times and could take care of himself. That's what I told myself (and anyone else who asked). In my heart, I figured something was wrong, but I didn't want to delve too deeply into the possibilities. I knew he was somewhere in the mansion and that was good enough for me. If I hadn't lost Edward in Japan, I wasn't going to lose him in Beverly Hills. How much trouble could he possibly find?

Bad question . . . bad answer.

I made my way upstairs—easier said than done, since

I was also trying to avoid any spontaneous krell parties. I couldn't just barge into any room; I had no idea where the couple might be hidden, what they were doing, and frankly I didn't care. This was supposed to be a celebration, and while it's true that it was also a workday for me, it wasn't like being at a concert. I trusted my guys (for the most part) and figured that on this day at least they would know where to draw the line when it came to respectable behavior. More important, I didn't want to know the details. Plausible deniability and all that.

Upstairs, I found a member of our security team standing guard outside a bathroom door.

"Who's in there?" I asked, although I already knew the answer.

"Edward and Valerie," he said.

I knocked. No answer. I knocked again. Still no answer. I slowly opened the door, just enough to squeeze through, since I was reasonably sure I didn't want anyone outside to get a view of what might be happening, and went into the bathroom. There I found Valerie in her beautiful white lace wedding gown, looking every inch the angel—except for the tears streaming down her cheeks. On what should have been the happiest day of her life, Valerie was holding her husband's head over a toilet bowl, pulling his hair back to make sure it didn't become encrusted with puke.

"I'm sorry," Edward said between retches. "I'm so sorry."

Valerie gave me the saddest look I had ever seen but said nothing. This was not a scene I had envisioned, not even in my worst nightmare of how this day might unfold. It occurred to me that after the wedding ceremony, they must have come directly from the parking lot to the upstairs bathroom. And now, here they were, immersed in a world of pain and embarrassment—on their wedding day. I tried to imagine what in the hell had happened, how Edward had managed to get so completely fucked up in some small window of opportunity. Of course, it didn't really matter. When the will is weak, there is always time.

I stayed for a few minutes to make sure they were okay. I wondered if I was going to have to go downstairs and tell a few hundred guests that the reception had been canceled, and how I would explain it. But Valerie was surprisingly strong. She coaxed Edward to his feet, cleaned him up, straightened his tie, and helped him comb his hair. In her eyes I saw not disappointment but compassion and love. On what should have been such a festive occasion, these two had just gone through a truly horrific experience, and yet they came out looking at each other through adoring eyes.

Valerie, and to a lesser extent Edward, both probably thought they had left behind the worst of Edward's drinking and drug abuse—as though a marriage license or even love could cure such a disease. He had promised with all his heart that he would beat back his addictions and demons, because she was worth it to him, and he wanted to be a better man for her. What he couldn't leave behind were his naïveté and insecurity, and a genetic predisposition to addiction. And he knew it.

They emerged from the bathroom hand in hand, and made a glorious entrance into the grand ballroom, where a crowd of family and friends and an assortment of Hollywood stars burst into applause. For a guy who had spent the previous half hour heaving his guts into a toilet bowl, Edward looked pretty damn good in his white coat and tails, long hair flowing, eyes beaming with adoration for his lovely bride.

For a few fleeting moments, everything was right with the world. Or so it seemed. Appearances, after all, can be deceiving. David now stood in the corner, alone, a drink in his hand, smiling tightly at the good fortune of his friend and bandmate. Granted, the grip on his glass seemed rather tight, and it was David's natural demeanor to be envious and territorial, so I can't be sure what was going through his head. I do know that he hated sharing the spotlight, but on this day, he ceded it completely. So did Alex, who had already watched his little brother become the more accomplished musician in the family, and now watched with what I assume was envy as he

married America's Sweetheart. And there was Michael, with his beautiful, blond high school girlfriend; the love of his life. As always, he reflected an air of happiness and satisfaction, as if he still couldn't believe his good fortune at simply being invited to the party.

At the center of it all were Edward Van Halen and Valerie Bertinelli, circling the room and accepting congratulations and good wishes from both friends and family and the Hollywood elite. It seemed almost too perfect, and I wondered what these people would think if they had seen Edward just a short time ago, praying to the porcelain god on his wedding day. Surely they would not have thought that this was a union destined to last. That it did, for roughly two decades, through an endless series of betrayals and addictions, is an upset I can barely comprehend.

I suppose that makes it a love story.

12

PAYOLA? I HARDLY KNOW HER!

n May 1981, a month after the wedding, Van Halen went back out on the road for a comparatively modest tour: eighty-one dates as opposed to the hundred-plus we had grown accustomed to playing. Sometimes, though, less is more, as the *Fair Warning* tour produced sellouts in all but two venues.

I sat out most of the first week, preferring instead to remain back in Los Angeles to catch up on business, knowing full well that something would happen soon enough and that I would be compelled to join the boys on the road for an extended period of time. When the shit hit the fan on tour, it usually happened in the beginning; it took a few weeks or even months to iron out all the wrinkles and for everyone to readjust to the inherent weirdness and claustrophobia of road life. The transition was rarely smooth. I went to my office each day knowing that a crisis was probably brewing, and that a panic-stricken phone call from the road was imminent.

And that is precisely what happened.

The band was in the Northeast, maybe three or four dates into the tour, when I got a call one night from Steve, the road manager. He was agitated, if not downright angry.

"Noel, we're having a problem with David."

This was not surprising; David was always a problem to some degree. But *problem* is a wildly vague term.

"What kind of problem, Steve? I mean, David is a pain in the ass, we all know that."

"Well, he kind of went nuts."

Again, this was too vague to be of any use, so I pressed Steve for more information, which at first he seemed reluctant to share. Eventually, though, he spilled the entire story.

David had gotten quite drunk—more so than usual—and had torn up the hotel room in his uniquely aggressive fashion. Furniture went out the window, walls and fixtures were damaged or destroyed. And not in a joyful way, as was typically the case in our first couple years.

"He was out of control," Steve assured me. "Being a real asshole, too."

Steve was not the most laid-back guy in the world; he generally abhorred violence and recklessness, which would normally be a useful character trait in a managerial position; however, when it came to serving as road manager for Van Halen, a certain patience and detachment were required. Sure, you had to be incredibly organized and efficient, but you couldn't lose your shit over every little bump in the road. This was rock 'n' roll—things got messy sometimes. You had to deal with it.

Steve had done exactly that, to the enormous consternation of one David Lee Roth.

"He wouldn't settle down," Steve explained. "So we put him in a straitjacket."

Rarely in my life have I been struck speechless by news delivered across a telephone line, but this was one such occasion. I let the word roll around in my head for a moment, to make sure I had heard it correctly.

Straitjacket . . .

The first thought that crossed my mind was, *Why in the hell do you even have a straitjacket?* Talk about planning for a worst-case scenario. I tried to picture David encased in a suit of heavy white cloth, his arms wrapped behind his back, his long hair flowing down over his face. This was not, to me, an amusing image. For one thing, I suffered from claustrophobia myself, so the very thought of being restrained in such a punitive manner caused the anxiety to rise in my throat. David frequently got on my nerves; I had seen him act in a multitude of unappealing ways, but never had I witnessed behavior that justified being placed in a straitjacket.

"Jesus Christ, Steve. How many people did it take to do this?"

"I don't know, three or four."

"Well, couldn't you have just sat on him until he calmed down or passed out?"

This was a fair and reasonable question. David was not the toughest guy in the world; any one of the legitimately tough guys on our security team could have overpowered him without assistance.

"I don't know," Steve said, annoyance again rising in his voice. "He was just going fucking nuts, and I had this straitjacket, so . . . we put him in it."

"Did it work? I mean, where is he now?"

"In his room, going batshit crazy. Keeps saying he's gonna rip my head off and shit down my neck. Stuff like that."

Again, to me, this did not seem an unreasonable response. I'd have reacted the same way. I tried to imagine if word of this incident got out: the lead singer of one of the biggest bands in the world, confined to a straitjacket by his own security team less than one week into a new tour. This was one story that would test the old axiom that any publicity is good publicity. I figured that as angry as David was at that moment, he'd be even angrier the next day. I envisioned the entire tour blowing up and Van Halen fracturing almost overnight. So I hung up

the phone, packed my bags, and drove to the airport. Within a couple hours I was on a red-eye bound for the East Coast.

The next morning I went to the band's hotel. I didn't even bother checking in before going straight to David's room. I found him sitting on his bed, no longer restrained, but looking very much like a man suffering from post-traumatic stress disorder.

Or maybe he was just severely hungover.

Aside from the bed, the room was practically devoid of furniture. There were stains on the carpet and holes in the walls. As I entered the room, David was rocking slowly back and forth, holding his arms across his chest. Although no longer confined, he seemed almost unable to move. I'm not sure I ever felt more compassion toward David than I did in that moment. He was a challenging and selfish personality, but it was hard to imagine that he had deserved being so completely dehumanized. And by his own road manager and security team? I almost wanted to give him a hug.

Almost.

"David, tell me what happened," I said.

His eyes widened as he leaned forward. His lips trembled. I thought he might start crying, but instead he merely unleashed a torrent of anger.

"Those motherfuckers!" he said. "They put me in a fucking straitjacket. Like I'm crazy or something." He paused. "I should have killed them. I should have killed every one of them. I could have, you know. They deserved it!"

What David lacked in vocal finesse he more than made up for in lung power, but I figured he had earned the right to rant hysterically for as long as necessary. An hour passed, maybe two hours, before exhaustion set in and the volume diminished. Most of his anger understandably was directed at the road manager, since, as far as we understood it, he had given the order for David to be treated like a patient in the midst of a psychotic break; the rest of the team had been merely following orders.

"He's gotta fucking go," David said. "I can't work with him anymore."

"Let's get through the tour," I said. "Then we can make some decisions."

David nodded. He was nothing if not a businessman. At this point in time he was unwilling to do anything that might jeopardize his own career or the continued upward trajectory of Van Halen. If that meant coexisting with a road manager and security team that had placed him in restraints, so be it. David could swallow that particular indignity for the sake of the greater good.

I STAYED WITH THE BAND for the duration of the tour, which soon took us into Canada. Incidents of true humiliation and degradation—I guess you could call it abuse—such as the straitjacket incident were incredibly rare. But certainly the lifestyle encouraged perpetual adolescence, and not merely in matters of sex and drugs and alcohol. On a night off in Calgary, for example, Alex and I went out to dinner and then took a stroll through a huge indoor market. We lived for these types of places on the road—massive one-stop shopping where you could have dinner, drinks, and then pick up anything you might need. On the road, after all, you didn't necessarily wash your clothes every three or four days. Sometimes you would just toss out your dirty socks and underwear and buy new ones. It was easier, and money was of no concern. So we looked for places where we could accomplish these mundane tasks while also soaking up the local culture and ambiance.

This being Canada, we eventually came to a large section of the market devoted to outdoor activities, notably hunting and fishing—row upon row of rifles and fishing rods and other paraphernalia. We came upon a massive commercial chest freezer, open on top and filled with packages of frozen fish: not the kind you take home and eat, but rather the type you hack into pieces and use for bait. I surveyed the contents and then looked at Al. He was already looking at me. Simultaneously, as if stricken with the same wicked idea, we both smiled.

We picked out a packet containing maybe a half dozen pieces of frozen fish, each roughly six to eight inches in length. After we'd paid for the fish and begun walking back to the hotel, I asked, "So what exactly are we going to do with this?" although I already knew the answer. It was just a matter of who our target was.

"Pete!" Al shouted. "We're going to fuck up Pete."

Why we chose Peter Angelus to perpetrate our stunt on, I don't really know. I suppose it was just because he was sure to respond with the appropriate degree of shock and revulsion. Anyway, we went back to the hotel and walked up to the front desk.

"Hi, my name is Pete Angelus," I said, rather convincingly. "I need a new room key, if you don't mind. I seem to have misplaced mine."

"No problem, sir. Here you go."

We went up to Peter's room. There were two beds, and since we didn't know which one was his, we had no choice but to sabotage both. Like mad housekeepers, we stripped the sheets and put a couple of fish in the bottom corner of each bed. Then we remade the beds as neatly as possible and walked out, leaving the faintest odor of thawing smelt in our wake.

"Good night, Al," I said, shaking his hand conspiratorially.

"Sleep tight, Noel."

By the time we left it was probably around eleven o'clock. Pete was still downstairs in the hotel bar, so I went back to my room, just down the hall, and waited for the festivities to begin. A couple hours later I woke to the sound of a blood-curdling scream, like something out of a slasher movie. And then a second shriek, this one even louder and more shrill. I smiled to myself.

Poor Pete . . .

I got out of bed and opened my door just a crack. In the hallway was Pete, wearing only his tighty whities.

"Pete," I said. "What the fuck are you doing?"

"Noel, you're not going to believe this," he said.

"Oh, try me."

"Well, I was in bed, reading a book—you know, one of my murder mysteries, and all of a sudden I felt something under the sheets. Something sticky and cold. It was on my foot and started climbing up my leg!" He paused, scrunched up his face in disgust. "Fucking stinks in there, too."

"Pete, you're just bullshitting . . . or dreaming. How much did you have to drink tonight?"

"What? Not much. And I'm not dreaming. Come in here and look."

"I'm tired, Pete, and I want to go to sleep. We'll deal with this in the morning, okay? I'm sure the slimy bed creatures will be gone by then."

I started to walk away, but by now Peter was growing frantic and would not be dissuaded. So I walked to his room, feigning a combination of irritation and disbelief, and tried not to laugh when he threw back the sheets on his bed to reveal a couple of dead fish in his bed.

"You see!" he shouted. "I told you there was something there!"

"My goodness, Pete. How the hell did that get in there?"

Peter stiffened. The fear drained from his face, replaced quickly by anger.

"You son of a bitch, Monk. You did this, didn't you? You and Al."

I shook my head dismissively. "I have no idea what you're talking about. Let's check the other bed." I pulled back the sheets to reveal another foul and slimy mess. "Holy shit," I said, trying to sound surprised. "Someone really had it in for you, Pete."

By now the whole room was beginning to reek, so I invited Peter down to my room, gave him a couple extra sheets, and invited him to sleep on the sofa, an offer he grudgingly accepted.

"Thanks for nothing, Noel. I know you did this. You guys are fucking crazy."

Not crazy. Just bored. The road will do that to you some-times.

FAIR WARNING WAS AN UNUSUAL ALBUM,

but certainly not a great album; I don't mind admitting that, and I don't think any of the guys in the band would dispute my opinion. It was a somewhat experimental effort, written and recorded on the same brisk schedule as the previous three albums, but with less emphasis on melody or memorable hooks. This stemmed in large part from Edward's increasing unease with the influence of Ted Templeman and David Lee Roth, both of whom had strong pop sensibilities and wanted Van Halen to continue along the well-worn path that had proven highly successful thus far. Edward had always bristled under these constraints, but during the making of *Fair Warning*, he began to assert himself to a much greater extent, often hanging out in the studio until the wee hours, tinkering and writing alone with the help of engineer Donn Landee. Songs that were worked out during daylight hours often became twisted into something entirely different when Edward was left to his own devices. He was an artist whose particular vision was beginning to veer sharply from the vision of those around him.

In retrospect, *Fair Warning* stands as Van Halen's hardest and most muscular album (the closest to being true metal), and for that reason it remains a favorite among the band's hard-core fans. But it lacked a single hummable track, or one that would easily translate to radio airplay, which made it a harder sell to a mass audience. Simply put, it was the band's least accessible album—a collection of songs that shared a common theme: Life is fucking hard. This was a far cry from the party songs that had marked Van Halen's arrival a few years earlier, as well as from subsequent albums that would catapult the band into the stratosphere of mainstream popularity.

While critical reviews for *Fair Warning* were relatively kind,

the album initially sold at a pace far below that of its predecessors. Released in late April, shortly before we went out on tour, *Fair Warning* was hampered by a lack of radio airplay. It was the strangest thing: here we were, out on the road, playing one sold-out arena after another, and yet fans apparently were not terribly enthusiastic about buying the new album. We were not accustomed to this, and frankly we weren't sure what to do about it.

I had an idea that things weren't going well, but it wasn't until Carl Scott called me into his office in the summer that I realized the extent to which *Fair Warning* had underperformed. The album had struggled to reach gold status, and looked very much like it might become the first Van Halen album to fail to go platinum.

"Carl," I said, "we can't not go platinum. That's unacceptable for this band."

He shrugged. "Unacceptable or not, it might just happen."

"Isn't there something we can do?"

Carl sighed deeply and nodded. "Yeah, there is. But it's not cheap. Go down and talk to the guys in promotion; they'll give you the details."

And with that, Carl wiped his hands of the whole sordid affair, which was precisely the right thing for him to do.

That same day I wound up having an enlightening conversation with the head of publicity at Warner, during which I learned the finer points of an age-old illicit system of promotion known as payola. Basically, it works like this: through intermediaries (payola brokers, for want of a better term), we could buy airplay for the album and various singles at any radio station in the country, which in turn was likely to result in increased sales for the album. That's just the way it worked; without massive radio exposure, it was very hard for an album to reach platinum status. I had heard of payola, of course, but had presumed that the practice had long faded away by the early 1980s. In fact, it was alive and well. With Van Halen, we had been fortunate in not needing such a boost with our first few albums. The band was a true organic suc-

cess, its audience expanding through word of mouth, fantastic live performances, and songwriting that resulted in numerous hit singles.

Now, though, we had a bit of a roadblock. It was time to play by the game's dirtiest unwritten rules. I had no idea what was involved or what it might cost, but as the plan was laid out for me, it became apparent that the fee would be substantial. A large station in a major market, such as Los Angeles or New York, was referred to as a P1. To guarantee airplay at a P1 would cost five thousand dollars.

For a single station!

A P2 was a secondary station, usually located in a smaller but still significant market: think Columbus, Ohio, and Grand Rapids, Michigan. The cost for airplay at a P2 was three thousand dollars.

Finally, at the bottom of the ladder, were the P3 stations, often located in the hinterlands, but sometimes with significant reach. Buying a P3 cost a thousand bucks. If this doesn't sound like a lot of money, well, it added up very quickly. As the meeting wore on, I did the math in my head and came up with a conservative estimate: it would cost us at least a couple hundred thousand dollars to guarantee coverage across the country. And the money would come directly out of our pockets. Warner Bros. would not be picking up the tab.

Armed with this disturbing information, I called a meeting with the band. I held nothing back.

"Here's the deal, boys. We made a mediocre album and we're not getting away with it this time."

Al was the first to speak up, which kind of surprised me, as David often dominated meetings that revolved around business matters. "What are you talking about, Noel? The album is doing great, isn't it?"

"No, it's not. In fact, right now it looks like we won't even go platinum."

Dead silence. It had been a long time since I had seen the band so utterly dumbstruck. Finally, Al spoke again.

"What are you talking about? We have to go platinum; we're a platinum band, for Christ's sake."

"Were," I corrected. "We *were* a platinum band. Right now we are a band whose latest album is being met with indifference."

This got David's attention. The last thing he wanted was to be . . . *average*.

"Fuck this, Noel," he said. "There has to be something we can do. We're out there every night on the road, working our asses off. There must be a way to turn this into big numbers for the album."

"Oh, there's a way, all right, but it has nothing to do with your live shows. Fact is, radio stations aren't crazy about the album. It's too . . . well . . . weird. So they aren't playing it. And until they start playing it, we're not going to get the numbers we want."

"Okay, so how do we get them to play it?" David asked.

"That's a great question," I responded. "But you're not going to like the answer."

I proceeded to explain the process of buying airtime at stations across the country. I told them how much it would cost per station; like me, they did the math in their heads and very quickly came to the conclusion that this was going to be an expensive endeavor. (They were no longer the clueless boys they had been when we first got together.)

"Five thousand fucking dollars? Per station?" Al shouted incredulously.

Even Michael, ordinarily quiet during band meetings, seemed flummoxed. "Oh, man, this is going to hurt."

"Yeah, it is," I said. "And we don't have to do it. I'll leave it up to you. But here's the truth: if we don't buy some airtime, this album is not going platinum anytime soon."

As was customary in these sorts of discussions, the band deferred to David. After a few moments of uncomfortable silence, he gave the plan his blessing.

"Bottom line is, we can't afford to be just a gold band any-

more. So do what you have to do. We trust you, Noel. Make it happen."

And so I did. For the next few weeks I took countless meetings and phone calls, setting up deals with radio stations large and small throughout the country. I wrote a check for more than two hundred grand and gave it to our promotion guy, who in turn handed it over to the payola brokers, who in turn wrote smaller checks—or handed over wads of cash—to scores of individual radio stations. What happened to those smaller payments is anyone's guess, but you can use your imagination: in many cases, I believe, the cash was used to buy drugs (primarily cocaine), which became a tool in the effort to convince programming directors and disc jockeys of the merits of a particular song or album. And lo and behold, *Fair Warning* began to get significant airplay. Tracks that were not even intended as singles started showing up in the regular rotation.

Go figure.

For me, it was an interesting position to be in. I had always represented either bands that got no airplay at all, and thus weren't worth any sort of payola investment, or bands that received all the airplay they wanted, without coercion of any type. But here was a band whose popularity and success had reached a level that created certain expectations, and those expectations had to be met. At any cost. In order to be deemed a platinum album for 1981, *Fair Warning* had to sell a million units within the calendar year. It never occurred to me that this would be a problem, but it was. In the end, though, our nearly quarter-million-dollar investment proved worthwhile, when the album reached platinum status on November 18, and we all breathed a sigh of relief. Eventually, *Fair Warning* would sell more than 2 million copies, but it was the slowest-selling album of the David Lee Roth era for Van Halen. Maybe that's because it was the album that least reflected the influence and interest of Roth himself. For better or worse, the guy was dialed in to his audience. And he wanted to make that

audience happy. I'm not sure Edward cared about any of that. First and foremost, he made music for himself.

But this was a significant come-to-Jesus moment for all of us. We realized that Van Halen couldn't continue to crank out one album per year, usually cobbled together in a few weeks of frantic recording after endless months on the road. Although still a remarkable live act, Van Halen as a studio band had begun to slip ever so slightly. And they knew it.

"We can't do this anymore," David said.

"Yeah, no more fourteen-day records," Edward added. "We've been coming off the road and cranking out these albums. We need more time, Noel."

"Fair enough," I said. "I'll make sure you get it."

THE *FAIR WARNING* TOUR ended in spectacular fashion, with a pair of sold-out shows at the Tangerine Bowl in Orlando, Florida, as the opening act for the Rolling Stones. This was the first time Van Halen had played with the Stones since opening for the band at the New Orleans Superdome in 1978. Since that time, Van Halen had ascended to superstardom; as for the Stones, well, they remained ageless. In '78 the band was touring to promote the critically acclaimed album *Some Girls*, a career highlight released at a time when the Stones were supposedly getting a little too long in the tooth to do this sort of thing. Now, three years later, they were at it again, with the album *Tattoo You*, a massive commercial and critical success anchored by "Start Me Up," which became not merely a hit single but one of the Stones' most enduring titles.

So, even with Mick Jagger and Keith Richards approaching forty years of age, the Rolling Stones were not merely still relevant but arguably the biggest band in the world. Van Halen wouldn't have played second fiddle to many bands in those days, but the Stones were icons, and when the call came to open two shows at the Tangerine Bowl in late October, we

didn't hesitate to accept. It seemed a perfect way to end the year—or at least the touring part of it.

Both shows were fantastic; sure, the crowd of 65,000 was there primarily to see the Stones, but Van Halen had its share of fans, as well, and did a stellar job of winning over those who might have been neutral on the subject. With only an hour of allotted stage time, the band jettisoned a half dozen songs from its normal playlist during the *Fair Warning* tour but added an ass-kicking version of "Summertime Blues"—a surefire crowd-pleaser.

One of my favorite memories from the first day occurred before the concert even began. It was after sound check and we were up on the deck, looking out over the Tangerine Bowl, somewhat awestruck by the scope of it, and the fact that we had come so far in a relatively short period of time. There is something at once exhilarating and humbling about playing in a sold-out football stadium, alongside one of the greatest bands in rock 'n' roll history. As we were standing there, out walked Mick Jagger; it was like God himself had entered our midst. Now, I had worked with the Stones before, back in '71, so I knew Mick a little bit. Though small and slightly built, not physically impressive in a traditional sense, there is something about the way he carries himself, even when offstage, that commands attention. He has that strut and swagger thing going all the time, and obviously his face is among the most unique in pop culture history. When Mick enters a room, you can't help but stop and stare. He has this effect not just on the average Joe but on other celebrities, as well, musicians in particular. The guys in Van Halen were no different. As Mick stopped to chat, they all fell silent, even David. But the cutest moment was when Mick turned his attention to Edward.

"You know, Edward," he began, in that unmistakably guttural, marble-mouthed way, "you are a fucking *brilliant* guitar player."

Coming from someone who shared the stage each night with Keith Richards, an acknowledged master of the art form, this was high praise indeed, and so we all turned to look at

Ed. How would he respond? The short answer is, he didn't. Instead, he just sort of scuffed the ground with the toe of his boot and avoided making eye contact while smiling like a nervous schoolboy (similar to the way he acted upon first meeting Valerie Bertinelli, who, it should be noted, was present for both of the Tangerine Bowl shows, and clearly starstruck in such close proximity to the Stones' singer). After several awkward moments, Edward half-whispered, "Thank you." And that was it.

But Mick did not just walk away. He hung out for a while, making small talk and surveying the scene. At one point he gestured toward Al's drum kit, attached to which were two large fire extinguishers.

"What's all that, then?" Mick said. "Fire extinguishers? You guys are known for pulling off some stunts, right?"

Nods all around.

"You wouldn't be doing some stunt with those fire extinguishers, now, would you?"

Heads shaking vigorously. "Oh no, no, no! We'd never do that. It's going to be a regular, you know, show . . . and . . . you know, we're not going to pull any stunts. We're just really glad to be here."

Mick smiled. "That's good."

I wouldn't say that Mick enjoyed the adoration being heaped upon him by his opening act, but I wouldn't say he hated it, either. I think it was utterly normal for him, and he accepted it. As for "stunts," well, those were actually left to the Stones, whose set concluded with a fireworks display in which tiny American and British flags rained on the audience. A nice touch, I thought.

Roughly twelve hours later we were back at the Tangerine Bowl for the second concert, and the last show of the year. Not surprising, the boys began partying well before they took the stage—not to the extent that it impaired their performance but enough that they were pretty riled up by the time we left the catering area and hopped into a private limo for a ride halfway around the stadium, where the dressing room was

located. Almost immediately upon entering the limo, they began behaving badly. This was not uncommon on the road, and it wasn't uncommon when traveling by limo. What made it unusual was that we hadn't played yet, and the limo was not simply a shitty cookie-cutter model that was part of a fifty-car fleet owned by a large company. This was a private car, owned and operated by the driver. It was a beautiful French limo, meticulously maintained. Unfortunately, with Van Halen, drinking often was accompanied by wanton disregard for the property and dignity of those in proximity. So I wasn't terribly surprised when Al, sitting in the front seat, asked the driver, leaning forward and tapping the glove compartment door mischievously, "What's in here, man?"

The driver smiled nervously. "Just some papers. Registration, manual—you know, the usual stuff."

"Really?" Al said. "Let's take a look."

He popped open the glove compartment, pulled everything out, and began tossing it around the limo, provoking howls of adolescent approval from the rest of the guys. The driver, meanwhile, tried to keep his eye on the road while casting a wary glance at Al.

And that was merely the beginning.

There is no way for me to put a positive or even a benign spin on what happened next. All of a sudden, as if he didn't want to be outdone, David began tearing apart the back of the limo. Armrests were ripped from their sockets. A door was opened and closed so hard and so fast, and so many times, that it came loose from its hinges. Most of this happened while we were still moving, as the car was traveling at less than twenty miles per hour around a parking lot. I couldn't believe what I was seeing and tried to calm the guys down, but they were in a frenzy by now. The driver offered only the meekest resistance, protesting, "Please . . . my car." At one point the car came to a stop and Edward jumped out and began dancing on the hood and then the roof, pummeling the sheet metal with his boots, until the car looked like it had been attacked with a baseball bat.

When we finally arrived at our destination, the guys jumped out, laughing hysterically. They offered neither an apology nor an explanation. They were rock gods, and in this state of inebriation exhibited complete and utter disregard for the personal property of others. Though Van Halen had a long history of trashing hotel rooms and dressing rooms, this was different. This was not a Holiday Inn. This was a car owned by their driver; it was his only source of income, and he clearly took great pride in caring for the vehicle. As the band walked away, I could see on the man's face not anger or even sadness but something closer to defeat. I waited until the guys were completely out of earshot, and then I approached the driver.

"I'm sorry, sir," I said. "Don't worry, I will pay for all the damage, and I will pay for all the work time that you'll miss if you can't use your limo. Whatever it costs, the band will take care of it."

"Really?" he said. "You can make that happen?"

"Yes," I said. "It's only fair. If you need five or six days to get the car fixed and painted and detailed, and you can't accept customers during that time, then we should compensate you, because it's our fault."

I paused. "And I apologize for our behavior."

As we shook hands, the driver said, "That's very nice of you, Mr. Monk."

"Not really. It's just the right thing to do."

I don't recall exactly how much it cost to repair the man's limo, but I'm sure it was comfortably into five figures. This was just another example of why Van Halen had trouble making money on the road: our expenses always seemed to outstrip revenue, in part because of the size of our entourage and equipment, but also because of the destruction so often left in the band's wake.

Although both shows at the Tangerine Bowl were terrific, the limousine incident left a bad taste in my mouth. Sometimes the guys could be very sweet, but other times, especially when they drank heavily, they could be not just inconsiderate but downright mean. And I had no control over any of it.

A few hours after the show I was sitting alone in the dressing room, just relaxing and sipping a beer, when Edward walked in. Limousine incident notwithstanding, I was in a pretty good mood—it's hard not to feel a giant sense of relief and accomplishment when a tour comes to an end, especially one as successful as this one.

"How's it going, Ed?" I asked. From the look on his face, I could tell that this was not the right question. For some reason, Edward was in a foul mood. He got that way sometimes, usually after drinking heavily. I found out later that he'd been hanging with some of his buddies out on the green, putting away copious amounts of vodka; no doubt smoking weed and doing coke as well. Whatever the cocktail, Edward was by now obviously wasted, and when he was drunk and mean, it was painful to be around him; the transformation was too sad and dramatic.

He took a seat next to me on the couch. I tried to make small talk but got only half-formed slurred responses. Having seen this routine before, I knew it wouldn't end well, so I decided to leave.

"Edward, you know what?" I said, pulling myself up from the couch. "I'm going for a walk."

Before I could take a step, Edward yelled at me. "Yeah, walk away, you fuckin' drunk."

With my back to Edward, I started to form a response, which was probably not a great idea. But before the words came out of my mouth, I felt a hand in the middle of my back. Edward gave me a big, drunken shove, causing me to instantly lose my balance. The floor of the dressing room (located in a trailer) was slick with a variety of liquids—water, beer, sweat, and soda, to name just a few—so I was basically put on skates by Edward's shove. And let me tell you—Edward might have looked like a skinny guitar geek onstage, but he was not a weakling. He was a tough kid who was deceptively strong. Combine that fact with his orneriness and my overly trusting nature (I should not have turned my back on him), and the result was a nasty injury. I careened across the trailer and

slammed headfirst into a doorknob. And by headfirst, I mean that most sensitive ridge along the eyebrow. The spot that always seems to burst open in boxing matches.

I hit the floor and just sat there for a moment in stunned silence. Then I felt a steady trickle of warmth as blood poured into my eye and down my cheek. Edward stood up from the couch and looked at me. He put a hand to his mouth.

"Oh, man. Noel . . . I'm so sorry. I didn't mean for that to happen."

I didn't even respond. I was too dazed. My ears were ringing and my head throbbed. As Eddie ran out the door, a couple other people came in and helped clean me up and get me into a limo. I ran a hand along the cut. It was nearly wide and deep enough for me to insert a finger.

"Better take me to the hospital," I said.

Several hours and nine stitches later I was back at my hotel room. I saw Ed briefly the next day, before we left, but neither of us mentioned the incident, despite the fact that I had a black eye and a bandage on my head. In fact, weird as it might sound, we never spoke of it again. When I got home, my girlfriend Jan, whom I lived with, was there to greet me.

"What the hell happened to you?" she asked.

"Ah, nothing. Just a little run-in with a doorknob."

She ran a sympathetic hand along my cheek and smiled. "You're in a tough fucking business, aren't you?"

I laughed. "Honey, you have no idea."

13

THE MIDAS TOUCH

Nobody knows anything," the great novelist and screenwriter William Goldman famously wrote. He was referring to the fickle and forever fucked-up movie industry in which he often toiled, but he might just as well have been talking about the music business. Brilliant albums sometimes fail, while shitty albums go platinum. Sometimes there are performers making music so wonderful and yet obscure that their work never sees the light of day. And even for those that do "make it," the music industry often remains mystifying; just when you think you've got everything figured out, they throw you another curveball.

As 1981 gave way to 1982, my goal for Van Halen was to do exactly what I said I would do: provide the band enough time and space to craft a truly great album. No more jumping off the road and straight into the studio, and then right back out on the road to support an album that had been furiously cobbled together in the span of a few weeks. Maybe

there wouldn't even be an album in 1982, and if there wasn't an album, maybe there wouldn't be a tour, or not much of one, anyway. We would rest and recharge our batteries, and take the time to write and record a masterpiece.

Or, at least, that was the plan.

Instead, here's what happened. When the *Fair Warning* tour ended in late October, everyone took a well-deserved break, one that carried over until the end of the year. There were no plans whatsoever to put together a new album for release in the first quarter of the new year, as we had done the previous four years. My job was to protect the band from outside interference and coercion, to shield them from the usual pressure to crank out another album and another tour. On a personal level, I had no desire to put out a product under the Van Halen brand that would require another late infusion of cash to ensure a platinum sales performance. The way I saw it, the band had been working hard enough and fast enough, and had earned the right to take a more leisurely and artistic approach to the recording process this time around.

Leave it to David to scuttle the entire plan, not that it was exactly his intent. David was an anxious and restless sort by nature, and after a couple months passed he became concerned about the possibility that Van Halen was beginning to fade from the public consciousness. I found this absurd. They were one of the biggest bands in the world, and a short respite—or even a long one—wasn't going to do anything to compromise that position, at least not in my view. If anything, a hiatus might have fueled an even greater hunger for the next album or tour. David generally agreed with this line of thinking, but only to a point. Rather than disappear completely (as if that was possible), he suggested the band record and release just one song early in the new year, and release it as a stand-alone single. Theoretically, this would keep both fans and critics at bay for a while, while Edward continued to craft brilliant and ambitious songs and everyone recovered from the brutal schedule of the previous years.

Opting for the path of least resistance, as he often did, David suggested the band simply cover a popular song, putting a Van Halen spin on an established product. If this was lazy thinking, it also was somewhat shrewd. After all, Van Halen's first hit single was a cover of the Kinks' "You Really Got Me." If the strategy worked in 1978, why wouldn't it work in 1982? It was simply a matter of finding the right vehicle. David was a cynical bastard, as his later musical direction would prove, but sometimes cynicism can be a highly effective marketing tool.

At least in the short term.

Dave's first suggestion for a cover was "Dancing in the Street," which had been a huge hit for Motown stars Martha Reeves and the Vandellas in 1964, and had been covered multiple times since. Dave gave Edward a copy of the song, and while he knew and liked it, he said he couldn't quite figure out a way to turn it into a Van Halen song. I get that. Edward was too creative an artist to simply replicate a song, no matter how great it might already have been. He had to personalize it. David's shrieking vocals were a signature, obviously, but to Edward, it was about recasting the song in such a way that it would be unmistakably Van Halen. And that started with the guitar. For whatever reason, Edward rejected "Dancing in the Street" as a stand-alone single, and instead suggested another staple from that same year: Roy Orbison's "Pretty Woman."

The song was recorded in a single day at Sunset Sound, again with Ted Templeman producing, and heaved into the marketplace virtually overnight. I had no expectations for this song, and I'm not sure the band did, either. It was intended as merely a diversion, a chance to have some fun with an old song and keep fans satisfied while they waited for a new album of great original material. But a funny thing happened: "Pretty Woman" quickly gained a foothold on radio stations across the country (and we didn't even have to pay for it!), and soon became one of the band's biggest hits, reaching number 12 on the *Billboard* singles chart.

Along with the single, the band also released its first concept video. And what a concept: Picture the four guys from Van Halen dressed as . . . well . . . an assortment of fictional types—David as Napoleon, Michael as a samurai warrior, Alex as Tarzan, and Edward as a cowboy (looking a lot like the Lone Ranger). Together this fearsome foursome rescues a damsel in distress from the evil clutches of two little people. (Think about that for a moment, and try to remember that political correctness was of little concern to the band in those days.) Adding another layer of controversy was the fact the fair maiden in question was actually a female impersonator. For the boys, it was all meant to be in good fun, but it was a head slapper for many who saw it, in particular MTV brass, who eventually deemed the video to be of such questionable taste that it was banned by the network. Fans, however, seemed to like it, and it certainly didn't hurt the single in any way.

On some level, I suppose, the success of "Pretty Woman" was cause for celebration. On another level, however, it was something of a disaster. Why? Because a stand-alone hit single is a lonely beast; it practically begs for companionship. As "Pretty Woman" climbed the charts, Warner Bros. responded with predictable greed and shortsightedness, saying, in effect: *Hey! We need an album to go along with this single!*

At first we all resisted, but the label kept pressuring the band, and eventually they relented. A compromise of sorts was reached: since the first single had been a cover, and since the guys hadn't written any new material, then why not do an album consisting primarily of cover songs? In theory, this would take some of the pressure off David and (especially) Edward to come up with new songs on such short notice. In practice, it was a venal decision that would compromise the band's integrity, make them look a bit too much like money-grubbing whores, and result in an album that has long been the most maligned in the band's catalog (at least from the David Lee Roth era).

In short, that album, *Diver Down*, was everything that the band hadn't wanted, and it was created in a pressure-packed atmosphere that I had promised to help prevent. Frankly, it made me kind of sick.

The title and album cover (which depicts the red and white "diver down" flag used to identify scuba excursions on the open water) had little to do with anything happening on the album from a musical standpoint, although David cleverly claimed otherwise. "[The flag] means there's something going on that's not apparent to your eyes," he told reporters in the wake of the album's release. "You put up the red flag with the white slash. Well, a lot of people approach Van Halen as sort of the abyss. It means, it's not immediately apparent to your eyes what is going on underneath the surface."

Personally, I don't think it was all that deep, but I admire David for putting a positive spin on a lousy situation. You had to give the guy credit for being a gifted slinger of bullshit. The same aptitude that was evident onstage, while delivering impromptu monologues or patter, made David a natural promoter, too. Maybe there was something to the whole "seen versus unseen" nonsense, but I also know the title of the album was basically just a sophomoric bit of double entendre:

Diver Down.

Dive . . . Her . . . Down.

See what I did there?

Anyway, in the wake of the album's release, and the accompanying bad press, I was busy getting reacquainted with my old friend Valium.

The best that can be said about *Diver Down* is that it is a "fun" and at times interesting album, and something of a miracle, given how quickly it was assembled. Most of the work was done in less than two weeks, in the winter of '82, a ridiculous schedule that resulted in an album that runs just a scant thirty-one minutes. Of the tracks, only four are full-length original songs. The rest are either covers (including "Dancing in the Street" and a silly little version of the Dale Evans cowpoke standard "Happy Trails," along with a version of "Big

Bad Bill" on which Jan Van Halen was recruited to play clarinet), or instrumental tunes that serve primarily as a chance for Edward to demonstrate what everyone already knew: that he was the most mesmerizing guitarist in the world. Unfortunately, blistering solos tend to work better in live performance than on vinyl. There was nothing wrong with any of the new material, which included a pair of balls-out rockers ("The Full Bug" and "Hang 'Em High") as well as the more nuanced and ambitious songs "Secrets" and "Little Guitars."

Still, there was no getting around the fact that *Diver Down* seemed sparse and rushed, a sentiment expressed by no small percentage of critics upon the album's April release. Consider this dagger from *Rolling Stone*:

"Strip away the four cover versions, the three brief instrumentals and the minute-long goof on 'Happy Trails' and Van Halen's fifth album, *Diver Down*, suddenly seems like a cogent case for consumer fraud. Van Halen, it appears, is running out of ideas: there's more excelsior here than in a shipment of glassware."

Harsh, but not inaccurate. And yet . . . *Diver Down* was a huge commercial success. Propelled by the singles success of "Pretty Woman" and the synth-pop of "Dancing in the Street" (a sound that would be expanded and refined on Van Halen's subsequent album, the masterful *1984*), *Diver Down* reached number 3 on the *Billboard* charts and went on to sell more than 4 million albums.

Quadruple platinum—not bad for something knocked off in less than two weeks.

Still, despite the album's success, or perhaps because of it, *Diver Down* contributed significantly to the steady erosion of the band's fragile chemistry. While David was perfectly content to belt out vocals of cover songs, so long as they became hits, Edward was unhappy with the impression that the band had compromised its principles. He would have preferred a less successful album of original material to a less inventive commercial album like *Diver Down*. And I don't blame him.

As for me, I wanted the band to have both: commercial success and brilliant originality. And I knew that Van Halen, at its best, was more than up to the task.

FOR EVERY GIGANTIC TASK that came my way as manager of Van Halen, there were a hundred smaller ones, often of a much more personal nature. Some were annoying, some were humorous, some were fulfilling. I never minded because it was all part of the job. In some ways, it was as important to be there to lend a shoulder to cry on as it was to help renegotiate a new record deal. I was a facilitator of opportunities large and small; a fixer of problems trivial and catastrophic. It was all in a day's work.

In '82, I helped David with a couple different issues that illustrate this point. The first involved a young lady who had somehow managed to hold David's attention for more than the usual two or three "dates." By this time our entire group had begun either to embrace or seriously consider the idea of commitment and monogamy (well, commitment anyway). Edward had married Valerie Bertinelli; Alex had fallen for a well-known and admittedly gorgeous groupie named Valerie Kendall; they were engaged and would soon embark on a short and tumultuous marriage. And Michael Anthony, of course, was married to his high school sweetheart, Susan Hendry, who was every bit his match in the niceness category and who seemed always to have only her husband's best interests at heart. They were an adorable couple and it's no surprise that their marriage endures to this day. As for me . . . well, that same year I got engaged to Jan. We were married in '83, and have been together ever since. I'm a lucky guy and I know it.

David, meanwhile, remained a tireless whore, fucking anything that moved, night or day, on the road or at home. Don't get me wrong, I don't begrudge him this. Hell, I think he'd agree with me. He might even take it as a compliment—he

worked very hard at it, after all. David didn't want a relationship and seemed to understand that he would have made for a restless and roguish partner.

Imagine my surprise, then, when David showed up at the house I shared with Jan one day, insisting on talking to me about a particular problem. He was completely lathered up, and not merely because he had made the twenty-mile trip from his home by bicycle. It seemed that David had fallen for a young lady and wanted to extend their courtship. There was, however, one problem.

"I just found out I got the clap," David said.

This did not surprise me in the least. Getting an STD was practically a rite of passage when traveling with Van Halen; David, like most of the guys, had absorbed a river of penicillin in his butt to stave off the effects of unprotected sex with strangers. I wasn't sure why he was so freaked about it this time.

"What's the big deal?" I asked. "Go see the doctor. You know the drill."

David shook his head. "You don't understand. I really like this girl, and I wanted to keep seeing her. But I'm pretty sure I've given her the clap, too."

I shrugged. "Yeah, that's probably true, David. What do you want me to do about it?"

David leaned in closer, smiled, and put a hand on my shoulder. "Come on, Noel. You're my manager . . . my friend."

Friend? I did not like the direction this was taking.

"Get to the point, David."

"Okay, I want you to make a phone call for me."

"To whom?"

He provided the name of the girl with whom he was now infatuated.

"And what would you like me to say?" I remained calm in part because I was curious, but also because the entire premise was so ridiculous that I couldn't resist playing along.

"You know," David said with a smile. "Tell her I love her,

and that I want to keep seeing her, and that I'm very sorry because I probably gave her the clap."

"Uh-huh."

"Easy, right? You can do that for me?"

I looked David square in the eye. He was not kidding. But I wanted him to know that this was well beyond my pay grade. Or maybe below my pay grade. Regardless, there were limits to the type and amount of shit I would shovel. I loved Van Halen and I loved my job. But this fell under the heading of "unreasonable request."

"Sorry, David. I'm not going to do that."

His eyes went big and round, like a puppy's. "Well, then, who's going to tell her?"

Even now, five years into our journey together, when they were one of the biggest bands in the world, these guys could still behave like children. As their manager—one who still did not have a long-term contract—I could be asked to do almost anything. And rarely did I decline. So, as much as I wanted to tell David to fuck off and grow up, in no particular order, instead I went into fix-it mode.

"David, I've got a great idea."

We were sitting across from each other at the kitchen table. David pulled his chair closer and straightened up. "What? Tell me."

"You send her a beautiful handwritten letter, along with a dozen long-stemmed roses."

David nodded. "What do I say in the letter?"

"Tell her how much she means to you. Tell her you were with someone else before you met her—that's very important— and unfortunately you contracted something. Be polite and discreet and very apologetic. Remember, she likes you. She doesn't know you're a whore."

David smiled. "You don't think so?"

"Well, she probably does, but for now she doesn't care."

"Yeah," David said. "I'll get on it. Thanks, Noel. You're the best."

When David left, Jan came into the room. "What did he want?" she asked.

I shook my head. "You wouldn't believe me if I told you."

BANGING HEADS WITH BOOTLEGGERS was more our speed, and we continued to do that with enthusiasm and vigor. Pat Kelly and I had gotten it down to a science by '82. Pat was a former Chicago cop who was head of our merchandising operation. We'd walk around the venue well ahead of time, look for rogue vendors, and then swoop down on them. We had the legal system working on our behalf by this point, so most of the confrontations were far less violent than they'd been in the early days. We'd simply hand a court-order notice of confiscation, which gave us the right to take possession of all unlicensed merchandise. We'd take the gear—T-shirts, mostly—then bag 'em, tag 'em, and put them in storage.

One day we were driving around outside the venue when we spotted a man and a woman selling T-shirts near the side of the road. It was a very small operation, just the two of them getting ready to sell a small amount of stock off a card table. But that's the way it often worked. Unlicensed vendors would set up shop at concerts, armed with just enough merchandise to move quickly—maybe a few dozen shirts. Then they'd shut down and turn their earnings over to the bootleggers, keeping a cut for themselves. On this particular day, as we passed the man and woman with the card table, Pat did a double take.

"Hey, I know that guy."

So we parked the car a short distance away and walked up to the table. The man turned white as soon as he spotted Pat, because he knew he was about to get busted and lose his income for the day. We moved in on them and gently pulled the man aside, while leaving the young woman to continue with her work. You see, we weren't really interested in confiscating such a small number of shirts. Instead, it was Pat's idea to coerce the guy into giving up information about his distributor, in this case an asshole named Johnny, one of the biggest boot-

leggers around. We knew ahead of time that this was one of his dates, and that he would be selling his shitty merchandise all over the place. Every time Johnny showed up at a Van Halen concert, it was with a couple vans, each filled with at least five hundred T-shirts, which he'd sell for ten bucks apiece. But I'll give the guy this much: he was good at his business. Not just the selling of bootleg merchandise, but doing it without getting caught. We could never seem to find him, so we always ended up settling for busting a few of his vendors.

Tonight would be different.

"Fuck this guy," Pat said. "Let's use him to get to his boss."

We scared the shit out of the guy, first, took him and his partner to a secluded area in a parking deck a short distance away. We told the young woman to sit tight while we led her partner away. Then we made him think we were not only going to take his merchandise but maybe rough him up a bit, as well. Not that we threatened him: we just looked at him in an unfriendly way, if you get my meaning.

"Look, you're going to be okay," I said to him. "We aren't even interested in you."

"Really?"

"Yeah, really. Just tell us where Johnny is keeping his van, and we'll let you sell your shirts. Shit, if your information is good, we'll even give you an extra five hundred bucks."

The man stopped trembling. He smiled warily.

"Are you fucking with me?"

Pat shook his head.

"Not yet. But we might."

"No, no. That's okay." And with that he proceeded to tell us exactly where we could find Johnny's van.

"Great," I said. "After the show, and after we do the bust, just come by and we'll give you your money."

"Thanks!" he said, before turning to walk away. Suddenly, he stopped and doubled back.

"Problem?" Pat asked.

The man rubbed his chin with a bony hand. He looked around conspiratorially.

"Yeah, I was just thinking. What do I tell my girl up there? I don't want her to know I made a deal with you; might get back to Johnny."

I looked at Pat. He nodded. The guy had a point.

"Tell you what," I said. "We'll beat you up."

The man recoiled in fear. "What?!"

"Relax," I said. "I mean we're going to make it seem like we beat you up; you know, forced you to give us information."

The man nodded. "Ahhhhh. . . . Okay. Good thinking."

Then Pat and I proceeded to smack our hands together and hit each other on the back while our "victim" cried out in pain, just loudly enough for his partner to hear. After a few minutes, we escorted him out to meet her. He squeezed out a couple perfunctory tears, and off they went. Later that evening, with local police and marshals in tow, we confronted Johnny selling hundreds of bootleg T-shirts out of the back of his van. And, oh, man, was he pissed off. It was one of the highlights of my career hunting bootleggers to see that piece of shit being hauled away in handcuffs, screaming at the top of his lungs.

"Monk, I'm gonna machine-gun you to death, you mother-fucker!" he screamed as they dragged him off.

Later that night, our young informant stopped by to collect his fee. I counted out five hundred dollars and placed it in his palm. The guy smiled. Then I handed him an extra hundred. He had earned it.

SOMETIMES THE BOYS were their own worst enemies. Even after five years of stardom, they still had moments where they would display business naïveté and overall immaturity.

Between the tour and merchandise and record sales, we cleared nearly 10 million dollars in 1982. Split that five ways, take out 50 percent for taxes, and you're still left with almost 1 million dollars per man. And, as good a year as '82 was, it could have been even better, at least for one member of the band.

In 1982 Michael Jackson went into the studio to begin recording *Thriller*. At some point in the process, Quincy Jones, the album's producer, reached out to Edward and asked if he would be interested in writing and playing a guitar solo for one of the tracks. That song was "Beat It." Like just about everyone else on the planet, Edward had enormous respect for Michael. And like most musicians, he knew that Quincy was an extraordinarily gifted and influential producer. In short, Edward was flattered that he was asked to contribute something to the record. As a fan, I could appreciate that; as a businessman, I had to advise him to consider the parameters of the arrangement very carefully.

I do not know whether Edward was offered a royalty for his contribution. I do know that he neither requested nor received a penny. In fact, he insisted on donating his time for free, and was quite proud to have done so.

Me? I thought he was a fucking idiot. A nice idiot, but an idiot nonetheless.

Four times Edward was in my office to talk about this project, and each time I told him the same thing: "For God's sake, Ed, just take a point. Or even half a point."

He would smile that stoner's smile of his and dismiss me with a wave of the hand.

"Nah, man. Can't do that. I love Michael."

"Yeah, I know. Everybody loves Michael. But trust me— he's not working for free. And if this album becomes a big hit, you're going to wish you hadn't given away your time."

My warning fell on deaf ears. Edward donated his time and talent, and his contribution helped make "Beat It" one of the signature songs on one of the decade's signature albums. By the time "Beat It" was released, in April 1983, *Thriller* had already spawned two hit singles in "Billie Jean" and "This Girl Is Mine." "Beat It" became a platinum-selling single, a massively popular video, a Grammy winner for Record of the Year, and helped catapult *Thriller* to an unprecedented level of artistic and commercial success. It was nothing short of a transformative song. *Thriller*, meanwhile, went on to become

the best-selling album in history, with sales of more than 30 million.

You don't have to be a genius to see that even a small royalty rate on the single and album would have netted Edward a very nice payday. But he was happy to do a favor for someone he admired, and he secured his place in history. So I guess that's something. I just hope it was enough.

Likewise, success had not put an end to the conflict that Edward and Alex could provoke in each other. One night in October we were staying at the Statler Hilton (also known as Hotel Pennsylvania) in Manhattan. We had just come from a show in Pittsburgh and were getting ready for another show at the Brendan Byrne Arena in New Jersey. At roughly two in the morning my phone rang. To my surprise, it was Edward, sounding strangely quiet. He said that there had been an accident and he was in a lot of pain.

"Can you come over?" he said. "I'll explain."

Edward's room was right next door to mine, so within a minute or two I was standing over Edward as he sat on a couch, bent over, clutching his right hand.

"Fucking Al! Fucking asshole!" he wailed.

"Calm down, Ed," I said. "Just tell me what happened."

"Al came over with his groupie girlfriend and stepped all over my guitar pieces."

I looked down at the floor, which was littered with tiny screws and assorted guitar parts. This was not an unusual sight in Edward's room—he often would take his guitar apart and then reassemble the pieces. He liked to tinker almost as much as he liked to play.

"No big deal, Ed. We can pick everything up and get you back to work putting it together again. Come on, I'll help you."

"That's the problem," Ed explained. "Al stepped on the rug and scattered some of the pieces where I can't find them."

He paused. I knew the other shoe was about to drop.

"Then I got so pissed I punched the wall."

I watched as Edward cradled one hand inside the other.

"How bad?" I asked.

He took a couple of slugs of vodka and said, "Well, that fucking wall is not Sheetrock."

It sure wasn't. It was a good old New York brick wall. Built in 1919, the Statler's walls were as solid as Edward's guitar playing. He was obviously in a lot of pain.

"Can you hold a guitar pick?" I asked.

Edward shrugged. "I don't fucking know."

There were three or four picks on the floor, which I gave him. To my horror, he couldn't close two fingers around the pick. And we had a show that night! The more Edward tried to grasp the pick, the more pain he exhibited. Obviously, he wasn't faking.

"We've got to get you to a hospital," I said.

Edward dropped his head. "Shit. I'm sorry."

I called Eddie Anderson, head of security, to come down to Edward's room. About five minutes later he came to the door, looking as though he didn't have a care in the world.

"You won't be smiling when I tell you what's happened," I said, closing the door behind us. Then he saw Edward, moaning in pain.

"Oh my God. What happened?"

"Ed fought the wall and the wall won."

"Fuck you, Noel!" Edward shouted. "It really hurts."

By now it had become obvious there was not going to be a Van Halen show that night. And since Ed's injury had not really stemmed from an "accident," we would have to pay for all the advertising, promotion, and any other costs involved. Before I faced that nightmare, though, we had to get Edward to a hospital. Fortunately, since it was the middle of the night, the hotel lobby was quiet. As we exited the stairway into the lobby, I got an idea.

"Okay, right here is where you tripped on the second step of this ratty rug."

Edward looked perplexed.

"Huh?"

"That's where you tripped and fell forward . . . breaking your fall with your hand. Got it?"

"What do you mean?"

"Look, Ed. It's simple. You didn't fight with the wall. You tripped on the rug." I looked at Eddie Anderson. "You understand, right?"

Finally, it began to sink in. I explained that if Edward injured his hand accidentally, by tripping and falling, the band would not be liable for expenses incurred as a result of canceling the show. But punching a wall? That would be a problem.

I tipped the cabdriver an extra twenty bucks to get us to the emergency room in a hurry. We were lucky. The ER was just about empty except for a couple of drunks and a guy who seemed to have been stabbed. He was holding a wet and stained towel over his side. We waited maybe a half hour before a young doctor examined Ed and ordered some X-rays.

"Good news," he said. "Nothing broken. But he does have a badly sprained wrist. Just give it some rest."

The doctor recognized Edward, as did the two starstruck nurses who were helping him. If Edward had wanted, he probably could have had both nurses continue their care back at the hotel. On this night, though, he wasn't interested; he was in too much pain. Downhearted, we headed back to the hotel. The doctor had prescribed some pain meds for Ed. Between this and the vodka, Ed soon was feeling no pain. As he started to nod off, I told him to call me if he needed anything.

"Remember, I'm right next door."

"Thanks," Edward said. "I'm fine."

I left Ed's room and went into mine. My phone started ringing almost immediately, despite the fact that it was almost five o'clock in the morning.

Who the fuck could that be?

I picked up the phone. A woman's voice said, "Hi, Noel. What's going on with Ed?" I recognized the voice but couldn't put a name to it.

"Who is this?"

"It's Lisa. How are you doing?" Now I remembered. It was Lisa Robinson, a reporter generally regarded as the queen of rock 'n' roll gossip.

"I'm fine, Lisa. What can I do for you?"

"You can tell me how Edward hurt his hand."

I wanted to be mad at her, but mainly I just had to admire the fact that she had somehow gotten this information so quickly. She must have had sources everywhere, including at local hospitals.

"Ed's fine," I said.

"But what about the sprained wrist? We were so looking forward to seeing the band."

At that point, I figured Lisa was as good a person as any to help me get my side of the story out. So I told her that Edward had tripped on a rug while walking down the lobby stairs and that he had injured his wrist trying to break his fall.

"Really?" she said. "That's it?"

"That's it," I said. "A really unfortunate situation. We might even have to cancel the Meadowlands show."

"Oh, that's too bad."

"Yeah, well, when the shit hits the fan, everybody gets splattered. But that's the whole story, and you got it first."

We ended up canceling three shows because of Edward's injury, and he even wore a brace on his right wrist for a while afterward. And while we later modified the story to suggest that Edward hurt his hand while "horsing around" in his hotel room, no one ever found out the real reason behind the injury.

14

NO PROBLEMS (OKAY MAYBE A FEW)

The Hide Your Sheep tour was supposed to end in mid-December of 1982, and would be followed by a long period of rest and artistic rejuvenation. This time there would be no backtracking or succumbing to industry pressure. The band would take some time off and then be given several months to write and record a new album. If I had my way, there would be no touring, no media responsibilities . . . nothing.

It almost worked out that way, too.

Shortly after the conclusion of the '82 tour, after we had all returned to Los Angeles, we got an offer to play a series of

dates in South America beginning in mid-January. It wouldn't be considered a new tour, merely a monthlong extension of the current tour. And then we would break. At first, this offer was met with a mixed response by the members of the band. David, as usual, saw dollar signs: the potential to tap into a market we had mostly ignored in the past (this would be our first tour of South America), while Edward was characteristically trepidatious. He remained a homeboy at heart, especially now that he was married; more than the others, Edward relished the idea of holing up in his newly built home studio, 5150, and crafting songs that would be remembered as more than mere contractual obligations. Although no longer afraid of visiting exotic locales, Edward still was happiest when left alone with his guitar in Southern California.

Alex and Michael were more pliable and basically said they would do whatever seemed to be best for the band, so I arranged a meeting with the promoter, who did a superb job of selling the tour to everyone, and in the end we agreed to a short and manageable tour: sixteen dates in thirty-two days, with multiple performances in some cities, thus allowing us to settle in for a period of time and actually relax. I wouldn't exactly call it a vacation, but it had the potential to be a legitimately enjoyable experience, as opposed to the sort of grinding tour to which we had grown accustomed, and which tended to leave us exhausted and at each other's throats by the end.

In late December I flew down to South America with our tour manager and stage manager, and we met up with the promoter and did a whirlwind tour of all the different venues under consideration. I always enjoyed the advance tours. They were quieter, less stressful, but obviously important from a logistical standpoint. For example, we visited one place in which we were supposed to set up the stage on an indoor basketball court, and we quickly realized that the weight of our gear would have caused the floor to sink. The advance tour allowed us to avoid these potential disasters well ahead of time and to plan accordingly.

While the advance tour was usually short on debauchery, it

did sometimes offer interesting experiences. On the final day of the advance, when we visited Caracas, a massive, pulsating city I had never experienced before, I was treated to a particularly potent strain of marijuana. Someone handed me a joint after dinner, I took a couple hits as I always did, expecting nothing more than the usual California mellow high, and suddenly found myself wandering around the city alone, stoned out of my mind, half trying to find my way home, and half just content to absorb the city's beauty and energy. I couldn't remember the name of my hotel, nor the neighborhood in which it was located, so there was no point in hailing a cab for assistance. Instead, I just strolled aimlessly, hoping I'd see something familiar or my memory would be jolted. Neither of those things happened, until I thrust my hands deep into my jacket for warmth and came across a matchbook bearing the name of my hotel. A half hour later, just as the sun came up, I walked into my hotel room. I had only a couple hours before my plane was scheduled to leave for Los Angeles, so I changed clothes quickly, stuffed everything into a suitcase, and grabbed a taxi for the airport. I made the flight with only minutes to spare.

Once home I called a meeting with the band, the point of which was to get them pumped up about the South American tour and also to reiterate the plans for the upcoming year. I pulled no punches this time, reminding them that they needed to take their time and improve the quality of the next record.

They kind of looked at me sideways, and no one really said anything. They knew I was right.

"So what do you want to do?" David asked. "We've tried taking time off in the past; it never happens. You know that."

"I understand. But this time it will happen. I promise to protect you guys. If you agree to take your time and make the best Van Halen album you can possibly make, I'll keep the label off your back. We'll take the whole year off after we go to South America. No touring. Just write a bunch of great fucking songs."

"One question," Al said.

"Yeah?"

"How will we make money?"

Honestly, money should not have been an issue. We'd all made enough in the previous couple years to be comfortable for a while. Rock stars, however, aren't exactly frugal, and Al was the least frugal of the group. So I understood his concern.

"Something will happen," I said. "Don't worry about money. We'll figure it out."

WE CALLED IT THE NO PROBLEMS TOUR, and for the most part that's exactly what it was, although we got off to a bit of a rough start. The promoter, you see, turned out to be an untrustworthy prick, which is not at all uncommon in that line of work but was distressing nonetheless. We arrived in Caracas in mid-January to discover that several dates had been added to the tour, usually in the form of a second or third show added to a particular city and venue. While this made for a more leisurely tour, it also put pressure on us to sell more tickets in a place where we had not yet established much of a foothold. I wanted the band booked into modest venues of three thousand to eight thousand seats, which would ensure sold-out venues and lively performances that would look great on video. But three shows on consecutive nights in a single city meant we had to sell three times as many tickets, and that was a challenge. Right from the beginning the band found itself playing to half-empty arenas. To say this pissed them off would be an understatement.

"What the fuck is going on?" David asked me during the first few nights in Caracas. "We're playing to orange seats out there. This is ridiculous."

"Orange seats" was a reference to empty seats—as in the color of the actual chair, visible only when it isn't occupied. It had been a long time since Van Halen played to orange seats. I had several heated discussions with the promoter, who ultimately left the tour and turned everything over to his assistant, who also happened to be his daughter. Fortunately,

she was far more adept than her old man, and much better at human interaction. In our last conversation before he left, the promoter had threatened me with the following declaration: "I know Los Angeles, and I know where you live."

Now, if I had still been single, I would have said, "Fuck you, I'll leave the door unlocked," and let it go at that. But since Jan and I had moved in together and would be getting married in a few months, I no longer took these types of threats lightly. The world was a hard place filled with bad people; I'd met enough of them to know. And this guy definitely fell under the umbrella of "bad"—he had both the means and the temperament to do damage to anyone who crossed his path. When someone threatened me, they were, by implication, threatening the people I loved most. So I did not just casually dismiss it. Instead, I called Jan in LA and told her about my falling-out with the promoter and what he had said. I also told her that she would have a bodyguard available 24/7 until I got back in the States.

"Don't you think you're overreacting?" she asked. "I mean, this guy isn't dangerous, right? He's just pissed off."

"He's more than pissed off."

"Okay, well, I still think you're being paranoid."

"Yup, that's me. Regardless, you're going to have an LAPD officer in plainclothes wherever you go."

So Jan had to explain to her family that she would have a shadow everywhere she went—including her brother's upcoming wedding. Maybe this was excessive, but it gave me peace of mind. Security was an accepted expense for the band and any of its family members. And I was part of the band.

Once we settled in, there were no problems with the No Problems tour. In fact, I look back on that brief little sojourn to South America as one of the highlights of my time with Van Halen, a period during which everyone got along well and had fun and played great shows night after night. There were no fights, or at least none that I can recall. The boys had rarely gotten along so well on the road, and they never would again. How do I explain this? Well, I think it was a combination of

factors: lovely, exotic cities; great food and weather; beautiful, endless beaches and even more beautiful women; and above all, the fact that it was a short and sweet tour. When you go out on tour for six, eight, ten months at a time, it can be incredibly daunting. The road loses its allure after a while and you spend a lot of time longing for home and growing irritated with your bandmates and crew. This was one month, after which we all knew we were returning to our homes and wives and girlfriends and families. We had never done this before, and it proved to be a wonderful experiment.

I used to measure the band's mood by the amount of damage they did on the road—food tossed, hotel rooms trashed, chairs broken. In South America we didn't Van Halenize anything. There was no trashing. There was no demolishing, largely because of the guys' perpetually sunny dispositions.

So, while I wouldn't say the boys were on their "best" behavior, they certainly were better behaved than on almost any other tour. Part of this, I suppose, could be attributed to the fact that South America is a unique place in so many ways—not just in terms of its beauty but also its frightening and often violent history. Simply put, you didn't fuck with the authorities in most South American countries . . . unless you were a complete fool. And while the guys in Van Halen might not have been the brightest of bulbs, they were smart enough to know they didn't want to spend time in a South American jail. These countries were basically run by military juntas; our protection while visiting there was provided mostly by the equivalent of CIA agents. It was all very dark and mysterious, and we learned quickly to keep our mouths shut and our eyes open.

"You guys fuck up down here, you're in big trouble," I said. "You don't want to end up in prison here. For one thing, I'm not sure I'll be able to get you out."

The thing is, when you're not trashing hotel rooms or otherwise attracting unwanted attention, you can do pretty much whatever you want. There was no shortage of quality krell and weed in South America, as you might imagine, and we par-

took freely. But everyone was in such a good mood that things never got out of hand. Valerie Bertinelli came with us on the tour, and she and Ed were still in the honeymoon stage, so they got along wonderfully, and Al spent most of his time tagging along with them. Michael's wife, Sue, also made the trip, and they were, as always, just happy to spend time together. David, meanwhile, was off doing the rock star thing, chasing one beautiful woman after another. So it wasn't like we were all hanging out together every night. But that was okay. We rehearsed and performed and fulfilled media obligations, and then everyone did what they wanted at night. Sometimes we'd all get together for dinner, sometimes not. There was no anger or jealousy. It was just a happy time and, in many ways, the most productive and fulfilling tour we ever did.

The crew loved the tour, as well, primarily because of the easy access to high-quality weed, but also because they had lots of time to smoke it and otherwise relax. Think about it: instead of setting up and tearing down the stage every night, they'd have three or four days in each city before moving on. This was a luxury rarely afforded our road crew, and they made the most of it. But again, not in a wild or destructive way; it was more like they just appreciated their good fortune and didn't want to do anything to fuck it up.

Here's the thing I discovered in South America: individually, the guys in Van Halen were generally agreeable and friendly people; even David, when separated from the claustrophobia and stress of the band, was at least tolerable. When thrown into the same space, fighting for oxygen, day after day—whether on the road or in the studio—they got on each other's nerves, and they got on my nerves (and I suppose I got on theirs). But when given room to breathe and time apart, we all got along just fine.

This helped us deal with a significant degree of culture shock. I think the boys figured that since they were going to South America, there would be a degree of comfort and familiarity, though I had warned them otherwise. Aside from Japan, they had never been to a place where so few people

spoke English. I mean, even in the handful of European countries where English is spoken only grudgingly, you can get by without speaking the native tongue. But in most of South America, this was simply not the case. Despite having grown up in Southern California, the guys did not speak a word of Spanish, and even if they had, it wouldn't have helped them in Brazil, for example, where we spent nearly two weeks, and where the native language is Portuguese. For the most part, the locals would stare at you blankly if you tried to speak to them in English; an exception was if you referred to yourself as an American, because, of course, they considered themselves Americans, as well.

We also had to get accustomed to the idea that just because a place was beautiful and exciting did not necessarily mean that it was safe. In Rio, the cabdrivers never stopped for red lights, especially at night, because they feared being robbed or carjacked, or simply executed. The city was that dangerous. The first time I took a cab in Rio I found myself in the backseat, clutching the armrests as we sped through town toward our hotel, ignoring stop signs and traffic lights at every intersection. The driver did not appear frightened but merely resolved. This was simply the unwritten rule.

Do not stop. Ever.

It was like going back in time thirty years to a beautiful yet almost lawless nation. Not quite like Castro's Cuba, but it certainly had an old-world feel to it. In most countries, each band member, including me, was assigned a bodyguard. A gun-carrying, hard-core bodyguard. This wasn't something I demanded or even requested; it was arranged by a promoter. The bodyguards were clearly serious men with military or law enforcement backgrounds, but they were all unfailingly pleasant and helpful. It was different in every city, but they mostly spoke English and were more than happy to accompany us anywhere we went. They could serve as tour guide or enforcer—whatever you needed—and it was comforting to have them with us, since their presence allowed us to enjoy

South America with a degree of comfort and security very few tourists would ever have.

No request was deemed inappropriate. In São Paolo, I was given a tour of their secret, underground CIA police headquarters, which was both fascinating and frightening. This never would have happened in the United States. And it was easy! I said to the promoter, "I want to see what security is like in this city," and the next thing I knew, I was in a bunker, getting a tour of the nerve center. The equipment looked somewhat antiquated, but there is no denying that they had a very secure system. In a conversation with the head of their version of the CIA, I was informed that he could ensure that the Brazilian portion of our tour went quite smoothly. It would cost only five thousand dollars. I did not ask how that money would be used. I merely wrote the check. And, indeed, we had no problems in Brazil.

As everywhere, cash is king.

You have to remember, most of South America had experienced multiple and major revolutions in the previous two decades, and most of them were much longer and bloodier than Argentina's conflict with Great Britain over the Falkland Islands in 1982, when the mighty Brits beat the Argentineans out of an island of sheep.

Most of the revolutions were much nastier, and all of them were put down with a mighty fist. Protesters were herded up, tossed into soccer stadiums, and in many cases never heard from again. That sense of control through fear and intimidation was pervasive on much of the continent, and you felt it even when traveling first-class, as we obviously did. We would hear the most callous remarks delivered with deadpan innocence. As we passed through Argentina into Chile, for example, I noticed a surprising lack of border security.

"How do you know this is even a border?" I asked.

The response from one of our bodyguards: "It's easy. When you start seeing black faces, you know you're in Chile."

From Brazil we went to Uruguay, for a single show at the

Cilindro Municipal in Montevideo. We arrived on February 3, 1983, around two in the afternoon, two days before our show. The local promoter was also a general in the Uruguayan Army. Interesting combination, huh? Military officer and concert promoter. The show was sponsored by CX 50 Independencia Radio, which sounds like the name of what should be a liberal, independent entity but was, in actuality, a government-owned radio station. We were staying at the Victoria Plaza Hotel at Plaza Independencia. From these names you get the idea: the Uruguayan revolution of 1973 truly had changed the country, initiating a military dictatorship that endured until the mid-1980s.

When we were there, it was apparent that the junta was completely in charge of everything. This was intimidating but also somewhat reassuring. As long as we stayed on the right side of the law and generally behaved appropriately, we would be treated very well. We were not citizens, and we were not ordinary tourists. We were rock stars, which made us very special guests indeed. Montevideo was the only place where we had a motorcade waiting to take us from the airport to our hotel: a veritable fleet of open-air limousines so that we could take in the sights on the drive. Montevideo was Nirvana for my boys. For the band and crew, it was just a fantastic place— fun, sun, drugs, women, and all the ingredients to finally make them a happy bunch of road warriors. And I stress that they were happy, because I had never seen them all like this. And I never would again. There was no snipping and sniping and all that other bullshit. We were united in a single cause: have fun and put on some great concerts. If I could have bottled this extraordinary elixir, we would still be touring today.

But you can't create the perfect scenario; it happens organically.

Montevideo was the biggest show of the tour. The Cilindro Municipal was an 18,000-seat arena, often used to host athletic events, and easily the largest venue that we played the entire tour. At the time, I didn't know that this arena is where they had warehoused the revolutionaries a decade earlier, and

where many executions had taken place, so I didn't have a creeping sense of dread when I walked into the building. In a way, I'm grateful for that. I'm not one to overlook history, but there is unquestionably something daunting about playing in an arena that has such a sad and violent past. And I know it would have freaked out the guys in the band. Sometimes it's just better to be blissfully ignorant.

The Cilindro was a huge cement circular structure—literally shaped like a cylinder, or a thick grain silo—that seemed capable of withstanding a thermonuclear attack. Or at least an airborne strike. It looked and felt like a massive, round fortress. However, in the opinion of the promoter, backed up by several high-ranking military officers who for some reason were deeply involved in decisions related to our show, was that Van Halen's sound system would do irreparable damage to the building. That only sounds like a joke; in fact, they were quite serious.

"What the fuck are they talking about?" David said when I told the guys of these concerns. "We're a rock 'n' roll band. We're loud. What are we supposed to do about it?"

"I'm not sure," I said. "But I do know that you don't argue with the junta. The army has no desire to see this fortress collapse on the audience. The last thing they need is another revolution because of a Van Halen concert. And, frankly, we don't need that either."

I tried to explain to the promoter that we had played hundreds of shows all over the world, often in arenas older and less stable than Cilindro Municipal.

"You're worrying about nothing," I said. "The building will be fine."

"I believe you, Noel," he said, "but I'm sorry. The generals won't go along with it. And I won't go along with it. I need proof that the building can withstand this much noise."

So we gave them proof. On the day before the show we set up all our equipment and cranked up the sound system as loud as it would go. And there, on the left side of the arena, sitting together like statues in the first few rows, were more

than a dozen ancient generals, all decked out in their brass-emblazoned uniforms. These guys had enough medals on their chests to make them stoop-shouldered; or maybe that was just because the average age appeared to be roughly eighty. They sat there stone-faced—not a smile among them, which kind of gave me chills—as we filled the arena with white noise. We didn't get out there and play or anything; we didn't even run a recording of our music. No, instead we just punished them with . . . sound. Rumbling, whining, high-pitched noise. The kind that would make most people run for cover.

We hit 115 decibels. No reaction from the generals.

Then 120. Still no response.

Eventually we pushed the sound all the way up to 135 decibels. By this time I had retreated to the dressing room with the band. We were all covering our ears and crying out in pain. But out in the arena, apparently, more than a dozen fossilized Uruguayan generals were barely affected. Maybe they were the toughest guys on earth. Or, more likely, they were deaf. Regardless, the Cilindro Muncipal withstood the aural onslaught, and Van Halen was given the go-ahead to play its concert the following night. Hallelujah!

From Uruguay, we traveled to Buenos Aires, Argentina, for a pair of concerts at the Estadia Obras Sanitarias. Great shows, great audiences, absolutely no problems. We were getting ready to go home, and the boys were all in good spirits. After the second show, the local promoter invited me to dinner, along with our state-sponsored security team of CIA agents—or the Argentinian equivalent, at least. Despite the fact that they were uniformly thin and lightly muscled, this was an intimidating and serious collection of men. They all wore black jackets with white shirts and thin black ties. They all had pencil-thin mustaches and ink-black hair that was slicked back with what I can only assume was a good portion of the world's supply of hair gel, or at least the country's (no small feat in 1983, let me tell you). They wore blank expressions, as if trained to reveal not the slightest hint of emotion (which I'm sure was the case). There was very little conversa-

tion during dinner, in part because of the language barrier, but also because, well, I don't think these guys were accustomed to making small talk. But at one point, near the end of the meal, the head of security asked me a rather pointed question. There was no prelude to it, just the strangest question that came out of the blue.

"So, Mr. Monk. Tell me—how many men have you killed?"

I expected laughter, but there was none. Instead, every head at the table turned to me, and waited to hear my response. I sat there quietly for a moment, fork in hand, before finally answering.

"None . . . that I know of."

With that, everybody at the table cracked up. They nodded knowingly at one another and spoke in whispered, rapid bites of Spanish, none of which I understood. But I got the gist of it. I realized then that these were not ordinary security officers but rather the best of the best (or the worst of the worst). These were men who had worked in the death squads; these were men who had rounded up revolutionaries and made them disappear. A chill went down my spine as I forced a weak smile and tried to go back to my meal. But my appetite was gone.

Unpleasant moments like this aside, even today this South American tour stands out in my memory. It wasn't just that everyone was getting along, it was more that it felt like old times, like a return to what things had been like. Everyone seemed to enjoy things in a way that they hadn't in a long while. It was a memorable tour for all the right reasons—the sense of camaraderie, brotherhood, and entertainment—but those same reasons were also what made it so fleeting. That tour was a lot of great things, but most of all, it was a high point that we would never return to.

ON FEBRUARY 14, 1983, I flew back from Buenos Aires to Los Angeles, along with most of the band. I say most, because David took a side trip with Ed Anderson to the Amazon rain forest. The road crew, meanwhile, remained in Bue-

nos Aires to load up the equipment and pay for shipment. This was another example of a promoter fucking with us: he tried to keep the equipment in Argentina because . . . well, because he could. I was gone and so he had to deal with only my crew. Eventually we got our equipment back, and while this particular incident left a slightly sour taste in my mouth, it went virtually unnoticed by the band. For them, this truly was the No Problems tour.

Once home, the band casually went about the business of preparing to record its next album. For a while, this mostly consisted of Edward hanging out at home in 5150 and playing with guitars and keyboards and synthesizers into the wee hours. We had no plans to play another live show until the new album was released, presumably sometime in the next year.

Then I got a phone call from Steve Wozniak, cofounder of Apple and also the money behind a massive concert event known as the US Festival. Maybe it had something to do with his being part of the Woodstock generation (as well as one of the most successful entrepreneurs of his generation), but Wozniak was committed to putting together an eclectic festival that would be "the musical event of the 80s," as the US Festival was breathlessly billed. In fact, this was the second version of the US Festival, the first having been held in 1982, over the course of three days on Labor Day weekend. This one would be bigger and better, Wozniak promised. Four days instead of three, at Glen Helen Regional Park in San Bernardino, California. Each day would be ascribed a particular theme or musical genre: punk/new wave one day, rock on the second day, heavy metal on the third, and country on the last day.

Van Halen, he said, would be the headliner on heavy metal day.

At first I was not interested. Festivals tend to be a pain in the ass, a logistical nightmare not worth the headache or the financial expense. Moreover, I wanted the band to continue to focus on writing and recording the best album they could possibly produce.

"What date are we talking about?" I asked Steve. If it was

Labor Day, or even midsummer, we might be able to squeeze it in.

"Memorial Day weekend," he answered.

I explained that this would not give us a lot of time to prepare, and that we were just getting started on a new album. I didn't want to be rude, because I appreciated what Steve was trying to do—he did seem to have a lot of passion for the project, which he viewed as a vehicle for blending music and technology to help make society better and more unified. Or some such bullshit. Like I said, he was a child of the sixties. As was I, of course, but I was a bit more practical.

"I don't know, Steve. I'm not sure this is a great idea for us right now."

"We're willing to pay you pretty well for your time," he explained. "You might want to think about it."

"How much?"

"A million and a half."

After five and a half years with one of the biggest bands in the world, I did not think there were many offers that would leave me even momentarily speechless, but this one did. I mean $1.5 million for a single 75-minute show? Sure—why not? You don't say no to that kind of offer. I mean, you can't.

I took it to the band and, predictably, they felt exactly as I did—that the money was simply too good to pass up. That said, I thought I'd try and squeeze a little bit more out of the promoters. Call me Icarus, but it paid off. See, what happened is that I decided to slip an unassuming little clause into the band's contract, called a "Most Favored Nation Deal." In essence, it said that no band could be paid more than we were. Well, in the following weeks, as more acts were added to the festival, David Bowie's team hiked up their fee, requesting a cool fifty thousand extra to cover the costs of transporting his equipment across the pond. That's when my clause kicked in. Suddenly, Van Halen was owed another fifty thousand, as well.

When Steve Wozniak called me up to tell me the good news, I couldn't have been happier. With the wind beneath my wings, so to speak, I felt like nothing could bring me down.

The truth was, I did indeed fly a little too close to the sun. The US festival, it turned out, was significantly more work and expense than we had anticipated, and we were all nearly clipped.

There was rehearsal space to rent, merchandise to prepare, a stage set to design. We couldn't just show up at the US Festival, in front of a couple hundred thousand people, and simply go through the motions like it was a club date. When you take a record-breaking paycheck, you're supposed to put on a record-breaking show. Or at least a memorable show. And memorable it was, although not exclusively for the right reasons.

But the preparation was actually kind of fun. We were excited to be part of this event, and not just a part but the headliner on a day that also included Ozzy Osbourne. So that was kind of cool—in just a few short years we had gone from opening for Ozzy to having him open for us (I don't believe he was paid even half the fee Van Halen received). Everything about my life was pretty fucking great during this short but wonderful time. I was the manager of the biggest band in the world, and for a change everyone was getting along.

For me, it wasn't just professional contentment. On April 24, Janice Cutler and I got married. We had met a couple years earlier, when I bought a guard dog from a company for which Jan was working. She quickly became my closest confidante and best friend, and the person with whom I would share all (or at least most) of the crazy stories of life on the road with Van Halen. Some of these she lived herself after we got married. The point is, I was happy. We all were happy, relatively speaking. But the band was far closer to breaking up than any of us realized, and while the album that would become *1984* helped set us simultaneously on the road to riches and ruin, it was at the US Festival that things began to turn weird.

Van Halen appeared on day three of the event. The other acts were allowed to sell their merchandise only on the day they appeared, but I negotiated, without much fuss, into our contract the right to sell Van Halen gear on each of the first

three days (we didn't bother with day four—not a lot of over-lap between our fans and the fans of Ricky Skaggs). Between merchandise, rehearsal time, and equipment prep, we spent nearly a hundred thousand dollars preparing for the US Festival. In the days leading up to the event, I was confident that everything would go well. Having been off the road for a few months, the guys were relaxed and excited about performing. What could possibly go wrong?

I still felt that way midafternoon, when I wandered over to the center stage to see how preparations for our set were going. I had left David behind in the trailer with our publicist, Steve Mandel. David liked to drink a little before going out on-stage, but very rarely had he imbibed so heavily that it affected his performance. There were a few times overseas when David had gotten drunk before media appearances, which made for interesting TV, but in the States he had always been smart enough to keep things under control. So imagine my surprise when I returned to the trailer a couple hours later and found David drunk and krelled out of his mind. I mean, I was morti-fied; he could barely stand up.

"What the fuck happened?" I said.

Steve threw his hands in the air. He wore a look of utter surrender.

"I don't know. I just . . . I couldn't stop him."

This I did not doubt in the least. If David wanted to get fucked up, he was going to get fucked up, and there was no force on earth that could stop him. The thing is, in the past, David had always known when to pump the brakes. You par-tied after the show, not before the show. And certainly not before the biggest concert of your career.

To put it mildly, this was not a good night for me or my band. In front of a couple hundred thousand people, and the largest collection of media ever assembled for a concert, Van Halen went out and nearly shit the bed. The best front man in rock 'n' roll slurred his way through a bunch of pre-show in-terviews, including, most notably, a nationally broadcast and

highly embarrassing conversation with MTV's Mark Goodman, in which David told a bunch of bad jokes that only he found particularly funny.

Actually, our lead singer was one of only two completely fucked-up Davids I had to contend with that night. The other David was Jan's brother. He and his wife, an old friend of Jan's, had been invited for the weekend by us. Since I would be working the whole time, David and his wife were company for Jan. Unknown to me, David had spent the afternoon of the US Festival alternately smoking weed, snorting coke, and drinking the very potent drinks served by the bartender at the backstage party area.

As Van Halen was about to go on, a bunch of us stood off to the side, just at the edge of the stage. I made sure they were safe and comfortable and could see the show, and then I left to check on the band. I didn't see any of them again until the next day. I missed a lot, as it turned out.

My brother-in-law got completely wasted, to the point where he became sick and had to be taken by ambulance to a temporary clinic a short distance away. He was accompanied by his wife and the band's attorney, Jules Zalon. Jules had just been to our wedding a few months before and had stayed with us for a fun-filled weekend recently. He was an old and trusted friend as well as a vital part of our merchandising company. He had flown out to California from New Jersey with his wife expressly to be at the US Festival. Needless to say, his weekend did not go exactly as planned. Not only did he miss much of the show, but on the drive to the clinic, David vomited into Jules's lap. Jan spent the rest of the night doing damage control. She knew that I would ban her brother from future band functions if I found out what had what happened. She also knew that I had my hands full with Van Halen business and, tonight in particular, festival business. So, although she wasn't one to lie to me or keep the truth from me, she decided this was something I didn't need to know. Everyone else agreed with her. Eventually, much later, I did find about the incident, which, in retrospect, was a fitting footnote to an

altogether horrible day, one of my worst as the manager of Van Halen.

While the vomit was hitting the fan around one David, I was watching the other David put on the worst performance I had ever seen from him. Now, admittedly, the bar was set pretty high with David. He was not one to simply go through the motions during a live performance. He lived to be onstage, and gave his best effort every night. When you came to a Van Halen concert, you expected to see Eddie Van Halen producing sparks with his fretwork, and you expected to see David Lee Roth dancing across the stage and jumping off the drum riser. It was part of the compact between band and fan. But on this night David did not live up to the terms of the deal. He forgot lyrics, staggered awkwardly around the stage, and for some reason kept saying, "Come on, folks, let's go across the street and have a drink!"

It was obvious to just about everyone—fans and media— that David was completely wasted. After the show there was a big party, but I was so depressed and ashamed that I didn't even want to take part. I crawled into our tour bus with a bottle of vodka and drank myself to sleep. My absence eventually went noticed and Jan came to check on me. After declining to join me in my impromptu pity party, she had the smarts to leave me to my own devices for the night.

The next day I didn't even want to read the trades or the newspapers to see what people had said about the show. I expected to be slaughtered. But when news began to trickle in, it wasn't nearly as bad as I anticipated. Despite what I had witnessed, it seemed that the band had played well enough to cover for the singer's inebriation; and anyway, David appeared to be having a good time onstage, which after all was a Van Halen hallmark.

At the end of the week I got a call from Unison, the production company charged with making a concert video for the US Festival. They needed three songs from Van Halen but couldn't find enough images of David jumping—this was a signature move, after all, and you couldn't very well make a

Van Halen video without repeated images of David soaring through the air, legs splayed like a gymnast's.

"Seriously," the guy said to me. "I don't think he got off the floor all night."

What could I say? I apologized, wished him luck, and hung up the phone.

Improbably, over the next couple months, the legend of Van Halen, buoyed by a drunken, subpar performance at the US Festival, continued to grow. It was some sort of cosmic joke: we disappeared for three months, played one concert with a shitfaced front man, and then disappeared again. And somehow, this only served to broaden the band's appeal.

Meanwhile, the boys were in the studio, day after relentless day, fighting and bickering over artistic and personal issues while ingesting a lot of cocaine and alcohol and weed. All of this would result somehow in Van Halen's most ambitious and successful album: *1984*.

They didn't know it at the time, and neither did I, but this was the beginning of the end.

15

1984

I'll be honest: by fall of 1983 I had little faith that Van Halen was putting the finishing touches on a masterpiece. I hadn't heard any tracks off the album that would become *1984*. I hadn't even heard much positive news coming from any of the band members. As usual, I stayed away from the studio, so I wasn't privy to actual recording sessions, but what little information I did receive was hardly encouraging.

For one thing, I was habitually sleep deprived, thanks to a seemingly endless barrage of phone calls in the middle of the night, a sure sign that the band, along with producer Ted Templeman, had managed to completely fuck up their circadian rhythms. They would work deep into the night or early morning, usually with vast amounts of cocaine and alcohol fueling the sessions, then sleep all day. Then they would repeat the process. I would get phone calls from David or Edward at three in the morning, and rarely did the voice on the other end

sound remotely sober. Nor did it sound particularly happy. Anger and frustration were the norm, with the caller complaining about . . . well . . . almost everything, but usually about one of the other band members or the producer. Many times I could hear the sound of equipment being abused or destroyed in the background, as Edward laid waste to his own studio.

The reason for his anger? I can't say for sure, but certainly the explanation provided over the years is not entirely without merit: artistic differences. Edward had one vision for *1984* (and for the direction Van Halen would take moving forward), while David and Ted Templeman had an entirely different vision. Edward, you see, had fallen in love with technology, primarily synthesizers and keyboards, and was adamant that these elements be heavily incorporated into the new album. David and Ted wanted to stick with a more guitar-heavy album—hewing closer to the sound for which Van Halen was traditionally known, and which, admittedly, had served the band well. You can't argue with success, right? (This obviously is somewhat counterintuitive, given that Edward was the guitar virtuoso and David was the singer who would soon become obsessed with cheesy remakes.)

Again, though, it should be pointed out that Edward was no ordinary metalhead. He had grown up in a musical family, had learned to play the piano at a very young age, and had always been prone to pushing the envelope when it came to writing and performing music. The fact that Ed was the most innovative and interesting guitarist of his generation might seem on the surface to make him an unlikely candidate to write and record an album filled with soaring keyboards and synthesizer hooks, but that's true only if you didn't really know the guy. Edward was thinking way outside the box long before there even was a box.

Doesn't mean he wasn't occasionally a gigantic pain in the ass, especially when he'd been drinking or doing lots of coke, but I forgave Edward a lot because he was so obviously the cornerstone of the band. And because, when sober, he was a genuinely sweet and introspective guy.

By the time the band went into the studio to begin recording *1984*, however, Edward had grown weary of two things: repeating the same formula, album after album; and putting up with David's bullying and bullshit. Had this been another balls-to-the-wall project—in and out of the studio in just a few weeks—their differences might not have escalated to the point that they did. But, over the course of many months and many fights, exacerbated by heavy drug use, their relationship unraveled. Never particularly close, Edward and David became that most familiar rock 'n' roll cliché: a lead singer and guitar player who could barely stand each other.

The irony that all the extra time in the studio had driven a wedge in Van Halen was not lost on me. After those years of trying, in vain, to get them an extended slot of recording time, we'd finally achieved it, but at the expense of perhaps the last few ties holding the band together. We were all so focused on giving them the space they needed to record that it never occurred to me it would be anything but an asset. But sitting in a tight space like a studio, night after night, week after week, can do odd things to people, especially when drugs and alcohol are involved. With some bands these experiences bring them together as they coalesce around a shared vision for the album, the band, and the future; with Van Halen it was the exact opposite, shining light on all the problems lying dormant just below the surface.

All this made my job exceedingly difficult. In addition to taking drunken calls and trying to referee disputes by phone, I would sometimes meet with the guys in my office, discuss plans or other matters for the next tour, and then get a call twelve hours later from David or Edward or Al asking me to cover the same territory all over again. Trust me when I say this: there is almost nothing that provokes more anxiety for a manager than the nagging sense that his band is incapable of paying attention to pressing business matters. And this is particularly true for a manager who does not have a long-term contract.

So it was with some trepidation that I gathered everyone

together in the fall of 1983 to discuss plans for the coming year. The album was nearly done, and it was time to start thinking about getting back out on the road. Given the stress of the preceding months, and the sheer volume of strange conversations I had endured, this particular meeting went reasonably well. Among the topics covered: the possibility of Van Halen's entering into the highly lucrative and low-maintenance world of sponsorship.

"It's time," I explained. "Most bands are doing it, and it's easy money just waiting to be collected."

All this was true. Product endorsement, once seen as contrary to the very soul of rock 'n' roll rebellion, by this time had become a significant revenue stream for many bands; as one of the biggest acts in the business, Van Halen had the opportunity to greatly increase its income while hardly lifting a finger.

"What do you say?" I asked. "Would you like me to solicit offers?"

They all nodded in agreement. Done deal, I figured. No-brainer.

A couple weeks later I went off to New York to finalize plans for the tour and to meet with a representative of a large and well-known advertising agency. Together we negotiated a deal with Sparkomatic, a company that specialized in high-end audio products, primarily for the automotive industry. To me it seemed like a logical fit, and the money was borderline crazy. The band would receive $1.2 million up front, in addition to additional revenue for advertising. In return, all we had to do was put the company's name on some of our licensed merchandise, in very small letters.

That's it.

We didn't have to participate in commercials or appear at trade shows or (God help us) perform some silly jingle. Just give Sparkomatic a small piece of real estate on Van Halen merchandise.

In exchange for $1.2 million.

The day we completed this deal, after several weeks of ne-

gotiation, I couldn't wait to call the band and give them the great news. From my vantage point, this was one of the best deals I had ever negotiated on behalf of Van Halen, second only to the band's recording contract with Warner Bros. Jan was waiting for me at the hotel when I returned from closing the deal.

"How much did you get?" she asked.

When I told her the number, her eyes widened. "You've got to be kidding. That's fantastic."

I thought so, too. So I picked up the phone to deliver the great news to the band. They were all at Edward's house, awaiting my call. David got on the phone first.

"Hey, Noel . . . what's up?" He sounded sleepy, a little aggravated, which wasn't unusual for David in those days. Nor for any of the guys.

"Guess what?" I began. "I caught a deal for a million two hundred thousand dollars. For a sponsorship."

There was a long pause, as opposed to the celebratory yelp I had anticipated.

"Really? Who's the sponsor?" David said.

"Sparkomatic."

Another long pause, followed by a grumble. "Never heard of them."

I pressed on. "That's okay. You will hear about them; they're a big radio company and they have a lot of money to throw around. Trust me, this is good. Better than good; it's fantastic."

I could not believe that I had been put in the position of trying to convince David that a $1.2 million endorsement deal was a good thing, but that is what happened.

"Let me go ask the guys," he said.

Before I had a chance to respond, David dropped the phone. I strained to hear what was happening, but David apparently had left the room. A minute passed, maybe two minutes, before he got back on the line. Either this had been the shortest band summit in the history of Van Halen, or he hadn't actually talked to anyone. Either way, I had a sinking feeling in my stomach.

"Noel?"

"Yes?"

"Fuck it. We don't want the deal."

A wave of nausea swept through my body. I got light-headed.

"David," I began, trying not to sound like someone who wanted to reach through the phone and strangle him. "Think about this for a moment. This is an incredible offer. We're talking about a quarter of a million per person. And you don't have to do anything."

"Yeah, yeah. I get it. We're not interested."

"Well, what exactly *are* you interested in, David? I mean, we want to make money, right?"

"Not like this," he said. "You want to get us a sponsorship, fine. Make it Marlboro or Levi's. Otherwise, it's fuck you."

Fuck you? Really?

This was pigheaded even by David's standards. Suddenly the most cynical member of the band wasn't interested in making money.

"David, you've got to be kidding," I said. "This is a tremendous opportunity."

"I'm not kidding," he said. "Levi's or Marlboro . . . or fuck your million two."

With that, he hung up the phone. I sat there for a moment, dumbstruck. Then I did what any smart and somewhat desperate manager would do in that situation: I called him back.

"David, I just want to make sure you aren't fucking with me right now. You do understand this deal, right?"

"You heard me right. We're not interested. I don't want to do it, and the guys don't want to do it. I'll speak to you when you get back to LA."

Again, he hung up. And that was that. I let the phone hang by my side for a moment and looked at Jan, who had witnessed the entire conversation but obviously heard only my side of it.

"What happened?" she asked.

"David turned it down. He says he wants Marlboro or Levi's—and nothing else."

With a look of utter disbelief, Jan said, simply, "You're kidding."

I shook my head. "Unfortunately, no."

Jan got up and walked to the minibar, knowing full well that my next words would be, "Please get me a vodka." That night we went out to dinner, as planned, despite the fact that we no longer had anything to celebrate. The next day I reached out to my friend at the advertising agency and broke the bad news. He was shocked. We had spent a good deal of time putting this sweetheart of a deal together, and I had basically accepted it on behalf of the band. Not in my wildest dreams did I imagine that they would turn the offer down. It made me look bad, and it made my friend look bad.

"Noel, this is really unfortunate," he said.

"I know," I said. "We really appreciate all your help. You have been extremely nice and accommodating. All I can say is thank you . . . and I'm sorry."

"Yeah . . . maybe next time," he said, which was very gracious considering there wouldn't be a next time—not for me, anyway.

During the months that they'd been holed up in the studio working on *1984* and calling me at all hours, I came to understand that the band was in a difficult place creatively and personally, but it wasn't until this deal fell apart that I realized it was much worse than I'd thought. My band was in trouble, which meant I was in trouble. The serious problems with drugs and alcohol that had been present for years were not only causing interpersonal strife but, in my view, anyway, affecting the band's ability to make clearheaded decisions on important business matters. I will always believe that David turning down Sparkomatic had nothing to do with his taking a moral or creative stand—*I smoke Marlboros and wear Levi's, so fuck everyone else*—but rather an arbitrary and self-destructive declaration of power. To this day, I don't know what David said to the other guys in the band on the day that I called.

One could obviously argue that this is the lot of the manager: to solicit and field offers on behalf of his client, and not to take it personally when his client says no or otherwise disagrees with his point of view. I get that. It's not like David and I had seen eye to eye on everything over the years. But this was a seismic shift, as it represented, in my opinion, a degree of incompetence, or at least negligence, on the part of the man who carried the most weight when it came to band decisions.

Simply put, I thought David was being stupid.

But what could I do? Sure, we were equal partners in deals such as this, and I was not happy with the idea of losing a quarter of a million dollars out of my own pocket, but when you got right down to it, I worked for the band. David was my boss, and if he didn't want to endorse Sparkomatic, then it wasn't my job to force the deal down his throat. Nevertheless, my suspicion about the fractured nature of the band was confirmed a couple weeks later, after I had returned to LA, when I got a call one afternoon from Alex.

"Hey, Noel," he began, sounding much more charming and agreeable than usual. "Remember that endorsement deal? With . . ."

His voice trailed off. He couldn't even remember the company's name.

"Sparkomatic," I said.

"Yeah, those guys."

"What about it, Al?"

"You think we could still get that?"

My first thought was . . . *Are you fucking kidding me?* But I took a deep breath and tried to remain in calm, managerial mode.

"It's been more than two weeks, Al. I don't even know if the offer is still on the table."

"Yeah, I understand," he said. "Just give it a try, okay?"

Long pause, followed by the kind of compliment Al rarely, if ever delivered. "You're really good at this stuff, Noel."

"I'll see what I can do."

I did not ask Al whether he had spoken to David about any

of this. Al didn't need David's permission to speak with me about band business, nor to direct me to inquire about opportunities. In theory, Van Halen was a democracy, with all band members holding equal power. In reality, because David flexed his muscle much more aggressively than everyone else, this made him the de facto leader. Which was fine, until they began to disagree about matters large and small, and with increasing frequency. Whether this was one of those times, I can't say for sure. Maybe David had second thoughts about the Sparkomatic deal but was prevented by his enormous ego from asking me to inquire about its continued availability. So he dispatched Alex to do his dirty work. Or maybe Al spoke with Ed and together they decided to go behind David's back. (Michael, sadly, would probably have been left out of the discussion in either case.)

So I tucked my tail between my legs and reached out to my advertising friend in New York. It seems the guys have had a change of heart (or perhaps sobered up), I explained. Suddenly $1.2 million sounds pretty good, I explained. Any chance the deal is still on the table?

"Sorry, Noel," was the predictable response. "Supertramp took it."

This really hurt.

Whether the offer was equivalent to what Van Halen was offered, I do not know. Regardless, we were out of luck. I called Al back and gave him the bad but predictable news; he seemed genuinely disappointed. And not just disappointed in the loss of a great opportunity, but in the way it had gone down. Unfortunately, I'm not sure he understood what had happened. There was a disturbing undercurrent of judgment in his voice as we spoke, and while he didn't specifically accuse me of "blowing the deal," I got the impression he might have felt that way. Again, I had no way of knowing what David had communicated to the other band members about the offer. Communication was beginning to break down along multiple lines, which made my job exceedingly difficult.

Incredibly, rather than getting paid for allowing Sparkomatic

to put its logo on some of our merchandise, we ended up negotiating with another company to allow us to use their logo. Well, not the exact logo, but a portion of it. There was a company called Western Exterminator Company, whose logo included a character known as The Little Man, a dapper gent in a black coat and top hat wielding a very large wooden mallet, which presumably was used to obliterate various types of pests in the greater Los Angeles area. David loved this image and wanted to use The Little Man as a mascot for our 1984 tour.

"You think you can get permission for us to use this?" he asked me one day.

"I don't know, David, but I'll see what I can do. It's probably going to cost us some money."

"That's fine," he said. "I want to be able to use it."

So I called the company and I got them to understand that allowing Van Halen to "borrow" their logo—just the image of the little guy with the hammer, without the company's name attached—would be the best possible free advertising, and they gave us the logo for nothing (aside from some free concert tickets). We used the logo for the whole tour. Each night the backdrop onstage featured multiple images of The Little Man, mallet held high, as if to warn the audience that they were in for one seriously intense show.

It was all kind of clever and cute, and I was happy to have been able to help our lawyer negotiate the deal without writing a check. Still, it didn't exactly erase the pain of losing $1.2 million from Sparkomatic. At that point, it was pretty clear that not only was I not on the same page as my band but they weren't on the same page with each other.

THOUGH NONE OF US recognized it at the time, in many ways the band's only remaining hope was the new album itself—not just its performance or critical reception or the tour or its sales, but whether it could remind the band of why they were together in the first place and what made them

the best rock band on the planet. That's a lot of pressure to put on any album, but if there was an album good enough to pull it off, it was *1984*.

By the middle of November, *1984* was essentially in the can. All tracks recorded and mixed, waiting to be applied to vinyl and prepared for release. There was just one little problem. A prominent member of the studio recording team, anxious almost to the point of hysteria, thanks to all the cocaine used during the recording process, had confiscated the master tapes and locked himself in a closet in his home. He refused to give up the tapes until they were, in his opinion, perfect. Whatever that meant. In the interim, he said, he would have to keep the tapes by his side to prevent anyone from stealing them. Was any of this logical? Of course not, but drugs will make people do illogical things, and Van Halen by now was surrounded by heavy drug users, both in and out of the studio.

Rather than engage law enforcement in the dispute—that would only have created tons of bad publicity, and possibly endangered the safety of the master tapes—I reached out to a friend at Warner Bros. who had not only the clout to intervene but also the right temperament for this sort of work, which was akin to hostage negotiation. The master tapes were quietly and safely retrieved, and the album was put into production. No charges were filed, no intervention staged, no employment terminated—as far as I know.

I got my first taste of *1984* in early December, and I was completely blown away. I had been concerned because there had been so much drug use and bickering and other complications during the long months of writing and recording. I wondered what sort of artistic and creative toll all this might have taken on the band. There's been no shortage of great art arising from stressful and arduous situations; there's also no shortage of shitty records produced under the same conditions. It can go either way. So, when I first heard the album, I was holding my breath.

But not for long.

From the minute-long instrumental title track that kicks

off the album and runs straight into the soaring, infectious keyboard riff that opens "Jump," I was hooked. Better yet, I knew that millions of Van Halen fans (and millions of soon-to-be Van Halen fans) would also be hooked.

It was fucking brilliant.

It was their album, obviously, and primarily it was Edward's album. That much was apparent. But I gave myself a little managerial pat on the back, as well.

Hey, my bet paid off. Give these guys some time, pull them off the road and let them put all their effort into making great songs, and this is what you get: a fantastic album.

The downside to all this creative time in close proximity was a band that emerged from the studio fractured and hostile. But, hey, we had a great album! Surely that would be enough to heal all wounds. I tried not to focus on the personality conflicts that had arisen, and instead threw all my effort into working on the upcoming tour and helping to put together a promotional package for the album. It had been two years since Van Halen's last studio release, and no one had been particularly excited about that one. This time was different. The band knew they had produced a terrific album. I knew it. The label knew it.

As usual, David was more deeply involved in promotion than his bandmates were. Once the album was finished, the other guys would pretty much sit at home and drink and do coke and smoke weed, and wait for word on when the tour would begin. David would drink and do coke and smoke weed, but he would do it in the office, and somehow he would actually manage to get some work done.

As always, David was particularly interested in the album's cover art; he had a knack for that sort of thing and liked being involved in the process, which in the case of *1984* was not only complicated but, ultimately, controversial. The band commissioned artist Margo Nahas to produce the cover art: original instructions were sparse but indicated a desire to have a quartet of beautiful young women dancing in various stages of undress—in true Van Halen fashion. After a period of what I

assume was deep reflection, the artist declined to follow those instructions, which might ultimately have led to her being forced to walk away from the project had it not been for the intervention of her husband, who decided to show the band samples of her portfolio. One painting in particular jumped out at the boys: an image of a cherub leaning against a table, eyes gazing off into the distance, a cigarette perched between the fingers of his right hand, and two packs stacked in front of him.

The painting, Nahas would later explain, was her way of expressing her fascination with both angels and devils, and the balance between good and evil. Well, she hit the mark, that's for sure. I mean, a cigarette-smoking, blue-eyed, blond-haired cherub? It was perfect for Van Halen. The painting was modified for the album cover, which also bore the Roman numerals MCMLXXXIV (it became known colloquially as *1984* only after its release). Then we all sat back and waited for the predictable (and not unwanted) shit storm of criticism from tight-assed conservatives. There was an uproar in some corners—the cover was temporarily censored and modified in the United Kingdom through the addition of decals that blocked out both the cigarette in the cherub's hand, and the packs sitting in front of him—but most people seemed to love it. Moreover, history has been kind to the artist, as *1984* is widely acknowledged as among the most iconic album covers of its time.

Obviously it didn't hurt that the album was every bit as compelling and innovative as the jacket in which it was sold.

While *1984* wasn't released until January 9, 1984, the band announced its intentions some three weeks earlier, when "Jump" was issued as an advance single. It was the perfect introduction to the album, signaling as it did a shift in direction spearheaded by Edward. The song became the band's biggest hit (and still holds that distinction all these years later), reaching number 1 on the *Billboard* singles chart. The song's trademark is a synthesizer riff that Eddie had written a couple years earlier, when he first began experimenting with

keyboard effects. I don't think David liked it, and neither did Ted Templeman, but with a studio in his home and a growing need to flex his artistic muscle, Edward became less inclined to bend to the will of his more egotistical bandmate. Or to the producer. In the end, David went along, crafted some lyrics that were perfect for the song, and even came up with the melody.

So, in this case anyway, creative tension produced Van Halen's biggest hit single and established a foundation for *1984* to become the band's most successful album, both commercially (selling more than 10 million copies) and critically (four stars from *Rolling Stone*). There would be three more hit singles— "I'll Wait," "Panama," and "Hot for Teacher"—and a seemingly nonstop presence on MTV featuring raucous and bawdy videos. Thanks to *1984*, Van Halen *owned* 1984. From the outside looking in, I'm sure it seemed like we had the world by the balls. In reality, by the time *1984* was released, Van Halen was a band cracking at the edges and on the verge of an epic collapse.

And what do you do under those conditions?

Why, you hit the road, of course.

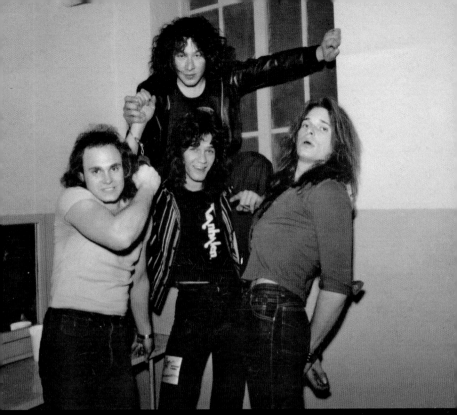

Backstage, 1978—with Michael, Alex, Edward, and David. When I first met them, they really were just four guys from Southern California.

Michael Anthony and his then-
girlfriend (now wife), Sue Anthony.

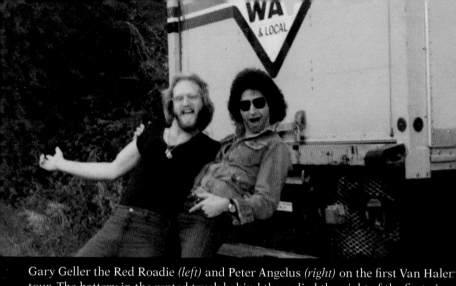

Gary Geller the Red Roadie *(left)* and Peter Angelus *(right)* on the first Van Halen tour. The battery in the rented truck behind them died the night of the first gig o the tour in Chicago at the Aragon Ballroom.

The logo on the Jimi Hendrix poster that turned up in a box of the band's things from Marshall Berle's office after he was let go. The similarities to the Van Halen logo hit me immediately.

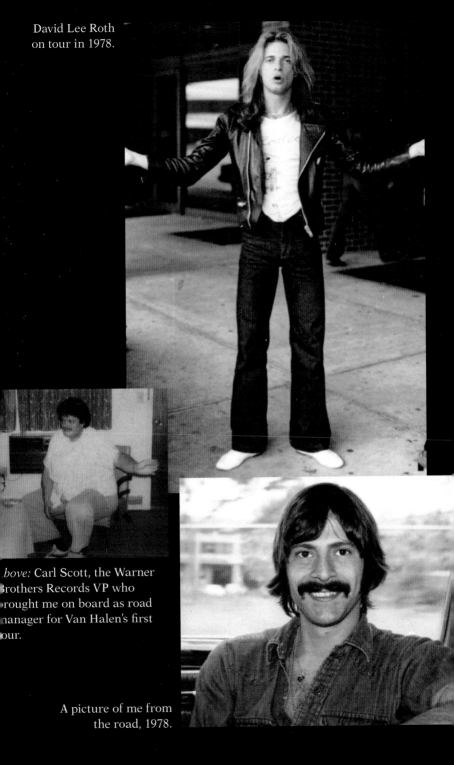

David Lee Roth
on tour in 1978.

above: Carl Scott, the Warner
Brothers Records VP who
brought me on board as road
manager for Van Halen's first
tour.

A picture of me from
the road, 1978.

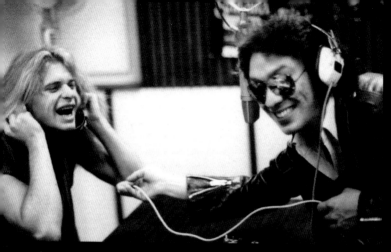

David and Alex, during a promotional trip to South Africa.

David and the South African cops.

David Lee Roth, 1979.

David checking out the view from a hotel window. Those first couple of years we were always on the road, but we loved it—all of us.

Below: Me (right), hanging out with Edward (left), and Alex (center) around 1980–81.

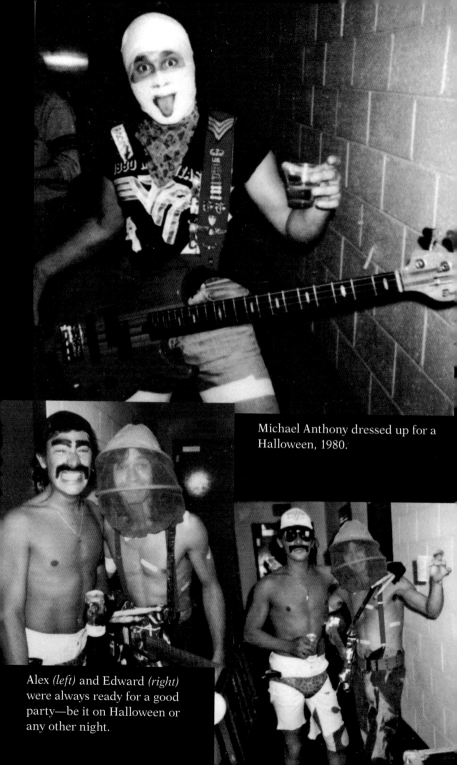

Michael Anthony dressed up for a Halloween, 1980.

Alex *(left)* and Edward *(right)* were always ready for a good party—be it on Halloween or any other night.

The whole band together on Halloween *(clockwise from the top)*, Alex, Michael, David, Edward).

Even on Halloween, he was still David Lee Roth.

A later Halloween with Edward and Valerie Bertinelli in which they dressed as each other.

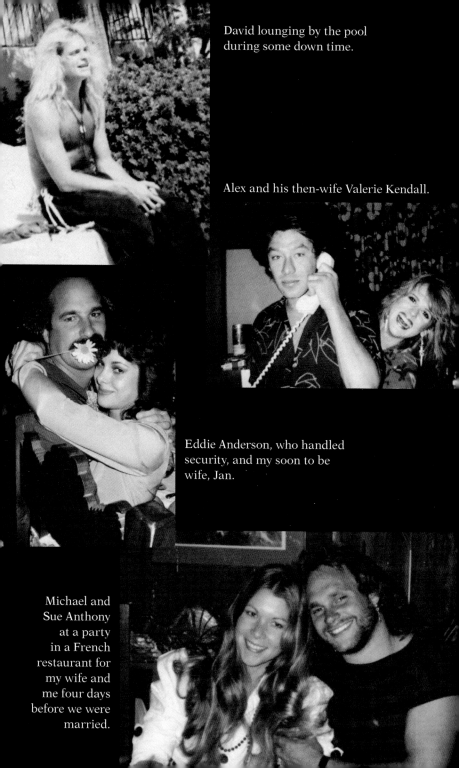

David lounging by the pool during some down time.

Alex and his then-wife Valerie Kendall.

Eddie Anderson, who handled security, and my soon to be wife, Jan.

Michael and Sue Anthony at a party in a French restaurant for my wife and me four days before we were married.

Though David and I had our differences at times, he was always fun at a party.

Alex Van Halen at his finest.

Valerie and Edward at the French restaurant. I was there the first time these two met in person, and I can say that if theirs was an odd match, it was nonetheless genuine. I could tell right away that they liked each other.

David Lee Roth at our pre-wedding party.

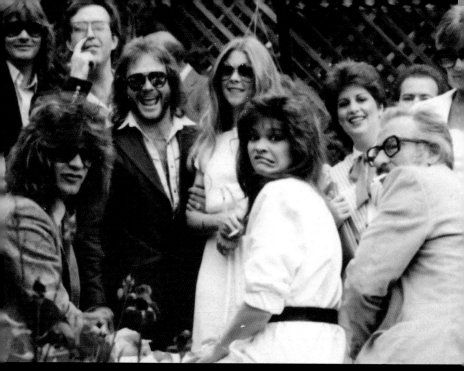

The Van Halen crew at my wedding in April 1983. In the front from *left to right:* Edward, Michael and Sue Anthony, Valerie Bertinelli, and Jan Van Halen (Edward's and Alex's father). ©Neil Zlozower

Sue, Michael, and Alex at my wedding. ©Neil Zlozower

Eddie Anderson, Edward, me, and Jan Van Halen. ©Neil Zlozower

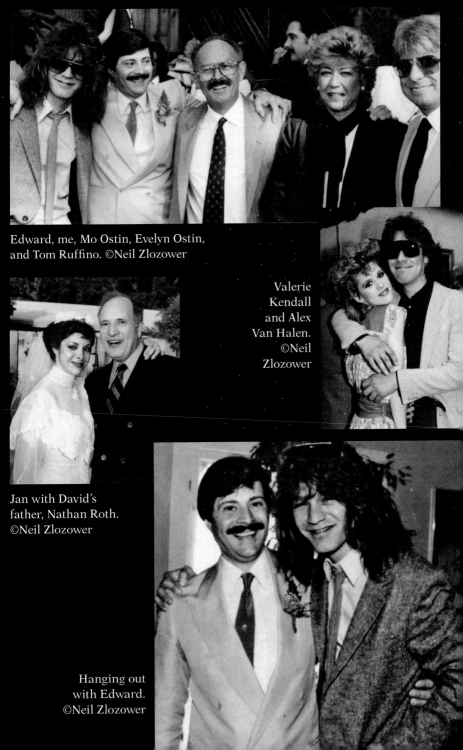

Edward, me, Mo Ostin, Evelyn Ostin, and Tom Ruffino. ©Neil Zlozower

Valerie Kendall and Alex Van Halen. ©Neil Zlozower

Jan with David's father, Nathan Roth. ©Neil Zlozower

Hanging out with Edward. ©Neil Zlozower

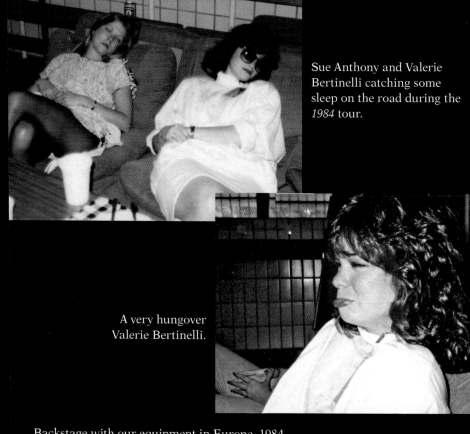

Sue Anthony and Valerie Bertinelli catching some sleep on the road during the *1984* tour.

A very hungover Valerie Bertinelli.

Backstage with our equipment in Europe, 1984.

Valerie with a bathrobe, waiting for Edward to finish playing during the *1984* tour.

Michael, Valerie, and Edward during the European leg of the *1984* tour.

David with Debbie Kelly, who sold merch at our shows and whose husband was the head of merchandising for us.

Michael and Sue Anthony, high school sweethearts, were great people through it all.

Backstage during the summer of 1984.

David Lee Roth in a hotel room in London.

Michael waiting for the Concord

Valerie backstage on tour

Michael backstage with Vince Neil of Mötley Crüe during
the Monsters of Rock tour.

Sue and Michael with Nikki Sixx and Tommy Lee on the
Monsters of Rock tour.

With my wife, Jan, in London, 1984.

My wife, Jan, has been through it all with me and then some.
All these years later, we've never forgotten what life was like with Van Halen.

16

GO ASK ALEX

Laziness was not the problem. I want to make that perfectly clear. Despite vast quantities of drugs and alcohol, and internal strife that led to a caravan of five separate buses when we went out on the road for the 1984 tour, Van Halen always managed to put in the work. Stoned and drunk and fighting like crazy, they recorded the best album of their careers and then went on a tour that filled arenas and left fans breathless. Night after remarkable night. I often watched these shows with a mix of awe and sadness. If not for the drugs, I thought—if not for the personality problems—these guys could run for the next five to ten years. They could sell 50 million records and play football and soccer stadiums all over the world.

They were that good.

But I knew in my heart that it wasn't meant to last, that what people saw on the stage every night was only a sliver of the Van Halen reality. The real story was being told during the

day, on those long and fractured bus rides, and deep into the morning hours, when the drugs and the drinking finally took their toll.

We netted roughly 2 million dollars per person in 1984, thanks in no part to this epic and practically cost-prohibitive tour. The goal was to put on the biggest and most entertaining show possible, which meant a fleet of nearly twenty trucks (in addition to the tricked-out tour buses), carrying hundreds of thousands of pounds (and dollars' worth) of equipment.

It's difficult to convey just how massive an enterprise this was, but here's an example: our stage show featured a lighting rig with more than two thousand lights. Even the biggest and most well-financed bands touring in those days settled for fewer than half that number. If you'd asked us, we'd have said that we were burning money to put on an unforgettable experience for fans; but in hindsight it was almost like we subconsciously knew it would be a farewell tour, and we wanted to go out in a blaze of glory.

A tour that stretched out over nearly nine months began on January 18, in Jacksonville, Florida, before a sold-out crowd of more than eleven thousand at the Jacksonville Coliseum. It was a nearly flawless show that ran almost two hours and betrayed none of the backstage tension that I knew to be a daily part of the Van Halen experience. Nor did it seem to be adversely affected by the lines of cocaine that Edward kept on a nearby amplifier, to be snorted whenever needed; or by the beer and whiskey that Alex would guzzle throughout the evening. As musicians and entertainers, Van Halen appeared to be at the top of their game. What else mattered? There were nights early in the first leg of that tour, when we were rolling through the South, that I allowed myself to believe things would be all right, that my guys were so talented and unique they could withstand pressures and influences that had been ripping apart bands since . . . well, as long as there had been bands.

This was clearly not the case.

Less than a month into the tour I got my first taste of just

how deeply Van Halen had fallen into the abyss of drug abuse, when I got word from our bookkeeper that Edward had been quietly advancing himself large amounts of cash. Now, there was nothing illegal or even improper about this practice; we all took cash advances from time to time. But Edward, I was informed, had been withdrawing more than usual, with no explanation (not that one was required). I'd been around the music business long enough to recognize this practice as a very large and vivid red flag. It often meant that the person taking the advance had either serious money problems or a serious drug problem (because obviously drugs are always purchased in cash).

Edward did not have a money problem.

What he did have was a personal drug dealer who would fly all over the world to meet Edward and supply him with his drugs of choice, primarily cocaine. I came to know this guy (not that we had a personal relationship), and I decided early in the tour simply to leave him alone. Crazy as it might sound, I figured that at least Edward had found a dealer he could trust, and who would meet him whenever and wherever he was needed.

This guy's apparent 24/7 availability meant that Edward would never have to sneak out into the night and prowl the nastier neighborhoods of whatever city we happened to be passing through when his supply ran low. I disliked this guy the first time I met him, and as Edward deteriorated, my feelings intensified. But I did not try to chase him away, although that would have been easy enough to do. Did this make me an enabler? I didn't look at it that way. I was the manager of one of the biggest rock bands in the world, which meant, in effect, that I was running a large and lucrative business with a bunch of employees and others who depended on that business for their livelihoods. I did what I had to do in order to keep the machinery operating smoothly. Nothing I said or did was going to prevent Edward from abusing cocaine (and vodka); he would have to reach that decision on his own, like any other addict. In the meantime, I was at least relieved that he had

found a way to obtain the drug that was unlikely to result in his being either arrested or assaulted.

So I made a decision to ignore his dealer, although there were times the guy really pushed his luck. I would see him outside a venue, for example, working the crowd, strolling casually among the rank and file, stopping occasionally to talk with concertgoers, who would then disappear. Or sometimes I'd see a surreptitious handshake, a little hug, and then they'd go their separate ways.

Any reasonable dealer would've realized that he had landed the gig of a lifetime working with Eddie, who, trust me, represented his fair share of business. Taking a chance and dealing in a parking lot—in addition to that business—is what really pissed me off. Especially in completely unknown cities with no real game plan. Somehow, through what I can only assume is dumb luck, the guy never got busted, and he remained Edward's purveyor of the finest cocaine throughout that year.

We were still on the Southern swing when Edward came into my room one night, a half-empty bottle of vodka in his hand. He was, it seemed, primarily drunk, but the time had come to reverse the alcohol slide with some coke. Edward withdrew from his pocket a small vial containing maybe an ounce of white powder. My wife was on tour with us at the time, and while she knew of Edward's cocaine use, she did not know the full extent of it. Until this night, neither did I.

"Hey, guys," he said, slurring his words badly. "Let me show you something." He held up the vial and smiled. "This is Peruvian flake. Awesome shit."

I looked at Jan. Then I looked at Edward. I shrugged. Cocaine in those days often had ridiculous nicknames denoting its supposed strength or purity.

The fact that it was late at night didn't matter. A point of contention on this tour, in fact, was Edward's penchant for working and writing (and drugging and drinking) well into the morning hours. He and Valerie had separate but adjoining bedrooms for precisely this reason—so that his incessant noodling on the guitar wouldn't keep her up all night. Edward

would just be going to bed when David would knock on the door and try to rouse everyone for a meeting, or for an impromptu session of roller skating or other forms of exercise that interested no one in the band other than David. Not that David was pure of mind or body, but he did work out like a beast—his preconcert stretching routine, always performed in front of the rest of the band and their wives and girlfriends—would sometimes last an hour; it was all part of the Diamond Dave Show. He liked to rise early most days, and his nagging, in combination with his continued role as a media magnet, got on everyone's nerves, Edward's most of all. I couldn't help but wonder how long Edward could continue to burn the candle at both ends before flaming out. That it never fully happened is something of a miracle.

God knows he tried.

"Peruvian flake, huh?" I said. "Gee, that sounds great, Ed." I wasn't even trying to feign interest; I was being sarcastic, but Ed was too far gone to note the difference. I was sick of hearing about cocaine, talking about cocaine, and witnessing its withering effect on my band.

Then Ed did something he occasionally did when he was sufficiently fucked up: rather than pulling up a chair next to me, he curled up in my lap and put his head on my shoulder. Like a toddler, this full-grown man would lean into me and tell me how much he loved me. And sometimes, as on this night, he would encourage me to join his private party.

Eddie poured out about two grams of coke and then made four lines with his bare hand. Now, normally the portioning of cocaine was done with a razor blade or a credit card—something to keep it precise—but Ed wasn't worried about wasting any of the product. There's a certain finesse that goes along with doing drugs—certain rituals that make it more of an experience than an action—for most people, anyway. For Edward, it was done with all of the grace of chugging a beer.

"Do you want me to get a bill?" Jan offered.

"Nah, I don't need it."

And then Jan and I watched in amazement as Eddie pro-

ceeded to put his head down onto the dresser and snort about half of what he'd just laid out.

"Well, that might work for you," Jan said, "but I need a bill."

I handed her a hundred. "Does this work?"

It did indeed. Jan did maybe a fraction of a line, which promptly knocked her on her ass.

"How do you do all that?" she asked. Eddie just laughed.

"It's no big deal," he said. "Would you mind if I talked to Noel alone? The girls are playing poker, why don't you go join them?" Eddie, even coked out of his head and in the middle of climbing back into my lap, was always thoughtful and mild-mannered to Jan. I appreciated it.

It was hard to imagine that Edward was capable of serious business talk at this point, but he had asked nicely, so Jan obliged. As Jan walked out of the room, she looked back at us—Edward rocking on my lap like a baby, suckling vodka instead of milk—and I could see on her face a look of bewilderment. We'd been together for a couple years and she'd seen and heard enough stories to get an idea of what life was like with Van Halen, but some things you just have to witness for yourself.

As it happened, Edward had no desire to discuss business; he simply wanted to conduct a private bitch fest about David. Nothing arose from this conversation that I had not heard previously, so none of it came as much of a surprise. But there was a persistent negativity, almost hatred, in his tone that suggested a shift in their relationship. Edward had long chosen a nonconfrontational path when dealing with David, but now he seemed more comfortable with the idea of standing up for himself. I admit that the image of a man curled up, childlike, on his manager's lap, does not exactly support this notion, but again, if you knew Edward, you'd understand. He could be sensitive and sweet; he could also be churlish or childish; depending on his mood and the level and type of intoxicants in his bloodstream, he was also capable of significant rage. By this time one thing was clear: he had grown weary of playing second banana to Van Halen's loudmouthed lead singer.

"Fuckin' guy just drives me nuts," Edward said, repeatedly and in many different forms, that night.

"Yes, I know, Ed. You've made that clear."

Later that night, when Jan returned, she told me all about her interesting night of cards. Jan liked Valerie and found her efforts to be treated as "just one of the girls" rather endearing and admirable. But, for a Hollywood superstar, Valerie was somewhat naive. She was surprised to learn, for example, that most of the other women had been on the tour since the beginning, whereas Valerie had just flown in for a few nights. Her biggest complaint?

"How come you only get laid on the first night?" she asked. "You'd think these guys would be so horny they'd be dying to see us when we visit."

This observation was met mostly with blank stares and suppressed laughter. None of the other women around the table could say what they were really thinking: *Well, maybe that's because Ed's fucking a different girl every night when you're not here. What are you, dizzy or something?*

But Valerie was nothing if not a spirited member of the tribe when she joined us. The ladies' card games were buoyed by alcohol and cocaine, and the TV star partook of both. Cocaine, she explained, helped suppress her appetite.

"And Ed likes me skinny."

Meanwhile, back in my room, between harangues about David, Edward kept telling me how much he loved me. Here's the thing about a drunk on cocaine: they tend to be a bit repetitious, and so Ed would repeat the usual complaints about David, then give me a big hug and a smile and tell me how grateful he was for my work on behalf of the band. This happened two or three times a week during the first few months of the tour, and after a while I learned to tune it out. But there was one night relatively early on when he said something that piqued my interest.

"I love you, Noel," he said, smiling drunkenly. "You know that, right?"

"Sure, Edward . . . I love you, too."

He reached up and tousled my hair like a child. Indeed, sometimes, if he was sufficiently shitfaced, Edward would even refer to me as Daddy. Jan would just look at him and laugh.

"He's at it again."

But this time he said something unexpected, and it gave me pause.

"I don't care what Alex thinks," Edward slurred. "He can go fuck himself. I always want you to be my manager."

Now, given Edward's level of inebriation, I wasn't about to interrogate him as to the root of this observation, but considering the level of turmoil within the band, and my ongoing status as a manager without a long-term contract, it did have a sobering effect.

Not on Edward, obviously, but on me. I couldn't help but think, *My time might be getting short here.*

But what could I do? I was far too busy to waste time obsessing about private conversations that might have taken place between the brothers Van Halen, especially if those conversations were fueled by drugs and alcohol, which they most certainly were. Interestingly, Jan had gotten rather close to Alex during the *1984* tour, which gave me a level of trust and comfort that might have been misleading. One thing I know for sure is that Alex's slide into addiction was every bit as disturbing as Edward's. While he might not have enjoyed cocaine quite as much as his brother, Alex drank like few people I have ever seen. Other drugs get most of the attention, but alcohol, in excess, will beat the shit out of you as thoroughly as heroin, cocaine, or anything else.

It sure as hell did a number on Alex.

It's always hard to pinpoint the exact moment when you recognize that someone has more than just a casual relationship with drugs or alcohol, or even when it becomes apparent that they have tumbled into the abyss of full-fledged addiction; as with going broke, it happens slowly . . . and then all at once. Remember, I hadn't spent that much time with the band during the months of writing and recording *1984*. I had

my suspicions about the extent of their deterioration based on phone calls and meetings and an abundance of otherwise erratic behavior, but it wasn't until we got out on the road together that I was able to witness it firsthand.

There was one moment relatively early in the tour—a month at the most—when Alex came into my room. It was 9:30 in the morning, which in itself was something of a surprise, as the boys of Van Halen were not generally morning people (David being the occasional outlier in this regard). Jan and I were not even up yet, but Alex's persistent knocking roused us from sleep. I opened the door to discover Al fully dressed and full of energy.

"Come on," he said. "Let's go shopping."

Now, as I said, Al and I sometimes would venture off together on sightseeing and shopping excursions, but not usually first thing in the morning. He had also become friendly with Jan, and sometimes, when I wasn't so inclined, the two of them would go off together while I stayed behind and took care of business. This would be one of those days.

"Al, I'm not really up for it," I said.

He waved a hand dismissively and looked at my wife.

"Guess it's just you and me, Jan. What do you say?"

Jan was usually up for a shopping excursion, and she didn't mind Al's company, so she agreed. As she stood to excuse herself and get dressed, Al walked casually to the minibar and popped open the door. He rummaged around for a moment, withdrew two small bottles of vodka, and drank each one in a single gulp. Jan saw this as she walked away and gave me a backward glance of disbelief. What she did not see, over the course of the next half hour, was Al repeating this ritual with another half dozen little bottles of booze: whiskey, gin, scotch, and a couple beers, too. He must have put away the equivalent of ten shots and two beers in a remarkably small window of time. By ten o'clock in the morning, he was completely shit-faced. And yet he seemed no more or less impaired than he had when he knocked on our hotel room door. Having grown up in an alcoholic family, I recognized this as a sign of main-

tenance: Al had reached the point where he was drunk most of his waking hours, and except when he drank to extraordinary excess (which he sometimes did), it was hard to differentiate between drunk and sober. Maybe he'd been up all night drinking; more likely, he had woken with a ferocious hangover and used my minibar to beat back the symptoms of withdrawal. I presume his minibar had already been drained. Regardless, this little show demonstrated to me that Al had escalated from heavy drinker to full-blown alcoholic.

And now he was about to head out for a day of shopping with my wife.

"You know what, Al?" I said. "Why don't you take a bodyguard with you, just to be on the safe side?"

He scoffed. "Aw, come on, Noel. I don't need a fucking bodyguard. I can take care of myself."

"I'm sure you can, but Jan is going to be with you, too, and I'll feel better if you have some protection. Okay?"

Grudgingly, Al agreed. He and Jan left the hotel in good spirits, and I went back to bed.

In those days—a good decade before the advent of cell phones—we often carried walkie-talkies to facilitate communication. I had given one to Al before he left the hotel. An hour later the walkie-talkie on my nightstand crackled to life.

"Noel, you there?" He seemed agitated.

"Yes, Al. Everything okay?"

"Nah, we got a little problem."

"Like what? You run out of alcohol?"

Al did not laugh, and his silence provoked a knot in my stomach. With Van Halen, a little problem might indeed be minuscule. Or it could be catastrophic. There was no way of knowing. Al, however, was not prone to hyperbole, and the fact that Jan was with him made me nervous.

"Seriously, Al. What's the matter?"

"We're in this shoe store," Al began. "Everything was fine, but then all of a sudden someone recognized me, and now there's a huge crowd outside the store. We can't get out, and your bodyguard can't clear the way. There's too many people."

"Okay, just sit tight. Tell me exactly where you are and I'll take care of it."

I sent down a team of eight security guards to clear a path out of the store and safely guide Al and Jan to freedom. A short time later Jan returned to the hotel—alone.

"Where's Al?" I asked.

Jan shrugged. "I don't know. He said he wanted to go drinking, asked me to go along."

"What did you say?"

"I told him it was a little too early for me."

That was life with Alex in 1984. I don't know what was worse: the fact that he wanted to "go drinking" at noon, or the fact that this supposedly indicated a starting point for the day of imbibing, when in fact he had already consumed more alcohol than most people could manage in an entire day. For Al, that minibar session was merely an appetizer; it didn't even count.

Al got away with this behavior for a couple reasons. One, he was Edward's brother, and the band bore their last name, so it would have taken an extraordinarily level of incompetence or some other egregious offense to get Al kicked out of the band. Frankly, I can't even imagine what that might have been. Two, Al somehow managed to show up and do his job every night, regardless of how much he'd been drinking. Was he a *great* drummer? That's debatable. But he was certainly a very good drummer, and that he was able to sustain that level of performance, while drinking nonstop, seven days a week, nearly every waking hour, is rather remarkable.

People would notice sometimes that Al drank beer throughout every Van Halen performance. It almost became part of the show—Al pouring Schlitz Malt Liquor all over himself and his drum kit, and then its spraying and splashing all around him as he flailed away. It looked great and was definitely in keeping with the party atmosphere of a Van Halen concert. And what the hell—it was just beer, right? What hardly anyone outside of Van Halen's inner circle realized was that this was the soberest part of the day for Alex. Before and after the

show, backstage, on the bus or in the hotel, malt liquor was mixed with hard liquor—and the occasional hit of weed or coke.

Sometimes, the morning after a show, Al would joke about having almost no memory of how he had played or even the crowd's response. And yet, despite performing in a virtual blackout, Al rarely fucked up. Unlike Edward, he wasn't an innovator; he was merely extremely competent. But Al remained competent until the very end, even as his mind and mood began to fray. He was like his father: a fully functional alcoholic.

Still, there were some genuinely weird and disturbing moments related to Al's drinking. Like Edward, Al periodically came to my room at night to chat with Jan and me. But whereas Ed was happy to curl up in my lap and tell me how much he loved me or just complain about David, Al would sometime appear to be losing touch with reality.

"I've been seeing things," he told us one night. "Crazy shit."

"Like what?" I asked.

He hesitated, as if he knew that there would be no taking back the information he was about to reveal.

"What is it, Al? You can tell me."

He nodded. "Sometimes I wake up in the middle of the night, and I see things coming out of the walls."

"What kind of things?" I asked. Now he had my attention.

"Penises," Al replied flatly, as if it were the most normal thing in the world. "Big penises. Giant fucking penises."

Jan and I looked at each other. Neither of us laughed, because, appearances to the contrary notwithstanding, there was nothing funny about it. Al wasn't kidding. In the moment, he had seen and believed that there were giant penises coming out of the wall, and I don't doubt for a minute that this hallucination was frightening. Even more disturbing was the revelation—again, shared late at night in our hotel room—that Al would sometimes go back to his parents' house and climb into bed between them.

While clutching a rifle.

"I just want to be safe," he'd explain.

Was this true? Did it really happen? I have no way of knowing. I can say only that Al told us it happened, and that was enough to make me worry about not only his safety but the safety of those around him. I would envision Alex, at twenty-nine years of age, creeping into his parents' bedroom, armed with a loaded gun, and lying there wide awake, prepared to fend off all types of interlopers—including giant penises.

This was the drummer for one of the biggest bands in the world: a paranoid, delusional alcoholic. What could possibly go wrong?

Quite a bit, as it turned out.

Here's another story, this one related by my wife, who withheld the details until after I had parted ways with the band.

We were bouncing across Canada in April '84. There were two big jumps in that portion of the tour, so we flew first-class rather than taking our usual fleet of buses. Jan and I were sitting together, with Alex and Edward in the row behind us. As usual, cocktails were served while we sat on the tarmac, and Alex wasted no time in getting started. After we'd been in the air for a while, Edward asked Jan if they could switch seats.

"I need to talk with Noel about some business," he explained.

Jan said sure, no problem. This sort of thing happened all the time, and Jan was forever gracious and accommodating when it came to the demands Van Halen placed upon my time. Besides, she didn't mind sitting next to Alex. As I said, they would often go shopping or sightseeing together, and despite his descent into alcoholism, Jan genuinely liked Al and found him good company on the road. For whatever reason, they just clicked, and had for as long as they'd known each other.

So I had no cause for concern when Jan slid into the seat next to Al. For the next couple hours, while Ed and I talked business and music—and he quietly complained about David—Jan and Al chatted behind us. I didn't pay any attention to their conversation, but as Jan reported later, it took

an unpleasant turn sometime around Al's sixth or seventh Bloody Mary, when Al began telling dirty jokes. Now, Jan was hardly a prude—she was a New York girl, raised in Queens, and could give as good as she got when jousting with the boys; you can't spend the better part of a year on the road with Van Halen and not develop a thick skin about carnal matters. Still, there is a line you don't cross, and Al should have known exactly where that line existed. But if alcohol can make you see giant penises, then I suppose it can trick you into thinking it's okay to tell disgusting jokes to your manager's wife and then put a sloppy move on her.

One joke became two, and two became four, and Al began slurring the punch lines in a way that Jan found troubling. It wasn't just that Al was drunk and inappropriate; he seemed to be hitting on her. At first, Jan hoped that she was mistaken, but eventually the jokes got dirtier and Al began to lean into her, and finally, out of the blue, he looked Jan in the eye and said, "You know, I would sure like to fuck you."

Okay, let's put the most generous possible spin on this and presume that Al was too shitfaced to know what he was doing, and simply hit the autopilot switch—the one that told him world-famous rock stars could talk trash to an attractive woman, and it would yield the desired result. Let's presume, also, that he was so fucked up that he forgot the identity of the person with whom he was flirting (if you can call it that). You know—the wife of his band's manager, who just happened to be sitting only a few feet away from him.

Even if you give Al the benefit of the doubt on every level, this was preposterously stupid and inappropriate behavior. Tough girl that she was, though, Jan tried to defuse a potentially catastrophic situation on her own.

"Don't be silly, Al. I'm married to your manager," Jan said. "What's wrong with you?"

Al's response was a drunken and dismissive wave, followed by, "I don't give a fuck who you're married to."

At that point Jan knew there was no shutting Al down. He

was too far gone. She excused herself, returned to my row, and asked Edward if she could have her seat back.

"Sure, we're all done here," Edward said politely. He got up, went back to his seat, and Jan sat down next down to me. I had no idea there was anything wrong, no inkling of the exchange that had taken place between my wife and my band's drummer. Looking back on it sometime later, though, I could remember that Jan seemed shaken in some way. She sat down and took my hand in hers.

"Everything all right?" I asked.

She squeezed my hand tightly. "Yeah, just a little motion sickness. I'll be fine."

Nearly a year later, after my tenure with the band had ended, Jan finally told me this story. I was neither surprised nor particularly angry; by then I had learned to expect the worst from Al. I just felt bad for my wife. Not only had she been badly disrespected but the perpetrator was someone she considered a friend. Al and Jan had spent quite a lot of time together on that tour, often hanging out backstage before the show. Jan had always considered theirs a strictly platonic relationship. She was married, after all—and to the band's manager. Her friendship with Al seemed safe, but there is no such thing when you are dealing with someone who has not only spent the past five years getting laid a couple hundred times a year but who is also an alcoholic.

"I guess it's true what they say about men," Jan said. "They can only be your friend for one reason—and it has nothing to do with friendship."

"Why didn't you tell me?" I asked, although I knew the answer.

She laughed.

"Because I didn't want my husband getting into a fistfight with one of his band members in the middle of an airplane. I didn't want to be the reason you got fired or Van Halen broke up."

"Oh, come on. I wouldn't have done that."

Again, Jan laughed. So did I.

"You know me well," I said.

ON THAT SAME LEG OF THE TOUR, Jan and I celebrated our first wedding anniversary: April 24, 1984. We were in Winnipeg, Canada, and had the night off. After a beautiful meal in the lovely hotel restaurant, a cake magically appeared at our table (I never did find out who sent it), adorned in icing with the message "Happy First Anniversary, Jan and Noel." It was a very nice gesture, but after a lavish meal and two bottles of wine, we had no room left for cake, so we decided to pack it up and take it back to our room.

Along the way we passed several people in our entourage who were hanging out outside their rooms on our floor. Many of them had attended our wedding and now offered congratulations and reminisced about what a great party the wedding had been. A few also reminded Jan that my getting married was one of the all-time great upsets, so obviously she must be something special (which she was, and is).

Before we went into our room we stopped to chat with Alex and his new girlfriend, Sherry, whom he had met recently on the road, and who was now traveling with him. She was a beautiful woman and they seemed rather taken with each other. Jan had spent some time with them backstage and liked Sherry. But, as with most of the women Alex met, she wasn't around long after that evening. Alex was in a good mood that night, not excessively drunk, and was quick to wish us a happy anniversary. He had taken the time to send us some flowers, and it's worth noting that he chose black orchids—sort of like our anniversary was a funeral rather than a celebration. Alex had a perverse sense of humor, so it wasn't much of a surprise. At least he had taken the time to mark the day. Outside our room we saw Michael Anthony hanging around and shooting the breeze with some people. We invited him to hang out for a while. He was at least as

drunk as we were and we were joking and laughing and having a great time, when Michael saw the vase containing the flowers and seemed curious.

"Are those for your anniversary?"

Jan nodded.

"Who the hell sends black orchids as an anniversary gift?"

"Take a guess," Jan said.

Michael laughed. "Alex, right?"

We all started laughing about what a sick joke it was, but exactly what you'd expect from Alex. All of a sudden, Jan got up, opened a window, and tossed out the flowers, vase and all. Considering we were on the eighth floor, this was not a great idea. Fortunately, no one was hurt.

Michael then spotted the box with the cake in it.

"What's that?" he asked.

"Our anniversary cake," Jan said. "Want to see it?"

"Yeah, sure."

"Want to smell the flowers on the cake?"

This was an old trick, but Michael was too drunk to notice. And probably too trusting. He leaned over the box, and Jan moved in for the kill, pushing Michael's face down into the cake. As Jan laughed and ran toward the bathroom in retreat, Michael picked up a handful of cake and tossed it at her. For the next five minutes, an all-out cake war ensued, until both of them were covered in icing.

It was one of the best nights we had on the entire tour.

THE BIGGER THE TOUR, the harder it is to control everything; there are simply too many moving parts. This sometimes applied to the crew as well as the band members. Indeed, there were days when everything seemed to be falling apart at once. Like the day I was on the stage talking with David during sound check at a venue in the Southeast, when my walkie-talkie began to beep. On the other end was Eddie Anderson, talking a hundred miles an hour. Eddie rarely

displayed much emotion, but now our chief of security was in panic mode, which both surprised and concerned me.

"Noel, you have to come to room 632 at the hotel. We have a real problem."

"I'm just working with David on a few things," I responded. "I'll be up in a while."

"No, you have to come right now," he insisted. "It can't wait. The police are here and they're going to arrest two of our roadies from the lighting crew."

"What? Slow down, Eddie. What happened?"

"Just get over here," he repeated. "Now!"

I turned off the radio and headed for the stage exit. I could hear David say, "What the fuck?" as I left, but this was not the time to placate him.

I ran to the hotel, jumped into the elevator, and punched the sixth floor. At the far end of the hall I could see Eddie pacing back and forth. When I got to him, I was shocked to see that he was actually sweating.

"Okay, spit it out," I said.

Eddie shook his head. "The best way to explain this is to show you." With that he opened the door. I was met with the strong smell of marijuana. I quickly glanced around the room and could barely believe my eyes. There were two uniformed police officers standing with two roadies whom I barely knew—that's how big our crew had gotten. Both of them had stupid, shit-eating grins on their faces. The room was completely trashed: lamps on the floor, tables turned upside down, television ripped out of the wall. It was a fine example of hotel trashing; I almost wanted to congratulate them—if not for one small thing.

As I took two steps into the room, I slipped on a piece of paper and wound up on my ass, staring at the ceiling. All around me were other pieces of paper, which I recognized as pages that had been ripped from a book. I picked up one of the pages and looked at it. Instantly I realized the problem: the pages had been torn from a Bible.

"Are you out of your fucking minds?" I said to the roadies, who suddenly stopped smiling. "You can't tear up a Bible!"

Especially in the South, where folks tend to take these matters rather seriously.

"Are you ready to arrest them?" I asked the officers.

One of the officers nodded grimly. "You've got that right."

"Well, I'm the manager of Van Halen and these pieces of shit are my responsibility. Do you think I could talk to you in the hall for a moment?"

Once outside, I apologized profusely on behalf of the entire organization, and then asked the cops for permission to handle the situation internally.

"I think my solution will be harsher than what you might do," I said. "They will be fired immediately. We'll drop them off at the bus station and give them just enough money to pay for a ticket home. Getting any work in the future in this business will be almost impossible." I paused to gauge the reaction of the officers. They wanted to hear more. "And obviously we will pay for all the damages, and then we will charge it back to these two assholes."

"Okay," one of the cops said. "You do that and they are all yours."

I went back into the hotel room and ordered the roadies to begin cleaning up the mess.

"And forget about the crew meal," I said. "You're going to work the show tonight, but you can do it on an empty stomach. And then you're gone."

Patrick, our production manager, made sure everyone knew what had happened. Two hours later I went down to the crew meal to see how everyone would react. To my surprise, I got a round of applause. They understood: there is a line you don't cross, and these guys had crossed it. They had to go.

THE WHINING was driving me crazy.

Edward whining about David; David whining about Edward and Alex; Alex whining about Michael (of all people). Michael . . . well, he didn't whine about anything or anyone. To the very end, he remained grateful for the gift that was

Van Halen. Maybe it was his natural personality, or maybe he was simply capable of greater perspective than everyone else. Maybe he wasn't quite as addled by drugs and alcohol. For whatever reason, Michael stayed on the sidelines as the rest of the band fought like a pack of starving wolves who have come across a carcass in the wilderness.

Previous tours, especially in the first couple of years, had always featured a fair amount of ball-busting and the occasional argument that was required simply to clear the air. For the most part, though, we had a blast on the road. It was a nonstop party punctuated by spectacularly energetic concerts. There had been a lightness to it all, a sense of being part of something special, and of wanting to enjoy every minute. But now the levity was gone. Even though they spent hardly any time together offstage, the boys were at each other's throats constantly, either directly or through a conduit—usually me.

Two more quick stories, both involving Al. We were all sitting outside by the hotel pool one day. A guy named Mike had been flown in for a couple days to take care of the boys' grooming needs. Mike was a hairdresser or stylist or whatever you want to call him. Point is, he was really good at his job, an artistic young man with a good sense of humor and the patience to deal with a bunch of egotistical rock stars. On this particular day, as he fussed over a grumpy Alex, Mike decided to lighten the mood by giving Al a little kiss. Now, I have no idea whether Mike was gay or straight, and it really doesn't matter in the least. The point is, Al took this humorous gesture as an affront to his manhood, and got seriously pissed off. He didn't try to hurt Mike or anything, but he did go on a rant that was far out of proportion to what had happened.

"I don't ever want that fucker working here again!" he screamed at one point.

Poor Mike was scared, bewildered, and disappointed. He liked Al; he liked all the guys in Van Halen. He simply hadn't realized that the band had mostly lost its collective sense of humor.

Another story, another hotel, midway through the tour, on

the night of a show. What city? I don't know. Doesn't really matter; could've been anywhere. In a throwback to earlier and more innocent times, David decided to play a practical joke on Alex. Actually, it wasn't much of a joke, and it required little ingenuity. It was more a case of David just fucking with his bandmate by inserting the nozzle of a fire extinguisher under his door and setting it off. The ensuing noise, and the accompanying blizzard of white powder, provoked a response from Alex that was probably a bit more heated than David had anticipated. Or maybe it was exactly the response he expected and hoped for.

Regardless, when I heard the commotion in the hallway, I left my room, and what I saw was at once comical and pathetic. There was Alex, naked (I presume he had a girl in his room), screaming at David, promising to rip his fucking head off, and David laughing in response. Between them, trying to deescalate the situation, was Eddie Anderson, our chief of security and David's personal bodyguard.

"I'm gonna fucking kill you, David!" Al kept screaming.

Emboldened by Eddie Anderson's presence, David would press forward, laugh a little, then toss off a threat in response.

"I'll kick your ass, Al. You're a fucking pussy."

But he didn't mean it. David was not a tough guy. He was all show. This was a man who once signed up for karate lessons and paid in advance for enough schooling to take him all the way through to a black belt, but I doubt that he went more than a few times. He liked to fashion himself as something of a martial artist, but it was all style and no substance. The best example of this? After a show at Madison Square Garden in New York, someone tried to break into the luggage compartment of our bus. We caught the guy—a skinny little Hispanic kid; must have weighed ninety-five pounds—before he could get away, and he wound up hiding under the back of the bus. David found out what was happening, and instead of letting security take care of the matter, decided to play the role of enforcer.

"I'll handle it," he said.

So, holding on to the back bumper, he slid beneath the rear of the bus and tried to kick at the poor kid while the rest of us stood around watching. We let this go on for about ten minutes, until David became exhausted and pulled himself out from the under the bus, his chest heaving, his legs covered with dirt. After he walked away, we coaxed the kid out. He was just a street kid, obviously poor and maybe homeless, so it was hard not to pity him.

"Don't be stupid," I told the kid. "Next time we'll send someone after you who knows what they're doing, and you might get hurt. Understand?"

The kid nodded and we sent him on his way.

So that was David. In a physical matchup against Alex Van Halen, he was a decided underdog. And he knew it. Had Eddie Anderson not been there to intervene, David would have been in serious trouble. Instead, with Eddie holding Alex at bay, David was able to scramble safely back to his room, shouting "Fuck you, Al," as he slammed the door.

"Fuck you, David!" Al responded before disappearing into his room. I looked at Eddie, who merely shrugged and walked away. He might have been thinking the same thing that I was thinking. In 1978, or even in 1982, spraying a fire extinguisher under a hotel door would have been viewed as an offense so minor it might have gone unnoticed. But now? In the middle of the biggest and most expensive tour in the history of Van Halen? It was, apparently, a crime punishable by death.

As the door of my room closed behind me and I staggered back to bed, all I could think was . . . *Jesus, these guys hate each other.*

ON THE 1984 TOUR, there were two parts of the day that I grew to dread: sound check and the postconcert meal. David ruled both of these events in a bilious and petulant manner: ordering everyone around during sound check, and then pointing out every little mistake after the show. Granted, he had long used these situations as a forum for flexing his

muscle as the de facto band leader, but drug and alcohol use, combined with the Van Halen brothers' growing resistance to David's dictatorial preening, made for a much more hostile environment all the way around. Being a natural bully, David began focusing his harangues less on Edward and Alex, and more on Michael. But the saddest part, to me, was that neither Alex nor Edward would stick up for Michael. It was like *Lord of the Flies*: the weak were destined to be destroyed.

Still, what happened one night roughly halfway through the tour caught me completely by surprise, not just because of the extent of the meanness but because of what it foreshadowed.

We were gathered in a hospitality suite, loading plates with food from a buffet table, while David did his usual critique. I had learned to tune him out by this point, and in fact often just left the room altogether. But on this night I was there for every word of David's postmortem, and for Edward's sudden and unexpected interjection. When he began to speak, I thought for sure that he would lash out at David. But he didn't. Instead, he began taking shots at Michael. And not just about his performance onstage, but about his role in the band.

Michael doesn't contribute as much as the rest of us, Edward observed. Michael doesn't write music or lyrics. He might as well have said that Michael was just taking up space, and that his role could be fulfilled by virtually anyone. Now, this may or may not have been a valid point. Michael was not a songwriter and thus contributed little to Van Halen from a composing standpoint. But the same could be said of Alex. Edward and David had always done most of the writing, and everyone was fine with the arrangement. Songwriting credits notwithstanding, royalties were split equally among the band members. For some reason, Edward now felt compelled to challenge that arrangement.

"Why does Michael get the same share as the rest of us?" Edward asked, and as he said this, he looked at me, like I had anything to do with an arrangement that predated my arrival and that supposedly was based on friendship and egalitarian-

ism. I had no answer for this; frankly, I had no idea what was going on, or why suddenly everyone seemed to be ganging up on the one member of the band who meant no ill will toward anyone.

Al jumped in behind Edward, asking the same sorts of questions and offering similar observations about Michael's value—or lack thereof—to the band. For the most part Michael just sat there quietly and took it—until David stood up from his seat, a plate of food in hand, and walked around the table. He stopped when he reached Michael's seat and stood over him for a moment, glaring menacingly but saying nothing. The entire scene reminded me of a junior high school cafeteria, with the cool kids picking on the shy and sensitive. My hope was that Michael would stand up for himself. But he didn't. He just sat there with David standing over him, until, finally, David exploded in a manner that was extreme even by his lofty standards. Without saying a word, David slammed his full plate of food down on top of Michael's full plate. The effect was startling. Food went flying everywhere. Glasses tipped over and shattered. Silverware fell to the floor.

And all conversation stopped.

We all stared at Michael and awaited his reaction. This is it, I thought. Here is the moment the quiet kid fights back. But he didn't. Instead, he simply pushed his chair back from the table and stood up. He lightly brushed at some of the food stains on his shirt, gave David a hard stare, and walked out of the room.

That was the end of it . . . until two weeks later, when Alex, Edward, and David all came to my room. Without Michael.

"What's up guys?" I asked.

Alex was the first to speak, but it was clear they were united in purpose.

"We have a problem with Michael," he said.

"How can you have a problem with Michael?" I said. "He's the nicest guy on earth."

No one disagreed with that sentiment; they also claimed it was beside the point. This wasn't a popularity contest. The

criticisms leveled at Michael the night David destroyed his meal had apparently intensified. No longer were Alex, Edward, and David content to merely complain about Michael's contributions. Now they wanted to take action. Severe, punitive, life-changing action.

"We want to cut Michael out of the royalties," Alex said.

"You mean, in the future?" I asked.

No, they explained. Not just moving forward, but for *1984*, as well. I couldn't believe what I was hearing. First of all, this was an incredibly cold and callous thing to do to someone who had been with your band all along. Second, Michael had a contract with the band that covered the current album, which, by the way, had already sold a couple million copies. I tried to explain this to the guys, but they were adamant about changing the parameters of the band's structure, effective not just immediately but backdated to a point prior to the release of *1984*.

"Fix it, Noel," David said. "Call the lawyer, have him draw something up, and we'll get Michael to sign it."

"Guys," I said, "are you sure about this?"

I couldn't imagine that Michael would go along with a contract modification that could cost him millions of dollars. Moreover, I couldn't believe that they really wanted to hurt Michael so deeply and irrevocably. It was an unconscionable thing to do to another human being, especially one with whom you had worked and lived and strived with for the better part of a decade.

But they all nodded in agreement.

"Just do it," David said.

You might reasonably wonder why I didn't protest louder, or why I didn't counsel Michael about how he could have protected himself. But remember—I was in a unique and highly challenging position. I was the manager of Van Halen; I worked for the band, and three members of that band were now unified in their desire to push the fourth member to the very fringes of the organization. Moreover, while I liked Michael, the truth is, he was the one member of the organization

who rarely came to me with any of his problems. Granted, that might have been because he was more emotionally mature and generally happier in his personal and professional life than the other guys. Michael had a degree of contentment that the others simply did not enjoy. So, while our relationship was cordial and professional, it would be inaccurate to say that we were close. My wife did not go shopping with Michael, the way she did with Al. Michael did not come into my room late at night and curl up on my lap, the way Edward did. And I did not spend endless hours discussing promotion and marketing with Michael, the way I did with David.

Michael was just . . . there. Quiet, dependable, unassuming. In the end this proved to be his undoing.

Within another week or so, a letter had been drafted by the band's attorney. As with most legal documents, it was cold and clinical, devoid of the feeling that such a grievous emotional betrayal signifies. It read as follows:

Dear Michael Anthony:

You and the members of Van Halen have reevaluated the writing and composing services in contributions of each member of the Van Halen group on behalf of Van Halen as a company—a corporation. As a result of such reevaluation, you and the undersigned have agreed that, in respect to musical compositions embodied in the record album entitled "MCMLXXXIV (1984)," and with respect to musical compositions embodied in any subsequent recordings performed by Van Halen thereafter, you shall not be entitled to share in the publisher's share of revenues derived from the 1984 compositions or subsequent compositions; nor will you be able to participate or share as a writer in any of the revenues derived from the writer's share of revenues from the 1984 compositions. Accordingly, for good and invaluable considerations, receipt of which is hereby acknowledged, the parties agree . . .

If Michael had come to me with that piece of paper, which was basically a contract addendum that would completely change the course of his life, and asked me my opinion, I would have told him, in no uncertain terms, "Tear it up. Tell them to go fuck themselves. You don't deserve to be treated like this." But Michael did not come to me. He did not share with me his opinion on any of this. He simply did what he was told by the other guys in the band.

He signed the paper. As did David, Alex, and Edward.

From that moment on, Michael was basically a wage earner, as opposed to a partner in the corporation. The largest part of his income was now derived from merchandising, and while that was not an insignificant amount, it paled in comparison to what the others were making. Think about it: Michael went onstage every night and played to the best of his ability. He was a founding member of Van Halen, currently one of the biggest bands in the world, and yet he was treated like a disposable piece of the machinery. It was bad enough that they were cutting him out of future revenue, but to rewrite the contract in such a way that he would not even share in royalties from the biggest album the band would ever produce, when that album was already out in the marketplace?

Utterly cruel.

I can't imagine how Michael was able to stand up there onstage every night, smiling and playing bass in his customary carefree manner . . . as if everything was right with the world, when in fact he had been stabbed in the back by the very people to whom he was closest; the people he should have been able to trust with his life and his livelihood. They had turned on him, and in so doing, it seemed, they had broken not just his spirit but the spirit of Van Halen, as well.

17

THE LONG GOODBYE

I've always been a show-off, but I've also always had
something to say. I will express myself through other
avenues. Just so long as I'm famous. So long as the
spotlight's on Dave.
—DAVID LEE ROTH (1984 INTERVIEW WITH
THE SUNDAY TIMES [LONDON])

Funny thing. Just about every time Van Halen walked
off the stage during the 1984 tour, David would lean
into the microphone and bid the band's adoring fans
farewell with the following message:

"Thank-you, (insert city name)! See you in 1985!"

This was a false promise. There would be no 1985. Not for
David Lee Roth. Not for me. And not for Van Halen as we
knew it.

The North American tour ended in mid-July with three
consecutive shows at Reunion Arena in Dallas. On the last
night, David insisted that the show close with a massive
number of balloons falling from the rafters. The rest of the
guys in the band thought this was stupid (and I agreed with
them)—it felt like something you'd see at a sporting event
or a pop concert, not a Van Halen show. But it was so ex-

hausting to fight with David that the rest of the band simply let him have his way. I mean, really—if David wanted to turn the concert into something resembling a giant children's birthday party, then let him. Unfortunately, a technical glitch temporarily obstructed the balloons' release; by the time they fluttered to the arena floor, most of the crowd had exited the building.

In retrospect, this was a fitting coda for Van Halen: despite the millions of records sold, and the still-brilliant stage show, there were massive problems behind the scenes. And no amount of superficial gimmickry (whether it be a few thousand balloons or an MTV Lost Weekend with Van Halen contest that drew more than a million entries) could make things right.

We took a month off after Dallas before embarking on the final, brief leg of the 1984 tour: five dates on the Monsters of Rock tour in Great Britain, Sweden, Switzerland, and Germany, playing alongside heavy metal and hard rock icons such as AC/DC and Ozzy Osbourne and a hot newcomer, Mötley Crüe. In theory, this should have been a great way to finish up the biggest tour in Van Halen history, celebrating the band's most successful album. In reality, it was something else entirely: a bitter and sad slog to the finish line by a band that was breaking apart.

The trouble began before we even got on the plane. And by plane, I mean the Concorde. We all were excited about taking the supersonic jet to London—it was a nice perk for the final portion of the tour and felt well earned. My hope was that it would put everyone in a better frame of mind. Just a handful of shows, a nice European trip spread out over a couple weeks. It should have been easy. As I climbed into a limo with Jan and David, bound for the airport, I was even somewhat optimistic. But it took only a few minutes for David to spoil the mood.

"Hey, Noel," he said, pulling a small cassette recorder out of his carry-on bag. "I want you to hear something."

David was a fan of all kinds of music, and was fond of putting together mix tapes, so I figured he just wanted me to hear an artist he liked. But no. That wasn't it all. As he hit the play button, I looked at Jan. What I heard sounded vaguely familiar, a cover version of a song I recognized but couldn't quite place. And then it hit me: "California Girls."

The intro sounded like a virtual mimic of the Beach Boys' standard, but when the vocal track kicked in, there was no mistaking the singer. *Diamond Dave.* I say that not as a compliment, but as an acknowledgment that this version of the song—plodding, treacly crap—perfectly fit the nickname. It was not the David Lee Roth who howled "I live my life like there's . . . no tomorrow!" Or even the Dave who could infuse covers of "You Really Got Me" and "Pretty Woman" with enough muscle and energy and sex appeal to make them sound like Van Halen songs. Those were covers that simultaneously paid tribute to and in some ways improved upon the originals.

But this?

This was an abomination.

I looked at Dave. He smiled and bobbed his head in time with the music. He mouthed the words along with his own vocals.

What in the name of Christ . . . ?

My assumption, at first, was that David had decided to record a cover of "California Girls" and then present it to the band as an option for the next album. But he had to have known that the song was an unlikely choice for a Van Halen cover, and that this interpretation—cheeky, kitschy, almost over the top in its silliness—was completely inappropriate for Van Halen. Shit, Edward and Alex would laugh him out of the room for even suggesting such a thing.

And David knew it. Which is why he had no intention of offering it to the band. Oh, no, David had other plans for "California Girls," and for his own career.

"What do you think? Pretty great, huh?"

"Well, David," I began. "It's . . . interesting. I'm just not exactly sure what to make of it. You really think the other guys will go for this?"

"No, I do not," he said with a laugh. "That's why I'm going to put it out myself."

There was a long pause as we both let this hang in the air. I finally asked David what he meant, and he went on to explain that he had already recorded demos of a few covers, and as soon as the tour ended he would be going into the studio with Ted Templeman to put together an EP. He had it all mapped out, and he expected me to be happy for him. I was his manager, after all, just as I was the manager of each member of Van Halen. If David had aspirations for a solo career, then I was supposed to help him achieve those goals. Or so he thought, anyway. But I did not shake his hand or pat him on the back, because I did not view this as a smart or considerate career move. I viewed it as a selfish and short-sighted self-indulgence, one that would not only set David on the path to becoming a Vegas lounge singer but would inevitably crush the soul of Van Halen.

If David put out an album, or even just an EP, in early 1985, as he planned, then what would become of Van Halen? There would be no new album. There would be no tour. David would be in one place, focusing on his solo endeavors, and the Van Halen brothers would be in another, doing whatever the fuck they were doing—plotting Dave's expulsion, in all likelihood.

But here was David, sitting next to me in a limo, preparing for the final leg of Van Halen's biggest tour, and he seemed utterly clueless as to the devastation he was about to wreak on the band and everyone involved.

"We're hoping to get it out in January," he said with a big smile. "What do you say?"

What do I say? I say you're a fucking idiot.

What came out of my mouth, however, was a much more benign and measured response: "Really? January?"

David nodded proudly.

"And when are you going to tell the other guys about this?" I asked.

"Soon as we get on the plane," he said. "I think they'll be excited."

"Oh, I'm sure they will be."

They were not excited. I watched from my seat in the Concorde lounge as David pulled out his cassette recorder and cued up "California Girls" for Edward. I could not hear their conversation, as they were a few seats away, but I could hear the music and read the body language: David smiling and bobbing his head rhythmically, clearly proud to share the news of this next phase of his professional life with his bandmates. And Edward slouched in his seat, staring straight ahead, his face devoid of emotion.

Now, this is precisely what I would have expected, and I have no idea why David would have anticipated a more gracious or enthusiastic response. Had this been a suggestion for a Van Halen song, I'm sure Edward would have shot it down, but this was not a collegial overture; whether he realized it or not, this was David telling his partner, in essence, *I'm going off in a different direction; and if you don't like it, well, fuck you.*

And Edward clearly didn't like it. There had been little communication between them in recent months, their interaction limited, for the most part, to their time onstage, when they could feign a sort of brotherhood for two hours in order to put on a great show and give the fans their money's worth. I never stopped admiring that aspect of Van Halen: no matter how uncomfortable the interpersonal dynamics became; no matter how much they abused alcohol and drugs before, during, and after the show, these guys somehow held it together when they went onstage. With only a few minor exceptions, almost all of which would have gone unnoticed by the casual observer, their concerts were nearly flawless. At the very least, they always provided the nonstop energy and party for which they had become famous. Honestly, given that they were riddled by substance abuse, had recently exiled their bass player,

and their lead guitarist and lead vocalist could barely stand to be in the same room together, I don't know how they survived for the duration of the tour.

But the truly curious thing was the way David presented his new venture. It was almost as if he didn't comprehend the weight of what he was doing. When you are the front man for a band as big as Van Halen, and you suddenly decide to put out a solo EP (which would be followed naturally by a full album), without consulting your bandmates ahead of time, the news is likely to be met with something less than wholehearted approval. And yet David didn't seem to understand this. Or maybe he just didn't care. Maybe this was his way of driving a nail into the Van Halen coffin. Rather than quit, he would release a solo album of aggressively mediocre material, bask in the spotlight on his own, and wait for his bandmates' response. I honestly have no idea what he was thinking, or whether he had any sort of strategy in mind.

Regardless, we embarked on the Monsters of Rock tour with this bizarre and distressing bit of news hanging over our heads. But if you saw Van Halen play at Donington Park in Leicestershire on August 18, you never would have known there was anything wrong. This was Van Halen's first UK performance since 1980, and they made the most of the opportunity, upstaging headliners and Australian heavy metal stalwarts AC/DC (in my opinion, anyway, and I wasn't alone). The band took the stage at sunset and proceeded to blow away a raucous and deeply inebriated crowd of some 65,000 spectators, many of whom had been camped out for days. Multiact festivals are challenging under the best of circumstances—by definition, they cater to a broad audience with divided loyalties—and Monsters of Rock was about as hard-core as any festival we played. When you share a bill with AC/DC, Mötley Crüe, and Ozzy Osbourne, you'd better bring your A game—and Van Halen surely did, ripping through sixteen songs in a little more than an hour, simultaneously playing to

their fans and deftly rebuffing the (not unexpected) hostility exhibited from some corners of the crowd. Some AC/DC fans, after all, were sure to view Van Halen as posers—prissy California pop/rock lightweights when compared to the heavier sound of the Aussies.

This, of course, would have been inaccurate, and Van Halen was more than up to the challenge. Not just from a musical standpoint but from an attitude standpoint. When a young lady near the stage flicked her tongue out at David, he replied sassily, "Don't stick your tongue out at me, honey—unless you intend to use it!"

Or, when an empty bottle of . . . something . . . was hurled toward the stage: "Throw another bottle up here and I'll come down there and fuck your girlfriend!"

This was David at his best: a wise-assed, hyperactive vocalist who atoned for limited range with spectacular stage presence and energy. And even now, in what would prove to be his final lap with the first iteration of Van Halen, he still had the swagger and showmanship of a rock 'n' roll superstar. He knew how to tuck away the anger and resentment for a couple of hours each night and give the people what they wanted. I was hugely disappointed and frustrated by David in that last month, but I remained impressed by his ability to keep one important thing in mind: *The play's the thing.*

Not that David would have recognized that line or could distinguish *Hamlet* from a ham sandwich, but he understood it intrinsically, and that was something. It just wasn't enough. Fans saw only the show, and they thought Van Halen was the tightest band in the world, on and off the stage. They weren't there when Edward was hanging out backstage with Neal Schon of Journey, ungraciously noting that Michael Anthony's solo, which the crowd loved (despite the fact that he ripped his pants in the middle of it), had been composed and spoon-fed to the bassist by Edward.

"I had to teach him that," Edward said. "Every note."

Nor were they around to see Edward's meltdown in the

dressing room after their set, provoked by a guitar glitch during the show. Valerie Bertinelli had been so frightened by the outburst—and I mean legitimately concerned for her own safety—that she sought out Jan for comfort and advice. Jan found me, and I went to the dressing room to calm Edward down—no easy task given that he was coked up and drunk off his ass. Unbeknownst to fans, this sort of damage control had become not just part of the job with Van Halen but, in fact, most of the job.

WE HAD A COUPLE DAYS OFF after the Donington Park show. Again, for the most part, we were a family divided. Although we all stayed in the same hotel, we didn't socialize much together—unless we had to. Valerie was with Edward; also there was Alex's new wife, Kelly, whose sister was married to a guy in the music management business (this was a problem for me, as I would later discover). And I was with Jan. That left David, as always, on his own. Which was a problem. As an example, one night there was a knock on our door. Jan answered to find David standing in the hallway, looking lonely and bored.

"Hey, guys," he said. "Want to smoke a joint?"

"Not really," Jan replied (she hated smoking weed, even if it was the most common thing in the world; it simply didn't agree with her).

David pulled a prerolled spliff out of his pocket, held it up to his nose and inhaled lovingly, then walked into the room, though he hadn't been invited in.

"Noel?" he said, looking my way.

"No, thanks, David. Not tonight."

He shrugged, pulled up a chair, and laughed. "Well, then, I guess you can just watch while I smoke alone. That okay?"

This was David at his most annoying but also his most vulnerable. There was something sad and needy about the way he would inject himself into situations where he wasn't nec-

essarily wanted; and about the way he was unable to form a relationship that could span more than a few weeks. But just as you'd work up some compassion for David, he'd start behaving like an egotistical prick, and you'd understand why he was always alone.

Although it was, by comparison, a rather trivial and benign encounter, this particular night has stuck with me over the years as a prime example not only of David's roaring narcissism but of his tone-deafness—not from a musical standpoint, but in terms of interpersonal relations.

David spent a few hours in our room that night, regaling us with stories that we had heard dozens of times but that he expected would provoke laughter or approval. He positioned himself for most of the evening in a chair that faced a mirror. I do not believe this was an accident, as David's affection for his own reflection by now bordered on the pathological. And so, as he told his stories and took drags on a joint, he would periodically pause and vamp for himself in the mirror—lowering his eyes, sucking in his cheeks, giggling in a come-hither manner.

"I'm hungry," David said at one point. "Let's order some food." He called Eddie Anderson and asked him to run out to an Indian restaurant and bring something back.

I protested, to no avail.

"David, no offense intended, but I'm not a big fan of Indian food. Can we get something else?"

He waved a hand dismissively.

"Nah, you'll love it. Trust me."

I looked at Jan. She shook her head and tried not to laugh. This was David in a nutshell. It wasn't like I hadn't ever tried Indian food. For Christ's sake, I had traveled around the world multiple times. Of course I had tried Indian food! I knew what I liked and did not like.

None of this mattered to David. He was, as always, unconcerned with anyone but himself. And so, like weary subjects before a clueless and arrogant emperor, we sat in my

hotel room all night, eating terrible Indian food (Jan actually got sick from it and stayed away from Indian food for many years afterward), listening to stale stories, and watching David, stoned out of his gourd, fall in love with his own reflection.

It was tedious . . . it was sad . . . it was intensely weird . . . it was old. And it made me realize how close we were to the end.

WE WERE WITH THE MONSTERS OF ROCK TOUR as it invaded Sweden and Switzerland and finally Germany. There was a show in Karlsruhe on September 1, and then, on September 2, in Nuremberg, which would turn out to be the last live performance by the original Van Halen lineup. And what an appropriately creepy and depressing venue it was.

The sprawling Zeppelinfeld complex was a place of enormous historical significance and weight. Originally named in the early part of the twentieth century, after Ferdinand von Zeppelin landed one of his dirigibles on the grounds, the Zeppelinfeld was redesigned and expanded a few decades later by Albert Speer, the favorite architect of Adolf Hitler. The complex included a stadium that could seat nearly 200,000 people, and it was here that the Nazi party held many of its biggest rallies, and where the Führer delivered his hate-filled diatribes. We played at a newer stadium on the same grounds, but the original stadium was still there, although not in great shape, and the sense of history that permeated the grounds was palpable. The place was so acoustically perfect that you could imagine every word being heard from the podium without much amplification at all. And yet, knowing the substance of those speeches, and their impact on the entire world, and the waves of death they inspired, it was hard not to be both moved and hugely saddened.

There was nothing special about that last show, aside from the fact that it was indeed the last show. Had the band known

it was such an important milestone, maybe they would have done things differently; then again, maybe not. As it happened, Van Halen churned through another superlative set, giving no indication that the end was near. Well, almost no indication. The band's final song was a cover of "Happy Trails," a song Van Halen rarely performed live, but one that could not have been more appropriate under the circumstances. There was David, at the edge of the stage, his hair matted and his face glistening with sweat, growling out the final verse, as the band played on . . .

> *Happy trails to you,*
> *Until we meet again.*
> *Happy trails to you,*
> *Keep smiling until then.*

The following day we boarded a luxury tour bus bound for Paris, where we would pick up our return flight home. It was a long, meandering ride through the lovely and scenic Black Forest of southwestern Germany. But what I mostly remember about that trip was the lack of euphoria and camaraderie that accompanied it. We were all tired—tired of the travel, tired of the tour, tired of each other. The trip home at the end of a tour usually feels celebratory; this time I was filled with resignation.

At some point on that endless bus ride David sat down next to me and Jan. He'd been drinking and smoking weed, and immediately began holding court—talking a mile a minute, repeating old stories, all to the accompaniment of a Motown mix tape on his cassette recorder. Of everyone on the bus, David, at that moment, was probably in the least foul mood. He was looking forward to getting home and working on the mixing and promotion of his EP. He wanted to talk about this in great detail, but he had no interest in talking about Van Halen, and what the future might hold for the band that had brought him wealth and fame.

As the bus rolled on, David began drinking harder and faster. He smoked more weed. There was cocaine all over the bus, and David partook of this, too. Eventually, and predictably, his mood began to sour. He got mean and nasty toward everyone on the bus—from his bandmates to the crew. Jan and I eventually made our escape and peeled off to a different section of the bus, leaving David talking to himself; eventually he fell asleep.

A short time later, Jan informed me that she had to use the bathroom. Having already seen the lavatory, I warned her against it.

"It's broken," I said. "There's shit everywhere. Believe me, you don't want to go in there. If you can hold on a little longer, I'll make sure the driver stops in the next town, and you can find a clean ladies' room."

But this was a tall order, for the distance between villages in the Black Forest can be extreme. At some point Jan made her way to the bathroom, with the hope that maybe the situation wasn't quite as dire as she had been led to believe. This was a mistake. As she got to the back of the bus, she noticed that the door was partially open, and inside she could see the figure of a man on his hands and knees.

That man was David Lee Roth.

Drunk, stoned, and no doubt riddled by motion sickness and bus fumes, David's head was deep in the bowl. Transfixed by the horror, Jan watched as David vomited into a toilet bowl that had already overflowed repeatedly. With his hands braced against the rim, his back rising and falling with each spasm of retching, he let his hair fall into the foulness of it all. It went on like this for what must have seemed like an eternity. Finally, she turned and walked away. When she sat down next to me, her face was ashen.

"What's wrong?" I asked.

"David is in the bathroom getting sick," she said. "And I don't feel so good myself."

More than thirty years later Jan will sometimes still cringe at the memory of that incident, at the sight of one of rock's

most famous and glamorous vocalists puking into a clogged toilet bowl in the back of a bus.

"I can't get that image out of my head," she will say. "How long before it goes away?"

My guess would be forever.

18

THE WRITING ON THE WALL

In January 1985 I got a call from Alex. I figured this wasn't a great sign, as I had heard very little from him or Edward in recent months. Most of my time was devoted to David, who had returned from the Monsters of Rock tour and immediately begun developing his solo career. He worked every day with me and Peter Angelus on developing a plan for his EP. As for the other guys? Well, they never came to the office, so my entire life, from a business standpoint, was now centered around David Lee Roth.

It was, to say the least, depressing.

More than once I found myself thinking, *What am I doing here?* I mean, the money was good—thanks to *1984*, Van Halen was still generating vast revenue—but I was enormously frustrated and bored out of my mind. Van Halen, as an active musical entity, had almost ceased to exist.

And the guys were so difficult to manage. Sometimes I'd catch myself thinking about what it had been like seven years

(or even three years), earlier, when they were straight, or at least half straight, and still hungry and playful, and I'd be overcome with melancholy. Van Halen should have been the biggest band in the world. But it wasn't. It was a band on hiatus . . . a band with no direction. David Lee Roth and Edward Van Halen were seminal figures in the world of hard rock, and now they were barely speaking to each other. And when they did speak, they didn't speak politely. They had different interests and different goals. In a sense, they were like parents going through a divorce; they just didn't know it. And I was like a kid caught in the middle.

A call from Alex was one of many dominoes that would fall in the ensuing months. I could tell by the tone of his voice that he was uncomfortable—the way someone sounds when they are making a call they have been avoiding for some time.

"Hey, Noel, we have to do some business," Alex said.

"Sure thing, Al. What did you have in mind?"

There was a long pause.

"Well, I'd like you to come with me to meet with our accountant. We're going to go over the books together."

Holy shit . . .

My heart began racing—not because I feared the discovery of any illicit activity (I knew I could account for every penny that passed through our organization) but simply because of what this represented: the first step (and an obvious one) toward having me removed as manager. It was a fairly standard tactic: try to prove financial malfeasance rather than admit you simply want to replace your manager because you'd rather work with someone else. I was intimately familiar with this strategy but tried not to let on.

"Sure, Al. No problem."

The next day Al picked me up and we drove together to the office of our accountant, Michael Karlin, who had been working with us for years. When I got there I was somewhat surprised (although not shocked) to see that Alex had invited Valerie Bertinelli's financial adviser, who was now apparently consulting for Edward and Alex, too. This could have been

a sticky situation, but I knew that I had truth and honesty in my favor. By the time I got there, Michael had everything laid out—expenditures and profits on touring, merchandising, record sales . . . everything. And as he and the moneyman went over the figures, it became apparent that there wasn't so much as a nickel out of place. Not only that, but when the numbers stare at you in that way, they don't lie.

"Wow, you guys have really done well," Michael said.

The moneyman nodded in agreement.

Al just sort of sat there looking bewildered and vaguely unhappy. I'm not sure exactly what he expected would come of this meeting, but he couldn't have thought they'd be placing a gold star on my forehead. Yet that's basically what happened.

We made uncomfortable small talk on the drive home. As I got out of the car, Al smiled and thanked me for my time, as if an unnecessary financial review—which by nature is accusatory and threatening—was no big deal. I bit my tongue and said, "Anytime, Al, don't worry about it."

As he drove away, I muttered under my breath, "You little fucker."

The writing was on the wall by now, and I decided to go down swinging. Seven years into my tenure as the manager of Van Halen, I still didn't have a legitimate contract. Just the same old month-to-month deal under which I had labored since 1978. Every time I thought about this it made me angry. I had gotten them out of an onerous contract with their record label and negotiated a new and lucrative contract that pushed the band to a place of prosperity and prominence. Financially speaking, we had all done very well, but I had no financial security, and after seeing what the guys had done to Michael Anthony, I knew I had to at least try to protect myself. I had my personal attorney write a formal request to the band asking for a new and long-term contract on my behalf.

I didn't demand anything unreasonable—just the same share I had always received. What I wanted was security, to ensure, for example, that I wouldn't suddenly be cut out of the proceeds from merchandising, a venture I had started and

turned into one of the most profitable parts of the Van Halen brand. I didn't ask for a greater percentage of anything. I simply asked for a real contract, one that reflected the industry standard: seven years, guaranteed. That way, at least, I'd be protected. If Van Halen wanted to replace me with a new manager, they'd have to buy out my contract. That much I had earned.

But the protection would not kick in until after I had a signed contract. Under the current arrangement, I could be terminated at any time, for any reason, on thirty days' notice. So, if they viewed my overture as threatening or ungrateful or simply an impediment to doing what they really wanted to do—which was to hire a new manager—as it stood, they could simply swat me out of the way. I knew this. I understood the risks. But I figured I was on the way out anyway, so I had nothing to lose. Maybe, I thought, this will prompt a period of reflection, followed by appreciation.

Or not.

The truth is, I had lost Van Halen; more important, they had lost themselves. I referred to them, only half-jokingly, as a DEA band: drugs, ego, alcohol. I really wondered how it had all fallen apart. Van Halen in 1978 had all the promise in the world. And the hunger to make good on that promise. They had the most gifted and innovative guitar player I'd ever heard; they had a brilliant front man; and they had a good drummer and a good backing bass player—competent musicians who understood their supporting roles and played them well. It didn't matter that Alex wasn't John Bonham or that Michael wasn't John Entwistle. They didn't need to be. They simply had to show up and keep time. More than anything else, a bass player and drummer must be in synch; on that level, Michael and Alex were perfect. They were right for each other and for Van Halen. Without Van Halen? Well, my personal opinion is that both Michael and Alex would have struggled. Gifted artists abound in the music business—some of the very best are unknown to the layperson simply because they spend most of their time in the studio, doing session work

as independent contractors. These guys neither need nor want the headache and stress that comes with being part of a band, the touring and the bickering and the endless struggle to break through on a major scale. Instead, they go to a comfortable studio every day and work with an eclectic mix of artists. They are handsomely compensated because they know how to do the job right, every time. They live relatively stress-free lives, and they want to keep it that way, thank you very much.

They are also insanely talented and completely reliable. In sum, they are consummate professionals in every sense of the word. Alex and Michael might have found the session world somewhat challenging. But as long as they were under the umbrella of Van Halen, they were protected. They were solid musicians who found the perfect vehicle and became superstars. I felt bad that Michael had been pushed to the periphery and I worried about what might become of him without Van Halen. I had a harder time working up much sympathy for Alex.

While three-fourths of Van Halen sat around waiting for divine inspiration, David Lee Roth proceeded, like a force of nature, with his plans to release a solo EP. To put it mildly, this was not the type of venture that David's fans would have anticipated, but it was very much in keeping with the sample he had played for me on the Concorde several months earlier, and in fact did not stray far from the flamboyant cabaret act that had long been trying to break through David's hard rock exterior.

The four-song EP, *Crazy from the Heat*, was released on January 28, and almost instantly became a polarizing entry in the Van Halen/David Lee Roth canon. Many fans hated it. Some found it interesting and fun. For David, though, the EP's primary purpose was not to placate or even entertain the legions of Van Halen fans but rather, to broaden his own audience and expand upon his brand by trying something different, while simultaneously recording the kind of music that he actually liked. David was into high-energy party music, and not just of the pop metal variety. He was a big fan

of Motown, for example, as his personal mix tapes often reflected. On that level there is no denying that *Crazy from the Heat* was an unqualified success. Critical response might have been lukewarm, at best, but the EP was embraced by Top 40 radio stations and fans alike (these things go hand in hand), spawning two hit singles and popular videos that propelled the EP to platinum status.

In other words, David Lee Roth had very quickly positioned himself as a bona fide superstar solo act—a campy, cheesy solo act, to be sure, but I don't think that bothered him in the least. The David who pranced around beaches in the video for "California Girls"? The guy who strutted about playfully while crooning a Louis Prima–inspired medley of "Just a Gigolo" and "I Ain't Got Nobody"?

That guy was the real David Lee Roth.

A great many Van Halen fans might have found this version of Diamond Dave repellent, but I honestly think it was liberating for him to finally unleash his inner lounge singer. And while I hated every song on the EP, even as I promoted the hell out of it, there is no arguing with success. Whether David had deliberately sabotaged Van Halen or merely planned properly and judiciously for a post-VH future, he had successfully taken the next step toward independence, and had done it in a fashion that was at once shameless and sly. Consider, for example, the winking third-person reference: "I'm just a gigolo, and everywhere I go, people know the part Dave's playing!"

Or did they? Was this just a temporary version of Dave? An experimental side project to fill time between Van Halen projects? Or a big fat, feather boa of a *fuck you* to the band that had made him a household name?

If it was the latter, David never let on. Whenever he was interviewed—and that happened a lot during the six months after the release of *Crazy from the Heat*—he repeatedly insisted that his heart still belonged to the band from Pasadena. He was merely flexing his creative muscles, trying to avoid typecasting, because, you know, Diamond Dave doesn't like to be put in a box.

Or some such nonsense.

Who the fuck knows? I was with David all the time in those days, and I had trouble separating the sincerity from the shit. The guy was impenetrable.

In some ways it was easier to deal with Alex, whose alcoholism could make him angry, vindictive, and manipulative, but also rather transparent. David was much harder to read. Which is why I did not know what to make of the call I received from David in early February '85. Most of my conversations with David in those days naturally revolved around his solo career, but this time he wanted to talk about Van Halen. He said the band wanted to have a meeting with me. The topic, he said, was my role as Van Halen's manager.

"The guys want to talk about the offer you've made," he said. "Is that okay?"

I said that it was, and suggested we have the meeting at my house, since it was easier than going to our office in LA. David said fine. Before he hung up, however, he informed me that Michael would not be part of the meeting, since he was no longer a full partner.

"Okay," I said, trying to sound calm, though for some reason that small piece of news struck me as ominous. But not nearly as portentous as what he said next.

"Noel, I have to tell you something," he said. "You'd better watch out for Al."

"Really?" I said, feigning surprise.

"Yeah. I can't tell you any more than that. Just be careful."

Now, you might reasonably ask why David would give me any advance notice about what was to come, and the answer was simple: at the same time that my departure was being engineered by Al, David was planning his own exit. And, frankly, he wanted me to be part of that strategy. He figured if I was fired by Van Halen, I'd be eager to help orchestrate his career. In other words, he was sort of working both sides of the street. A more generous reading of the situation would be that David honestly felt we were friends, which only speaks to how deluded he really was.

The next day we got together at my house. Al and Edward drove over together, while David, as usual, rode his bicycle. It was the first time in several months that I had been in the same room with Alex, Edward, and David. Hell, it was probably the first time the three of them had been in a room together. It felt weird to be conducting official band business without Michael present, but clearly the parameters of our organization had changed. We were no longer a family; we were a business entity that was breaking apart.

It's funny the way certain events in your life become not just memories but something closer to archival footage, forever playing on a loop in your mind's eye. All you have to do is press play. Sometimes you don't even have to do that. The video just starts on its own, whether you want to relive it or not. And it never loses clarity. I can still see Alex and David sitting together on my sofa, Al appearing grim, and David looking like he wanted to run out of the room. I see Edward lying on the floor directly in front of them, his eyes glassy, as usual, but his ever-present smile strangely missing. Edward used to remind me of Pig-Pen, the *Peanuts* character forever surrounded by a cloud of dust. In Edward's case the cloud was white and stemmed from his intractable use of cocaine. As he shifted his weight from one arm to the other, tiny little puffs of white powder rose like talcum from his shirt. He was obviously high, but not happy. But then, "happy" was a word that rarely applied to Van Halen at that time.

For what seemed like an eternity, we sat there in silence, no one willing to get the meeting started. I felt like I was hosting my own execution—in my own home. So, what the hell? Why not just pull the trigger myself?

"Okay, boys," I began. "What have you decided?"

They all exchanged glances. Obviously, they hadn't developed a strategy for the meeting. To my surprise, Edward spoke first.

"You know I love you, right, Noel? And I'll always want you around . . . to be part of this."

I shrugged. "Thanks, Ed. What does that mean?"

Edward looked at the floor, then at his big brother. Ed's reaction was so sad and weak that I almost felt bad for him. On cue, Alex assumed the role of enforcer.

"Noel, here's the way it is. We're not going to give you a long-term contract."

There was a pause . . . an opening for me to speak . . . but I opted to remain silent. I didn't want to make this any easier for Al or for any of them. Moreover, I had nothing to say. If this was indeed my execution, I would not go down screaming and crying. I would leave the world of Van Halen rather stoically.

"In fact," Alex continued, "we're not giving you a contract at all. We've decided we're not going to give you any of the merchandising, we're not giving you any of the publishing. We're not giving you any royalties or touring revenue. All we want you to do is book our tour."

Another long pause as Alex waited for me to say . . . something. I did not. I just stared at him.

"Noel," he finally said, "we're getting new management."

I had been staring hard at Al, but the sound of someone trying to catch his breath caught my attention. I looked at David. There were tears rolling down his cheeks.

Come on, Dave! Get a grip!

I'm not sure what was going through David's mind at that moment. The silence in the room eventually prodded Al into offering a few vague and feeble reasons for my dismissal—*it's time for a change, we want to move in a new direction,* that sort of thing. The only specific thing he mentioned regarding my performance was his disappointment over losing the Sparkomatic endorsement to Supertramp. I didn't even have time to respond to that bit of nonsense; David beat me to it.

"That . . . that wasn't Noel's fault," he said, his voice hiccupping through the tears. "That was my fault. I fucked it up."

Alex gave David a hard and quizzical look, and I realized then that Alex was hearing this news for the very first time.

Holy fucking God. . . . David never told them what really happened!

Anyway, water under the bridge, or over the dam, or wherever the hell it is that water goes when the damage is done. It might have been nice for David to demonstrate some accountability before they had decided to shit-can the manager, but I'm not sure it would have made much of a difference. There were personal factors in play here that rendered any reasonable arguments about performance superfluous. That much was obvious. The contract I negotiated on their behalf had doubled the band's income, and would continue to do so for many years. Apparently, that had been forgotten. So, too, had the fact that these guys weren't even interested in a merchandising venture until I put it all together for them and showed them how much money we could make.

And now they were going to cut me out of that very same business? As if I'd had nothing to do with it?

This was a very cold room, indeed.

After all I had done for Van Halen—after dedicating my entire life to the band for the previous seven years—I was left with virtually nothing. I was no longer the band's manager. I wasn't even the road manager. The small and meatless bone they tossed my way was a meager stipend to book their next tour and then get the fuck out of the way. In retrospect, it seems incredible. And yet, at the time, I wasn't even surprised.

As much as I disliked Al by then, he was the only member of the group behaving somewhat like a grown-up in this particular meeting. David sat on the couch with his face buried in his hands, unable to speak after coming clean about the Sparkomatic endorsement. And Edward? Prone on the floor, hungover and coked out, he could barely muster anything more than utter passivity.

"Ed, would you care to weigh in on any of this?" I said at one point, though I'm not sure why. I guess it's because Edward was the one member of the band for whom I had always felt genuine affection. On some level I wanted to hold him accountable for what was happening. But Ed was much too weak and too far gone to get involved.

"Whatever Al wants," he said, his eyes brimming with tears. "I can't fight with him anymore."

A few minutes later it was over. The last thing I said, as I walked them to the door, was, "It's been a pleasure, guys."

There was no response, just a nod from Alex and muted sniffling from Edward and David. As the boys walked away, Jan came out of our bedroom. We stood together and watched out the front window. For a moment they stopped at the end of the driveway and began talking to each other. The conversation quickly became animated—it looked like David and Alex were arguing, though I can't be sure. But it ended quickly. David hopped on his bike and pedaled away, and the brothers Van Halen got into their car and drove off into the California sunset.

I never spoke with any of them again.

EPILOGUE

few weeks later Jan went into the hospital. She'd been sick for some time, and had finally reached the point where surgical intervention was required to remove adhesions in her abdomen. It was a painful procedure and an even more painful recuperation, but she tolerated both with courage and good humor, as she did just about every inconvenience in her life. I was sitting by Jan's hospital bed one day, holding her hand, when a nurse entered the room carrying a large vase filled with roses and other flowers. It was beautiful, and the very sight of it brought a smile to Jan's face.

"Who are they from?" she asked.

I shook my head. "Let's take a look." There was a small envelope on a plastic pitchfork in the middle of the arrangement. I plucked it from its perch and removed a card. Inscribed on it was a brief message:

"Get well, Jan!"

It was "signed" by Van Halen. Not individually, by each member of the band, but rather by the band as a sterile corporate entity.

I looked at Jan and tried to muster a smile. She shrugged, squeezed my hand tighter. Neither of us knew what to say. On one hand, it was nice of them to at least acknowledge Jan's illness, even in this small and perfunctory way. On the other hand . . .

Fuck you guys.

A half hour later, as karmic support of this response, I got a phone call from my attorney. We exchanged pleasantries for a few minutes, he asked how Jan was doing, and then he got to the reason for his call.

"The band just sent over your termination letter," he said. "You have officially been fired."

"Is that so?"

"Yeah . . . They're giving you thirty days to clean out your office and turn over all band property. I'm sorry, Noel."

There was no reason to apologize. The news was hardly unexpected. Still, to receive it in the same hour that flowers had been sent to my wife's bedside? That was harsh. And it couldn't have been merely coincidental. Someone in the band, or a representative of the band, had sat down that morning with a "to-do" list, and among the items on that list were the following:

- Send flowers to Janice Monk
- Fire Noel Monk

If it weren't so sad and utterly lacking in compassion, you'd almost have to laugh. Actually, go ahead and laugh anyway. I know I did.

Predictably, the band went on the offensive at this point. It wasn't enough simply to fire me; they had to challenge my reputation as well, starting with a demand that all financial records for the past seven years be thoroughly and painstakingly reviewed. Through my attorney I heard that Alex was behind all of this, which did not surprise me in the least. He demanded a line

audit to trace every penny spent on the band since I had taken over as manager. Adding insult to injury? I was required to pay for one-fifth of the audit. But that's okay. I knew I had nothing to hide. Whatever else I might have been, I was as honest and diligent a manager as you could hope to find. And, after some time and expense, that is precisely what the audit revealed. Not a single dime was deemed missing or poorly invested.

I had been vindicated.

That was small consolation given all that I had lost: my band, my livelihood, my raison d'être. I had waited years for a band like Van Halen to come along, and when it finally did, I gave every ounce of my being to the cause. For it to end the way it did was nothing short of heartbreaking.

For a while I didn't do much of anything. I still believe that David wanted me to be his manager and expected me to call. Together we could have ridden his solo career for a while. But I had no interest in that, so I never picked up the phone, and David never reached out to me. The EP was followed by a solo album and finally, in August, the news Van Halen fans already suspected was confirmed by Edward in an interview with *Rolling Stone*: David Lee Roth had left the band.

Over the years, it has been rumored that David left Van Halen on April 1, 1985—a supposed nod to his skewed sense of humor (you know—April Fool's Day). But that story is somewhat apocryphal. The truth is, as with most such breakups, it happened over a period of months and after much discussion and acrimony between the principals. In addition to the obvious personality conflicts, there were two primary issues: Edward's desire for a slower recording pace and less time on the road, and David's desire to be King of the World. It wasn't enough for David to be the voice of Van Halen; he wanted to have a solo career, he wanted to be a movie star! Indeed, this was perhaps the final straw. David had plans to develop and star in a movie that would share the title of his EP (and, later, his autobiography), *Crazy from the Heat*. He sought not only Ed's approval for this vanity project but also his creative input: he wanted Edward to help score the movie.

And therein lies the fundamental difference between the two major personalities behind Van Halen. Edward likely viewed this overture as an affront to both Van Halen and to his own personal integrity. David, on the other hand, no doubt thought that Edward should have been flattered.

The term *irreconcilable differences* comes to mind. And the funny thing is, I understood both sides. It's actually amazing that they made their partnership work for as long as they did.

As for me . . . I went through the various stages of grief, which included the filing of a lawsuit, the purpose of which was to recoup lost revenue and—as with any lawsuit—to exact at least a small measure of revenge. In neither case did it help much. Shortly after I was fired, the band began liquidating assets, including the building and all equipment associated with our merchandising operation. This was a deal worth hundreds of thousands of dollars. I did not receive a penny. Based on this deal and the forfeiture of proceeds from Van Halen revenue going forward, I sued for several million dollars. We settled "amicably" for a fraction of that amount. Among the conditions of that settlement were that no one reveal the exact dollar figure, but trust me, it was a pittance. Moving forward, I was not allowed to profit from anything associated with the band's name or logo, and I was specifically forbidden for an extended period of time from publishing a book or producing a movie related to my time with the band.

Fortunately, the statute of limitations on that one has expired, so now I can tell my story, and the story of Van Halen, as it really happened.

Okay, I know what you're thinking. Van Halen did not end in 1985. David left the band, and Sammy Hagar was brought in as a replacement. To me, that band was not Van Halen; it was, as others have said, Van Hagar. No offense to Sammy; I've not heard bad things about him, and he is a decent vocalist, certainly more versatile and blessed with a broader range than David Lee Roth. But it was never about technical proficiency with David; it was about attitude and showmanship and ego—the ability to will yourself into the spotlight, to take

a song and own it. David knew how to do that like few singers in rock 'n' roll history, and if his arrogance and ego sometimes brought out the worst in his bandmates . . . well, it also brought out the best in them.

Van Hagar sold a few million albums and filled arenas for a while, but the band lacked the sound and swagger that made Van Halen unique. I know Van Hagar has its supporters and critics, and both camps can be extremely passionate and voluble. I fall into neither camp. I simply don't care.

I've not spoken to anyone in the band since we parted ways, although I nearly crossed paths with David a couple years later. Jan and I spent the better part of 1986 traveling around the world—a delayed and very extended honeymoon, you might say. After we came home, I thought about getting back in the business. One night Jan and I went to the Roxy to see a new band. After the show we went backstage to introduce ourselves, and there, waiting in the wings, was Van Halen's former security chief, Eddie Anderson.

"Noel!" he said, pulling me in for a bear hug. "How have you been?"

I had always liked Eddie and we had enjoyed a great relationship. It was nice to see him. We talked for a few minutes, and then Eddie excused himself. He returned quickly while Jan and I were still backstage, waiting to meet with the band. I could tell that something was bothering him.

"You guys know I love you, right?" Eddie said, his voice shaking.

"Of course, Eddie. We love you, too. What's the problem?"

The problem, as it turned out, was that Eddie still worked for David. They had come to the Roxy together. David liked to go out on the Strip. He liked to listen to music, and he liked to be seen. But apparently he did not want to be seen by me.

"You have to leave," Eddie said. "David is flipping out. He doesn't want to talk to you, and he doesn't want to be anywhere near you."

To be honest, I wasn't thrilled at the prospect of seeing David, either, but his response seemed excessive.

"Eddie, I can appreciate that you're in a difficult position here, but we came to see a band, and I'm waiting to talk with them. I'm not going anywhere. David can go fuck himself."

Eddie grew more nervous.

"Please, Noel. If you stay, there's going to be a fight. It'll be a huge scene and it will be in all the papers. I don't want to have to defend David against you, but he's my boss. And if that's what I have to do . . ."

Eddie hung his head as his voice trailed off. "It's just not worth it," he finally added, in almost a whisper.

I looked at Jan, and then at Eddie. He was one of the toughest guys I knew, but in this moment he just seemed . . . sad.

"Eddie, you're right," I said. "It's not worth it."

Eddie walked us to the door, we said goodbye, shared another hug, and then stepped out onto Sunset Boulevard—home to not only the Roxy but the Whisky a Go Go, Gazzarri's, and the Starwood, where, so many years ago, Van Halen had gotten its start. In a sense, I guess, things had come full circle.

I WILL SAY THIS: for quite a long period of time I found it nearly impossible to hear a Van Halen song (circa 1978–84) without feeling anger, resentment, sadness—or some combination of the three. I never willingly listened to a Van Halen album. If I was in my car and "Runnin' with the Devil" or "Jump"—or any of a dozen other hit singles—came on the radio, I would instantly curse under my breath and change the station. It wasn't just that the song hit me in the wallet; it hit me in the heart.

But time can be a wonderful balm. As the years passed—and I don't know exactly when it happened—I found myself feeling something else. Nostalgia, perhaps. Or pride. "Runnin' with the Devil" comes on the radio now and I don't bother to change the channel. I'll listen, allow myself to be transported to a time and a place when Van Halen was one of the biggest bands in the world, and I'll think . . .

That's a fucking great song by a great fucking band.

And I was part of it.

ACKNOWLEDGMENTS

Thanks to my wife, Jan, and my daughter, Sarah, who, without either of them, this book could not have, would not have ever come to fruition. Thanks for dragging my sorry ass out of bed, and pushing me to never give up—even when I wanted to. I love you both.

Thanks to Matt Harper at HarperCollins, who gave me a shot, listened to all my stories, and decided, maybe, other people would like to hear them, too. You're the best editor a guy could ask for.

And thanks to Joe, a man of unmeasurable will and patience, for taking the little fragmented pieces of my life and transforming them into something tangible. This is a mosaic, and you are a godsend.

Thanks to Carl Scott, to Neil Zlozower, and to Justin Malet; to Dr. Sex Pistol and Zak Wilson; to Katie Steinberg and Victor Hendrickson of HarperCollins, and to Frank Weiman at Folio Literary Management. You guys made it possible.

Thanks to Gail and John Warner, for cracking skulls and taking IOUs.

Thank you to David Edward Byrd, for making my life's work

something beautiful, and to his husband, Jolino Beserra, for doing the same to my adopted home, Los Angeles.

And thanks to the boys in the band, for giving me something to talk about.

This book is for the legion of fans who, after thirty years, still find a way to email me, call me, write me, break into my backyard, and startle my dogs; and for the more polite ones who stop me on the street, in restaurants, in stores and once at the library, and almost never follow me home. I don't know how, but you guys are still interested in knowing what really happened. Well, here you go; here it is. This is for the ones who want to know all of the juicy, gory, dirty little details about my time with Van Halen—and this is for the ones who never bought the party line about what really happened in the end. This is for the truth-seekers, and maybe for the journalists, too.

Have at it.

ABOUT THE AUTHORS

NOEL MONK helped stage-manage Woodstock, served as Bill Graham's right-hand man at the legendary Fillmore East, and worked with rock musicians including Jimi Hendrix, Janis Joplin, the Grateful Dead, the Rolling Stones, and the Sex Pistols. He is also the author of *12 Days on the Road: The Sex Pistols and America,* and he lives in Colorado.

JOE LAYDEN has authored or coauthored more than thirty books, including multiple *New York Times* bestsellers.